Art and its Histories: A Reader

Art and its Histories: A Reader

Edited by Steve Edwards at The Open University

Yale University Press
New Haven and London
in association with The Open University

First published 1999

Set in Garamond and Chianti by Northern Phototypesetting Ltd, Bolton, Lancs
Printed in Great Britain by Biddles Ltd, Guildford and King's Lynn

Library of Congress Catalog Card Number 98–51422
ISBN 0-300-07704-1 (hbk.)
 0-300-07744-0 (pbk.)

A catalogue record for this book is available from the British Library

10 9 8 7 6 5 4 3 2 1

Summary

Contents

A Note on the Text and Footnotes

Editorial deletions are indicated in the usual way with ellipses [. . .]. All editorial insertions are contained within square brackets.

When explanatory footnotes have been added, they are followed by the initials of the course team member responsible in square brackets. All other footnotes are original.

Illustrations

Acknowledgements

The first and most important debt of thanks in this anthology must go to the artists, critics, theorists and historians who have generously allowed their work to be included and, in many cases, subject to editorial deletions. We are grateful for their generosity. This book forms one part of the Open University course: A216 Art and its Histories. Open University courses are by nature collaborative procedures. In the case of a volume like this, where members of the course team selected the texts and wrote their introductions, this collaborative effort should be particularly acknowledged. The course team were: Emma Barker, Tim Benton, Colin Cunningham, Gill Perry, Steve Edwards, Catherine King, Diana Norman, Anabel Thomas, Linda Walsh, Nick Webb and Paul Wood. The role of those members of the editorial and educational technology staff who participated in the discussion about, and selection of, the texts included in this book also needs to be given due credit. These colleagues will understand if the contribution to this book of Gill Perry, the course chair, is singled out for special recognition. Kim Woods, whose role went substantially beyond that of 'consultant' deserves particular thanks. Gary Elliott was the course manager for A216; his work made the completion of the manuscript much easier. Jonathan Hunt of the Open University's Co-Publishing Department was thorough and helpful at all stages of this project.

We are especially grateful to Griselda Pollock for kindly allowing us to print here an extract from a yet unpublished manuscript. This work is to be published by Routledge in 1999 as *Differencing the Canon: Feminist Desire and the Writing of Art's Histories*. Gavin Butt, Fred Orton, Adrian Rifkin, and John Seth generously gave advice on texts: no doubt this would be a better book if these suggestions had been followed to the letter. Gail Day knows more about this volume than she would probably have wished to; I am grateful for her tolerance.

Introduction

Steve Edwards

This book forms one component of the Open University second level course: A216 *Art and its Histories*.[1] In addition to this reader and material accessed via the broadcast media, this course consists of six books: *Academies, Museums and Canons of Art*, edited by Gill Perry and Colin Cunningham; *The Changing Status of the Artist*, edited by Emma Barker, Nick Webb and Kim Woods; *Gender and Art*, edited by Gill Perry; *The Challenge of the Avant-Garde*, edited by Paul Wood; *Views of Difference: Different Views of Art*, edited by Catherine King; and *Contemporary Cultures of Display*, edited by Emma Barker. All six volumes are published by Yale University Press. This reader is divided into six sections, with each part corresponding to one of the volumes in the series: the material in each section has been selected by the editors of the book to which it relates. Each text is prefaced by a short introduction that provides a full bibliographic reference, information on the author, and indicates the basic issues raised. It is hoped that these introductions offer some elementary guidelines to reading this material.

In the first instance, the role of this anthology is to provide students with original documents from the history of art with which to supplement the teaching texts contained in the six volumes. It is hoped, however, that it will also stand as a self-contained volume for the general reader. There are a number of excellent art historical anthologies currently available. The present book, however, covers a much wider historical period than most of these and because it is designed to provide primary sources for an introductory course, it is particularly suited to offer a basic overview of issues and debates in the history of art. The texts in this volume can be used alongside the six books, but they can also be read independently in order to throw light on the ways in which many of the basic judgements that we make about art have been shaped.

The texts in each of the six sections of this book are organised in two parts: source texts and critical approaches. The sources are texts that have been, in some way, either formative of the discipline or are informative about historical and recent debates about art. They include seminal works that have been incessantly discussed, such as the writings of Vasari, Le Brun and Baudelaire, or they are included as examples of the different kinds of literature on art: a contract, a biography, an academic discourse and so on. Part of the task when working with these texts is to decide what they are evidence of. They might, for instance, provide

evidence of a particular event or offer information about a way of working, or about a life, but they could, equally, provide a way of thinking about art. Often the same texts do both of these things at once. Art history involves questioning what evidence is, and in what way it is relevant to the interpretation of works of art, as well as using that evidence to make critical judgements. The texts in the critical approaches sections present some perspectives from recent critical debates about art. These writings are not intended to provide answers to the problems of the documents. Rather, these texts should be seen as offering different perspectives and ways of thinking about art. The critical texts should not then be accepted at face value, they are also sources that need to be tested for their cognitive adequacy against the objects, texts and problems that they interpret. The difference of perspective and evaluation between these critical approaches is crucial. Art history is often made out of these differences of interpretation.

The balance of sources to critical texts varies from section to section. Section Three: Gender and Art, for instance, is heavily weighted towards the latter: this is because, like book three in the series, it is concerned with the feminist revision of art history. The kinds of writing it examines are, therefore, by nature critical of, and reflective on, art history. Section Six: Contemporary Cultures of Display presents a different problem: here all the texts are of recent origin and so any simple distinction between original documents and art historical assessment is bound to fail. In this section we have opted to maintain the demarcation we have been working with and divide the texts between those that, on the one hand, are the statements of museum directors, curators, and so on, and on the other, those of a reflexive nature that can be applied to the display of art. If the distinction between source texts and critical approaches is always a convenient fiction, it is especially so in this section since curators (and reviewers) are also involved in making theoretical decisions about art. It should be borne in mind that the organisation of texts into these two categories risks, in this case, ideologically naturalising the work that people like curators do.

NATURALISING THE CANON

This danger of naturalisation takes us to the substantive heart of this book that deals with some of the ways in which art historical thinking has shaped our experience of art. Art history is a specialist academic discipline and, at first sight, it would appear to have little impact on the way most people encounter works of art. Artworks, however, are always organised into some schema of presentation that, invariably, draws on art historical models. When we see artworks, either at first hand in a gallery or museum, or in reproduction in a classroom, book, magazine, or on television or a computer screen, they exist within a narrative constructed by their author (and here an author could be an institution like a museum, or a TV production unit). The kind of information provided, the links established between different artists and their works, the sequence of objects, and what is included and excluded all cast the work of art in a particular light. These forms of presentation are not simply moulded by individual judgements of taste

but, more significantly, by intellectual traditions, conceptual frameworks and social practices. The standard way in which art history has organised and presented works of art is as part of a single narrative of evolutionary progress structured around individual artists – their biographies, oeuvres, and movements – a structure arguably traceable to Giorgio Vasari's *Lives of the Artists* written in the sixteenth century.[2]

The underlying pattern of assumptions and values involved in these narratives constitutes what art historians refer to as the canon of Western art. The canon is a term that covers the set of works of art that are thought, at a particular moment, to embody the peaks of Western civilisation. These artworks are seen to encapsulate the height of artistic excellence and aesthetic value. The works in this category are the ones which art historians have traditionally seen as worthy of study. Introductory books that cover a broad sweep of art history are often very revealing here; due to restrictions on space such works concentrate on the canonical works from each period. The fourth edition of H. W. Janson's influential *History of Art*, for instance, covers architecture and photography as well as painting, drawing and sculpture, and stretches from prehistory to the present in 850 pages and 1151 images.[3] What a book like Janson's presents, when individual idiosyncrasies are put to one side, is one individual's summary of the Western canon as it has been selected by a group of connoisseurs and scholars. Even within these canonical works a ranking is established, in books like this, between those works illustrated in colour and those in black and white. Judgements and choices about which works of art are to be included, of course, have to be made; after all, they can't all be represented. In the process of selection, however, a tradition with its own priorities and blindnesses is established.

Museums as much as books participate in this construction of a canon. In fact, it can be argued that the major museums of the West act as the repositories of the canon. The works that are hung on the walls of these galleries are the results of art historians and curators deciding what they think is worthy of being seen. In turn, these prioritised works tend to be the ones that get illustrated in books because they are the best known and the most easily accessed for reproductions. Equally the works of art held in storage are there because someone has concluded that they do not make the grade. (Section One of this book contains material that is concerned with how certain works got to be in British national collections. The role of the museum in presenting the history of art is also assessed in Section Six: Contemporary Cultures of Display where the focus is on recent debates and reconsiderations of the museum.) This book draws together materials that enable a critical examination of some of these canonical assessments, values and assumptions.

In 1915 the art historian Heinrich Wölfflin proposed a series of formal distinctions or comparisons through which works of art could be understood. These were: linear and painterly; plane and depth; closed and open form, multiplicity and unity; and clarity and obscurity. Wölfflin's categories have had an enormous influence on subsequent thought, providing art historians with a basic grammar for discussing the formal construction of works of art. E. H. Gombrich has noted, however, that far from presenting objective criteria of assessment, these categories

are relative and unstable.[4] When compared with artist Y, painter X's work may appear linear, but when set against the images of Z it will look painterly. Gombrich suggests that Wölfflin's categories attain some working stability because they are based on an unacknowledged classical standard (the art of ancient Greece, Rome and the Italian Renaissance). Because Wölfflin's oppositions have been so influential, it can be argued that many of the elementary concepts that we use to talk about artistic form have canonical assumptions built into them. This distinction between an art based on classical models and an anti- or non-classical Northern art has played a significant role in the history of art. The distinction between a virtuous classical tradition and a barbarous Northern art can, as Gombrich demonstrates in this essay, be traced back to Renaissance interpretations of Vitruvius's *On Architecture*. (An extract from Gombrich's essay is published as text xi in Section One of this book.)

The normative structure of an art based on classical models was enshrined in the European academies of art that developed in the seventeenth and eighteenth centuries and which remained the dominant force in art until the early twentieth century. The academic tradition, through its educational practices, exhibition policy and published discourses, established a hierarchy of values and genres for art. At the top of this hierarchy of genres stood large-scale paintings of mythological, historical or Biblical subjects; next came portraits and scenes from everyday life, followed by landscape paintings (pictures of classical or Italianate landscapes would be ranked higher, domestic landscapes lower), while still life was seen as the lowest of the genres. Line was elevated over colour; general effect over particular detail; figure over ground; and so on. (Texts relating to the academic tradition can be found in Section One: Academies, Museums and Canons of Art.) The academic tradition was certainly not homogeneous, emphases varied from one National Academy to another, and even within a particular Academy the weight attached to an approach could be debated. What is significant here, however, is that ways of making and thinking about art that were developed within a particular set of historical priorities have acquired a general character. These classical preferences and academic values continue to shape our understanding of art even when we are dealing with the explicitly anti-classical and anti-academic art of the twentieth century. It is even possible that the focus, in the canon of twentieth-century art, on French painting with its preference for harmony, balance, and order rather than the work produced in, say, Berlin or Moscow (based on very different 'tastes'), is the outcome of just these long-running patterns of preference.

To say that the classical tradition plays an important role in our understanding of art is not to suggest that these values are fixed or immutable; there are plenty of art historians who have made a specialism of the art of the North, or Russian Constructivism; and an artist like Rembrandt enjoys enormous critical reputation in art history despite his non-classical or non-academic pedigree. The canon is best understood as a relatively fluid body of values and judgements about art that are subject to constant dispute and redefinition. Sir Joshua Reynolds, writing in the eighteenth century,[5] was certain who were the canonical painters. For him, artists like Michelangelo, Raphael, Correggio, and Andrea del Sarto were self-evidently

the great figures. Today, while Michelangelo's reputation has remained secure, the status of the other figures in this list has been revised. Raphael is still, of course, seen as one of the greats but his work now appears a little too bland and sentimental; Correggio is just too sickly sweet for contemporary taste; and Andrea has become almost invisible (he is deemed not even to warrant a reference in some recent dictionaries of art). At the same time, the star of an artist like Titian, whom Reynolds thought to be a 'mere colourist' and therefore weaker than any of those listed above, has risen in the heavens. The canon, then, should be thought of as a frame, containing a range of different evaluations and views about which works deserve to be elevated and studied. Canonical judgements are, as the example of Reynolds makes clear, regularly subject to contestation, revision and change as new assessments are brought forward. Indeed it is probably correct to say that the canon comes into being as the result of these disputes. Within this relatively open structure, however, there are a definite series of reference points that often endure over long periods of time, and the classical preference is one of them, against which rival claims about artworks can be assessed.

Much of what follows surveys criticisms of the canonical tradition of art history. It may, therefore, be worthwhile to sketch briefly the strengths of canonical art. Firstly, it can be argued that as long as we continue to find it valuable to look at, and think about, works of art, some framework of comparison and evaluation is unavoidable. Short of abandoning art history altogether, some form of canon will exert a powerful claim on our attention. The strongest argument for the canon of Western art, however, is the art it contains. Whatever criticisms may be made of canonical art history, the aesthetic charge of the works of Michelangelo, Rembrandt or Matisse should be acknowledged. It is a serious problem of many recent critical perspectives that much of the art that they champion in opposition to the canon looks, when set against this art, insipid, uncompelling and just plain bad. Those who wish to challenge canonical art and canonical judgements would do well to bear in mind the often powerful and complex nature of this art. While what I have been calling traditional or canonical art history may have encoded all manner of spurious value judgements into its account of art, it has latched on to a valuable aesthetic tradition. The tenacity often demonstrated by this form of art history in the face of criticism stems from the deeply felt conviction concerning the value of the art in question. For these reasons the most substantial challenges to the canon of art are those which maintain a constant and ongoing dialogue with it. The remainder of this introduction aims to survey some of these critical approaches. It is not my intention here to argue for a particular approach to the canon, rather this essay provides some initial contexts for the texts assembled in the six sections. The reader will, ultimately, have to test the cognitive adequacy of these perspectives against the material contained in this volume.

CONTESTING THE CANON

During the last thirty years the canon of Western art and the values upon which it rests have been challenged from a variety of perspectives. Not least among these

have been the directions taken by art practice itself. From the middle of the nineteenth century through to the end of the first third of the twentieth century the canonical academic values were challenged by a range of avant-garde artists and movements. (See the texts collected in Section Four: The Challenge of the Avant-Garde.) Courbet, Manet and the Impressionists undermined the technical norms of academic practice, concentrated on what had been seen as minor genres, and rejected the idealisation of the human figure; the Fauves and the Expressionists elevated (non-local) colour, and asserted 'primitive' intensity in direct contravention of academic and classical values; the Cubists and the Dadaists, 'distorted' the figure and fragmented the picture plane. By the 1960s even the anti-canonical tradition of modern art had come to seem conservative as ambitious artists increasingly abandoned the traditional forms of painting and sculpture for new media and practices. When E. H. Gombrich, in his Romanes lecture of 1973,[6] came to defend the idea of absolute criteria of value in art against relativist arguments that the canon was founded on subjective taste and historically specific judgements, he selected Michelangelo as a standard against which other works of art could be objectively measured. When Gombrich's contrast was with other paintings, the claims that he was making for an objective criterion of value could appear, however debatable, at least credible or conceivable. To contrast Michelangelo, however, with some of the best art that was being produced in the 1960s and 1970s, and which consisted of anything from musings on art recorded in bunches of Xeroxes and file index cards to holes excavated in the desert, appeared to make no sense at all. It is now possible to argue, or at least there is a powerful recent tradition that would do so, that works as radically dissimilar as these can be compared and judged on the basis of their aesthetic *effects*. An argument like this might even accept Gombrich's assumption of some absolute criteria of value and suggest that certain artistic works produced during the 1960s and 70s can hold their own alongside the standard of Michelangelo.[7] The predominant response to post-sixties art, however, was to see these new forms of art as calling into question not just certain canonical judgements but the very criteria on which these judgements were based. Contemporary art, then, provided a powerful impetus for art historians to adopt the relativist approaches to the canon which Gombrich cautioned against.

A second impetus for re-evaluating the role of the canon came from the radicalisation of many intellectuals that took place in the wake of the 1960s. In the first phase this radicalisation involved a reawakening of academic interest in Marxism. For art historians the revival of Marxism led to a questioning of the ideological role of art in class society and to a search for moments when artists had identified with the labouring classes. This perspective challenged the dominant view that suggested the making and viewing of art was above social and political interests. Much traditional art history claimed to speak in the name of universal human experience, in contrast to such universalist assumptions Marxist historians insisted that works of art had to be seen as the products of specific social actors working in particular social conditions and emphasised the historical production and consumption of meanings and values. In one kind of account influenced by Marxism the canon came to be seen as a weapon employed by the middle class in

an ideological struggle for cultural dominance. Traditional art history was based on an idea that the canon was morally uplifting (which assumes that there are some with lax morals that require elevation) and that the values of discrimination, taste, refinement, cultivation and so on resulted in a 'discerning viewer'–'the connoisseur'. It is important to note at the outset of this discussion that few contemporary art historians would see themselves as connoisseurs. It would be fair to say, however, that many of the values of connoisseurship have passed into the 'common sense' of the discipline. For the connoisseur the cultivation of 'good taste' became a lifelong project. On the basis of this intimate acquaintance with works of art, connoisseurs assumed the role of arbitrators of aesthetic value.

It should be clear that in the present society the rigorous study involved in the development of connoisseurial modes of attention limits this position to the members of a leisured and wealthy social class. To say this, however, is not to claim that connoisseurs have not produced serious knowledge about art.[8] Such people often display an understanding of art unmatched by their critics. The intimate knowledge connoisseurs display of works of art means that a great deal can be learnt from the judgements and unexpected comparisons and connections in their writings. Connoisseurs are often extremely good guides to art and sometimes their engagement with art leads to critical or ethical assessments that are profoundly at odds with the dominant values of our society – not least because this activity appears to have no use[9]. The connoisseur's intense study of works of art seems, in important ways, to refuse the means–ends rationality of the cash nexus. The disinterested study of art claimed by connoisseurs can, in this respect, provide some elements of a utopian model for knowledge. However, while not wishing to dismiss this knowledge it must be acknowledged that connoisseurial judgements are often encrusted with class values and spoken in a tone of high snobbery. The rhetoric of good taste in which connoisseurs frequently cloak themselves serves to mark them off from other people. In this way a knowledge of the canon, its norms and values, has often been deployed to demarcate certain classes of persons as culturally superior to the barbarian hordes and thus suited to rule. It is readily apparent how the idea of an objective canon of taste can be used to position working class people in the category of cultural inferiority. This argument can also be extended, however, to suggest that the standards of canonical taste form part of the armoury of a liberal middle class in a struggle, *within* the ruling political bloc, against the dominant industrial bourgeoisie. From this perspective of the canon of art a section of the liberal middle class could present the industrial faction of their class as stupid utilitarian philistines, interested only in money. In their attachment to the 'finer things of life' the connoisseur could claim to transcend particular economic interests and represent the interests of the majority.[10] It is important to reiterate that the canonical tradition and its active proponent – the connoisseur – represent both of these tendencies – a critical rejection of ruling values and a classbound perspective – in quite complex and entwined patterns.

The second phase in the development of new critical priorities in art history, as in the humanities more generally, derived from the impact made by what have come to be known as the 'new social movements': the women's liberation move-

ment, the gay liberation movement and a range of anti-imperialist and anti-racist movements. Art historians working from within these different perspectives have all called into question the systematic exclusions and assumptions that under-pinned the canon. When, for instance, H. W. Janson was asked by Eleanor Dickinson why no women featured in his *History of Art* he answered that none were important enough. Dickinson then enquired what the criteria for inclusion were. He replied:

> The works I have put in the book are representative of achievements of the imagination . . . that have one way or another changed the history of art. Now I have yet to hear a convincing case made for the claim that Mary Cassat has changed the history of art.[11]

Janson seems to be suggesting that women have made no substantial contribution to the history of art: if they had, he would be glad to incorporate them into his account, but they have not and so he has not. A generation of feminist art histo-rians have sought, in contrast to Janson's apparent comfort with this situation, to understand why the canon is almost exclusively composed of the works of men. One feminist response to the justification for the canon's overwhelming domi-nance by men has been to uncover large numbers of women who had made art throughout history and to propose that the canon be extended to incorporate them. This response has been very useful in revealing the volume and variety of art made by women that has been ignored by traditional art history. The problem here is that from his own perspective Janson is correct: once the idea of a canon based on supposedly disinterested judgements of quality is accepted, the same artists will continue to come out 'on top'.

Rather than being an excuse for complacency, however, Janson's perspective should lead us precisely to question the criteria of judgement involved. Feminist art historians like Linda Nochlin[12] and Griselda Pollock[13] have argued, in this manner, that the missing great women artists will not be found to take their place alongside Michelangelo or Picasso because they do not exist. The problem with the additive approach, they suggest, is that it assumes that the structures of canon-ical art history are neutral and that the procedures of evaluation and selection are unproblematic. Judith Leyster or Marie Laurencin can be added to the canon but, if the value judgments that sustain the structures of art history are left in place, they will always appear as 'women artists' with the term 'woman' signifying inferior or secondary. Assumptions about gender differences are, then, constitu-tive of the canon rather than some superficial anomaly. This argument has lead Pollock, in particular, into a sustained investigation of the gendered grounds on which the canon is secured. In this manner feminist historians of art have demon-strated that the canon cannot encompass the work of women without a profound transformation of the ways in which we think about art and its values. A gay and lesbian art history has built on many of these feminist insights to show that art history has assumed heterosexual ways of looking at art to be exhaustive. In con-trast, gay/lesbian art history establishes patterns of identification with works of art that are open to the range and diversity of human sexual and emotional desires.

In looking at art from the perspective of same-sex desire, gay and lesbian art historians highlight the fictions of gender identity assumed by the canonical tradition. (The issues of gender and sexuality in art history are explored in Section Three: Gender and Art.)

The Western canon, by definition, is built on the work of European and North American artists. In much art history, however, the force of this point has been inadequately recognised. The claims made by traditional art history to embody universal human experiences are rendered highly problematic when the experience of the (majority) non-Western peoples is broached. At the most simple level, for instance, the idea of beauty embodied in the canon is based on *Western* notions of beauty. When non-Western objects have appeared in the canon they have usually done so at moments when Western artists have appropriated them for their own ends. It is usual, in this way, to find African carvings in the accounts of Expressionism or Cubism where European artists took up the artefacts of so-called 'primitive cultures' as a resource with which to break the grip of academic norms in their own culture. These objects are presented by Western artists and historians in terms of an immediacy, directness or vitality that has been lost to Western culture. While such an account appears to celebrate non-Western art it results in two problematic outcomes: firstly it contrasts a stereotypical view of non-Western cultures as simple and authentic (often involving sexualised fantasies of these cultures as uninhibited and openly libidinous) to the complex and developed culture of the West. Secondly, while non-Western artifacts figure in this argument the spotlight remains fixed on Western artists like Picasso, or Kirchner, who used them to reinvent the art of their own culture. It has frequently been observed that even when non-Western objects are treated as worthy of attention in their own right, (Clive Bell, for instance, saw no difference between a Chinese vase, a Persian carpet, and a modern painting as aesthetic objects[14]), this involves the projection of a Western conception of art onto objects made in the light of very different priorities and concerns. One important influence on recent art history has been the development of a post-colonial perspective that challenges such a Eurocentric view of art. Section Five: Views of Difference: Different Views engages with these issues, but does so by circumventing the focus on 'Primitivism' in order to consider both accounts of art produced outside the Western context and the work and ideas of non-Western artists working in Britain.

A consideration of the meanings of the word 'canon' throws many of the issues touched on here into relief. The literary critic John Guillory provides a useful overview of the origin of this term. The idea of the canon, he suggests, has its roots in the ancient Greek word for reed or rod and implies a rule or a law.[15] Guillory goes on to discuss the use of the term canon in Christian disputes in the fourth century. He argues that in these debates the term canon signified a series of preferred texts – which we now associate with the Bible and certain early theologians – in opposition to rival Christian teachings. This is significant, as Guillory notes, because it implies that the canonical tradition is based on a process of active selection and repression. On the one hand, some texts are canonised (carrying the additional Christian sense of ascension to sainthood) while on the other some fall

outside the law. The canon, then, is, as we have seen, based on a series of inclusions and exclusions. In opposition to the legitimated tradition of the canon, excluded works constitute an illegitimate, or to extend the metaphor, 'criminal', lineage. In the process of constructing this tradition literary critics or art historians have claimed to make their judgements of taste and value on the basis of universal interests while centring the experiences and perspectives of certain groups of persons. What each of these challenges surveyed above has done is to underline the different ways in which the supposed universal norms of canonical art history were built on an implicit conception of both artist and viewer: a conception that conforms to a very specific and very small section of even the European public. These various challenges to the canon should indicate why we have used the plural *histories* in the title of this book. While these different perspectives frequently overlap, with Marxist-feminists, post-colonial feminists, and so on, it is important to recognise that different, and rival, versions of art's histories are on offer here. Contemporary art history is to a large extent made up of just these differences and this book has made no attempt to synthesise the different priorities and claims currently on offer.

ART HISTORY AT THE MARKET-PLACE

In addition to these criticisms of the canon that are broadly shared across the disciplines of the humanities there is an additional problem particular to art history: this is the relation of the work of art to the market as a unique commodity. While works of literature or music are distributed in large and cheap editions, works of art can be extremely expensive objects, those with any kind of canonical pedigree can be astronomically so. One of the driving forces behind the development of art history as an academic discipline was the necessity to provide the trained personnel who could supply the 'production apparatus' of the salesroom with the intelligence required to pursue its business. Art history was shaped, for much of the twentieth century, by its role in the art market: the catalogue raisonné, the monograph, the one-person show, as well as many of the basic working concepts – provenance (establishing the history of ownership); attribution (is it a Rembrandt or merely a Gerard Dou?[16]); authentication (is it by the hand of Rembrandt or is it a copy, or a work by one of his students?)—are all geared to establishing a 'clean bill of health' for the artistic commodity. These art historical procedures are founded on the idea that a high market value is based on individuality and genius. The real commodity for sale here, it could be argued, is the mythic idea of artistic personality – the genius. This eccentric genius, in playing the role of exception, participates in establishing social conventions of the 'normal' individual. The artist genius adds spice to dull lives and provides a smiling mask for the face of power. (Section Two: The Changing Status of the Artist deals with the emergence of artistic subjectivity.) In response to criticisms of the canon, art history can, like literary studies, focus on works by working people (much more common in the latter discipline than the former), non-white people, women, etc. in order to explore other subjectivities and forms of social experience. But while literary

studies can do this and remain with its traditional object – the text – it is clear art history cannot develop a serious critique of the canon without coming to terms with the commodity status of its object.

The challenge to the status of canonical values has legitimated a wide range of approaches to art's histories. Unremarkably, one response to the crisis of the canon has been a conservative retrenchment that insists on the eternal verities and sees the new versions of art history as so many kinds of intellectual vandalism[17]. For this kind of art historian the rabble at the gates of the estate now includes many members of their own profession. A second response, and it is unquestionably the dominant one at the moment in Britain, is to expand the traditional range of art objects studied and to alter the vocabulary for talking about them. In this approach work by women might be considered or images of non-European persons might be scrutinised; the words 'ideology', 'power', or 'desire' might replace terms like 'exquisite', 'delightful', or 'genius'; social history might be foregrounded, but, it can be argued that in this approach the basic structures and values of traditional art history remain fundamentally unchanged. Journal articles and books continue to appear on the same artists, the same periods and national schools receive paramount attention; the artistic commodity remains in the fore-ground, and so on. In important ways this is the 'business as usual' approach of a modernised version of traditional art history that has managed to re-secure its cen-tral role by absorbing weak versions of the critical perspectives outlined above. There is, however, a third approach that takes the criticisms of the canon to the point where, if taken seriously, art history would disappear as a discipline. A cen-tral representative of this approach, Adrian Rifkin, has written:

> . . . if a painting like Picasso's Demoiselles d'Avignon (1907) produces its meanings only in the way in which it constructs a relation with colonised African cultures (in its use of masks); through a fear of prostitution and venereal disease as part of a dominant discourse on women (its setting in a brothel); and the emergence of a provincial (Spanish) artist in Parisian cultural life, then, in which museum should it be put? Assuming an ideal world, in which such museums exist, should it be in the museum of colonial oppression and liberation, the museum of gender formation, or the museum of social climbing?[18]

What Rifkin is pointing to here is that while much recent writing about art has sought to locate its objects in the field of wider historical problems, it fails to ques-tion the central role occupied by the art object in this work. Art is now regularly written about in the context of, for example, the transformation of Paris in the nineteenth century, or the role of prostitution in modern societies, but all too fre-quently this kind of work only develops new ways of valuing and appreciating the standard list of artists and objects. In this essay Rifkin argues that rather than recontextualise the work of art by placing 'trolley-buses alongside the Monets, looms with the Courbets, images of workers confronting the culture of the middle class', art historians should radically decentre the art object in their accounts. For Rifkin, once the issues of prostitution or colonialism have been

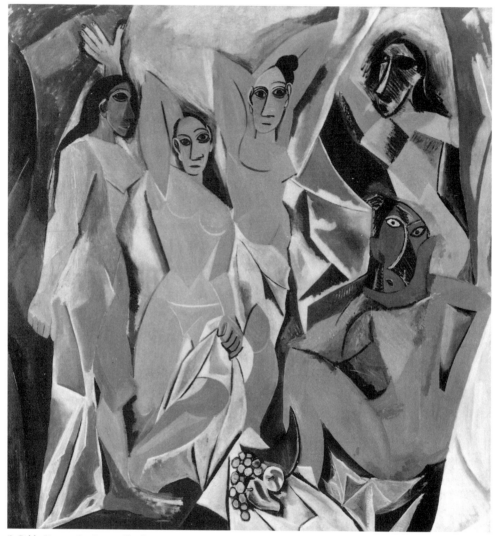

i) Pablo Picasso, *Les Demoiselles d'Avignon*, 1907. Photograph © The Museum of Modern Art, New York. © Succession Picasso DACS 1998.

raised it represents a weak intellectual move to restore the art to a pivotal place in the account since these histories are more complex and have a greater social effect than any story about art. To pursue this line of thought would lead to a broad cultural history in which the work of art appeared as just one kind of evidence amongst others. It should be apparent, not least from the word 'only' in the opening lines of this quotation, that such an account sees the meanings of a work of art to be grounded in history rather than in aesthetic value.

The debate on the canon has now been around for some time and, as I have suggested, the dominant perspective in art history is not a thorough-going cri-

tique, but a modernised version of the traditional perspective. One important reason that the canon has not been fundamentally overhauled is the strength, indeed, in recent years, the hyper-ventilation of the art market. As long as the commodity trade in works of art endures, and it will do so for as long as capitalist society exists, some artists will rise and others fall, but the canon is likely to remain in place. The recognition of the reality of the market could be taken as a reason to sneer at radical critics of the canon. It might be suggested that these critics have been hopelessly deluded in believing the canon could be fundamentally restructured, and that the liberal perspective that seeks to expand the canon is much more realistic and pragmatic. Even if we leave to one side the way that this account fits neatly into the current cynical mood about the possibility of social change, I think that such an argument is mistaken. While some radical art historians have, at times, seemed to believe that they could ignore the market and get on with reconstructing the discipline, others have not succumbed to this illusion. I would argue that the central aim of these critiques is not, in fact, to displace the canon but to foreground its role in the constitution of knowledge. While the particular points made in these critiques are significant it is the critical attention focused on the canon that is the most important contribution of this work. It can be argued that these critiques represent the most serious engagement with canonical art. In highlighting the way that canonical art history shapes its object critical perspectives have made art history into a self-reflexive discipline. Such perspectives may be unable to replace the canon, or produce convincing alternative structures to it, but they play a necessary and decisive role in pointing to the closures, absences and elisions in other approaches to the discipline. The fact that the canon is likely to continue for the foreseeable future makes these critical challenges more, not less, relevant because these positions force us continually to confront the values out of which we make art's histories. I am suggesting here that the canon cannot be abandoned but as long as it exists forceful criticisms of its structures and priorities will be needed.

CONCLUSION

The canon is a structural condition for art history. It contains differing evaluations, but it can also be seen to generate debate and enable discussion to take place. The canon, because it foregrounds certain artists, periods and national schools, acts as a kind of limited public realm establishing common points of reference that are required for communities of dialogue (and here dialogue might involve ferocious disagreement as well as polite chit-chat) to be established. The canon of art both provides an agenda for collective acts of dialogue and is continually contested and renegotiated on the basis of these acts that it calls into being. Non-canonical art history, in fact, draws much of its force from the existence of the canon; when this antagonistic structure is removed the choices made by the alternative approaches tend to look very arbitrary. Negative arguments, by which we mean arguments that are articulated contrary to some other position, are, as the theorist Laura Mulvey has noted,[19] to a large extent

shaped by the position of their interlocutor. The very existence of the canon is one powerful argument for those accounts of art's histories that reject its values. In important ways accounts of art like those offered by feminist or post-colonial thinkers are shaped, and even made possible, by the existence of the canon and its values. Negative criticism, because it requires this other perspective to work upon, is often dismissed as a parasitic form, but the opposite can be argued: that it is through the act of criticism that the canon can really be seen. Criticisms of the canon bring its, often unacknowledged, values and judgements into focus and allow us to see what kind of knowledge the canon produces. It can also be argued that these criticisms draw attention to the strengths of the canon. The power of the canonical art history is, in part, rooted in its institutional power but it is possible to suggest that it is also based on the aesthetic force of the art it celebrates and the strength of its judgements. Any critical perspective that believes that the art that is embodied in this tradition can be easily dismissed will find the force of its own argument substantially diminished. Some recent art historians seem to believe that judgements about works of art can be avoided in a kind of happy pluralism where any interpretation, and any object of investigation, is as good as any other. Interpretation, however, always establishes the kinds of critical hierarchies that we call value judgement. Many recent accounts of art focus on the semantic density, or philosophical complexity, of works of art and see art as a practice that leads to critical perspectives on the world. Often they do so in direct opposition to the idea that some artworks demonstrate more aesthetic value than others but, it should be noted, if some art objects are seen to be more intellectually complex than others, and it is difficult to see how this view can be denied, then a conception of value has been reintroduced into the assessment of art whatever the semantic quibbles involved. Once the problem of interpretation is seriously raised a tension is established between history and value. This does not mean that it is possible to return to transcendental judgements: judgements are always made by social actors who carry their specific investments with them, but neither can the issue of value be dissolved into historical explanation.

The arguments outlined in this introduction, while recognising that canonical art history is a serious adversary that cannot simply be swept away, suggest that it is important and productive to work against the canon's closures, silences, and priorities. The canon and its critique, for some time to come, exist in a necessary tension. The issues which surround the canon raise difficult intellectual questions to which there are no straightforward answers. Accordingly, this volume presents some materials through which the constitution of the canon of Western art can be scrutinised and evaluated. Reading the texts collected in this book should alert the reader to the way in which our judgements about works of art are the outcome of complex historical and intellectual processes. To recognise this is to make a start on understanding art's histories.

NOTES

1 I would like to thank all those who commented on this introduction. In particular I am grateful to
 Gail Day and Paul Wood for their careful criticisms of this text.

2 Giorgio Vasari, *The Lives of the Artists* (1568), 10 vols., trans. Gaston DuC. de Vere, Philip Lee Warner
 (paperback, AMS Press, 1976) Vasari's 'Life of Ambrogio Lorenzetti. Painter of Siena' is published as
 text i in Section Two.

3 H.W. Janson, *History of Art* (fourth edition revised and expanded by Anthony F. Janson), Thames
 and Hudson, 1991.

4 E. H. Gombrich, 'Norm & Form. The Stylistic Categories of Art History and Their Origins
 in Renaissance Ideals, in *Norm and Form. Studies in the Art of the Renaissance*, vol. 1, Phaidon, 1966,
 pp. 83–94: an extract from this essay is published as text xi in Section One of the present volume.
 Wölfflin's argument appears in *The Principles of Art History. The Problem of the Development of Style
 in Later Art* (1915), trans. M. D. Hoffinger, Dover, 1950.

5 Sir Joshua Reynolds, *Discourses on Art*, Robert R. Walk, ed., Yale University Press, 1997. Extracts from
 Reynolds are included in Section One of this book.

6 E. H. Gombrich, 'Art History and the Social Sciences', in *Ideals & Idols, Essays on Values in the His-
 tory of Art*, Phaidon, 1979, pp. 131–66. This discussion was continued in an exchange with Quentin
 Bell published as: 'Canons and Values: A Correspondence With Quentin Bell', published in the same
 volume, pp. 167–83.

7 I take it that a conception somewhat like this underpins Charles Harrison's *Essays on Art & Language*,
 Blackwell, 1991

8 For a compelling account of the intuitive knowledge of the connoisseur, see: Carlo Ginzburg, 'Clues:
 Roots of an Evidential Paradigm', *Myths, Embiems, Clues*, Hutchinson Radius, 1990, pp. 96–125

9 To take only one example, the account by John Szarkowski, ex-director of photography at the
 Museum of Modern Art, New York, of press photography is as perceptive and critical of the way
 meaning is constructed in these images as anything in modern cultural studies. See John Szarkowski,
 From The Picture Press, Museum of Modern Art, New York, 1973

10 This position is to be found in a fairly pure form in the writings of the influential early twentieth-
 century British art historians Clive Bell and Roger Fry. Examples of this writing include: Clive Bell,
 Art (1913), Capricorn Press, 1958; Clive Bell, *Civilisation* (1928), Penguin Books, 1938; and Roger Fry,
 Vision and Design (1920), Chatto and Windus, 1928. Important criticisms of this approach are to be
 found in Raymond Williams, 'The Bloomsbury Fraction': *Problems in Materialism and Culture*,
 Verso, 1980, pp. 148–69; and Simon Watney, 'The Connoisseur as Gourmet', *Formation of Pleasure*,
 Routledge and Kegan Paul 1983, pp. 66–83

11 Quoted in Nanette Salomon, 'The Art Historical Canon: Sins of Omission', in Donald Preziosi, ed.,
 The Art of Art History: A Critical Anthology, Oxford University Press, 1997, p. 347

12 Linda Nochlin, 'Why Have There Been No Great Women Artists?' (1975), *Women, Art and Power
 and Other Essays*, Thames and Hudson, 1989, pp. 145–78. An edited version of this essay is included
 as text v of Section Three.

13 See Rozika Parker and Griselda Pollock, *Old Mistresses. Women, Art and Ideology*, Pandora Press, 1981;
 Griselda Pollock, *Vision and Difference: Femininity, Feminism and the Histories of Art*, Routledge,
 1988. An extract from Pollock's book, *Differencing the Canon: Feminist Desire and the Writing of Art's
 Histories*, Routledge, 1999, is published as text vii in Section Three.

14 Clive Bell, *Art*, op. cit., p. 17

15 John Guillory, 'Canon', in Frank Lentricchia and Thomas McLaughlin, eds., *Critical Terms for Lit-
 erary Study*, The University of Chicago Press, 1990, pp. 233–49

16 Gerard (or Gerrit) Dou (1613–75) studied with Rembrandt. His early works were heavily influenced
 by, and have sometimes been mistaken for, the work of his master.

17 Several art historical candidates spring to mind here but the most forceful version of this reaction
 comes from literary studies. It is to be found in Harold Bloom, *The Western Canon: The Books and
 School of the Ages*, Macmillan, 1995.

18 Adrian Rifkin, 'Art's Histories', in A.L. Rees & F. Borzello, eds. *The New Art History*, Camden Press,
 1986, p. 159.

19 Laura Mulvey, 'Changes: Thoughts on Myth, Narrative and Historical Experience', *History Workshop
 Journal*, no. 23, 1987, p. 8.

Section One
Academies, Museums and Canons of Art

The recent impetus for challenging and re-evaluating the role of the canon of western art has encouraged art-historical approaches which analyse critically the cultural, political, aesthetic and institutional forces which have shaped such a canon. However, unpicking the value systems, assumptions and art historical narratives which have participated in its construction is no easy task, and in the introduction to this Reader Steve Edwards maps out some of the different forms of art history which have engaged critically with the problem. The texts included in this section provide examples of one aspect of the discourse which helped to establish canonical values in western art – that which emerged from within European (mainly British and French) academies and institutions of art. The first group of source texts provides examples of some of the aesthetic preoccupations and issues which formed the backbone of French and British academic theory. Extracts from Lebrun's 'Lecture on Expression' and Félibien's lectures at the *Académie Royale* illustrate some of the aesthetic and critical issues which accompanied the formation of the French Academy in the seventeenth century. While Lebrun's lecture reveals contemporary attempts to institute academically approved conventions for representing human expression, Félibien's Preface engages with a key concern in European academic theory – the need for intellectual knowledge or 'grand' ideas, as well as observation from nature, in the pursuit of beauty. Extracts from Reynolds's *Discourses*, which were originally given as lectures at the Royal Academy of Art in Britain (founded 1768) echo Félibien's concern with 'grand' ideas, and set out some of the former's ambitions for a British 'school' of academic painting. Written over a period of twenty years, the *Discourses* form an important document in the history of European art theory, revealing aesthetic and intellectual ambitions which were often modified in Reynolds's practice, partly in response to the economic realities of the British market. To help provide a picture of the contested and shifting nature of the British canon, and the complexity of the British art market from this period, short sections are also included from Hogarth's *Analysis of Beauty*. A key concern which underpins the inclusion of this group of texts is the crucial relationship between claims for canonical values or standards and the establishment (in theory at least) of a category of 'high art'. A notion of 'high art', clearly separated from the supposedly 'lower' or 'lesser' arts, assumed a central role within some seventeenth and eighteenth century writings on 'greatness' in art, and has contributed to the

air of spurious precision which such notions assume in some of the texts included
here.

The second group of sources is derived from the minutes of Parliamentary
Committees and from National Gallery catalogues in Britain during the nine-
teenth century, and are designed to show some of the debates and aesthetic
preferences which helped to determine the contents of national British art
collections during this period. These include extracts from 'Evidence to the
Parliamentary Commission on the Earl of Elgin's Marbles' from 1816 and from
'The Parliamentary Commission on the National Gallery' of 1853, both of which
debate the value of the Parthenon marbles, and their status as examples of 'clas-
sical' art worthy of display in a major British collection. The attitudes revealed by
such texts and the institutions which they support have significantly affected pub-
lic perceptions of what might constitute a canon of Western art.

The texts in the critical approaches section have been selected to bring
together some recent work which examines critically the discourses of the clas-
sical ideal, itself a central concern within academic theory. The extract from
E. H. Gombrich's essay 'Norm and Form' explores the nature of stylistic cate-
gorisations and the influence of the aesthetic values and ideals established
during the Renaissance in the evolution of these categories. The section from
Alex Pott's book *Flesh and the Ideal*, examines the attempts of the German art
theorist Johann Joachim Winckelmann to formulate a theory of ideal beauty
rooted in observation of the sculpted male nude. Winckelmann's theories had
a significant impact on the development of academic theory within late
eighteenth-century Britain and France, and on the importance of study from
classical sources within both academic cultures. The final text in this section,
from Thomas E. Crow's *Painters and Public Life in Eighteenth-Century Paris*,
examines the role of the public as a factor in the making of artistic meaning. In
this text Crow draws out an important distinction between the empirical audi-
ence for a work of art and its constitutive public. [GP]

i) From *Report of the Parliamentary Select Committee On The Earl of
 Elgin's Collection of Marbles* (1816)

In the closing years of the eighteenth century Lord Elgin, as ambassador to the
Sublime Porte (Ottoman Turkish Empire) collected a number of fragments of the
sculptures from the Parthenon temple to Athena the Virgin (*parthenos*). This tem-
ple was built in the Doric style between 447–432 BCE on the site of the Acropolis
in Athens. Elgin had these marbles shipped back to England and displayed in a
shed in the courtyard of Burlington House. Partly because of financial problems,
Elgin offered the marbles to the new British Museum, and a Royal Commission
was established to determine their proper price. (In the end Elgin received
£35,000, about half of what he hoped for.) The Commission took evidence from
most of the leading sculptors, painters and art critics. Their evidence explains the
reasons for admiring the works, and is recorded verbatim in the series of British

Parliamentary Papers. Evidence is reproduced here from John Flaxman, R.A., Richard Westmacott R.A., Francis Chantrey R.A., and William Wilkins. F.S.A. [CC]

Source: *Report of the Parliamentary Select Committee On The Earl of Elgin's Collection of Marbles, Evidence of John Flaxman; R. Westmacott; Francis Chauntry* [sic]; *William Wilkins*, London, 1816, pp. 6; 31–4, 34–6, 44–5

[. . .]

The Testimony of several of the most eminent Artists in this kingdom, who have been examined, rates these Marbles in the very first class of ancient art, some placing them a little above, and others but very little below the Apollo Belvidere, the Laocoon, and the Torso of the Belvidere. They speak of them with admiration and enthusiasm; and notwithstanding the manifold injuries of time and weather, and those mutilations which they have sustained from the fortuitous, or designed injuries of neglect, or mischief, they consider them as among the finest models, and the most exquisite monuments of antiquity. The general current of this portion of the evidence makes no doubt of referring the date of these works to the original building of the Parthenon, and to the designs of Phidias, the dawn of every thing which adorned and ennobled Greece. With this estimation of the excellence of these works it is natural to conclude that they are recommended by the same authorities as highly fit, and admirably adapted to form a school for study, to improve our national taste for the Fine Arts, and to diffuse a more perfect knowledge of them throughout this kingdom.

[. . .]

John Flaxman, Esquire, R. A. called in, and Examined.

ARE you well acquainted with the Elgin collection of Marbles—Yes, I have seen them frequently, and I have drawn from them; and I have made such enquiries as I thought necessary concerning them respecting my art.

In what class do you hold them, as compared with the first works of art which you have seen before?—The Elgin Marbles are mostly basso-relievos, and the finest works of art I have seen. Those in the Pope's Museum, and the other galleries of Italy, were the Laocoon, the Apollo Belvidere; and the other most celebrated works of antiquity were groups and statues. These differ in the respect that they are chiefly basso-relievos, and fragments of statuary. With respect to their excellence, they are the most excellent of their kind that I have seen; and I have every reason to believe that they were executed by Phidias, and those employed under him, or the general design of them given by him at the time the Temple was built; as we are informed he was the artist principally employed by Pericles and his principal scholars, mentioned by Pliny, Alcamenes, and about four others immediately under him; to which he adds a catalogue of seven or eight others, who followed in order; and he mentions their succeeding Phidias, in the course of twenty years. I believe they are the works of those artists; and in this respect they are superior almost to any of the works of antiquity, excepting the Laocoon and Toro Farnese; because they are known to have been executed by the artists whose names are recorded by the ancient authors. With respect to the beauty of the

basso-relievos, they are as perfect nature as it is possible to put into the compass of the marble in which they are executed, and that of the most elegant kind. There is one statue also which is called a Hercules or Theseus, of the first order of merit. The fragments are finely executed; but I do not, in my own estimation, think their merit is as great.

What fragments do you speak of?—Several fragments of women; the groups without their heads.

You do not mean the Metopes?—No; those statues which were in the east and west pediments originally.

In what estimation do you hold the Theseus, as compared with the Apollo Belvidere and the Laocoon?—If you would permit me to compare it with a fragment I will mention, I should estimate it before the Torso Belvidere.

As compared with the Apollo Belvidere, in what rank do you hold the Theseus?—For two reasons, I cannot at this moment very correctly compare them in my own mind. In the first place, the Apollo Belvidere is a divinity of a higher order than the Hercules; and therefore I cannot so well compare the two. I compared the Hercules with a Hercules before, to make the comparison more just. In the next place, the Theseus is not only on the surface corroded by the weather, but the head is in that impaired state, that I can scarcely give an opinion upon it, and the limbs are mutilated. To answer the question, I should prefer the Apollo Belvidere certainly, though I believe it is only a copy.

Does the Apollo Belvidere partake more of ideal beauty than the Theseus?—In my mind it does decidedly: I have not the least question of it.

Do you think that increases its value?—Yes, very highly. The highest efforts of art in that class have always been the most difficult to succeed in, both among ancients and moderns, if they have succeeded in it.

Supposing the state of the Theseus to be perfect, would you value it more as a work of art than the Apollo?—No; I should value the Apollo for the ideal beauty before any male statue I know.

Although you think it is a copy?—I am sure it is a copy; the other is an original and by a first rate artist.

[. . .]

Do you think it of great consequence to the progress of art in Britain, that this Collection should become the property of the Public?—Of the greatest importance, I think, and I always have thought so as an individual.

Do you conceive practically, that any improvement has taken place in the state of the arts in this country, since this Collection has been open to the Public?—Within these last twenty years, I think sculpture has improved in a very great degree, and I believe my opinion is not singular; but unless I was to take time to reflect upon the several causes, of which that has been the consequence, I cannot pretend to answer the question: I think works of such prime importance could not remain in the country without improving the public taste and the taste of the artists.

In what class do you hold the Metopes as compared with the Frieze?—I should think, from a parity of reasoning adopted between the Metopes and the flat basso-relieves with that adopted between the Apollo Belvidere and the Theseus or Her-

cules, the Metopes are preferable to the flat basso relievos, inasmuch as the heroic style is preferable to that of common nature.

[. . .]

Which do you think the greatest antiquity?—Lord Elgin's; the others I take to be nearly twenty years later.

In what rate do you class these Marbles, as compared with Mr. Townley's collection?—I should value them more, as being the ascertained works of the first artists of that celebrated age; the greater part of Mr. Townley's Marbles, with some few exceptions, are perhaps copies or only acknowledged inferior works.

Do you reckon Lord Elgin's Marbles of greater value, as never having being touched by any modern hand?—Yes.

In what class do you hold the draped figures, of which there are large fragments?—They are fine specimens of execution; but in other respects I do not esteem them very highly, excepting the Iris, and a fragment of the Victory.

[. . .]

Richard Westmacott, Esquire, R. A. called in, and Examined.

ARE you well acquainted with the Elgin Marbles?—Yes.

In what class of art do you rate them?—I rate them of the first class of art.

Do you speak generally of the principal naked figures, and of the metopes and the frieze?—I speak generally of their being good things, but particularly upon three or four groups; I should say that two are unequalled; that I would oppose them to any thing we know in art, which is the River God and the Theseus. With respect to the two principal groups of the draped figures, I consider them also of their kind very superior to any thing which we have in this Country in point of execution.

Do you reckon the metopes also in the first class of art?—I should say generally, for style, that I do.

Do you say the same of the frieze?—I think, both for drawing and for execution, that they are equal to any thing of that class of art that I remember.

Do the metopes and the frieze appear to you to be of the same age?—They do not appear to me to be worked by the same person, but they appear to me of the same age; the mind in the compositions, the forms, and consent of action, only lead me to think so; their execution being not only unequal in themselves, but very inferior to the Panathenæan Procession.

Do the general proportions of the horses appear to you to be the same?—Generally so, I think.

Should you have judged the metopes to be of very high antiquity, if you had not known the temple from which they came?—I should consider them so from their form.

In what rate should you place the Theseus and the River God, as compared with the Apollo Belvidere and the Laocoon?—Infinitely superior to the Apollo Belvidere.

And how as to the Laocoon?—As to the Laocoon it is a very difficult thing for me to answer the question, more particularly applying to execution, because there is not so much surface to the Theseus or Ilissus as there is to the Laocoon; the whole surface to the Laocoon is left, whereas to the other we cannot say there is

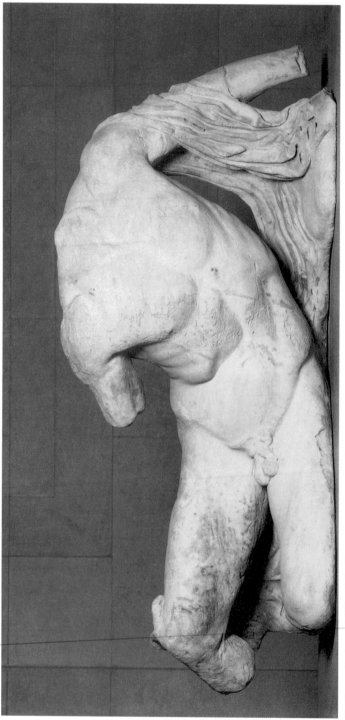

ii) Figure of a river god (Illissos), Parthenon, 440–432 BCE © The British Museum.

more than one-third of the surface left.

Which do you prefer; the Theseus, or the River God?—They are both so excellent that I cannot readily determine; I should say the back of the Theseus was the finest thing in the world; and that the anatomical skill displayed in front of the Ilissus, is not surpassed by any work of art.

[. . .]

Do you think it of great consequence to the improvement of art, that this Collection should become the property of the Public?—Decidedly so; from the great progress which has been made in art in this country for the last fifty years, we have every reason to think, that even the present men as well as young men rising up, having these things to look to, are less likely to be mannered.

Do you think these Marbles are well calculated for forming a school of artists?—I have no doubt of it.

You state, that you think the Theseus much superior to the Apollo Belvidere; upon what particular view do you form that opinion?—Because I consider that the Theseus has all the essence of style with all the truth of nature; the Apollo is more an ideal figure.

And you think the Theseus of superior value, on that account?—Yes; that which approaches nearest to nature, with grand form, Artists give the preference to.

[. . .]

... *Francis Chauntry* [sic], Esquire, called in and Examined.

ARE you well acquainted with the Elgin Marbles?—I have frequently visited them.

In what class as to excellence of art, do you place them?—Unquestionably in the first.

Do you speak generally of the Collection?—I mean the principal part of the Collection, that part that belonged to the Temple of Minerva.

As compared with the Apollo Belvidere and Laocoon, in what class should you place the Theseus and the River God?—I look upon the Apollo as a single statue; the Theseus and the River God, form a part of a group. I think, looking at the group in general, I should say they are in the highest style of art; that degree of finish which you see in the Apollo, would be mischievous in them. I think they are quite in a different style of art from the Apollo.

Are they not more according to common, but beautiful nature, than the Apollo?—Certainly; I mean nature in the grand style, not the simplicity of the composition visible in every part; but simplicity and grandeur are so nearly allied, it is almost impossible to make a distinction.

Do you place the metopes, and the frieze of the Festival, in the highest class of art?—The frieze, I do unquestionably; the bas relief, I mean.

Do you think that superior in execution and design, to the alto relievo?—I do not know, speaking of them comparatively; they are different in their style.

Do they appear to you to be of the same age?—I think they do; I never thought otherwise.

Do the horses appear to you to be treated in the same manner, and to be formed

according to the same principles?—Considering the difference between basso relievo and alto relievo, I think they are; but that makes a great difference in the general appearance of them.

In what class of art do you place the draped female figures?—As applied to their situation, I place them also in the first class; but, if they were for the inside of a building, I should say they were not in the first class; those were for a broad light, consequently the drapery is cut into small parts, for the sake of producing effect; for we find through the whole of that collection, effect has been their principal aim, and they have gained it in every point.

Have you ever looked at this Collection, with a view towards its value in money?—I really do not know what to compare them with.
[. . .]

William Wilkins, Esquire, called in, and Examined
[. . .]

Do you think that they lose much of their value as models of instruction, by being removed from the edifices to which they originally belonged?—I do not conceive they can possibly lose any thing; for there are so many on the spot still, that the artist who goes there will find an ample field for study.

Does each particular piece of architecture lose its value as a model of instruction, by its being removed from the edifice?—No, I conceive not, because the means by which it is connected with the pieces adjoining are obvious.

Are the designs we have of the remains of Athens, particularly those published by Stuart, correct?—Perfectly correct I know, from having measured a great many of them myself.

Do you think the temples themselves much injured as schools for art, in consequence of what Lord Elgin has taken from them? Not at all.
[. . .]

From the differences you must have observed between the state of the temple in the time of Stuart and when you saw it, and the knowledge you acquired on the spot, of the danger to which those objects would be subject from the wanton barbarity of the Turks, do you think that Lord Elgin may not be considered, in removing these statues, as having rescued and preserved them from imminent destruction?—By the statues is it meant the sculpture in general?

It was meant in general, but it will be satisfactory to the Committee, to have your opinion on particular parts?—I think, that by removing the portions of the frieze, that Lord Elgin has certainly preserved that which would otherwise have been lost; for the frieze is much more easily accessible. As to the metopes and the figures in the Tympanum in the pediment, I am not quite so sure; for although they have suffered since the time that Stuart's representations were made, it may have been in consequence of their being more exposed to the action of the elements; the cornice of the building which has been their great protection, having fallen from time to time. At the time that Lord Elgin was at Athens, there existed amongst the Turks certainly a great desire to deface all the sculpture within their reach; and I believe that that would still have prevailed, if Lord Elgin's operations in Greece had not given them a value in the eye of the Porte: For at present, I understand, from people lately returned from Greece, that the Turks show a

greater disposition to preserve them from violence.

[. . .]

Are you of opinion, that the study of these originals would not be more useful to architects, than drawings and casts?—I am not aware that any artist would obtain much more information than what might be conveyed from drawings.

The Committee wish to have your general opinion as to the merit of the sculpture of the Elgin Marbles, compared with any other Collection in the Country?— The sculpture of the Parthenon had very many degrees of merit; some are extremely fine, while others are very middling; those of the Tympanum are by far the best. The next in order are the metopes; some parts of the frieze in the cell are extremely indifferent indeed. I think a very mistaken notion prevails, that they are the works of Phidias, and it is that which has given them a value in the eyes of a great many people; if you divest them of that recommendation, I think that they lose the greater part of their charm.

Do you speak of the frieze alone now, or of the sculpture generally?—Of the sculpture generally. I have before stated those of the Tympanum are far superior to the others.

Is it your opinion that none of the statues are the works of Phidias?—I do not believe he ever worked in Marble at all. Pausanias mentions two or three instances only, and those are rather doubtful. Phidias was called, by Aristotle, Lythourgas, in contradistinction to Polyclates, whom he terms a maker of statues, and this because he commonly worked in bronze. If any thing could be inferred from this distinction, it would be that Phidias worked wholly in marble, which is contrary to the known fact. Almost all the instances recorded by Pausanias, are of statues in ivory and brass.

[. . .]

ii) Sir Richard Westmacott, Evidence to the Parliamentary Select Commission on the National Gallery (1853)

In connection with the establishment of the British National Gallery there was a suggestion that the 'art' contents of the British Museum should be transferred to the National Gallery, a suggestion that was ultimately rejected. (At the same time the idea of moving the natural history collections in the British Museum to a separate new museum was successfully promoted.) The Parliamentary Commission set up to decide on the art works took advice from a number of prominent artists, including Sir Richard Westmacott (1775–1856), the President of the Royal Academy, who had been responsible for the way the 'Elgin marbles' were displayed in the British Museum. Westmacott was concerned about the way sculptures should be displayed, and argued strongly that the art collections in the British Museum should be amalgamated with the national collection of pictures. He believed that this was important because the sculptures were vital in the training of painters as well as sculptors. [CC]

Source: *Report of the Parliamentary Select Committee on the National Gallery*, Evidence of Sir Richard Westmacott, (1853), Irish University Press Reprint, Education – Fine Arts 4, 1970, pp. 634–9

Sir *Richard Westmacott*, called in; and Examined.

8988. *Chairman.* YOU have been employed, have you not, by the trustees of the British Museum, in the arrangement of the marbles, for several years?—For nearly 40 years.

8989. And you have naturally looked with interest at their state and condition in the Museum?—Yes.

8990. Do you think that the Elgin Marbles, for instance, are deteriorated by the smoke of London?—I think their colour is certainly deeper than it was; we clean them twice a year, but simply with water.

8991. You consider that there is no danger in cleaning them with water?—Not the least; I should be afraid of acids.

8992. Even when they are cleaned with water that does not restore them to their former state of whiteness?—No, it will not.

8993. Therefore, as I understand, in spite of this cleaning with water twice a year, they are still growing more dark?—I would not say they are growing more dark, but they are certainly much darker than I remember them to have been when they arrived in this country.

8994. Do you think that with a view of preserving them, it would be desirable or objectionable to cover them with glass?—I think it would be very objectionable, certainly.

8995. It would prevent persons from seeing the contour?—Quite.

8996. Lord *W. Graham.* In consequence of the reflection?—Yes; if you put any object under glass, the angles of light will always depend on the position of the earth with reference to the sun.

8997. Mr. *B. Wall.* Would not that answer apply equally to pictures as to sculpture?—Not so much to pictures.

8998. Why less so?—Because you place the glass close to a picture.

8999. That is supposing the marble you cover to be greatly in relief?—Of course.

9000. *Chairman.* You have always taken an interest in the progress of art in this country; do you think it desirable that the art collections in the British Museum should be removed and combined in one building with the pictures?—Undoubtedly, if it were possible, and for this reason: a painter is taught in the same way that a sculptor is; he begins upon the plaster cast, because it is more easy to draw from than the marble, the marble being of different colours from its antiquity, and he is taught form from the plaster cast; he then goes to the statue. Now a painter has the same education that a sculptor has in being taught form; but when he comes to be a painter, he must forget the statue; but that is not so with the sculptor.

9001. Do I understand you to say you consider it desirable that students, whether of painting or of sculpture, should equally commence to study from casts?—From casts, certainly.

9002. I understand you to say it is in your opinion desirable that a student, who is a painter, should also study from the marble as well as from the cast?—Certainly.

9003. But do you think it of so much importance that he should have frequent

access to the marbles as to make it desirable to put them in the same building with the pictures?—Certainly; because it is the duty of the painter, as well as of the sculptor, to preserve form; it is very true that we have not in this country advanced so much in painting as they have on the Continent, and for this reason, that there artists have been employed, for it is employment that makes artists: you will find that we are very great in landscapes, and for the best reason in the world; there is a stronger inducement to the painter to become a landscape painter than to become a historical painter, because he will find employment in the one case when he will not in the other; it is from that cause that our deficiency in form in painting arises.

9004. Mr. *Hardinge*. Is it not the case that a man who intends to be a figure painter must show his proficiency as a master of drawing from casts before he is allowed to paint in the Royal Acadamy?—Certainly; we do not allow them to paint till they have received either a silver medal, or shown that they are fully conversant with form; we never allow them to take a brush till they are fully conversant with form.

9005. Consequently it would be a great advantage to have the two branches of art combined under one roof?—Certainly. I have always considered that it would be a very desirable thing if the National Gallery of pictures and the sculpture were together.

[...]

9029. Do you consider that a gallery, for the purpose of the arrangement of the collection of pictures, requires a much larger space, in the same manner as you have said the sculptures require a larger space?—Certainly; whatever building is adopted should be upon the principle of a telescope, so that as you required more room you should be able to extend the building without injuring the effect of it; that will be the case with respect to sculpture, I have no doubt, because we must recollect that in Asia Minor very few cities have been examined, and those few which have been examined have been very beautifully given in the work of the Dilettante Society. I do not suppose there have been half-a-dozen cities examined in Asia Minor, and I have very little doubt that if you were to examine the mounds you would find a great deal of sculpture, and so in the Grecian Islands; there you would have a chance probably of getting a higher class of art than you have in Asia Minor, because it would be most probably the Roman art that you would get in Asia Minor; but I have no doubt, from what I have seen in the British Museum (and I speak from the last 20 years), that there must be, at least, between 400 and 500 feet more added to the capacity for the collection than there was, and that will go on I hope.

9030. Lord *W. Graham*. Do you mean square feet or in length?—In length; an impetus has scarcely been given until within the last 20 years; it is not more than 40 years, I think, since Mr. Townley's collection was purchased by the country, and you see what has been done in those 40 years; our taste has improved, our manufactures have advanced; everything has shown, as clearly as possible, the connexion of the arts with everything that is civilised.

9031. *Chairman*. You think it has had a good effect, generally, upon the

education of the people in works of art?—Certainly; just see how well the people behave who go to the British Museum; we never hear of any accident; yes, by the bye, there was one accident, but that was caused by a madman. I am very much at the British Museum, and I see there the strongest manifestation of a desire for information, and a great deal of good behaviour, from a very low class of people too.

[. . .]

9050. Mr. *M. Milnes.* Have you observed any change of feeling among the visitors at the British Museum with regard to the Elgin Marbles during the time you have been there?—No.

9051. Are the Elgin marbles as much the subject of interest and admiration now as they were in former years?—With all persons conversant with art they must be and will be always, because they are the finest things in the world; we shall never see anything like them again.

9052. Do you think the liberal introduction into the British Museum of works of earlier and oriental art, has had any effect upon the interest felt by the public with regard to the Elgin Marbles?—None whatever, I should say.

9053. Do you think there is no fear that by introducing freely into the institution objects of more occasional and peculiar interest, such for instance as the sculptures from Nineveh, may deteriorate the public taste, and less incline them than they otherwise would be to study works of great antiquity and great art?—I think it impossible that any artist can look at the Nineveh Marbles as works for study, for such they certainly are not; they are works of prescriptive art, like works of Egyptian art. No man would think of studying Egyptian art. The Nineveh Marbles are very curious, and it is very desirable to possess them, but I look upon it that the value of the Nineveh Marbles will be the history that their inscriptions, if ever they are translated, will produce; because, if we had one-tenth part of what we have of Nineveh art, it would be quite enough as specimens of the arts of the Chaldeans, for it is very bad art. In fact it is as I have said with respect to Egyptian art, an art which the hierarchy insisted on, and no man dare depart from; that is clear; but as monuments of a period eight hundred years before Christ, they are very curious things.

9054. Do you think that the great interest works of that kind excite, those works being much more objects of curiosity than of art, exercises an injurious effect upon the public mind in matters of art?—I do not think they influence the public mind at all with respect to art.

9055. Do you think that as many persons attend and take an interest in the Elgin Marbles, when they are side by side with the Nineveh sculptures, as would take an interest in them if the Elgin Marbles were alone?—No; persons would look at the Nineveh Marbles and the thinking of their Bible at the time they were looking at them; they would consider them as very curious monuments of an age they feel highly interested in; but the interest in the Elgin Marbles arises from a distinct cause; from their excellence as works of art.

[. . .]

iii) Charles Le Brun, from *Lecture on Expression* (1698)

Charles Le Brun (1619–90) was a painter who was instrumental in establishing The French Royal Academy of Painting and Sculpture in 1648. He was appointed first painter to the king, and from 1668 Rector of the Academy. Le Brun's *Lecture on Expression* was published in 1698, 1702, 1718 and again in 1728. It exerted a great influence on history and genre painting until the early part of the nineteenth century. A written record of one of the lectures delivered by Le Brun to students and fellow academicians, the *Lecture On Expression* outlined a system of expressing the emotions of painted and drawn figures through their physical characteristics and in particular the configuration of their facial features. Le Brun's ideas on this subject were derived from René Descartes's analysis of the physiological effect of 'passion' or emotion in his *The Passions of the Soul*, first published in 1649. Le Brun followed Descartes in his view that the soul did not reside in any one particular part of the body, but that it exercised its functions particularly in the brain. This was because of the accumulation there of the 'animal spirits' carried by the blood. As a highly sensitive, almost immaterial mass, the animal spirits accumulated in the brain respond to the slightest external stimulus and cause marked bodily, nervous and muscular changes. Basing his argument on the views of Aristotle, Le Brun divided the soul into three parts: the vegetative (aligned with physical life and existence); the reasoning (allied with human rationality); and the sensitive (aligned with the capacity to experience sensations and emotions). It is with the latter that he is principally concerned in this *Lecture*. Lebrun subscribed to the Aristotelean view that the sensitive (feeling) part of the soul was divided into two 'appetites', one concupiscible (desire) the other irascible (anger). As he merged these ideas with those of Descartes, he came up with the view that the concupiscible appetite experienced what he called 'simple' passions (love, hatred, wonder, etc) while the irascible experienced 'wilder and mixed' passions (fear, courage, despair, anger, etc.). In later parts of his lecture Le Brun offers facial prototypes for these various passions. [LW]

Source: Charles Le Brun, *Lecture on Expression* (1698), printed in J. Montagu, *The Expression of the Passions: The Origin and Influence of Charles Le Brun's Conférence sur l'expression générale et particulière*, trans. Jennifer Montagu, Yale University Press, 1994, pp. 127–31, 134

[. . .]

Expression, in my opinion, is a simple and natural image of the thing we wish to represent, it is a necessary ingredient of all the parts of painting, and without it no picture can be perfect; it is this which indicates the true character of each object; it is by this means that the different natures of bodies are distinguished, that figures seem to have movement, and everything which is imitated appears to be real.

[. . .]

First, a passion is a movement of the sensitive part of the soul, which is designed to pursue that which the soul thinks to be for its good, or to avoid that which it believes to be hurtful to itself. Ordinarily, anything which causes a passion in the soul produces some action in the body.

[. . .]

An action is nothing else but the movement of some part, and this movement can be effected only by an alteration in the muscles, while the muscles are moved only by the intervention of the nerves, which bind the parts of the body and pass through them. The nerves work only by the spirits which are contained in the cavities of the brain, and the brain receives the spirits only from the blood which passes continuously through the heart, which heats it and ratifies it in such a way that it produces a thin air or spirit, which rises to the brain and fills its cavities.

The brain thus filled sends out these spirits to the other parts by means of the nerves, which are like so many little filaments or tubes which carry the spirits into the muscles, varying the amount to suit the needs of the muscles in performing the action to which they are called.

Thus the muscle which pulls the most receives the most spirits, and consequently becomes more swollen than the others which are deprived of them, and which by such a deprivation seem comparatively flaccid and shrunken.

Although the soul is linked to all the parts of the body, nevertheless there are various opinions concerning the place where, most specifically, it exercises its functions.

Some hold that it is a little gland in the centre of the brain, because that is the only part which is single, whereas all the others are double, and, as we have two eyes, two hands, and two ears, and all the organs of our external senses are double, there must be some place where the two images which enter through the two eyes, or the impressions which come from a single object through the double organs of the other senses, can reunite before reaching the soul, so that there will not be two objects represented instead of one.

Others say that it is the heart, because it is there that we feel the passions. For my part, it is my opinion that the soul receives the impressions of the passions in the brain, and that it feels the effects of them in the heart. The external movements which I have observed strongly confirm me in this opinion.

[. . .]

The soul being linked, as I have told you, to the whole body, every part of the body can serve to express the passions: Fear, for example, may be expressed by a man runing or fleeing away, Anger by one who clenches his fists, and seems to strike another.

But if it is true that there is one interior part where the soul exercises its functions most immediately, and that this part is in the brain, then we may also say that the face is the part where it makes its feelings most apparent.

And as we have said that the gland which is in the middle of the brain is the place where the soul receives the images of the passions, so the eyebrow is the part of the face where the passions are best distinguished, although many have thought that it was the eyes. It is true that the pupil, by its fire and movement, shows the

agitation of the soul, but it does not show the nature of this agitation. The mouth and nose also play a large part in expression, but ordinarily these features only follow the movements of the heart [. . .]

And as we have said that the sensitive part of the soul has two appetites, from which all the passions are born, so there are two movements of the eyebrows which express all the movements of these passions.

These two movements which I have observed have a strict correlation with these two appetites, for that which rises up towards the brain expresses all the gentlest and mildest passions, and that which slopes down towards the heart represents all the wildest and cruellest passions. But I will tell you further that there is something particular in these movements, and that in proportion as these passions change their nature, the movement of the eyebrow changes its form, for to express a simple passion the movement is simple and, if it is mixed, the movement is also mixed; if the passion is gentle, so is the movement, and, if it is violent, the movement is violent.

But it must also be noted that there are two ways in which the eyebrow can be raised: one whereby it arches in the middle which expresses agreeable emotions, and another whereby the eyebrow slopes up towards the middle of the brow, which represents an emotion of pain and sorrow.

It should be observed that when the eyebrow is raised in the middle, the mouth is raised at the corners, whereas in sorrow the mouth is raised in the middle.

But when the eyebrow is lowered in the middle, it expresses physical pain, and then the mouth moves in the opposite direction, for it is pulled down at the corners.

In laughter all the parts of the face go in one direction, for the eyebrows slope down towards the middle of the face, and cause the nose, the mouth, and the eyes to follow this movement.

In weeping the movements are mixed and contrary, for the inner ends of the eyebrows will sink, and the eyes and the mouth will rise in the middle.

There is one other observation to make, which is that when the heart is dejected all the parts of the face will be cast down.

But, on the other hand, if the heart feels some passion which heats and hardens it, all the parts of the face will share in this change, and particularly the mouth, which proves that, as I have already said, it is the mouth which most particularly indicates the movements of the heart. For it should be observed that when the heart grieves the corners of the mouth sink, and when the heart is happy the corners of the mouth are raised and when the heart feels any aversion the mouth is thrust out and raised in the middle. This, Gentlemen, is what we shall see on these simple outline drawings I have made, to help you to understand what I am talking about.

WONDER

As we have said that Wonder is the first and most temperate of all the passions, in which the heart feels the least disturbance, so the face also undergoes very little change in any part. If there is any change, it is only in the raising of the eyebrow, but the two ends of it will remain level; the eye will be a little more open than usual, and the pupil will be situated equidistant from the two eyelids, and immobile, fixed

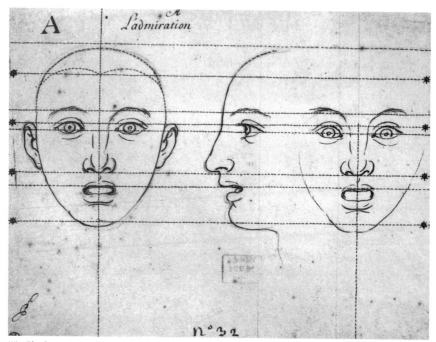

iii) Charles Le Brun, 'Wonder', (1698) Musée du Louvre, Paris, © Photo RMN.

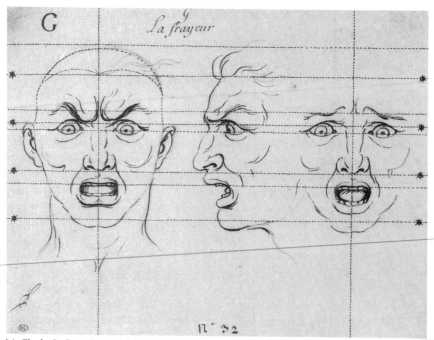

iv) Charles Le Brun, 'Terror', (1698) Musée du Louvre, Paris, © Photo RMN.

on the object which causes the wonder. The mouth will also be slightly open, but it will appear otherwise unchanged, as will the rest of the face. This passion produces a suspension of movement only to give time to the soul to deliberate on what it should do, and to consider the object before it attentively, for if it be rare and extraordinary, out of this first simple movement will come Esteem.

[...]

TERROR

Those affected by extreme Terror have the eyebrow raised high in the middle, and the muscles which produce this movement very prominent and swollen, pressing against each other and drawn down over the nose; both the nose and the nostrils must appear drawn up. The eyes must appear wide open, the upper lid hidden below the eyebrow, the white of the eye surrounded with red, the pupil in an unsettled movement, but nearer the lower part of the eye than the upper, the lower eyelid swollen and livid; the muscles of the nose will be swollen, and also the nostrils. The muscles of the cheeks will be extremely prominent, forming a fold on either side of the nostrils, the mouth wide open with the corners drawn back, and all the veins and tendons very prominent. Everything will be strongly marked, as much on the forehead as around the eyes: the muscles and veins of the neck must be very taut and prominent: the hair will stand on end, and the complexion be pale, while the extremities of the features, such as the end of the nose, the lips, the ears, and the parts around the eyes, will be somewhat livid.[1]

If the eyes appear wide open in this passion, it is because the soul makes use of them to discover the nature of the object which causes this Terror. Raised at one end and lowered at the other, the eyebrow seems to show by the raised end that it wishes to rise to the brain to protect it from the danger which the soul apprehends, while the other end appears drawn down and swollen due to the spirits which flow in quantity from the brain, as if to cover the soul and defend it from the evil which it fears. The widely open mouth marks the spasm of the heart which is oppressed by the blood which withdraws towards it, obliging whoever is subject to this passion, if he would breath, to make such an effort that the mouth opens very wide, and the air passing through the vocal organs produces an inarticulate sound. If the muscles and the veins appear swollen, this is only because of the spirits which the brain sends into those parts.

[...]

There, Gentlemen, are some of the external movements I have observed in the face.

But as we have said at the beginning of this discourse that the other parts of the body may help to express the passions, it should be as well to say something of this in passing.

If Wonder brings little change to the face, it produces scarcely any alteration in the other parts of the body, and this first movement can be represented by a person standing upright, both his hands open, the arms fairly near the body and standing with his feet still and close together.

[. . .]

But in Horror the movements must be much more violent than in Aversion, for the body will appear drawn violently back from the object which causes the Horror, the hands wide open and the fingers spread, the arms drawn tight against the body, and the legs in the act of fleeing.

Terror has something of these movements, but they will appear more exaggerated and wilder, for the arms will be stretched stiffly forwards, the legs in the act of fleeing with all their might, and the whole body in disorder.

All the other passions can produce actions in the body according to their nature, but some, such as Love, Hope, and Joy are scarcely visible, for these passions produce no great movements in the body.

[. . .]

NOTE

1 We can see an example of 'Terror' in the fleeing figure (one of Darius's lieutenants, centre foreground) in Le Brun's *The Battle of Arbella* (1689). The original idea for the action and pose of this figure was taken from a fleeing youth represented in Pietro da Cortona's *Battle of Arbella*. [LW].

iv) André Félibien des Avaux, from the Preface to *Conférence de l'Académie Royale de Peinture et de Sculpture* (1669)

André Félibien des Avaux (1619–95) was an architect and biographer who was appointed as *amateur honoraire* (an honorary expert or consultant) to the French Royal Academy of Painting and Sculpture. The Royal Academy had been established in Paris in 1648, as an intellectual, élite alternative to the artists' guild, the *Maitrise*, which had up to that point regulated the working opportunities and conditions of artists in Paris. The new Academy attempted to break with the craft-based traditions of the guild in order to establish painting as a Liberal Art, with an intellectual basis, of equal status with epic poetry and ancient rhetoric. It organised lectures, many of which were transcribed (we do not know how accurately) by Félibien.

In the passage reproduced here Félibien outlines what is commonly known as the hierarchy of genres, that is the order and status attributed to the different types of subject treated by artists. These are arranged in a scale which has inanimate objects (still life) at the lowest point and the human figure, particularly when engaged in actions of legendary, historical or allegorical significance, at the highest. This scale of values was derived from Renaissance commentators such as Leon Battista Alberti, whose treatise, *On Painting*, had been published in the 1430s. These extracts were translated for this volume by Linda Walsh. [LW]

Source: André Félibien des Avaux, from the Preface to *Conférence de l'Académie Royale de Peinture et de Sculpture* (1669), reprinted in T. Besterman, ed., *The Printed Sources of Western Art*, vol. 8, trans. Linda Walsh, Collegium Graphicum, 1972, unpaginated.

[. . .]

As the pleasure and instruction we receive from the works of painters and sculptors derive not only from their knowledge of drawing, the beauty of the colours they use or the value of their materials, but also from the grandeur of their ideas and from their perfect knowledge of whatever they represent; it follows that there is a particular kind of art quite separate from the artisan's manual skill and physical materials, involving the prior creation of pictures in the mind, without which a painter and his brush cannot create a perfect work. This art is not like those in which hard work and manual skill alone can create beauty.

It is precisely this grand art and this intellectual knowledge which can be learned from these lectures; all its constituent parts are discussed by the most knowledgeable contemporary painters. But in order to help people to understand these parts more easily, I believe I can say a little which will provide those who wish to learn about them with at least some small notion of what is to follow so that they can acquire some idea of the most essential elements of perfection in painting.

This art generally applies itself to all kinds of ways of representing natural forms. And although painters sometimes create unnatural forms, such as the monsters and grotesques they invent, these forms are nevertheless composed of elements observed and copied from different animals, so that we cannot say they are purely creations of the imagination.

That part of the representation of a natural form which consists simply of drawing lines and mixing colours is considered to be work of a mechanical kind. It therefore follows that, as different practitioners of this art apply themselves to various subjects, the more difficult and noble their choice of subject, the further they move away from what is common and base, and the more they distinguish themselves by a more illustrious kind of work.

Thus, the artist who does perfect landscapes is superior to another who paints only fruit, flowers or shells. The artist who paints living animals deserves more respect than those who represent only still, lifeless subjects. And as the human figure is God's most perfect work on earth, it is certainly the case that the artist who imitates God by painting human figures, is more outstanding by far than all the others. However, although it is a real achievement to make a human figure appear alive, and to give the appearance of movement to something which cannot move; it is still the case that an artist who paints only portraits has not yet achieved the greatest perfection of art and cannot aspire to the honour bestowed on the most learned of his colleagues. To achieve this, it is necessary to move on from the representation of a single figure to that of a group; to deal with historical and legendary subjects and to represent the great actions recounted by historians or the pleasing subjects treated by poets. And, in order to scale even greater heights, an artist must know how to conceal the virtues of great men and the most elevated mysteries beneath the veil of legendary tales and allegorical compositions. A great painter is successful in ventures of this kind. Herein lie the force, nobility and greatness of his art. We must, above all, be quick to learn this and to educate pupils accordingly.

We shall therefore show how an artist is not only, in his imitation of natural forms and of men's actions, an incomparable artisan, but also an ingenious and

learned author, in the invention and creation of ideas which are entirely original. Thus he has the advantage of being able to represent all that is in nature and all that has happened in the world, while at the same time revealing new things of which he is a kind of creator. [. . .]

v) Sir Joshua Reynolds, from *Discourses on Art* III, IV & VII (1769–90)

Sir Joshua Reynolds (1732–92) was the first president of the Royal Academy of Arts, founded under royal charter in 1768. Between 1769–1790 he produced his *Discourses*, a series of fifteen lectures delivered to students and academicians. The Royal Academy was formed to teach and disseminate the principles of academic art practice in Britain, to give the discipline of painting and sculpture the status of a Liberal Art, thus distinguishing it from craftsmanship or the mechanical trades.

The *Discourses* were delivered over a period of twenty years and reveal some shifts in Reynolds's views, although they are consistent in advocating the acquisition of knowledge in order to produce great art. The importance of study from antique and Italian Renaissance sources is a recurring theme. However, the *Discourses* were primarily intended as lectures, as guidelines for an art practice as well as theoretical treatises. Reynold's tendency in later lectures – to qualify and revise some of the theoretical ambitions of the earlier discourses – reveals both the influence of contemporary developments in philosophy and aesthetics, and his experiences and interests as a practising artist.

The following extracts from *Discourses* III, IV, and VII (editor's notes omitted) have been selected because they exemplify Reynolds's key concerns: his perception of painting as a 'Liberal Art'; the extent to which the artist should copy from nature; his views on history painting and 'invention'; and his ideas on 'genius' and 'taste'. [GP]

Source: Sir Joshua Reynolds, *Discourses on Art* (1769–90), Yale University Press, Robert R. Wark, ed., 1997, pp. 41–50; 57–71; 117–24

DISCOURSE III

[. . .]

Nature herself is not to be too closely copied. There are excellencies in the art of painting beyond what is commonly called the imitation of nature: and these excellencies I wish to point out. The students who, having passed through the initiatory exercises, are more advanced in the art, and who, sure of their hand, have leisure to exert their understanding, must now be told, that a mere copier of nature can never produce any thing great; can never raise and enlarge the conceptions, or warm the heart of the spectator.

The wish of the genuine painter must be more extensive: instead of endeavouring to amuse mankind with the minute neatness of his imitations, he must endeavour to improve them by the grandeur of his ideas; instead of seeking praise, by deceiving the superficial sense of the spectator, he must strive for fame, by captivating the imagination.

The principle now laid down, that the perfection of this art does not consist in mere imitation, is far from being new or singular. It is, indeed, supported by the general opinion of the enlightened part of mankind. The poets, orators, and rhetoricians of antiquity, are continually enforcing this position; that all the arts receive their perfection from an ideal beauty, superior to what is to be found in individual nature. They are ever referring to the practice of the painters and sculptors of their times, particularly Phidias,[1] (the favourite artist of antiquity,) to illustrate their assertions. As if they could not sufficiently express their admiration of his genius by what they knew, they have recourse to poetical enthusiasm. They call it inspiration; a gift from heaven. The artist is supposed to have ascended the celestial regions, to furnish his mind with this perfect idea of beauty. 'He,' says Proclus[2], 'who takes for his model such forms as nature produces, and confines himself to an exact imitation of them, will never attain to what is perfectly beautiful. For the works of nature are full of disproportion, and fall very short of the true standard of beauty. So that Phidias, when he formed his Jupiter, did not copy any object ever presented to his sight; but contemplated only that image which he had conceived in his mind from Homer's description.' And thus Cicero, speaking of the same Phidias: 'Neither did this artist,' says he, 'when he carved the image of Jupiter or Minerva, set before him any one human figure, as a pattern, which he was to copy; but having a more perfect idea of beauty fixed in his mind, this he steadily contemplated, and to the imitation of this all his skill and labour were directed.'

The Moderns are not less convinced than the Ancients of this superior power existing in the art; nor less sensible of its effects. Every language has adopted terms expressive of this excellence. The *gusto grande* of the Italians, the *beau ideal* of the French, and the *great style, genius,* and *taste* among the English, are but different appellations of the same thing. It is this intellectual dignity, they say, that ennobles the painter's art; that lays the line between him and the mere mechanick; and produces those great effects in an instant, which eloquence and poetry, by slow and repeated efforts, are scarcely able to attain.

Such is the warmth with which both the Ancients and Moderns speak of this divine principle of the art; but, as I have formerly observed, enthusiastick admiration seldom promotes knowledge. Though a student by such praise may have his attention roused, and a desire excited, of running in this great career; yet it is possible that what has been said to excite, may only serve to deter him. He examines his own mind, and perceives there nothing of that divine inspiration, with which, he is told, so many others have been favoured. He never travelled to heaven to gather new ideas; and he finds himself possessed of no other qualifications than what mere common observation and a plain understanding can confer. Thus he becomes gloomy amidst the splendour of figurative declamation, and thinks it hopeless, to pursue an object which he supposes out of the reach of human industry.

But on this, as upon many other occasions, we ought to distinguish how much is to be given to enthusiasm, and how much to reason. We ought to allow for, and we ought to commend, that strength of vivid expression, which is necessary to convey, in its full force, the highest sense of the most complete effect of art; taking care at the same time, not to lose in terms of vague admiration, that

solidity and truth of principle, upon which alone we can reason, and may be enabled to practise.

It is not easy to define in what this great style consists; nor to describe, by words, the proper means of acquiring it, if the mind of the student should be at all capable of such an acquisition. Could we teach taste or genius by rules, they would be no longer taste and genius. But though there neither are, nor can be, any precise invariable rules for the exercise, or the acquisition, of these great qualities, yet we may truly say that they always operate in proportion to our attention in observing the works of nature, to our skill in selecting, and to our care in digesting, methodizing, and comparing our observations. There are many beauties in our art, that seem, at first, to lie without the reach of precept, and yet may easily be reduced to practical principles. Experience is all in all; but it is not every one who profits by experience; and most people err, not so much from want of capacity to find their object, as from not knowing what object to pursue. This great ideal perfection and beauty are not to be sought in the heavens, but upon the earth. They are about us, and upon every side of us. But the power of discovering what is deformed in nature, or in other words, what is particular and uncommon, can be acquired only by experience; and the whole beauty and grandeur of the art consists, in my opinion, in being able to get above all singular forms, local customs, particularities, and details of every kind.

All the objects which are exhibited to our view by nature, upon close examination will be found to have their blemishes and defects. The most beautiful forms have something about them like weakness, minuteness, or imperfection. But it is not every eye that perceives these blemishes. It must be an eye long used to the contemplation and comparison of these forms; and which, by a long habit of observing what any set of objects of the same kind have in common, has acquired the power of discerning what each wants in particular. This long laborious comparison should be the first study of the painter, who aims at the greatest style. By this means, he acquires a just idea of beautiful forms; he corrects nature by herself, her imperfect state by her more perfect. His eye being enabled to distinguish the accidental deficiencies, excrescences, and deformities of things, from their general figures, he makes out an abstract idea of their forms more perfect than any one original; and what may seem a paradox, he learns to design naturally by drawing his figures unlike to any one object. This idea of the perfect state of nature, which the Artist calls the Ideal Beauty, is the great leading principle, by which works of genius are conducted. By this Phidias acquired his fame. He wrought upon a sober principle, what has so much excited the enthusiasm of the world; and by this method you, who have courage to tread the same path, may acquire equal reputation.

This is the idea which has acquired, and which seems to have a right to the epithet of *divine*, as it may be said to preside, like a supreme judge, over all the productions of nature; appearing to be possessed of the will and intention of the Creator, as far as they regard the external form of living beings. When a man once possesses this idea in its perfection, there is no danger, but that he will be sufficiently warmed by it himself, and be able to warm and ravish every one else.

Thus it is from a reiterated experience, and a close comparison of the objects in nature, that an artist becomes possessed of the idea of that central form, if I may so express it, from which every deviation is deformity. But the investigation of this form, I grant, is painful, and I know but of one method of shortening the road; this is, by a careful study of the works of the ancient sculptors; who, being indefatigable in the school of nature, have left models of that perfect form behind them, which an artist would prefer as supremely beautiful, who had spent his whole life in that single contemplation. But if industry carried them thus far, may not you also hope for the same reward from the same labour? We have the same school opened to us, that was opened to them; for nature denies her instructions to none, who desire to become her pupils.

[. . .]

Having gone thus far in our investigation of the great stile in painting; if we now should suppose that the artist has formed the true idea of beauty, which enables him to give his works a correct and perfect design; if we should suppose also, that he has acquired a knowledge of the unadulterated habits of nature, which gives him simplicity; the rest of his task is, perhaps, less than is generally imagined. Beauty and simplicity have so great a share in the composition of a great stile, that he who has acquired them has little else to learn. It must not, indeed, be forgotten, that there is a nobleness of conception, which goes beyond any thing in the mere exhibition even of perfect form; there is an art of animating and dignifying the figures with intellectual grandeur, of impressing the appearance of philosophick wisdom, or heroick virtue. This can only be acquired by him that enlarges the sphere of his understanding by a variety of knowledge, and warms his imagination with the best productions of ancient and modern poetry.

A Hand thus exercised, and a mind thus instructed, will bring the art to an higher degree of excellence than, perhaps, it has hitherto attained in this country. Such a student will disdain the humbler walks of painting, which, however profitable, can never assure him a permanent reputation. He will leave the meaner artist servilely to suppose that those are the best pictures, which are most likely to deceive the spectator. He will permit the lower painter, like the florist or collector of shells, to exhibit the minute discriminations, which distinguish one object of the same species from another; while he, like the philosopher, will consider nature in the abstract, and represent in every one of his figures the character of its species.

If deceiving the eye were the only business of the art, there is no doubt, indeed, but the minute painter would be more apt to succeed: but it is not the eye, it is the mind, which the painter of genius desires to address; nor will he waste a moment upon those smaller objects, which only serve to catch the sense, to divide the attention, and to counteract his great design of speaking to the heart.

This is the ambition which I wish to excite in your minds; and the object I have had in my view, throughout this discourse, is that one great idea, which gives to painting its true dignity, which entitles it to the name of a Liberal Art, and ranks it as a sister of poetry.

DISCOURSE IV

[. . .]

Invention in Painting does not imply the invention of the subject; for that is commonly supplied by the Poet or Historian. With respect to the choice, no subject can be proper that is not generally interesting. It ought to be either some eminent instance of heroick action, or heroick suffering. There must be something either in the action, or in the object, in which men are universally concerned, and which powerfully strikes upon the publick sympathy.

Strictly speaking, indeed, no subject can be of universal, hardly can it be of general, concern; but there are events and characters so popularly known in those countries where our Art is in request, that they may be considered as sufficiently general for all our purposes. Such are the great events of Greek and Roman fable and history, which early education, and the usual course of reading, have made familiar and interesting to all Europe, without being degraded by the vulgarism of ordinary life in any country. Such too are the capital subjects of scripture history, which, besides their general notoriety, become venerable by their connection with our religion.

As it is required that the subject selected should be a general one, it is no less necessary that it should be kept unembarrassed with whatever may any way serve to divide the attention of the spectator. Whenever a story is related, every man forms a picture in his mind of the action and expression of the persons employed. The power of representing this mental picture on canvass is what we call Invention in a Painter. And as in the conception of this ideal picture, the mind does not enter into the minute peculiarities of the dress, furniture, or scene of action, so when the Painter comes to represent it, he contrives those little necessary concomitant circumstances in such a manner, that they shall strike the spectator no more than they did himself in his first conception of the story.

I am very ready to allow that some circumstances of minuteness and particularity frequently tend to give an air of truth to a piece, and to interest the spectator in an extraordinary manner. Such circumstances therefore cannot wholly be rejected; but if there be any thing in the Art which requires peculiar nicety of discernment, it is the disposition of these minute circumstantial parts; which, according to the judgment employed in the choice, become so useful to truth, or so injurious to grandeur.

However, the usual and most dangerous error is on the side of minuteness; and therefore I think caution most necessary where most have failed. The general idea constitutes real excellence. All smaller things, however perfect in their way, are to be sacrificed without mercy to the greater. The Painter will not enquire what things may be admitted without much censure: he will not think it enough to shew that they may be there; he will shew that they must be there; that their absence would render his picture maimed and defective.

[. . .]

The great end of the art is to strike the imagination. The Painter is therefore to make no ostentation of the means by which this is done; the spectator is only to

feel the result in his bosom. An inferior artist is unwilling that any part of his industry should be lost upon the spectator. He takes as much pains to discover, as the greater artist does to conceal, the marks of his subordinate assiduity. In works of the lower kind, every thing appears studied, and encumbered; it is all boastful art, and open affectation. The ignorant often part from such pictures with wonder in their mouths, and indifference in their hearts.

But it is not enough in Invention that the Artist should restrain and keep under all the inferior parts of his subject; he must sometimes deviate from vulgar and strict historical truth, in pursuing the grandeur of his design.

[. . .]

A Portrait-Painter likewise, when he attempts history, unless he is upon his guard, is likely to enter too much into the detail. He too frequently makes his historical heads look like portraits; and this was once the custom amongst those old painters, who revived the art before general ideas were practised or understood. An History-painter paints man in general; a Portrait-Painter, a particular man, and consequently a defective model.

Thus an habitual practice in the lower exercises of the art will prevent many from attaining the greater. But such of us who move in these humbler walks of the profession, are not ignorant that, as the natural dignity of the subject is less, the more all the little ornamental helps are necessary to its embellishment. It would be ridiculous for a painter of domestick scenes, of portraits, landscapes, animals, or of still life, to say that he despised those qualities which has made the subordinate schools so famous. The art of colouring, and the skilful management of light and shadow, are essential requisites in his confined labours. If we descend still lower, what is the painter of fruit and flowers without the utmost art in colouring, and what the painters call handling; that is, a lightness of pencil that implies great practice, and gives the appearance of being done with ease? Some here, I believe, must remember a flower-painter whose boast it was, that he scorned to paint for the *million*: no, he professed to paint in the true Italian taste; and despising the crowd, called strenuously upon the *few* to admire him. His idea of the Italian taste was to paint as black and dirty as he could, and to leave all clearness and brilliancy of colouring to those who were fonder of money than of immortality. The consequence was such as might be expected. For these petty excellencies are here essential beauties; and without this merit the artist's work will be more short-lived than the objects of his imitation.

[. . .]

DISCOURSE VII

[. . .]

Every man whose business is description, ought to be tolerably conversant with the poets, in some language or other; that he may imbibe a poetical spirit, and enlarge his stock of ideas. He ought to acquire an habit of comparing and digesting his notions. He ought not to be wholly unacquainted with that part of philosophy which gives an insight into human nature, and relates to the manners,

characters, passions, and affections. He ought to know *something* concerning the mind, as well as *a great deal* concerning the body of man. For this purpose, it is not necessary that he should go into such a compass of reading, as must, by distracting his attention, disqualify him for the practical part of his profession, and make him sink the performer in the critick. Reading, if it can be made the favourite recreation of his leisure hours, will improve and enlarge his mind, without retarding his actual industry. What such partial and desultory reading cannot afford, may be supplied by the conversation of learned and ingenious men, which is the best of all substitutes for those who have not the means or opportunities of deep study. There are many such men in this age; and they will be pleased with communicating their ideas to artists, when they see them curious and docile, if they are treated with that respect and deference which is so justly their due. Into such society, young artists, if they make it the point of their ambition, will by degrees be admitted. There, without formal teaching, they will insensibly come to feel and reason like those they live with, and find a rational and systematick taste imperceptibly formed in their minds, which they will know how to reduce to a standard, by applying general truth to their own purposes, better perhaps than those to whom they owed the original sentiment.

Of these studies, and this conversation, the desired and legitimate offspring is a power of distinguishing right from wrong; which power applied to works of art, is denominated *Taste* [. . .]

It has been the fate of arts to be enveloped in mysterious and incomprehensible language, as if it was thought necessary that even the terms should correspond to the idea entertained of the instability and uncertainty of the rules which they expressed.

To speak of genius and taste, as in any way connected with reason or common sense, would be, in the opinion of some towering talkers, to speak like a man who possessed neither; who had never felt that enthusiasm, or, to use their own inflated language, was never warmed by that Promethean fire, which animates the canvas and vivifies the marble.

If, in order to be intelligible, I appear to degrade art by bringing her down from her visionary situation in the clouds, it is only to give her a more solid mansion upon the earth. It is necessary that at some time or other we should see things as they really are, and not impose on ourselves by that false magnitude with which objects appear when viewed indistinctly as through a mist.
[. . .]

Genius and taste, in their common acceptation, appear to be very nearly related; the difference lies only in this, that genius has superadded to it a habit or power of execution: or we may say, that taste, when this power is added, changes its name, and is called genius. They both, in the popular opinion, pretend to an entire exemption from the restraint of rules. It is supposed that their powers are intuitive; that under the name of genius great works are produced, and under the name of taste an exact judgment is given, without our knowing why, and without our being under the least obligation to reason, precept, or experience.

One can scarce state these opinions without exposing their absurdity; yet they are

constantly in the mouths of men, and particularly of artists. They who have thought seriously on this subject, do not carry the point so far; yet I am persuaded, that even among those few who may be called thinkers, the prevalent opinion allows less than it ought to the powers of reason; and considers the principles of taste, which give all their authority to the rules of art, as more fluctuating, and as having less solid foundations, than we shall find, upon examination, they really have.

[. . .]

The first idea that occurs in the consideration of what is fixed in art, or in taste, is that presiding principle of which I have so frequently spoken in former discourses, – the general idea of nature. The beginning, the middle, and the end of every thing that is valuable in taste, is comprised in the knowledge of what is truly nature; for whatever notions are not conformable to those of nature, or universal opinion, must be considered as more or less capricious.

My notion of nature comprehends not only the forms which nature produces, but also the nature and internal fabrick and organization, as I may call it, of the human mind and imagination. The terms beauty, or nature, which are general ideas, are but different modes of expressing the same thing, whether we apply these terms to statues, poetry, or picture. Deformity is not nature, but an accidental deviation from her accustomed practice. This general idea therefore ought to be called Nature, and nothing else, correctly speaking, has a right to that name. But we are so far from speaking, in common conversation, with any such accuracy, that, on the contrary, when we criticise Rembrandt and other Dutch painters, who introduced into their historical pictures exact representations of individual objects with all their imperfections, we say, – though it is not in a good taste, yet it is nature.

[. . .]

NOTES

1 Phidias (*c.*500–*c.*432 BCE) was a Greek sculptor whose work has constantly been seen as a touchstone of quality. He produced the statue of Athena for the Parthenon and that of Zeus for the temple at Olympia (one of the famed seven wonders of the ancient world). He is also thought to have contributed relief sculptures to the Parthenon. [SE]

2 Lib.2, in Timaeum Platonis, as cited by Junius de Pictura Veterum.

vi) William Hogarth, from *The Analysis of Beauty* (1753)

The painter and engraver William Hogarth's (1687–1764) views on art and design were first published in 1753 as *The Analysis of Beauty; Written With A View to Fixing the Fluctuating Ideas of Taste*. This book was intended to be one of the volumes in a series, of which it alone was completed, and includes Hogarth's attempt to provide criteria of beauty in an accessible language. In his introduction he explains his aversion to the 'over pompous terms of art' and his belief in an approach which gains knowledge through careful observation of nature, rather than endless studies of 'the various *manners* in which pictures are painted, the histories, names, and characters of the masters, together with many other little circumstances belonging

to the mechanical part of the art'. His treatise was intended as a partial challenge to those 'connoisseurs' of art who had absorbed, in their travels in Italy on the Grand Tour, an elevated conception of art modelled on classical and Renaissance ideals.

A key concern of this treatise is what Hogarth called 'the line of beauty', a serpentine curve which he observed throughout nature and which he believed to be intrinsic to all beautiful forms. Such views contributed to contemporary debates on ideals of beauty and the desirability of classical models, by challenging the classical emphasis on values of simplicity and symmetry. As is revealed in the extracts below, Hogarth values 'variety' and the lack of uniformity which, he argues, is observable in nature. (All notes omitted.) [GP]

Source: William Hogarth, *The Analysis of Beauty* (1753), Ronald Paulson, ed., Yale University Press, 1997, pp. 17–19, 25–9, 32–3, 48–52

INTRODUCTION

I now offer to the public a short essay, accompanied with two explanatory prints, in which I shall endeavour to shew what the principles are in nature, by which we are directed to call the forms of some bodies beautiful, others ugly; some graceful, and others the reverse; by considering more minutely than has hitherto been done, the nature of those lines, and their different combinations, which serve to raise in the mind the ideas of all the variety of forms imaginable. [...]

And in this light I hope my prints will be consider'd, and that the figures referr'd to in them will never be imagined to be placed there by me as examples themselves, of beauty or grace, but only to point out to the reader what sorts of objects he is to look for and examine in nature, or in the works of the greatest masters. My figures, therefore, are to be consider'd in the same light, with those a mathematician makes with his pen, which may convey the idea of his demonstration, tho' not a line in them is either perfectly straight, or of that peculiar curvature he is treating of. Nay, so far was I from aiming at grace, that I purposely chose to be least accurate, where most beauty might be expected, that no stress might be laid on the figures to the prejudice of the work itself. For I must confess, I have but little hopes of having a favourable attention given to my design in general, by those who have already had a more fashionable introduction into the mysteries of the arts of painting, and sculpture. Much less do I expect, or in truth desire, the countenance of that set of people, who have an interest in exploding any kind of doctrine, that may teach us to *see with our own eyes*.
[. . .]

To those, then, whose judgments are unprejudiced, this little work is submitted with most pleasure; because it is from such that I have hitherto received the most obligations, and now have reason to expect most candour.

Therefore I would fain have such of my readers be assured, that however they may have been aw'd, and over-born by pompous terms of art, hard names, and the

parade of seemingly magnificent collections of pictures and statues; they are in a much fairer way, ladies, as well as gentlemen, of gaining a perfect knowledge of the elegant and beautiful in artificial, as well as natural forms, by considering them in a systematical, but at the same time familiar way, than those who have been pre-possess'd by dogmatic rules, taken from the performances of art only: nay, I will venture to say, sooner, and more rationally, than even a tolerable painter, who has imbibed the same prejudices.

The more prevailing the notion may be, that painters and connoisseurs are the only competent judges of things of this sort; the more it becomes necessary to clear up and confirm, as much as possible, what has only been asserted in the foregoing paragraph; that no one may be deterr'd, by the want of such previous knowledge, from entring into this enquiry.

The reason why gentlemen, who have been inquisitive after knowledge in pic-tures, have their eyes less qualified for our purpose, than others, is because their thoughts have been entirely and continually employ'd and incumber'd with considering and retaining the various *manners* in which pictures are painted, the histories, names, and characters of the masters, together with many other little cir-cumstances belonging to the mechanical part of the art; and little or no time has been given for perfecting the ideas they ought to have in their minds, of the objects themselves in nature: for by having thus espoused and adopted their first notions from nothing but *imitations*, and becoming too often as bigotted to their faults, as their beauties, they at length, in a manner, totally neglect, or at least dis-regard the works of nature, merely because they do not tally with what their minds are so strongly prepossess'd with.

Were not this a true state of the case, many a reputed capital picture, that now adorns the cabinets of the curious in all countries, would long ago have been committed to the flames: nor would it have been possible for the Venus and Cupid, represented by the figure [under fig. 49, plate v], to have made its way into the prin-cipal apartment of a palace.

It is also evident that the painter's eye may not be a bit better fitted to receive these new impressions, who is in like manner too much captivated with the works of art; for he also is apt to pursue the shadow, and drop the substance. This mis-take happens chiefly to those who go to Rome for the accomplishment of their studies, as they naturally will, without the utmost care, take the infectious turn of the connoisseur, instead of the painter: and in proportion as they turn by those means bad proficients in their own arts, they become the more considerable in that of a connoisseur. As a confirmation of this seeming paradox, it has ever been observ'd at all auctions of pictures, that the very worst painters sit as the most pro-found judges, and are trusted only, I suppose, on account of their *disinterestedness*. [. . .]

CHAPTER I: OF FITNESS
Fitness of the parts to the design for which every individual thing is form'd, either by art or nature, is first to be consider'd, as it is of the greatest consequence to the beauty of the whole. This is so evident, that even the sense of seeing, the great inlet

of beauty, is itself so strongly bias'd by it, that if the mind, on account of this kind of value in a form, esteem it beautiful, tho' on all other considerations it be not so; the eye grows insensible of its want of beauty, and even begins to be pleas'd, especially after it has been a considerable time acquainted with it.

It is well known on the other hand, that forms of great elegance often disgust the eye by being improperly applied. Thus twisted columns are undoubtedly ornamental; but as they convey an idea of weakness, they always displease, when they are improperly made use of as supports to any thing that is bulky, or appears heavy.

The bulks and proportions of objects are govern'd by fitness and propriety. It is this that has establish'd the size and proportion of chairs, tables and all sorts of utensils and furniture. It is this that has fix'd the dimensions of pillars, arches, &c. for the support of great weight, and so regulated all the orders in architecture, as well as the sizes of windows and doors, &c. Thus though a building were ever so large, the steps of the stairs, the seats in the windows must be continued of their usual heights, or they would lose their beauty with their fitness: and in shipbuilding the dimensions of every part are confin'd and regulated by fitness for sailing. When a vessel sails well, the sailors always call her a beauty; the two ideas have such a connexion!

The general dimensions of the parts of the human body are adapted thus to the uses they are design'd for. The trunk is the most capacious on account of the quantity of its contents, and the thigh is larger than the leg, because it has both the leg and foot to move, the leg only the foot, &c.
[. . .]

The Hercules, by Glicon [fig. 3, plate v], hath all its parts finely fitted for the purposes of the utmost strength, the texture of the human form will bear. The back, breast and shoulders have huge bones, and muscles adequate to the supposed active strength of its upper parts; but as less strength was required for the lower parts, the judicious sculptor, contrary to all modern rule of enlarging every part in proportion, lessen'd the size of the muscles gradually down towards the feet; and for the same reason made the neck larger in circumference than any part of the head [fig. 4, plate iv]; otherwise the figure would have been burden'd with an unnecessary weight, which would have been a drawback from his strength, and in consequence of that, from its characteristic beauty.
[. . .]

CHAPTER III: OF UNIFORMITY, REGULARITY, OR SYMMETRY

It may be imagined that the greatest part of the effects of beauty results from the symmetry of parts in the object, which is beautiful: but I am very well persuaded, this prevailing notion will soon appear to have little or no foundation.

It may indeed have properties of greater consequence, such as propriety, fitness, and use; and yet but little serve the purposes of pleasing the eye, merely on the score of beauty.

We have, indeed, in our nature a love of imitation from our infancy, and the eye is often entertained, as well as surprised, with mimicry, and delighted with the exactness of counterparts: but then this always gives way to its superior love of variety, and soon grows tiresom.

If the uniformity of figures, parts, or lines were truly the chief cause of beauty, the more exactly uniform their appearances were kept, the more pleasure the eye would receive: but this is so far from being the case, that when the mind has been once satisfied, that the parts answer one another, with so exact an uniformity, as to preserve to the whole the character of fitness to stand, to move, to sink, to swim, to fly, &c. without losing the balance: the eye is rejoiced to see the object turn'd, and shifted, so as to vary these uniform appearances.

Thus the profile of most objects, as well as faces, are rather more pleasing than their full fronts.

Whence it is clear, the pleasure does not arise from seeing the exact resemblance, which one side bears the other, but from the knowledge that they do so on account of fitness, with design, and for use. For when the head of a fine woman is turn'd a little to one side, which takes off from the exact similarity of the two halves of the face, and somewhat reclining, so varying still more from the straight and parallel lines of a formal front face: it is always look'd upon as most pleasing. This is accordingly said to be a graceful air of the head.

It is a constant rule in composition in painting to avoid regularity. When we view a building, or any other object in life, we have it in our power, by shifting the ground, to take that view of it which pleases us best; and in consequence of this, the painter if he is left to his choice, takes it on the angle rather than in front, as most agreeable to the eye; because the regularity of the lines is taken away by their running into perspective, without losing the idea of fitness: and when he is of necessity obliged to give the front of a building, with all its equalities and parallelisms, he generally breaks (as it is term'd) such disagreeable appearances, by throwing a tree before it, or the shadow of an imaginary cloud, or some other object that may answer the same purpose of adding variety, which is the same with taking away uniformity. [. . .]

CHAPTER V: OF INTRICACY

The active mind is ever bent to be employ'd. Pursuing is the business of our lives; and even abstracted from any other view, gives pleasure. Every arising difficulty, that for a while attends and interrupts the pursuit, gives a sort of spring to the mind, enhances the pleasure, and makes what would else be toil and labour, become sport and recreation. [. . .]

This love of pursuit, merely as pursuit, is implanted in our natures, and design'd, no doubt, for necessary, and useful purposes. Animals have it evidently by instinct. The hound dislikes the game he so eagerly pursues; and even cats will

risk the losing of their prey to chase it over again. It is a pleasing labour of the mind to solve the most difficult problems; allegories and riddles, trifling as they are, afford the mind amusement: and with what delight does it follow the well-connected thread of a play, or novel, which ever increases as the plot thickens, and ends most pleas'd, when that is most distinctly unravell'd?

The eye hath this sort of enjoyment in winding walks, and serpentine rivers, and all sorts of objects, whose forms, as we shall see hereafter, are composed principally of what, I call, the *waving* and *serpentine* lines.

Intricacy in form, therefore, I shall define to be that peculiarity in the lines, which compose it, that *leads the eye a wanton kind of chace*, and from the pleasure that gives the mind, intitles it to the name of beautiful: and it may be justly said, that the cause of the idea of grace more immediately resides in this principle, than in the other five, except variety; which indeed includes this, and all the others.

That this observation may appear to have a real foundation in nature, every help will be requir'd, which the reader himself can call to his assistance, as well as what will here be suggested to him.
[. . .]

CHAPTER IX: OF COMPOSITION WITH THE WAVING-LINE

There is scarce a room in any house whatever, where one does not see the waving-line employ'd in some way or other. How inelegant would the shapes of all our moveables be without it? how very plain and unornamental the mouldings of cornices, and chimney-pieces, without the variety introduced by the *ogee* member, which is entirely composed of waving-lines.

Though all sorts of waving-lines are ornamental, when properly applied; yet, strictly speaking, there is but one precise line, properly to be called the line of *beauty*, which in the scale of them [fig. 49, plate v] is number 4: the lines 5, 6, 7, by their bulging too much in their curvature becoming gross and clumsy; and, on the contrary, 3, 2, 1, as they straighten, becoming mean and poor; as will appear in the next figure [50, plate v, top] where they are applied to the legs of chairs.

A still more perfect idea of the effects of the precise waving-line, and of those lines that deviate from it, may be conceived by the row of stays, figure [53, plate v bottom], where number 4 is composed of precise waving-lines, and is therefore the best shaped stay. Every whale-bone of a good stay must be made to bend in this manner; for the whole stay, when put close together behind, is truly a shell of well-varied contents, and its surface of course a fine form; so that if a line, or the lace were to be drawn, or brought from the top of the lacing of the stay behind, round the body, and down to the bottom peak of the stomacher; it would form such a perfect, precise, serpentine-line, as has been shewn, round the cone. [figure 26 in plate v] – For this reason all ornaments obliquely contrasting the body in this manner, as the ribbons worn by the knights of the garter, are both genteel and graceful. The numbers 5, 6, 7, and 3, 2, 1, are deviations into stiffness and meanness on one hand, and clumsiness and deformity on the other. The reasons for

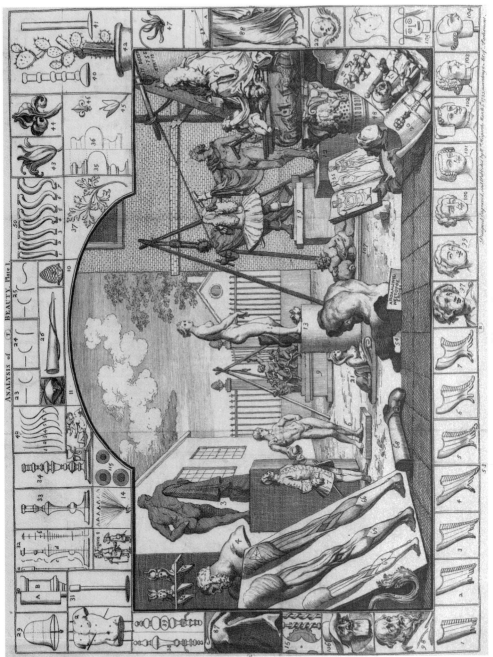

v) William Hogarth, *The Analysis of Beauty*, plate 1 (1753). By Permission of the British Library.

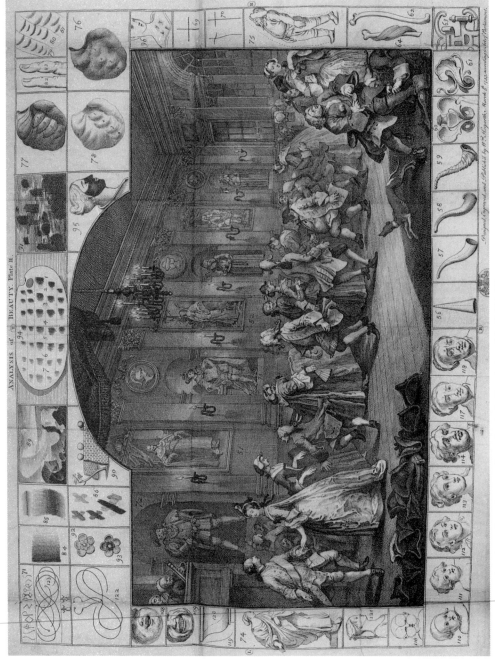

ANALYSIS of ᵗ BEAUTY. Plate II.

Designed, Engraved, and Published by Wᵐ Hogarth. March 5ᵗʰ 1753 according to Act of Parliament.

2. Wᵐ Hogarth, The Analysis of Beauty, plate 2 (1753). By Permission of the British Library.

which disagreeable effects, after what has been already said, will be evident to the meanest capacity.

It may be worth out notice however, that the stay, number 2, would better fit a well-shaped man than number 4; and that number 4, would better fit a well-for-m'd woman, than number 2; and when on considering them, merely as to their forms, and comparing them together as you would do two vases, it has been shewn by our principles, how much finer and more beautiful number 4 is, than number 2: does not this our determination enhance the merit of these principles, as it proves at the same time how much the form of a woman's body surpasses in beauty that of a man?

From the examples that have been given, enough may be gathered to carry on our observations from them to any other objects that may chance to come in our way, either animate or inanimate; so that we may not only *lineally* account for the ugliness of the toad, the hog, the bear and the spider, which are totally void of this waving-line, but also for the different degrees of beauty belonging to those objects that possess it.

CHAPTER X: OF COMPOSITIONS WITH THE SERPENTINE-LINE

The very great difficulty there is in describing this line, either in words, or by the pencil (as was hinted before, when I first mention'd it) will make it necessary for me to proceed very slowly in what I have to say in this chapter, and to beg the reader's patience whilst I lead him step by step into the knowledge of what I think the sublime in form, so remarkably display'd in the human body; in which, I believe, when he is once acquainted with the idea of them, he will find this species of lines to be principally concern'd.

First, then, let him consider fig: [56, plate vi, bottom], which represents a straight horn, with its contents, and he will find, as it varies like the cone, it is a form of some beauty, merely on that account.

Next let him observe in what manner, and in what degree the beauty of this horn is increas'd, fig: [57, plate vi bottom] where it is supposed to be bent two different ways.

And lastly, let him attend to the vast increase of beauty, even to grace and elegance, in the same horn, fig: [58, plate vi bottom] where it is supposed to have been twisted round, at the same time, that it was bent two different ways, (as in the last figure).

In the first of these figures, the dotted line down the middle expresses the straight lines of which it is composed; which, without the assistance of curve lines, or light and shade, would hardly shew it to have contents.

The same is true of the second, tho' by the bending of the horn, the straight dotted line is changed into the beautiful waving-line.

But in the last, this dotted line, by the twisting as well as the bending of the horn, is changed from the waving into the serpentine-line; which, as it dips out of

sight behind the horn in the middle, and returns again at the smaller end, not only gives play to the imagination, and delights the eye, on that account; but informs it likewise of the quantity and variety of the contents.

I have chosen this simple example, as the easiest way of giving a plain and general idea of the peculiar qualities of these serpentine-lines, and the advantages of bringing them into compositions, where the contents you are to express, admit of grace and elegance.

And I beg the same things may be understood of these serpentine-lines, that I have said before of the waving-lines. For as among the vast variety of waving-lines that may be conceiv'd, there is but one that truly deserves the name of *the line of beauty*, so there is only one precise serpentine-line that I call *the line of grace*. Yet, even when they are made too bulging, or too tapering, though they certainly lose of their beauty and grace, they do not become so wholly void of it, as not to be of excellent service in compositions, where beauty and grace are not particularly design'd to be express'd in their greatest perfection.

Though I have distinguish'd these lines so particularly as to give them the titles of *the lines of beauty and grace*, I mean that the use and application of them should still be confined by the principles I have laid down for composition in general; and that they should be judiciously mixt and combined with one another, and even with those I may term *plain* lines, (in opposition to these) as the subject in hand requires. Thus the cornu-copia fig: [59, plate vi, bottom], is twisted and bent after the same manner, as the last figure of the horn; but more ornamented, and with a greater number of other lines of the same twisted kind, winding round it with as quick returns as those of a screw.

This sort of form may be seen with yet more variations, (and therefore more beautiful) in the goat's horn, from which, in all probability, the ancients originally took the extreme elegant forms they have given their cornu-copias.
[. . .]

Almost all the muscles, and bones, of which the human form is composed, have more, or less of these kind of twists in them; and give in a less degree, the same kind of appearance to the parts which cover them, and are the immediate object of the eye: and for this reason it is that I have been so particular in describing these forms of the bent, and twisted, and ornamented horn.

There is scarce a straight bone in the whole body. Almost all of them are not only bent different ways, but have a kind of twist, which in some of them is very graceful; and the muscles annex'd to them, tho' they are of various shapes, appropriated to their particular uses, generally have their component fibres running in these serpentine-lines, surrounding and conforming themselves to the varied shape of the bones they belong to: more especially in the limbs. Anatomists are so satisfied of this, that they take a pleasure in distinguishing their several beauties.
[. . .]

vii) William Young Ottley, 'Fra Sebastiano Del Piombo – The
 Raising of Lazarus', from *A Descriptive Catalogue of the Pictures
 in the National Gallery* (1832)

William Young Ottley's Descriptive Catalogue opened with a series of critical
responses to pictures from the Angerstein collection of 40 paintings which
formed the original nucleus of the National Gallery. His comments on Sebastiano
del Piombo's 'The Raising of Lazarus' follow on from an opening entry on
Raphael's portrait of Pope Julius II. Sebastiano's work is thus given prominence
both by its position in the catalogue and through its close textual association with
a leading artist of the High Renaissance. As the title of the catalogue suggests, the
text here is largely 'descrivite' [*sic*]. Technique, content and individual detail is
considered first and then explained against the context of the depicted narrative.
The excerpt with its didactic tone offers revealing insights into English nine-
teenth-century art historical comment. [AT]

Source: William Young Ottley, 'Fra Sebastiano Del Piombo – The Raising of
Lazarus', from *A Descriptive Catalogue of the Pictures in the National Gallery, With
Critical Remarks on their Merits*, London, 1832, pp. 8–10

FRA SEBASTIANO DEL PIOMBO — THE RAISING OF LAZARUS

This picture, the production of an eminent colourist, aided by the greatest
designer that Italy has yet produced, is alike admirable for its merits as a work of
art, and interesting from the circumstances which are connected with its history.
 It was painted by Sebastiano in 1518–1519, in competition with Raffælle, who
was then employed upon his celebrated Transfiguration. The invention, we think,
ought principally to be ascribed to Michelangiolo and the point of time chosen is
after the completion of the miracle. Lazarus is represented sitting on the stone cof-
fin which had contained his body, supported by three men, who, having been
employed to remove the lid from the sepulchre, are now relieving him from the
grave clothes with which he was enveloped. Jesus, standing in the midst, appears
to be addressing him after his return to consciousness, in words, as may be
supposed, not unlike those which he had before used to Martha: 'I am the resur-
rection and the life; he that believeth in me shall live though he die.' Lazarus, his
countenance at once strongly expressive of awe and gratitude, gazes upon him,
wildly, but stedfastly, listening to his words, whilst with his right hand and foot he
assists in disengaging his limbs from the linen bandages which bound them; eager
to prostrate himself at the feet of his Saviour.
 The first great moment is past; and the overwhelming and indescribable emo-
tions, occasioned by the miracle in the breasts of the spectators, have somewhat
subsided; and have given place to varied feelings of astonishment, reverence, or
devotion. Immediately behind the figure of Christ is an old man who looks,
awe-struck, upon the reanimated corpse, elevating both his hands; – a figure,

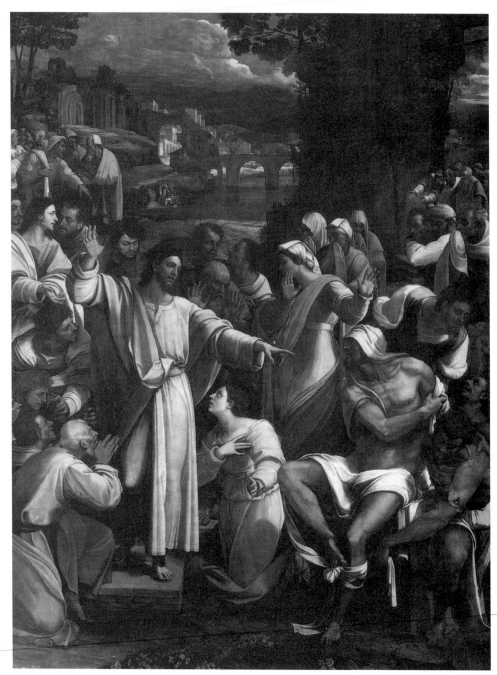

vii) Sebastiano del Piombo, *The Raising of Lazarus*, c. 1517-19. Reproduced by courtesy of The Trustees, The National Gallery, London.

admirable for the expression, and which Buonaroti repeated many years after-
wards in his Last Judgment; – and on the left is seen another old man, kneeling at
the feet of Jesus, his hands joined together in devotion, impatiently awaiting the
moment when he may express to him the soul-felt conviction that he is indeed the
Messiah, the Son of God.

The figure of Lazarus is a master-piece, as well for the invention as the execu-
tion; and forms, with the men employed to unbind him, the most prominent
group of the picture. The hand of Michelangiolo is apparent in every part of this
figure; (and the same may be said of that of the man who is releasing the legs of
Lazarus), and it cannot be doubted that the Florentine artist, finding Sebastiano
utterly incompetent to give to it that energy of character, and intelligence in the
naked parts, which he desired, seized his pencils, whilst the colours were still in a
moist state, and with that prodigious power which he had acquired by his long
practice in fresco painting, modelled the head, limbs, and body, in every part;
leaving untouched the kneeling figure of Mary, in the middle of the composition,
and immediately behind the figure of Lazarus; in order, perhaps, to prove, by the
comparison, to such as should hereafter examine the work with attention, how lit-
tle the Venetian could have achieved without his aid. The drapery of Lazarus is so
disposed as greatly to assist the effect: as is also the figure of the man who supports
his body: the latter leans forward, speaking to one of his companions, who is look-
ing up; and thus the upper part of his figure overshadows the neck, and part of the
head of Lazarus, whose face, by being kept entirely in shade, acquires increased
sublimity.

At a small distance behind the figure of Christ is seen St. John, who, with a
frankness of expression and gesture becoming an apostle of the truth, appears
answering objections raised against the credibility of the miracle by a man who is
addressing him. Further off, behind these figures, is a group of Pharisees, whose
unbelief of the divine character and mission of Jesus, is combatted by a man who,
pointing energetically towards the action represented in the foreground, seems to
say, 'Could any one not sent from God have restored, as he hath done, a dead per-
son to life?' The figure of Mary has already been noticed; behind her is seen her
sister Martha, whose attitude is somewhat equivocal; for we are unwilling to
ascribe the same sentiment to her, as to the three other women beyond her, who,
holding their mantles over their mouths and nostrils, seem to indicate that they
are not yet convinced the body of the restored man is inoffensive. It is
unnecessary to describe the other subordinate figures and groups contained in this
extensive composition.

The point of sight is high up in the picture, a choice which was no doubt
adopted by Sebastiano, in order that he might be the better enabled to fill his work
with rich matter. The distance represents a view of Jerusalem, and a river, traversed
by a bridge, on the banks of which is seen a group of women washing clothes. A
striking effect is produced in this part, by the bridge and the arched entrance into
the city being represented in shadow; while the houses and bank of the river,
which are shown through them, appear illumined by sunshine.

The masses of light and shadow, in this picture, are broad and simple in their

principle; and the colouring has all the depth and richness of tone of the Venetian school, without any ill-suited mixture of its characteristic gaiety. Upon the front of the raised pavement, whereon stands the figure of our Saviour, is the inscription:

SEBASTIANUS VENETUS FACIEBAT[*]

This picture was painted by order of Cardinal Giulio de Medici, then Archbishop of Narbonne in France, and was presented by him to the principal church of that city; from which it was at length obtained, at a vast expense, by the Duke of Orleans for his well-known collection.

It was originally painted on wood; but in the last century was transferred to canvass. *h.* 12–6. *w.* 9–6.

[*] Sebastiano of Venice made this

viii) Evidence from: a) The Right Hon. Lord Overstone. b) J. Dennistoun to The Parliamentary Select Committee on the National Gallery (1853)

In 1853 the British House of Commons appointed a Select Committee to 'Inquire into the Management of the National Gallery; and also to consider in what mode the collective Monuments of Antiquity and fine Art possessed by the nation may be most securely preserved, judiciously augmented, and advantageously exhibited to the Public'. The committee structure involves a team of politicians who select and interview witnesses before presenting recommendations for changes in law to Parliament. The Select Committee of 1853 was responding to the perception that the National Gallery collection was 'very imperfect' and contained 'few, or scarcely any specimens of higher treatment of sacred subjects by great artists'. In this context, The Right Hon. Lord Overstone (one of the Gallery's Trustees) was questioned about the extent to which acquisition policy should engage with the improvement and refinement of national taste. Overstone's response shows that he distinguished between moral education and the development of artistic taste. Dennistoun on the other hand elaborated upon the need to improve public taste through the exhibition of 'the highest works of the best masters' (i.e. from the period 1450–1540) and the representation of 'the progress of art in its various schools'. These excerpts illustrate the importance placed upon decorum, pedigree and quality in acquisition policy. [AT]

Source: *Report from the Parliamentary Select Committee on the National Gallery* (1853), Evidence from a) The Right Hon. Lord Overstone. b) J. Dennistoun, Irish University Press Reprint, Education – Fine Arts 4, 1970, pp. 367–8, 403–11

a) Lord Overstone

5394. Your Lordship is aware that there has never been any principle of purchase carried out, as Lord Aberdeen has stated, by the trustees?—The collection of

pictures is under the control of the Treasury; the Treasury call in the aid of the trustees to assist them in managing the details of business, and when what appeared to the trustees to be a good picture has presented itself in the market, they have made a representation to the Treasory, and upon that representation the picture has been bought; but the whole proceedings of the trustees have been, as I have said, of a desultory kind, without any definite purpose, and with no distinct definition of their duties.

5395. Do you concur in the opinion which has been frequently stated, that our national taste requires improvement and refinement, and that it is desirable that our larger purchases should in future, as far as possible, be made from those schools which represent art in its purer, more ideal, and more refined state?—There is no doubt that our knowledge with reference to matters of taste, and matters of art, is exceedingly deficient, and that it requires great cultivation and great advancement; what is the best mode of accomplishing that end, is a question more deep and refined than I pretend to be able to fathom.

5396. Are you of opinion that the two pictures which have lately been purchased, or rather that the picture by Velasquez, of the Adoration of the Shepherds in particular, is calculated to improve the taste for art in this country?—That is a question which would be more properly addressed to some eminent artist: but I apprehend that it is. I apprehend that improvement in art may be effected by presenting to persons even those works which may not be desirable for direct imitation; even faults and errors may be exceedingly useful subjects of instruction, and still more of comparison with reference to different schools, and different masters; in what respect they excelled, and in what respect they were deficient. I should apprehend that if such a picture as that of Velasquez were placed in the National Gallery, with a proper professor to lecture upon it, it might be made a subject of very useful instruction. There might be a lecture given on that picture of Velasquez, comparing it with the best works of the Italian school; and I should imagine that a descriptive lecture on that picture would be rendered highly instructive, and the presence of those pictures would aid the lecturer in conveying that instruction.

5397. Does not that remark apply rather to a gallery on a more extensive scale, with already a fine collection of works of different schools, than to one which is very imperfect, and which contains very few, or scarcely any specimens of the higher treatment of sacred subjects by great artists?—The more complete the gallery, no doubt the more complete will be the force of your observation.

5398. Do you not think that the purchase of such a picture as that would be more appropriate in a gallery containing several thousand pictures, like the great galleries abroad, than in a gallery which is singularly defective in the higher specimens of the school; and do you not think that to place before the public for their inspection and admiration a picture of that character, being a representation of a sacred subject, is calculated to deteriorate rather than to improve the taste of the public?—I do not at all intend to set myself up as a judge of what is calculated to improve or to deteriorate the taste of the public; we must deal with all human affairs as they present themselves; you must first see whether you have an

opportunity of purchasing better pictures. In the second place, you must watch your opportunities; it may be, that you would rather at the present moment have purchased a picture of a different character, and that you would have postponed the purchase of these pictures; but that assumes that you have before you the opportunity of purchasing a picture of a different character, and that you will by-and-by have that opportunity which is now passing by you. I apprehend that, in forming a great National Gallery, you must take things as they turn up; provided you take care as you go on to make the gallery more and more complete.

5399. Has not that principle of purchase, which you describe as one of chance, that is, purchasing any picture that may take the fancy of the moment, been exactly the principle upon which you have proceeded, instead of commencing with the higher and nobler specimens of art, and proceeding on a regular system for the purpose of doing that which is considered so desirable, improving the taste of the British public?—I think that in that question there are several expressions which assume that which I should not be prepared to admit; but passing that by, I do not look upon the matter as one of limitation and bounds. I look upon it as a limitation of opportunities. Show me the means of purchasing that which, as the gallery becomes more and more complete, I believe will be more and more useful, and fill up a desirable gap, and I will recommend the purchase of it; but I apprehend that the nation is quite unworthy to set about furnishing a National Gallery, unless it has sufficient funds to enable it to take advantage of opportunities that may offer. The only question therefore is, whether the picture which they present to you for purchase is one which, when the National Gallery is completed, will occupy an important and a useful position in that collection, and the absence of which in that collection would be a thing to be regretted.

5400. Are you not of opinion that the taste of the mass of the people, who frequent the National Gallery, and who are not used, or but little used to see objects of that kind treated in the way in which they ought to be treated, is likely to be deteriorated by having placed before them a very large picture, treating a very sublime and very sacred object in a very low and undignified manner?—As I said before, everything connected with the National Gallery is dependent on your clearly setting down what you are going to aim at; if you merely aim at presenting before an uninstructed public a collection of a few pictures, which either from the sentiment and feeling and devotion thrown into them shall excite the moral feelings, and exercise a moral influence upon the public, that is one thing, and if that be the only great object you aim at, it should be distinctly understood. If it is to be a great school of art, in which the public mind of all orders and classes is to be trained up; that is to say, artistic taste, the knowledge of amateurs, and the knowledge of professional artists, then you must purchase on different principles.
[...]

5402. Has not that been the principle on which hitherto the collection has been formed; that, namely, of picking up, as opportunities occurred, pictures of any school or master, a principle which has been objected to by several witnesses who have stated their opinions before us?—I do not think that the collection has been formed on any principle whatever; when a picture has been presented to our

notice it has been inspected and looked at. I think the pictures have been pur-
chased more with reference to the name of the master than the real character of
the work. I should be very glad to see every trace of the name of the master effaced,
and I should desire that every picture should be judged of by its own merits. I
think we buy pictures too much because they are attributed to this or that master.
[. . .]

5409. Is not Velasquez a painter whose reputation is almost unrivalled in his
particular line?—I am rather cautions in giving an opinion on points on which
my opinion is not worth having: I am speaking as a person who takes pleasure in
the contemplation of works of art, but I do not pretend to a critical knowledge of
the details of art.
[. . .]

b) J. Dennistoun

[. . .]

5828. *Chairman.* With respect to the principle, which has been alluded to by
yourself, of endeavouring to elevate the public taste by higher and purer examples
derived from the best age of painting, have you any special suggestions to make as
to the mode of carrying that object into effect?—I think that in a national gallery
there ought to be two great objects kept in view; one should be to elevate the pub-
lic taste by exhibition of the highest works of the best masters, and the other to
represent the progress of art in its various schools.

5829. In a very limited gallery like our own, where we have not the means, and
perhaps may not have the means for a very long period, of showing the progress
of art in any number of schools, would it not be better to limit your purchases in
the first instance to what are considered the more pure and fundamental schools,
the Italian schools, or one or two of them only?—I have never been able to dis-
cover in the purchases of the trustees of the National Gallery any system whatever;
they certainly have not followed the latter object to which I refer, viz., that of
extending the collection so as to illustrate the progress of art; neither, on the other
hand, in my humble apprehension, have their selections, generally speaking, been
from the highest examples of art, because they have neglected completely what I
look upon, and what I believe is now looked upon generally, as the highest schools
and the best periods of art, and have preferred purchases to a considerable extent
from the schools of Bologna and the Netherlands.

5830. In acting upon the principle of showing the succession of schools and the
progress of art, and combining that principle with the other of elevating the pub-
lic taste, do you not think it desirable, in the first instance, to direct attention
more particularly to making up a series of works of the early Florentine school,
and perhaps the early Venetian school, and the Lombard school, rather than
extending the collection to the inferior schools, the Spanish school, and schools
of the Netherlands and Holland?—My wish would be to see for a time the funds
of the trustees expended chiefly in purchasing works of the best age. I apprehend
the best age of art to have been the period between 1450 and 1540, which period

has been hitherto exceedingly inadequately represented, and in many instances it appears, from the instances Mr. Christie has just given, has been greatly neglected.

5831. Lord *W. Graham.* Can you instance any masters or schools that you refer to in particular?—I should say that there are perhaps 20 masters of various schools during that period, specimens of whose paintings are not to be found in the gallery, and all of whom are of very great importance, owing to their intrinsic merits, as well as to their being illustrative of the history of those schools.

5832. *Chairman.* Does that remark extend to all the other schools, or is it limited to the Italian schools?—I think there are some other masters, whose works would be of very great value, as illustrating the history of art; masters of the Flemish school, and the German and Upper Rhine school, which are completely unknown here; there are two fine specimens of the early Flemish painters in the gallery, but only two.

5833. Do you not think that there are more than 20 original masters of the earlier Italian schools, of whose works we want specimens in the gallery? – I think it might be very desirable to possess the works of many other masters; but it has occurred to me, on giving the subject a little consideration, that there are at least 20 names of painters of high importance whose works we do not at present possess.

5834. Of the Italian school alone?—Chiefly of the Italian school. I ought to have qualified what I said just now; I meant to say there were at least 20 names before Raphael, and I believe that there are at least 20 other names between the years 1450 and 1540, during the lives of Raphael and his immediate successors, of not less importance, which we do not possess.

5835. Lord *W. Graham.* To what extent would you admit pictures of recent purchase or English schools?—I think that our National Gallery ought to include valuable specimens of all schools, but at present I should wish to see large portions of their funds devoted in the first instance to what appears to me to be the more important class of pictures, and that in which at present we are unfortunately the least rich. I may add, as an additional reason for giving a marked preference to such purchases, that the public taste perhaps requires instruction upon that more than any other description of art. Unquestionably, other schools being already more appreciated in this country, are more likely to come into the National Gallery by gift and bequest, than pictures of the class to which I have just referred.

5836. But if the public taste is not prepared for those pictures, might it not be possible that the public would call them trash?—I should hope that a very brief acquaintance with those pictures would correct the public taste.

5837. Mr. *Vernon.* Perhaps it is within your experience, as it is within that of a preceding witness, that of late years the public taste has gone very much in the direction of that severe and earlier school of art?—It certainly has; within my experience, a very great change has taken place in that direction; and I may add, in reference to the question proposed by the noble Lord, that I have seldom known any amateurs who showed a great preference for that class of early art, who had not at first looked upon it with indifference, or perhaps with contempt; becoming able only on further acquaintance in Italy with the higher works of masters of that class, to appreciate their excellence.

5838. Is it not very desirable, both for artists and the public generally, that when we talk of pre-Raphaelites, we should really know what that word means?—I think it is certainly desirable, although not necessary in the first instance, that the National Gallery of pictures should contain specimens of what ought to be avoided, as well as what ought to be followed, in so far as regards the gradual progress of art. But true pre-Raphaelite pictures, when good, show much to be admired.

5839. Do you consider that in many of those early works, although the execution may be inferior, the feeling and intention of the painter, in some cases, is more plain than in works of a later day, and that great instruction may be obtained by the best artist, as well as by the public, from the sight of such pictures?—I think that little advantage is to be gained from them, except by persons possessed of a considerable amount of intelligence, which intelligence can only be obtained from seeing the best examples; but from such, studied in a proper spirit, a great deal indeed may be acquired.

[. . .]

5841. Do you think it would be desirable to put a check upon the practice which has hitherto prevailed, of snatching pictures up here and there, merely because they happen to be striking in effect, or because they have some name or some great mechanical merit, or otherwise, which practice may have interfered with the adoption of any general and better principle?—No doubt it might be advisable; but at the same time, if it were to go out to the public, through a Report of this Committee, or any other authoritative source, that purchases for the National Gallery were hereafter to be made from any particular class of pictures, the immediate result would be to increase at once in the market the price of that class; and, with reference to those occasional and unsystematic purchases to which the Chairman has referred, I must say, with every leaning to the higher schools of Italian art, it does not appear to me that the National Gallery trustees ought to be precluded from making purchases of other descriptions, from time to time, as opportunity occurs; and the question with me, in many cases, would be, not so much whether the picture or pictures purchased were themselves immediately desirable or not, as whether, under the whole circumstances of the case, it was a desirable employment of the funds. For example, a good deal has been said with reference to the latest purchase for the National Gallery of a large Spanish picture. With reference to that, it humbly appears to me that that picture was important as a link in the history of the Spanish school, making it desirable that our gallery should possess it; but when I consider what an immense amount of pictures more valuable, in my apprehension, the sum of 2,200 *l.* might have obtained, I am not disposed to think that purchase judicious. I think that, even at the sale of the Spanish pictures, a smaller sum might have been better spent in obtaining several specimens of that school, of a quality perhaps not inferior, and at all events of an interest nearly as great, which were exposed for sale, and which brought comparatively but small prices.

5842. Were there not a number of pictures in that collection, which, if purchased systematically, might have given us something like a series, showing the progress of the Spanish school?—I consider that there were.

5843. There were some very early ones, were there not?—I believe that those were on the whole deficient; but there was a considerable variety of masters and schools represented.

5844. There were pictures illustrative of the effect of Italian art on the Spanish school, were there not?—I observed several such.

5845. Do you not think that that was a class of pictures which it was highly desirable to obtain, in order to show the influence of the great Italian schools on the other European schools of art?—Certainly, and I believe that those pictures did fetch a moderate price.

5846. And do you think it would have been desirable for the National Gallery, in an historical point of view, to obtain them?—I do not think it desirable to spend very large sums of money on pictures merely of an historical class, but I think that every opportunity ought to be taken of securing such pictures when they come into the market at a low figure, especially where they are signed and dated, or where anything approaching to certainty can be obtained either as to the master, or as to the period when they were painted.
[. . .]

5850. Do you happen to be aware that the 'Velasquez' which was purchased here was well known to be a perfectly original and highly prized picture by all persons acquainted with works of art in Spain?—My evidence on that subject can only be hearsay. I certainly consider, regarding as I do Velasquez chiefly as a portrait painter, that, had it been wished to secure a first-rate specimen of his handiwork, it would have been better to have paid a large sum for one or more of his best portraits than for that picture which, to my mind, treated a sacred subject in a manner characteristic of the school, but not likely to elevate taste in any degree in this country.

5851. Do you not consider that in a public collection of pictures it is impossible at all times to regard the mere treatment of a subject; that you must look also to the mode of execution, and that that is one of things which distinguishes private from public collections?—Unquestionably; I do not except to the purchase of 'Velasquez' as a purchase; I only stated that the large amount of money for which it has been purchased might probably have been better spent.

5852. *Chairman.* Is it not your opinion that a very limited collection like ours should be made up, as far as possible, from the higher schools of art for the pur-pose of elevating public taste, and that it is not desirable to purchase pictures on high and sacred subjects where those subjects are treated in a degrading or offen-sive manner?—Certainly; but at the same time it must be borne in mind, that if we are to have sacred subjects treated by the Spanish school, the pictures will prob-ably, in many instances, be liable to the criticism which the Honourable Chair-man has made.

5853. Would not that be a reason for following the principle to which I have alluded in endeavouring, in the first place, to bestow our funds in making up our collection from the early Italian school? – That I consider ought unquestionably to be the primary object.
[. . .]

5901. *Chairman.* Are you aware of the historical series of pictures that exist in several of the Italian galleries, in the Academy of Florence, another at Siena, and another at Pisa; do you think it advisable, in enlarging and improving our own gallery, to have something in the way of a complete series, say of the Italian school, without reference to the higher merit of the pictures, in order to bring under one view the progress of art in Italy in particular, as the source and foundation of art throughout Europe?—I think I have already stated, that as a secondary object it is desirable to bring many such specimens together, although not to the extent to which it is carried in some galleries in Italy, where many works of exceedingly small importance are preserved, more from local interest than anything else; but up to a certain point, I think this is an object which the trustees of the National Gallery should carefully keep in view. I have already stated that I think they should omit no favourable opportunity of obtaining any monument illustrative of the progress of art in any school, such as pictures authenticated by signature or date, and of sufficient interest to be specimens of art of that period; but I think it is desirable that they should, in the first place, bestow their attention and dedicate their funds to that more particularly interesting and valuable period of Italian art which I have already considered in the course of my evidence.

5902. My question related not so much to procuring these specimens as to the arranging of them, because there are various modes by which the different schools might be chronologically arranged; I alluded to a series of them in one long gallery which should embrace a wider compass, a longer period, and a greater range of art, irrespective of those special arrangements of the individual schools in their own particular departments?—I think the principle is a very valuable one; it is followed, more or less, in all galleries which have been recently arranged, such as Munich and Berlin, and I believe it will be followed also in the new gallery which is now in the course of erection at Dresden.

[. . .]

iv) Evidence of J. Ruskin to the *Parliamentary National Gallery Site Commission* (1857)

In 1857 Queen Victoria appointed six commissioners to form a Royal Commission to determine the site of the new National Gallery. Amongst other things, this commission was required to consider whether or not to endorse the recommendation of the 1853 Select Committee that the National Gallery should be combined with the Fine Art and Archaeological collections of the British Museum. Over thirty individuals presented evidence to the commission, among them was the art critic and social theorist John Ruskin (1819–1900). In response to the desirability of uniting painting with sculpture under one roof, Ruskin observed that this was essential if a national gallery was to teach the 'course of art'. Ruskin hoped that the new National Gallery would become a 'perfectly consecutive chronological arrangement'. He was also concerned with display, urging greater space for larger works and hanging on one level rather than the mosaic effect favoured at the time.

Commenting on the arrangement of Venetian art at the Louvre, Ruskin suggested that whilst producing a 'most noble room' and presenting a 'mass of fire on four walls' such displays prevented the appreciation of detail. For Ruskin the most important characteristics of a national gallery were good quality works and an accessible and appropriate display. Only by such a combination could the eyes of onlookers be educated and refined. Ruskin emerges from such evidence as the champion of current acquisition policy at the National Gallery. [AT]

Source: Evidence of J. Ruskin to the *Parliamentary National Gallery Site Commission* (1857), Irish University Press Reprint, Education – Fine Arts 3, 1970, pp. 93–7

[. . .]

2422. *Chairman.* I see that in your 'Notes on the Turner Collection,' you recommended that the large upright pictures would have great advantage in having a room to themselves. Do you mean each of the large pictures or a whole collection of large pictures? – Supposing very beautiful pictures of a large size, (it would depend entirely on the value and size of the picture), supposing we ever acquired such large pictures as Titian's Assumption, or Raphael's Transfiguration, those pictures ought to have a room to themselves, and to have a gallery round them.

2423. Do you mean that each of them should have a room?—Yes.

2424. *Dean of St. Paul's.* Have you been recently at Dresden?—No, I have never been at Dresden.

2425. Then you do not know the position of the Great Holbein and of the Madonna de S. Sisto there, which have separate rooms?—No.

2426. Mr. *Cockerell.* Are you acquainted with the Munich Gallery?—No.

2427. Do you know the plans of it?—No.

2428. Then you have not seen, perhaps, the most recent arrangements adopted by that learned people, the Germans, with regard to the exhibition of pictures? – I have not been into Germany for 20 years.

2429. That subject has been handled by them in an original manner, and they have constructed galleries at Munich, at Dresden, and I believe at St. Petersburgh upon a new principle, and a very judicious principle. You have not had opportunities of considering that?—No, I have never considered that; because I always supposed that there was no difficulty in producing a beautiful gallery, or an efficient one. I never thought that there could be any question about the form which such a gallery should take, or that it was a matter of consideration. The only difficulty with me was this – the persuading, or hoping to persuade, a nation that if it, had pictures at all, it should have those pictures on the line of the eye; that it was not well to have a noble picture many feet above the eye, merely for the glory of the room. Then I think that as soon as you decide that a picture is to be seen, it is easy to find out the way of showing it; to say that it should have such and such a room, with such and such a light; not a raking light, as I heard Sir Charles Eastlake express it the other day, but rather an oblique and soft light, and not so near the picture as to catch the eye painfully. That may be easily obtained, and I think that all other questions after that are subordinate.

2430. *Dean of St. Paul's.* Your proposition would require a great extent of wall?
—An immense extent of wall.

2431. *Chairman.* I see you state in the pamphlet to which I have before alluded,
that it is of the highest importance that the works of each master should be kept
together. Would not such an arrangement increase very much the size of the
National Gallery?—I think not, because I have only supposed in my plan that, at
the utmost, two lines of pictures should be admitted on the walls of the room; that
being so, you would be always able to put all the works of any master together
without any inconvenience or difficulty in fitting them to the size of the room.
Supposing that you put the large pictures high on the walls, then it might be a
question, of course, whether such and such a room or compartment of the Gallery
would hold the works of a particular master; but supposing the pictures were all
on a continuous line, you would only stop with A and begin with B.

2432. Then you would only have them on one level and one line?—In general;
that seems to me the common-sense principle.

2433. Mr. *Richmond.* Then you disapprove of the whole of the European hang-
ing of pictures in galleries?—I think it very beautiful sometimes, but not to be
imitated. It produces most noble rooms. No one can but be impressed with the
first room at the Louvre, where you have the most noble Venetian pictures one
mass of fire on the four walls; but then none of the details of those pictures can
be seen.

2434. *Dean of St. Paul's.* There you have a very fine general effect, but you lose
the effect of the beauties of each individual picture?—You lose all the beauties: all
the higher merits; you get merely your general idea. It is a perfectly splendid room,
of which a great part of the impression depends upon the consciousness of the
spectator that it is so costly.

2435. Would you have those galleries in themselves richly decorated?—Not
richly, but pleasantly.

2436. Brilliantly, but not too brightly?—Not too brightly. I have not gone into
that question, it being out of my way; but I think, generally, that great care should
be taken to give a certain splendour – a certain gorgeous effect – so that the spec-
tator may feel himself among splendid things; so that there shall be no discomfort
or meagreness, or want of respect for the things which are being shown.

2437. Mr. *Richmond.* Then do you think that Art would be more worthily treated,
and the public taste and artists better served, by having even a smaller collection of
works so arranged, than by a much larger one merely housed and hung four or five
deep, as in an auction-room?—Yes. But you put a difficult choice before me, because
I do think it a very important thing that we should have many pictures. Totally new
results might be obtained from a large gallery in which the chronological arrange-
ment was perfect, and whose curators prepared for that chronological arrangement,
by leaving gaps to be filled by future acquisition; taking the greatest pains in the
selection of the examples, that they should be thoroughly characteristic; giving a
greater price for a picture which was thoroughly characteristic and expressive of the
habits of a nation; because it appears to me that one of the main uses of Art at
present is not so much as Art, but as teaching us the feelings of nation. History only

tells us what they did; Art tells us their feelings, and why they did it: whether they were energetic and fiery, or whether they were, as in the case of the Dutch, imitating minor things, quiet and cold. All those expressions of feeling cannot come out of History. Even the contemporary historian does not feel them; he does not feel what his nation is; but get the works of the same master together, the works of the same nation together, and the works of the same century together, and see how the thing will force itself upon every one's observation.

2438. Then you would not exclude the genuine work of inferior masters?—Not by any means.

2439. You would have the whole as far as you could obtain it?—Yes, as far as it was characteristic; but, I think, you can hardly call an inferior master one who does in the best possible way the thing he undertakes to do; and I would not take any master who did not in some way excel. For instance, I would not take a mere imitator of Cuyp among the Dutch; but Cuyp himself has done insuperable things in certain expressions of sunlight and repose. Vander Heyden and others may also be mentioned as first-rate in inferior lines.

2440. Taking from the rise of art to the time of Raphael, would you in the National Gallery include examples of all those masters whose names have come down to the most learned of us?—No.

2441. Where would you draw the line, and where would you begin to leave out?—I would only draw the line when I was purchasing a picture. I think that a person might always spend his money better by making an effort to get one noble picture than five or six second or third-rate pictures, provided only, that you had examples of the best kind of work produced at that time. I would not have second-rate pictures. Multitudes of masters among the disciples of Giotto might be named; you might have one or two pictures of Giotto, and one or two pictures of the disciples of Giotto.

2442. Then you would rather depend upon the beauty of the work itself; if the work were beautiful you would admit it?—Certainly.

2443. But if it were only historically interesting, would you then reject it?—Not in the least. I want it historically interesting, but I want as good an example as I can have of that particular manner.

2444. Would it not be historically interesting if it were the only picture known of that particular master, who was a follower of Giotto? – For instance, supposing a work of Cennino Cennini were brought to light, and had no real merit in it as a work of art, would it not be the duty of the authorities of a National Gallery to seize upon that picture, and pay perhaps rather a large price for it?—Certainly, all documentary art I should include.

2445. Then what would you exclude?—Merely that which is inferior, and not documentary; merely another example of the same kind of thing.

2446. Then you would not multiply examples of the same masters, if inferior men, but you would have one of each. There is no man, I suppose, whose memory has come down to us after three or four centuries, but has something worth preserving in his work—something peculiar to himself, which perhaps no other person has ever done, and you would retain one example of such, would you

not?—I would, if it was in my power, but I would rather with given funds make an effort to get perfect examples.

2447. Then you think that the artistic element should govern the archæological in the selection?—Yes, and the archæological in the arrangement.

2448. *Dean of St. Paul's.* When you speak of arranging the works of one master consecutively, would you pay any regard or not to the subjects. You must be well aware that many painters, for instance, Correggio, and others, painted very incongruous subjects; would you rather keep them together than disperse the works of those painters to a certain degree according to their subjects?—I would most certainly keep them together. I think it an important feature of the master that he did paint incongruously, and very possibly the character of each picture would be better understood by seeing them together; the relations of each are sometimes essential to be seen.

2449. Mr. *Richmond.* Do you think that the preservation of these works is one of the first and most important things to be provided for?—It would be so with me in purchasing a picture. I would pay double the price for it if I thought it was likely to be destroyed where it was.

2450. In a note you wrote to me the other day, I find this passage: 'The Art of a nation I think one of the most important points of its history, and a part, which, if once destroyed, no history will ever supply the place of – and the first idea of a National Gallery is, that it should be a Library of Art, in which the rudest efforts are, in some cases, hardly less important than the nobles:' Is that your opinion?—Perfectly. That seems somewhat inconsistent with what I have been saying, but I mean there, the noblest efforts of the time at which they are produced. I would take the greatest pains to get an example of 11th Century work, though the painting is perfectly barbarous at that time.

2451. You have much to do with the education of the working classes in Art. As far as you are able to tell us, what is your experience with regard to their liking and disliking in Art – do comparatively uneducated persons prefer the Art up to the time of Raphael, or down from the time of Raphael – we will take the Bolognese School, or the early Florentine School – which do you think a working man would feel the greatest interest in looking at?—I cannot tell you, because my working men would not be allowed to look at a Bolognese Picture; I teach them so much love of detail, that the moment they see a detail carefully drawn, they are caught by it. The main thing which has surprised me in dealing with these men is the exceeding refinement of their minds – so that in a moment I can get carpenters, and smiths, and ordinary workmen, and various classes to give me a refinement which I cannot get a young lady to give me, when I give her a lesson for the first time. Whether it is the habit of work which makes them go at it more intensely, or whether it is (as I rather think) that, as the feminine mind looks for strength, the masculine mind looks for delicacy, and when you take it simply, and give it its choice, it will go to the most refined thing, I do not know.
[. . .]

2462. *Chairman.* Do you not consider that it is rather prejudicial to art that there should be a gallery notoriously containing no first-rate works of art, but second-rate or third-rate works?—No; I think it rather valuable as an expression of

the means of education, that there should be early lessons in art – that there should be this sort of art selected especially for first studiès, and also that there should be a recognition of the exceeding preciousness of some other art. I think that portions of it should be set aside, as interesting, but not unreplaceable; but that other portions should be set aside, as being things as to which the function of the nation was, chiefly, to take care of those things, not for itself merely, but for all its descendants, and setting the example of taking care of them for ever.

2463. You do not think, then, that there would be any danger in the studying or the copying of works which notoriously were not the best works?—On the contrary, I think it would be better that works not altogether the best should be first submitted. I never should think of giving the best work myself to a student to copy – it is hopeless; he would not feel its beauties – he would merely blunder over it. I am perfectly certain that that cannot be serviceable in the particular branch of art which I profess, namely, Landscape painting; I know that I must give more or less of bad examples.

[. . .]

2472. You speak as a connoisseur; how would the common eye of the public agree with you in that opinion?—I think it would not agree with me. Nevertheless, if I were taking some of my workmen into the National Gallery, I should soon have some hope of making them understand in what excellence consisted, if I could point to a genuine work: but I should have no such hope if I had only copies of these pictures.

2473. Do you hold much to the archæological, chronological, and historical series and teaching of pictures?—Yes.

2474. Are you of opinion that that is essential to the creative teaching, with reference to our future schools?—No. I should think not essential at all. The teaching of the future Artist I should think might be accomplished by very few pictures of the class which that particular Artist wished to study. I think that the chronological arrangement is in nowise connected with the general efficiency of the gallery as matter of study, for the Artist, but very much so as a means of study, not for persons interested in painting merely, but for those who wish to examine the general history of nations; and I think that painting should be considered by that class of persons as containing precious evidence. It would be part of the philosopher's work to examine the art of a nation as well as its poetry.

2475. You consider that art speaks a language and tells a tale which no written document can effect?—Yes, and far more precious; the whole soul of a nation generally goes with its art. It may be urged by an ambitious king to become a warrior nation. It may be trained by a single leader to become a *great* warrior nation and its character at that time may materially depend upon that one man, but in its art all the mind of the nation is more or less expressed: it can be said, that was what the peasant sought to, when he went into the city to the cathedral in the morning – that was the sort of book the poor person read or learned in – the sort of picture he prayed to. All which involves infinitely more important considerations than common history.

[. . .]

2496. *Dean of St. Paul's.* Of the German as well as the Italian?—Yes.

2497. Mr. *Richmond.* Spanish, and all the schools?—Certainly.

2498. Mr. *Cockerell.* You are quite aware of the great liberality of the Government, as we learn from the papers, in a recent instance, namely, the purchase of a great Paul Veronese?—I am rejoiced to hear it. If it is confirmed, nothing will have given me such pleasure for a long time. I think it is the most precious Paul Veronese in the world, as far as the completion of the picture goes, and quite a priceless picture.

2499. Can you conceive a Government, or a people, who would countenance so expensive a purchase, condescending to take up with the occupation of the upper story of some public building, or with an expedient which should not be entirely worthy of such a noble Gallery of Pictures?—I do not think that they ought to do so: but I do not know how far they will be consistent. I certainly think they ought not to put up with any such expedient. I am not prepared to say what limits there are to consistency or inconsistency.

2500. Mr. *Richmond.* I understand you to have given in evidence that you think a National Collection should be illustrative of the whole art in all its branches?— Certainly.

2501. Not a cabinet of paintings, not a collection of sculptured works; but illustrative of the whole art?—Yes.

[. . .]

x) T. C. Horsfall, *Art in Large Towns: In What Way Can the Influence of Art be Brought to Bear on the Masses of the Population in Large Towns* (1882)

T.C. Horsfall (*fl.* 1880–1900), the Manchester social scientist and pamphleteer, was one of the body of high-minded middle-class campaigners for social reform. He could be counted alongside people like Matthew Arnold, Henrietta Barnet, Octavia Hill, and Ebenezer Howard, or, in the field of the arts, William Morris and John Ruskin. Ruskin was effectively Horsfall's mentor and supported his attempts to bring art, and what was believed to be the improving influence of beauty, to the working people of Manchester. In addition to his paper *Art in Large Towns*, which was read before the Nottingham Congress of The National Association for the Promotion of Social Science in 1882, Horsfall wrote pamphlets on *The Study of Beauty* (1885), *Education Under Healthy Conditions* (1885), and *The Improvement of the Dwellings and Surroundings of the People* (1904). He was also a regular correspondent to the *Manchester Guardian*. [CC]

Source: T. C. Horsfall, *Art in Large Towns: In What Way Can the Influence of Art be Brought to Bear on the Masses of the Population in Large Towns*, Paper Read at the Nottingham Congress of the National Association for the Promotion of Social Science, 1882, pp. 1–11

I take for granted that the object which we wish to attain by bringing the influence of art to bear on the masses of the population in our large towns, is the giving to them of the power and the wish to discriminate between beauty and ugliness, in order that they may give beauty to their work, and that they may get much of the pleasure and happiness which beautiful things can give.

Probably the best way to discover by what means the masses of the population in towns can be enabled to gain the power and the wish to discriminate between beauty and ugliness, is to observe how those people have been trained who have the power and the wish. All the people possessed of great sensibility to beauty who are known to me have, in infancy, habitually seen beautiful things, especially beautiful natural objects, – flowers, trees, grass, birds, butterflies, clean clouds, blue sky, and during the years in which the feelings and the mind receive their earliest impressions, have gained innumerable pleasant associations with the beautiful things amidst which they have lived. They have also very early been led by the influence of older people to notice some of the differences between beautiful and ugly things. Art, too, has very early begun to have an important part in their training. The influence of many beautiful things which they could never see reached them through pictures, and, by the same means, the influence on their thoughts and feelings of beautiful things which they sometimes saw was often renewed and strengthened.

[. . .]

In spite of the filthiness of town air, and of the mischief due to lack of places of wholesome recreation for children and young people in towns, a considerable measure of success in spreading knowledge and love of beauty may, I believe, be attained by means of a sensibly managed art gallery; and it is certain that if art galleries can be made to spread amongst work-people love of beauty, which includes hatred of ugliness, art galleries will be effective means for bringing on that good time when the working classes shall insist on smoke prevention, and on the provision of places for physical exercise.

Our Manchester Art Museum will be placed, as I think all such galleries should be, in a district filled with workpeople's houses. As we intend that the museum shall contain only things which must make those who study them 'think nobly' both of the world and its Maker, and of that wonderful human nature whose powers are revealed by art, we feel that no sensible person can object to its being open on Sunday afternoons and evenings, as well as on the evenings of all work days.

As Sunday is the only day on which many workpeople can go to a museum, we know that if ours is to be of great usefulness, it must be open on Sunday.

[. . .]

It has, I believe, been found in nearly all art galleries that people will not come often to them if the galleries contain only things to be seen. To induce people to come often and to stay long in our museum, we propose to have good music on one or two evenings each week.

In the choice of the contents of a gallery which is intended to make people love art, there is one principle to be observed which is so obviously of immense importance that I almost dread lest a statement of it be regarded by the Art Section as

an insult, but which is so entirely disregarded by the managers of all art galleries known to me, that I doubt whether the persistent enunciation of it would not be the most useful work which this Section could do for the next few years.

The principle I refer to is, that, as art is the giving of right or beautiful form, or of beautiful or right appearance, if we desire to make people take keen interest in art, if we desire to make them love good art, we must show it them when applied to things which themselves are very interesting to them, and about the rightness of appearance of which it is therefore possible for them to care a great deal. Though the truth of this statement will probably not be denied by anyone who has thought about art, a very different theory is acted on by a considerable number of cultivated, or 'cultured,' people, with the result of making most of their fellow-creatures believe that art is but a plaything for idle people. The language and action of many 'aesthetic' persons show that they believe beautiful rightness of appearance to be precious almost in proportion to the worthlessness of that to which the appearance is given, so that mellifluous verses, with no meaning to draw attention from their lovely sound, fairly represent what is accepted as the most important art by many who profess to be lovers of art, but who in effect, are its bitterest enemies. Success in bringing the influence of art to bear on the masses of the population in large towns, or on any set of people who have to earn their bread and have not time to acquire an unhealthy appetite for nonsense verses or nonsense pictures, will certainly only be attained by persons who know that art is important just in proportion to the importance of that which it clothes, and who themselves feel that rightness of appearance of the bodies, and the houses, and the actions, in short of the whole life, of the population of those large towns which are now, or threaten soon to be, 'England,' is of far greater importance than rightness of appearance in all that which is usually called 'art,' and who feel, to speak of only the fine arts, that rightness of appearance in pictures of noble action and passion, and of beautiful scenery, love of which is almost a necessary of mental health, is of far greater importance than art can be in things which cannot deeply affect human thought and feeling.

[. . .]

We believe that every town should have one collection of pictures to tell everyone who enters it, in the beautiful language of art, of all that is best worth knowing of the place and its surroundings, and its history, and to make him feel, if it is in him to feel, the best influences which nature and history can exert, as well as those of art. So we desire that part at least of our museum collection shall do this for Manchester people. We intend to have a series of pictures of all the most beautiful places near the town, of the most interesting buildings in and near it, of the most remarkable incidents in its history, of the wild flowers, birds, and butterflies found near it. We have already acquired some pictures for this series, but such a collection necessarily takes a long time to form. Of the best of our pictures of beautiful scenery we intend to have copies, perhaps etchings or photo-engravings, or even chromo-lithographs, and we hope that many of these copies will find their way into workpeople's houses. We shall have many other kinds of pictures of course, respecting which all I need say is that a clear, brief explanation of the subject will

accompany each picture, and that, if the subject be one which is not familiar to most workpeople, its connection with familiar things will be pointed out. Some of the pictures of the series have served to prove that with regard to art, as with regard to most other things, the law holds good that to him that hath shall be given. It is those workpeople who care for botany or ornithology whom we find most interested in our pictures, because the pictures of flowers, or birds, which they examine for the sake of their subjects, make the whole collection interesting to them.

I must only add, in the fewest words possible, that we have formed large collections of good etchings, engravings, photoengravings, and other kinds of pictures, of which good examples can be bought for a low price, and that we state the price of most of them, in order that workpeople may see how much good art can be obtained by those who have fair wages; that we have obtained many pictures illustrating events in the Life of Christ, and other important events, persons, and places; and that, for the purpose of obtaining close attention to the difference of effects produced by different processes, we place some of Mr. Ward's wonderfully accurate facsimile copies of Turner's water-colour drawings side by side with etchings and engravings of the same drawings, and form some groups containing pictures, water-colour drawings, and engravings, of similar objects.
[. . .]

xi) E. H. Gombrich, from 'Norm and Form: The Stylistic Categories of Art History and their Origins in Renaissance Ideals' (1963)

Sir Ernst Gombrich (b. 1909), one of the twentieth century's most influential art historians, was born in Vienna and studied there and in London. In 1959 he became Director of the Warburg Institute, a post he held until his retirement in 1976. Professor Gombrich has written a number of acclaimed essays and books on Rennaissance and Mannerist art, theories of perception, and art historical method. His books include: *The Story of Art* (1950); *Art and Illusion* (1960); and *Meditations on a Hobby Horse* (1963). In the extracts published here he examines the stylistic categories used by art historians and the basis of these categories in Renaissance thought. Many of the ways in which the supposed anti-classical styles (Mannerism, Gothic, Baroque, Rococo), have been seen, he suggests, have their roots in a single text, Vitruvius's *On Architecture* (published c.27BCE.). In this work Vitruvius celebrates classical style in opposition to what he sees as corrupt or decorative style. Gombrich demonstrates how the value judgements about non-classical art from Vasari to Winckelmann adopt this conception. In the second section of the essay reproduced here, Gombrich examines the distinctions established by the art historian Heinrich Wölffin (1864–1945) in his *Principles of Art History* (published in German in 1915). The analytical oppositions proposed by Wölfflin between the linear and the painterly; plane and depth; closed form and open form; multiplicity and unity; and clarity and obscurity, have been enormously influential in shaping a formal language for thinking about art. Gombrich argues, however, that without some fixed point of reference these categories are inherently unstable. He proceeds to demonstrate that Wölfflin's categories are

based on an unacknowledged normative classical standard. In this text Gombrich refers to a morphological approach to Art History, by which he means a study of the derivation, and patterns of change, of a style or concept. (Notes omitted and re-ordered.) [SE]

Source: E. H. Gombrich, from 'Norm and Form: The Stylistic Categories of Art History and their Origins in Renaissance Ideals' (1963), *Norm and Form: Studies in the Art of the Renaissance, vol. I*, Phaidon, 1966, pp. 83–94

[. . .] the variety of stylistic labels with which the art historian usually appears to be operating is in a sense misleading. That procession of styles and periods known to every beginner – Classic, Romanesque, Gothic, Renaissance, Mannerist, Baroque, Rococo, Neo-Classical and Romantic – represents only a series of masks for two categories, the classical and the non-classical.

That 'Gothic' meant nothing else to Vasari than the style of the hordes who destroyed the Roman Empire is too well known to need elaboration[1] What is perhaps less well known is the fact that in describing this depraved manner of a non-classical method of building, Vasari himself derived his concepts and his categories of corruption from the only classical book of normative criticism in which he could find such a description ready-made – Vitruvius *On Architecture*. Vitruvius of course nowhere describes any style of building outside the classical tradition, but there is one famous critical condemnation of a style in the chapter on wall-decoration, where he attacks the licence and illogicality of the decorative style fashionable in his age. He contrasts this style with the rational method of representing real or plausible architectural constructions.

But these [subjects] which were imitations based upon reality are now disdained by the improper taste of the present. On the stucco are monsters rather than definite representations taken from definite things. Instead of columns there rise up stalks; instead of gables, striped panels with curled leaves and volutes. Candelabra uphold pictured shrines and above the summits of these, clusters of thin stalks rise from their roots in tendrils with little figures seated upon them at random. Again, slender stalks with heads of men and animals attached to half the body.

Such things neither are, nor can be, nor have been. On these lines the new fashions compel bad judges to condemn good craftsmanship for dullness. For how can a reed actually sustain a roof, or a candelabrum the ornaments of a gable, or a soft and slender stalk a seated statue, or how can flowers and half-statues rise alternatively from roots and stalks? Yet when people view these falsehoods, they approve rather than condemn.[2]

Turning from this description to Vasari's image of the building habits of the northern barbarians, we discover that the origins of the stylistic category of the *Gothic* do not lie in any morphological observation of buildings, but entirely in the prefabricated catalogue of sins which Vasari took over from his authority.

There is another kind of work, called German . . . which could well be called Confusion or Disorder instead, for in their buildings – so numerous that they

have infected the whole world – they made the doorways decorated with columns slender and contorted like a vine, not strong enough to bear the slightest weight; in the same way on the façades and other decorated parts they made a malediction of little tabernacles one above another, with so many pyramids and points and leaves that it seems impossible for it to support itself, let alone other weights. They look more as if they were made of paper than of stone or marble. And in these works they made so many projections, gaps, brackets and curlecues that they put them out of proportion; and often, with one thing put on top of another, they go so high that the top of a door touches the roof. This manner was invented by the Goths . . .[3]

I do not share that sense of superiority which marks so many characterizations of Vasari. His work amply shows that he could give credit even to buildings or paintings which he found less than perfect from his point of view. We should rather envy Vasari his conviction that he could recognize perfection when he saw it and that this perfection could be formulated with the help of Vitruvian categories – the famous standard of *regola, ordine, misura, disegno a maniera** laid down in his Preface to the Third Part and admirably exemplified in his Lives of Leonardo and Bramante.

These normative attitudes hardened into an inflexible dogma only when the stylistic categories were used by critics across the Alps who wanted to pit the classic ideals of perfection against local traditions. Gothic then became synonymous with that bad taste that had ruled in the Dark Ages, before the light of the new style was carried from Italy to the north.

If Gothic thus originally means 'not yet classic', *barocco* began its career as a similar denunciation of the sin of deviation. Indeed, it is noteworthy that the identical passage in Vitruvius that served Vasari as a pattern for his description of Gothic served Bellori for his condemnation of the corrupt architecture of his time, the architecture of Borromini and Guarini:

Each individual thinks up in his own head a new *Idea* or phantom of architecture in his own manner, and then exhibits it in the *piazza* and on the façades – men certainly without any of the knowledge proper to the architect, whose title they vainly hold. So, deforming building and whole cities and the monuments of the past, they juggle madly with corners, gaps and twirling lines, discompose bases, capitals and columns with stucco nonsense, trivial ornament and disproportions; and Vitruvius too condemns novelties of a similar kind . . .[4]

Bellori does not yet use the term *barocco* for this denunciation, but the eighteenth century sometimes used the terms Gothic and Baroque interchangeably as descriptions for such bad or bizarre taste, Gradually the two terms for the non-classical divided their functions, Gothic being increasingly used as a label for the not-yet-classical, the barbaric, and *barocco* for the no-longer-classical, the degenerate.

* rule, order, measure, drawing, style

The introduction, at the end of the eighteenth century, of the word *rococo* to denote a fashion especially worthy of condemnation by the severe and virtuous classicists added a new facet to a terminology which has remained in use. It still describes for us the very style that Johann Joachim Winckelmann condemned in the middle of the eighteenth century, invoking once more the standard normative passage from Vitruvius:

> Good taste in our present-day ornament, which since Vitruvius complained bitterly about its corruption has in modern times been even more corrupted . . . could at once be purified and gain truth and sense through a more through study of allegory.
>
> Our scrolls and that ever-so-pretty shell-work, without which no decoration can nowadays be modelled, sometimes has no more of Nature about it than Vitruvius's candelabra, which supported little castles and places.[5]

Winckelmann thus singled out the *rocaille* as a characteristic of the style – possibly because of its association with the grotto, a place which favoured excesses of irregularity and whimsy.

The *rococo*, then, was an identifiable type of licence even before the particular word 'rococo' made its appearance, as it seems, in the studio of David, when the master's most extremist pupils condemned one of his paintings as insufficiently severe, and derided it as 'Van Loo, Pompadour, rococo'.[6]

[. . .]

What concerns us is the claim which arose in the nineteenth century that the historian can ignore the norm and look at the succession of these styles without any bias; that he can, in the words of Hippolyte Taine, approach the varieties of past creations much as the botanist approaches his material, without caring whether the flowers he describes are beautiful or ugly, poisonous or wholesome.[7]

It is not surprising that this approach to the styles of the past seemed plausible to the nineteenth century, for its practice had kept step with its theory. Nineteenth-century architects and decorators used the forms of earlier styles with sublime impartiality, selecting here the Romanesque repertory for a railway station, there a Baroque stucco pattern for a theatre. No wonder that the idea gained ground that styles are distinguished by certain recognizable morphological characteristics, such as the pointed arch for Gothic and the *rocaille* for the Rococo, and that these terms could safely be applied stripped of their normative connotation.

[. . .]

I do not imply that the origin of a word must always be respected by those who apply it. The discovery that the Gothic style has nothing to do with the Goths need not concern the art historian, who still finds the label useful. What should concern him in the history of the term, I think, is its original lack of differentiation. The stylistic names I enumerated did not arise from a consideration of particular features, as do Vitruvius' terms for the orders; they are negative terms like the Greek term Barbarian, which means no more than a non-Greek.

If I may introduce a harmless term, I should like to call such labels terms of exclusion. Their frequency in our languages illustrates the basic need in man to

distinguish 'us' from 'them', the world of the familiar from the vast, unarticulated world outside that does not belong and is rejected.

It is no accident, I believe, that the various terms for non-classical styles turn out to be such terms of exclusion. It was the classical tradition of normative aesthetics that first formulated some rules of art, and such rules are most easily formulated negatively as a catalogue of sins to be avoided. Just as most of the Ten Commandments are really prohibitions, so most rules of art and of style are warnings against certain sins. We have heard some of these sins characterized in the previous quotations – the disharmonious, the arbitrary and the illogical must be taboo to those who follow the classical canon. There are many more in the writings of normative critics from Alberti *via* Vasari to Bellori or Félibien. Do *not* overcrowd your pictures, do *not* use too much gold, do *not* seek out difficult postures for their own sake; avoid harsh contours, avoid the ugly, the indecorous and the ignoble. Indeed it might be argued that what ultimately killed the classical ideal was that the sins to be avoided multiplied till the artist's freedom was confined to an ever narrowing space; all he dared to do in the end was insipid repetition of safe solutions. After this, there was only one sin to be avoided in art, that of being academic [. . .]

It is no accident, therefore, that the terminology of art history was so largely built on words denoting some principle of exclusion. Most movements in art erect some new taboo, some new negative principle, such as the banishing from painting by the impressionists of all 'anecdotal' elements. The positive slogans and shibboleths which we read in artists' or critics' manifestos past or present are usually much less well defined. Take the term 'functionalism' in twentieth-century architecture. We know by now that there are many ways of planning or building which may be called functional and that this demand alone will never solve all the architect's problems. But the immediate effect of the slogan was to ban all ornament in architecture as non-functional and therefore taboo. What unites the most disparate schools of architecture in this century is this common aversion to a particular tradition.

Maybe we would make more progress in the study of styles if we looked out for such principles of exclusion, the sins any particular style wants to avoid, than if we continue to look for the common structure or essence of all the works produced in a certain period.

[. . .]

Obvious as this reminder is, it still indicates the rock on which the morphology of style suffered shipwreck. By reducing the idea of the classical and the non-classical to a mere morphological distinction of equally justified alternatives the morphologist blurs what is, in my view, the vital distinction among unclassical styles: those which are unclassical from a principle of exclusion and those which are not; or, to put it more clearly, the distinction between the anti-classical, as it is exemplified in its extreme in twentieth century art, and the unclassical for which, perhaps, Chinese art may offer a good example, in so far as the Chinese artists never rejected principles of which they could have no cognizance.

This distinction may look harmless enough, but it threatens the whole idea of a morphology of styles. For exclusion implies intention, and such an intention cannot be directly perceived in a family of forms. The greatest and most success-

ful champion of the morphological approach, Heinrich Wölfflin, was not unaware of this difficulty, and yet his search for objective principles of organisation has tended to obscure its relevance for the teaching of art history.

It was Wölfflin who gave art history the fateful tool of systematic comparison; it was he who introduced into our lecture rooms a need for two lanterns and two screens, for the purpose of sharpening the eye to the stylistic differences between two comparable works of art – let us say a Madonna by Raphael and another by Caravaggio. It is a pedagogical device that has helped many teachers to explain to their students certain elementary differences, but unless it is used with care it subtly but decisively falsifies the relationship between the two works. It is legitimate and illuminating to compare the Caravaggio with the Raphael, for, after all, Caravaggio knew Raphael's work. He could even have imitated it, had he wanted to, at least as far as Annibale Carracci did in his immediate proximity. Instead, he clearly rejected this possibility and struck out on a path of his own. The comparison will therefore help us to understand why Bellori objected to Caravaggio and branded his manner as a departure from the classical norm. But when we read the comparison the other way round and contrast the Raphael with the Caravaggio we are on more dangerous ground. We imply that Raphael, too, deliberately rejected the methods of Caravaggio and that his art sets up the value of restraint and the ideal of beauty against the harshness of Caravaggio's naturalism. Bellori might even have agreed with this reasoning, for we have seen that he was concerned with the avoidance of sins. But, if we want to see Raphael in his own terms, we cannot ignore the dimension of time and the horizon of his knowledge. He cannot have rejected what he never knew.

This simple observation helps to account both for Wölfflin's success and for his occasional failure. The sequence of his books reminds us how closely his pretended morphology of style clung to the original normative function of these comparisons.

[. . .]

What the art historian was asked to consider [by Wölfflin], when he compared a work of the Renaissance with one of the Baroque, were five alleged polarities which Wölfflin thought to be purely descriptive. They are the basic conceptual tools or *Grundbegriffe* of *Linear und malerisch, Fläche und Tiefe, Geschlossene Form und offene Form, Vielheit und Einheit, Klarheit und Unklarheit* – linear and painterly, plane and depth, closed form and open form, multiplicity and unity, clarity and obscurity. Wölfflin made it quite clear that he wanted these contrasts to be regarded mainly as principles of order which could apply to patterns no less than to representation. It was his conviction that nature could be represented as well in sharp pencil lines as in broad brushstrokes, in the plane and in depth. His choice of examples and his powers of description are so persuasive that we must focus on the weakest point in his argument. It concerns the relation of these modes of representation to the objective appearance of reality. Clearly a linear art tied to the plane will not be able to cope with the kind of motifs Turner or Monet made their own. Wölffin is aware of this objection. He explicitly raises the question of whether one might not distinguish between representational and decorative aspects of style, but having faced this question he answers it with an

ambiguous 'Yes and no'. The later phase is for him not a more developed mode of representing nature, but simply a different one. 'Only where the decorative feeling has changed, can we expect a change in the mode of representation.'[8] Wölfflin would have replied in the same way to the objection that an art committed to 'closed form' will be less free in the rendering of natural phenomena than an art that can resort to 'open forms'. I shall not go on dissecting his pairs of opposites in any detail. What matters to me is the fact that his polarities are not true polarities at all. We have seen before how fatally easy it is for our minds to see opposing principles where only differences of degree exist. There was a time when cold and heat, moistness and dryness, even light and dark were considered such entities in their own right, just as we still think of negative and positive electricity. But clearly the contrast between heat and cold makes sense only in relation to a norm, mostly the hidden norm of our own body temperature. Science, of course, tries to eliminate this norm and prefers to plot temperature along a scale. A real morphology of forms would have to aim at a similar scale or spectrum of configurations. It is true that a form in nature may be rendered by a line or suggested by its shadow, but there are any number of possibilities in between and beyond, and the habit of thinking in polarities may actually mask these from us. Much has been written in English about the exact meaning of *malerisch* and the best way of translating this elusive word. Looking at Wölfflin's purpose we can safely translate it as a term of exclusion and call it 'less linear'. Less than what? Less than Wölfflin's hidden norm, the classical.

[. . .]

NOTES

1 Augusto Guzzo, *Il gotico e l' Italia*. Edizioni di Filosofia (1959).
2 Vitruvius, *On Architecture*, VII, 5, trans. F. Granger (London, 1934), II, p. 105. What Vitruvius is referring to is discussed by Ludwig Curtius, *Die Wandmalerei Pompejis* (Leipzig, 1929), pp. 129 ff.
3 *Le vite*, Introduzione, Dell' architettura, Capitolo III.
4 *Le Vite* (Roma, 1672), p. 12.
5 *Gedanken über die Nachahmung der griechischen Werke in der Malerei und Bildhauerkunst* (Dresden und Leipzig, 1755), pp. 166–67.
6 Fiske Kimball, *The Origins of Rococo* (Philadelphia, 1943).
7 *La Philosophie de l'Art*, I (Paris, 1865), 3.
8 *Kunstgeschichtliche Grundbegriffe*, 8th ed. (Munich, 1943), pp. 29–31.

xii) Alex Potts, 'Oneness and the Ideal' (1994)

Johann Joachim Winckelmann (1717–68) is often seen as the founder of modern art history. Winckelmann came from a poor background but established himself as a scholar, travelling to Rome and publishing highly influential works on ancient Greek art. His conception of ancient Greek nude sculptures as the highest expression of human civilisation had a significant impact on the development of Neoclassicism and academic culture. In his book *Flesh and the Ideal: Winckelmann and the Origins of Art History* (1994), Alex Potts, Professor of Art History at the University of Reading, draws on psychoanalytic theory to explore the masculine desires involved in looking at sculpted nudes. Potts argues that this

looking often involved men scrutinising male nudes and takes Winckelmann's writings as a model for examining this dynamic of same sex desire in academic culture. In the extract included here, Potts examines the assumptions about class and race embedded in Winckelmann's conception of the ideal nude. (Notes omitted and re-ordered.) [SE]

Source: Alex Potts, from 'Oneness and the Ideal', *Flesh and the Ideal: Winckelmann and the Origins of Art History*, Yale University Press, 1994, pp. 155–64

[. . .]

Winckelmann put the notion of oneness – what he called 'unity' (*Einheit*) or 'simplicity' (*Einfalt*) – very explicitly at the centre of his definition of ideal beauty.[1] There was nothing exceptional about this. Indeed the categorical denials of difference entailed by such a mythic notion of the perfect human figure were central to the conception of the ideal nude in the aesthetics of the period. What he calls 'beauty' (*Schönheit*) in this context, beauty as an ideal of art, is precisely what theorists writing in French at the time would describe in more technical academic terms as *beau idéal* or ideal beauty.[2] What is unusual is the seriousness with which Winckelmann worked through the implications of this theoretical paradigm, exposing the difficulties and disturbances involved in imagining an ideal figure that would really be purged of all marks of physical and cultural difference.

There were several levels at which Winckelmann gave evidence of the impossibility of realizing the ideal beauty supposedly epitomized by Greek art. For one thing, his general definition of beauty failed to single out any known statues that could stand as the full embodiment of the very highest beauty. Here there is some analogy with the way that he defined the highest style of Greek art, the sublime, as virtually impossible to exemplify in a full-bodied way. Ideal oneness always remained a never quite realizable abstract imperative, both implicit in but never quite adequately embodied by any actual beauty.

[. . .]

If you were to take the art theory of the period literally, the ideal figure would have to be an abstraction from which all marks of particular identity were effaced. No actual image of a body could of course fulfil this imperative. The mark of difference on which it would most emphatically founder would be that of sex – the fig-leaf might hide but could not efface the suggested presence or absence of the phallus. The notion of a single ideal figure that would stand as the model for all imperfectly particular figures that occur in reality is also a sociocultural phantasm, however much a youthful nude might be an effective visual correlative to the mythic idea of a self unformed or unmarked by history and environment.

The unresolvable tensions between the notion of an ideal oneness of subjective being and bodily form, and the divergences of identity marked out on the body, involved Winckelmann in complex denials and involuntary recognitions of two main kinds of difference. In addressing these differences we now ritually label as those of race and class, he tackled the challenges they posed to the idea of a single immutable ideal of bodily beauty quite directly. At one level, then, he

acknowledged that there were powerful factors at work producing radical diver-
gences in people's conceptions of what a beautiful human figure should look like.
At the same time he sought to argue that, in the final analysis, these divergences
would not stand up to the higher claims of an absolute ideal.

In the case of sexual difference the negotiation was more indirect, and not
explicitly acknowledged by him as a problem. That there were significant differ-
ences of sexual identity, not just the most evident ones of gender, but also of age
– the man versus the boy, for example – marked out in visibly different formations
of bodily type, was at one level recognized by Winckelmann. His account of the
ideal nude includes a catalogue of different types devised by the ancient Greeks,
arranged systematically according to gender and age.[3] But the tensions between
this recognition of an irreducible multiplicity of bodily forms and the insistence
on a single high ideal of bodily beauty was never explicitly addressed. The ideal of
oneness that Winckelmann could only imagine by way of radical negation and
sought to associate with the relatively ungendered and undifferentiated figure of
the boyish male nude, or with an abstracted image of perfectly flowing contours,
existed as a fetishistic denial of irreducible sexual differences that he could not
negotiate directly, but simultaneously had to avow and disavow. Sexual difference
was the most visible fault line in the notion of the ideal nude, but also the one
whose reverberations gave this erotically charged fantasy of oneness a large part of
its resonance.

Signs of class difference were at one level bracketed out by the very conception
of the ideal nude. It quite literally removed the particularities of costume through
which distinctions of social status were normally marked. But Winckelmann felt
it important to acknowledge that the image of the ideal nude, if it did not directly
embody the characteristic identity of a particular class or social group, and indeed
seemed to make such social distinctions irrelevant, did depend for its appeal and
its symbolic value on the class-inflected attitudes brought to it by the spectator.
One of the more insistent modern misconceptions of beauty, Winckelmann
argued, was fostered by corrupt artists such as Bernini, whose work appealed
through a 'plebeian flattering of the coarser senses. Bernini sought so to speak to
ennoble forms through exaggeration, and his figures are like common people who
have suddenly achieved good fortune'.[4] While the ideally beautiful figure is not
itself the symbol of an enlightened middle class, the proper understanding of it is.

If the ideal figure is on the surface a socially and culturally empty image, its
forms are supposed to be a denial of the coarsely sensual rhetoric that would
appeal to the common people, that is, to the uneducated and labouring classes. It
is in effect held up by Winckelmann as an enlightened standard against more mar-
ketable modern images of the body that reach out to a larger public through their
immediately gratifying and obvious appeal. In the ideal nude, then, you have an
image that seems to represent a common humanity lying beneath the clothing of
social identity, but so conceived as to exclude those who lack the education and
discrimination to appreciate the distinction between mere sensual appeal and a
beauty informed by intellectual understanding.[5] In thus giving ideal beauty an
explicitly anti-plebeian cast, Winkelmann is very much at one with attitudes

deeply ingrained in Enlightenment culture, namely that the social distinction between the educated classes and the common people, between what we might somewhat anachronistically call the middle classes and the working classes, was immutably grounded in the nature of things, and that the latter by the very nature of their role in society were excluded from an active participation in and enjoyment of true culture.[6]

What prompted the most extensive discussion in Winckelmann's preliminary negative definition of beauty was not so much deviant or corrupt notions of beauty, in part, as we have seen, inflected by ideas of class difference. Rather it was a case made against the very idea that there existed a single ideal of bodily beauty based on the evidence of racial difference. Winckelmann's analysis here can be seen as an attempt to situate the Greek ideal of beauty as transcending the particularizing effects of environmental context. It was commonly believed that the different physical types associated with non-European races could be explained by environmental factors, or, to use a term current at the time, climate.[7] Winckelmann himself embraced these theories, and subscribed to the notion that people's conceptions and ideals depended upon their empirical experience of the particular milieu they inhabited. [. . .]

For Winckelmann, racial difference was visibly more problematic than class difference for the notion of a single norm of ideal beauty, partly for the very obvious reason that racial difference, unlike class difference, was at the time defined so much in terms of different bodily types. There was a growing body of anthropological and travel literature, to some of which Winckelmann himself made reference, which drew attention to the varying ideals of bodily beauty among different peoples.[8] In addition to relying on the Eurocentrism embedded in the culture of his time, Winckelmann also adopted a strategy for negotiating this potential challenge to a single norm of ideal beauty that relates closely to the logic at work in his whole definition of the Greek ideal. In the first instance, the Greek ideal was rescued as a universal paradigm by defining it negatively, as the relatively empty image of the human figure that emerged once the 'inadequate' particularities determined by custom and environment were expunged. It emerged as the negation of all particular ideals, with no definable characteristics of its own that might be seen as distinctive or different.

Accepted without question in Winckelmann's analysis is an assumption common to Enlightenment speculation on racial difference, namely that the Eurocentric white Greek ideal was closest to the original type of humanity, to the ideal human being as it emerged from the hands of God, while other racial types were deviations from this model. Winckelmann, however, frames his argument in abstract aesthetic terms rather than in those of the more explicitly racist anthropological theories current at the time, namely that non-European racial types were literally produced by a degeneration from the original model of humanity. He attempts to argue that such features as the slanted eyes of the Chinese and Japanese, the relatively flatter noses of oriental peoples, the relatively larger lips of negroes, were inadequate because they were not in conformity with the principles of unity and symmetry that should govern the shape of an ideal face.[9] At the same

time, he does from time to time draw on fashionable theories of climatic determinism to explain certain supposed 'deformations' of facial features in non-European physical types. At times, particularly when he makes an appeal to the popular physiognomic theory that marked departures from an ideal norm represented a bestializing of the human form, there is more than an incipient racism, particularly in his discussion of black peoples: 'The pouting inflated mouth, which moors have in common with apes, is a superfluous growth and a swelling, produced by the heat of their climate, just as our lips swell up as a result of heat, or sharp salty moisture, or in some people as a result of anger.'[10]

If some of the imagery here recalls the clichés of the biological racism of the nineteenth century, it involves a different, less polemically insistent Eurocentrism. Thus for example, where Winckelmann argues that white skin will make a body appear more beautiful, because white reflects back more light rays and stimulates the senses more vividly, this superiority of whiteness is conceived as a matter of appearances, not of the essence of beauty. And there is more than that. He makes the point that in the end bodies of one colour appear less pleasing to the eye than another, not because of anything inherent in them, but because of the viewer's particular expectations and experience, in other words because of his or her prejudices:

> A Moor can be called beautiful when his facial features are beautifully formed, and a traveller assures us that daily contact with Moors takes away the untoward quality of the colour, and reveals the beauty that they have; just as the colour of a metal, or of black or green basalt, is not detrimental to the beauty of ancient heads.[11]

[. . .]

It was far easier for Winckelmann to elaborate the significant divergences in people's sense of what a beautiful figure might be, and to explain these divergences, than to make a case for a basic consensus on the essentials of beauty. The latter was not amenable to clear and full demonstration, and in the end he could only assert, almost against the evidence he provided, that such a consensus – a oneness of views on beauty that would echo the oneness of its metaphysical and ethical essence – did at some level exist.

[. . .]

Anxiety over cultural and ethnic relativity was common in Enlightenment thought, and was given a particular edge by the study of non-European cultures that accompanied the new wave of European colonial expansion in Africa, Asia, and the South Seas. The terms in which Winckelmann negotiated this anxiety were more 'Enlightened', less explicitly racist, than equivalent apologias for the primacy of the Greek ideal among those who took up his Graecomania in the nineteenth century.[12] Not only did these assert in ways that Winckelmann could not have conceived that the 'superiority' of the 'white' Greek ideal had a basis in scientific fact, was a matter of a biologically determined superiority of the white or Indo-European races. But they had no place for countenancing the relative validity of non-European perspectives on beauty in the way Winckelmann occasionally did. Winckelmann, of course,

was living in a political context where the issue of racial difference was not so immediately urgent a matter as it was to become for later European intellectuals, for whom the colonization of Africa and the Near East in particular made contact with non-European peoples a much more immediately pressing reality. Winckelmann's 'Enlightened' attitudes were in part a factor of the confidence Western Europeans of his time could feel that there was no very visible challenge within their own culture to European norms being seen as universal ideals.

As we have seen, Winckelmann's negotiation of racial difference involved a process of negation, whereby the ideal figure was projected as a largely empty cipher, one in whose abstract clarity of form bodily traces of a distinctive racial identity would be purged. In negotiating sexual difference he followed a similar logic, but it involved a more powerful negation registered at a more unconscious level. That the issue of sexual identity would be so heavily loaded is hardly surprising, not only because of the unavoidable visibility of sexual difference in images of the nude, but also because this imagery functioned so explicitly in the artistic culture of the time as a focus of erotic interest – it was designed to be desirable. The problematics of desire, as distinct from the problematics of inclusion and exclusion from the Greek ideal arising from racial and class differences, were particularly pervasive in Winckelmann's analysis of beauty, and were no doubt too intractable to be addressed directly in his preliminary discussion of misconceptions of ideal beauty. The issues involved here were complex and highly invested, for they had to do both with fantasies of abolishing or evading what is commonly understood as sexual difference – the effacement of any too insistent suggestions of the particularities of masculine or feminine identity – and also with imagining an ideal oneness of being that would abolish all hint of psychic tension, all disturbance to subjective self-sufficiency, produced in the projection of desire. It is where subjectivity and desire come together in this way that Winckelmann offers his most powerfully political projections of the ideal figure. In his so-called positive definition of ideal beauty, he was very insistent that imagining an ideally beautiful figure, from which all disturbing signs of particularity and difference were expunged, entailed a radical denial of anything we might understand as human desire. A figure that embodied the highest beauty should exist in a state of total absence of feeling, particularly any directed outside it that might disturb its state of blissful self-sufficiency – a state of 'absolutely self-sufficient narcissism' as Freud would describe it, a state of complete 'absence of stimulation and avoidance of objects', corresponding to sleep or the impossibly regressive 'blissful isolation of intra-uterine life', in which life itself was on the boundaries of being extinguished.[13]
[. . .]

The most ideally beautiful figure, according to Winckelmann, had quite literally to be divested of its humanity. The very highest beauty would be the image of a god in which 'those parts of the body that are required to nourish it' were entirely absent.[14] The absolute 'contentedness' of a divine state would be represented by a body divested of all physical channels of sustenance and feeling, and would have no veins or nerves.[15] The 'hands of the (Greek) artists brought forth figures that were

purged of human need'. When Winckelmann explained how the human body might be remade in the image of an abstract perfect beauty, he conceived this as a process of burning out, of annihilating any recalcitrant flesh and blood signs of its humanity: 'This concept of beauty is like a spirit extracted out of matter by fire, which seeks to create a being conforming to the model of the original rational creature traced in the mind of the god (*Gottheit*).'[16] It is 'matter' purged so it takes on the 'unity' and 'indivisibility' of an abstract idea. It should be so emptied of sensual particularity that it is 'like the purest water taken from the source of a spring, that the less taste it has, the more healthy it is seen to be, because it is cleansed of all foreign elements'. Taken to its extreme, the ideally beautiful human figure is a radical negation of any bodily substance, a crystal-clear nothing, formless and transparent.

It was only then in a totally inhuman figure, from which all signs of flesh and blood existence had been purged, that the oneness of an ideal state of being could be imagined. Yet the Greek ideal was supposed to be the most perfect realization of human subjectivity. The divine figures of the ancient Greeks were seen as exemplary precisely because in them the very highest ideals had taken on a fully sensuous bodily form. We have here a radical contradiction at the heart of the humanist ideology that made the Greek ideal the model of a perfectly integrated humanity, at one with itself and the world. The Enlightenment fantasy of a self-sufficient oneness of being that would be embodied in a single model of the human subject, transcending all material difference, could only, it seems, be fully realized in an image quite divested of its humanity.

NOTES

1 J. J. Winckelmann *Geschicte der Kunst des Alterthums*, Dresden, 1769, p. 150.
2 On Winckelmann's indebtedness to traditional theories of ideal beauty in art as formulated by seventeenth century classicists such as Bellori, see G. Baumecker, *Winckelmann in seiner Dresdner Schriften* (Berlin, 1933), and G. Heres, 'Winckelmann, Bernini, Bellori, Betrachtungen zur Nachahmung der Alten', *Forschungen and Berichte*, 19, 1979, pp. 9ff. My discussion of this tradition is strongly indebted to Panofsky's still classic study (E. Panofsky, *Idea: A Concept in Art Theory* [New York, 1968], first published 1924).
3 *Geschichte*, pp. 177–84.
4 *Geschichte*, p. 144.
5 Compare also J. J. Winckelmann *Kleine Schriften. Vorreden. Entwürfe*, Berlin, 1968, p. 213.
6 For a particularly explicit representation of the supposedly 'natural' divide between the 'common people' and the educated classes, see J. B. Basedow's influential progressive educational primer, *Das Elementarwerk. Ein geordneter Vorrath aller nöthigen Erkentnis* (Altona, 1774), vol. I, p. 391, and the commentary to Pl. XIX.
7 On theories of racial difference in Enlightenment thought, see L. Poliakov, *The Aryan Myth* (London, 1974), pp. 158ff., N. Stepan, 'Biological Degeneration', in J. E. Chamberlain and S. L. Gilman (eds), *Degeneration: The Dark Side of Progress* (New York, 1985), pp. 97ff., and S. L. Gilman, *On Blackness without Blacks: Essays on the Image of the Black in Germany* (Boston, 1982), chapters 2, 3, and 4. On the impact of increasingly systematic theories of white supremacy on the scholarly study of the ancient Greeks, as evidenced in arguments for the autonomy of Greek culture from that of the Egyptians, see M. Bernal, *Black Athena: The Afroasiatic Roots of Classical Civilization*, vol. I (London, 1987), particularly pp. 197ff., 219ff.
8 There is a particularly full compendium of this literature in G. L. L. de Buffon's *Histoire naturelle*, vol. III (Paris, 1749), pp. 371ff.
9 When Martin Bernal (*Black Athena*) traces aspects of nineteenth-century classical scholars' racist attitudes back to the romantic Hellenism of the Enlightenment period, he is careful not to equate the two. Ideas about the supremacy of the Greeks over the Egyptians, which gained ground in the

Enlightenment, took on a different cast once they combined with the full-blown racism that often accompanied nineteenth-century scientific positivism.

10 S. Freud, 'Group Psychology (1921)', vol. 12, p. 163; 'Introductory Lectures on Psycho-Analysis' (1915–17), *Freud Library*, vol. 1. p. 466.

11 *Geschichte*, pp. 167–8.

12 *Geschichte*, p. 151.

13 See *Geschichte*, p. 162.

14 *Geschichte*, p. 162.

15 *Geschichte*, p. 149.

16 *Geschichte*, pp. 150–1.

xiii) Thomas E. Crow, from 'Introduction. The Salon Exhibition in the Eighteenth Century and the Problem of its Public' (1985)

Thomas E. Crow is Robert Lehman Professor of History of Art at Yale University. He writes on both the art of eighteenth-century France and on contemporary art. On its publication, *Painters and Public Life* was hailed as a ground-breaking text, which challenged the prevailing account of eighteenth-century French art. It is primarily concerned with the significance of the new public exhibition ('the Salon') for artistic practice and, in particular, with the emergence of art criticism during this period. Crow shows that, from the first, the Salon critics' assertion of the right to publish their comments on the grounds that they represented public opinion had an oppositional character and that public discourse on art never achieved uncontested legitimacy prior to the French Revolution. In the extract printed here, Crow examines the complex relationship between the Salon audience and the idea of the 'public'. [EB]

> Source: Thomas E. Crow, from 'Introduction. The Salon Exhibition in the Eighteenth Century and the Problem of its Public', *Painters and Public Life in Eighteenth-Century Paris*, Yale University Press, 1985, pp. 1–17

Ambitious painting most conspicuously entered the lives of eighteenth-century Parisians in the Salon exhibitions mounted by the Academy of Painting and Sculpture. These had begun as regular events in 1737; held in odd-numbered years, except for a brief early spell of annual exhibitions, they opened on the feast-day of St. Louis (25 August) and lasted from three to six weeks. During its run, the Salon was the dominant public entertainment in the city.[1] As visual spectacle, it was dazzling: the *Salon carré* of the Louvre – the vast box of a room which gave the exhibition its name – packed with pictures from eye-level to the distant ceiling, the overflow of still-life and genre pictures spilling down the stairwells that led to the gallery; an acre of color, gleaming varnish, and teeming imagery in the midst of the tumble-down capital (the dilapidation of the Louvre itself was the subject of much contemporary complaint). 'Ceaseless waves' of spectators filled the room, so the contemporary accounts tell us,[2] the crush at times blocking the door and making movement inside impossible. The Salon brought together a broad mix of classes and social types, many of whom were unused to sharing the

same leisure-time diversions. Their awkward, jostling encounters provided constant material for satirical commentary.

The success of the Salon as a central Parisian institution, however, had been many decades in the making. Its actual origins lay in the later seventeenth century, but these had not been particularly auspicious. The Academy's initial efforts at public exhibition had been limited to a few cramped and irregular displays of pictures, first in its own meeting rooms and later in the open arcades of the adjoining Palais Royal. The disadvantage of the latter practice, according to an early account, was that the artists 'had the constant worry of damage to the paintings by the weather, which pressed them often to withdraw the pictures before the curiosity of the public had been satisfied.'[3] By 1699 the Salon was more comfortably installed inside the Louvre, and Parisians were spared the sight of academicians hustling their canvases out of the rain. By all accounts, that exhibition was a popular success, but it was almost forty years before the Salon became a permanent fixture of French cultural life.

After 1737, however, its status was never in question, and its effects on the artistic life of Paris were immediate and dramatic. Painters found themselves being exhorted in the press and in art-critical tracts to address the needs and desires of the exhibition 'public'; the journalists and critics who voiced this demand claimed to speak with the backing of this public; state officials responsible for the arts hastened to assert that their decisions had been taken in the public's interest; and collectors began to ask, rather ominously for the artists, which pictures had received the stamp of the public's approval. All those with a vested interest in the Salon exhibitions were thus faced with the task of defining what sort of public it had brought into being.

This proved to be no easy matter, for any of those involved. The Salon exhibition presented them with a collective space that was markedly different from those in which painting and sculpture had served a public function in the past. Visual art had of course always figured in the public life of the community that produced it: civic processions up the Athenian Acropolis, the massing of Easter penitents before the portal of Chartres cathedral, the assembly of Florentine patriots around Michelangelo's *David* – these would just begin the list of occasions in which art of the highest quality entered the life of the ordinary European citizen and did so in a vivid and compelling way. But prior to the eighteenth century, the popular experience of high art, however important and moving it may have been to the mass of people viewing it, was openly determined and administered from above. Artists operating at the highest levels of aesthetic ambition did not address their wider audience directly; they had first to satisfy, or at least resolve, the more immediate demands of elite individuals and groups. Whatever factors we might name which bear on the character of the art object, these were always refracted through the direct relationship between artists and patrons, that is, between artists and a circumscribed, privileged minority.

The broad public for painting and sculpture would thus have been defined in terms other than those of interest in the arts for their own sake. In the pre-eighteenth-century examples cited above, it was more or less identical with the

ritualized assembly of the political and/or religious community as a whole – and it could be identified as such. The eighteenth-century Salon, however, marked a removal of art from the ritual hierarchies of earlier communal life. There the ordinary man or woman was encouraged to rehearse before works of art the kinds of pleasure and discrimination that once had been the exclusive prerogative of the patron and his intimates. There had been precedents for this kind of exhibition, of course, in France and elsewhere in Europe: displays of paintings often accompanied the festival of Corpus Christi, for example, and there were moves under way in many places to make royal and noble collections available to a wider audience.[4] But the Salon was the first regularly repeated, open, and free display of contemporary art in Europe to be offered in a completely secular setting and for the purpose of encouraging a primarily aesthetic response in large numbers of people.

There was in this arrangement, however, an inherent tension between the part and the whole: the institution was collective in character, yet the experience it was meant to foster was an intimate and private one. In the modern public exhibition, starting with the Salon, the audience is assumed to share in some community of interest, but what significant commonality may actually exist has been a far more elusive question. What was an aesthetic response when divorced from the small community of erudition, connoisseurship, and aristocratic culture that had heretofore given it meaning? To call the Salon audience a 'public' implies some meaningful degree of coherence in attitudes and expectations: could the crowd in the Louvre be described as anything more than a temporary collection of hopelessly heterogeneous individuals? We can and shall arrive at empirical knowledge concerning the Salon *audience*, because an audience is by definition an additive phenomenon: we identify, and count if possible, the individuals and groups recorded as making it up; no one who was present can be disqualified from membership. But what transforms that audience into a public, that is, a commonality with a legitimate role to play in justifying artistic practice and setting value on the products of that practice? The audience is the concrete manifestation of the public but never identical with it. In empirical terms, we are confronted only with the gross totality of the audience and its positively identifiable constituent parts: individuals and group categories defined by sex, age, occupation, wealth, residence, etc. The public, on the other hand, is the entity which mediates between the two, a representation of the *significant* totality by and for someone. A public appears, with a shape and a will, via the various claims made to represent it; and when sufficient numbers of an audience come to believe in one or another of these representations, the public can become an important art-historical actor.

It follows from this that the role of the new public space in the history of eighteenth-century French painting will be bound up with a struggle over representation, over language and symbols and who had the right to use them. The issue was never whether that problematic entity, the public, should be consulted in artistic matters, but who could be legitimately included in it, who spoke for its interests, and which or how many of the contending directions in artistic practice could claim its support. [. . .]

But we need to entertain the possibility [. . .] that the Salon audience of eighteenth-century Paris was so fragmented, distracted, and incoherent that it did not deserve the title of 'public'. This is to say that it could present no useful demands or criteria to which an artist could respond. It certainly enjoyed no 'natural' affinity with much of the work on display. Through the first several decades of Salons, there were almost no pictures produced primarily to be shown there; they were works of art meant for other places and other onlookers. There were pieces of Rococo confection looking naked in the cavernous space, rows of interchangeable portraits, and high above, the large history paintings, their life-size figures reduced by the distance to the scale of miniatures. Though ostensibly the most 'public' in their purpose, these last were not only physically remote from the Salon visitor, but difficult to decipher once seen. A literate Parisian would have had a certain degree of familiarity with the motifs and narratives of classical literature, more than is usually recognized today, but academic artists tended to choose subjects few viewers would have understood adequately. [. . .] The recondite character of this sort of literary subject matter, its meaning often carried in details and stylistic nuances nearly invisible from the gallery floor, plainly communicated the ambivalence of the Academy toward the business of public exhibition. There was an inevitable gap in comprehension which distinguished the secondary from the primary consumers of art.

The placement of pictures on the walls of the Salon was, of course, partly the result of practical necessity: the lower sections were packed with small pictures so they could be seen. The elevated placement of history painting in the Salon did not represent a willful withdrawal of access, but it did unavoidably express the contradictory character of the public exhibition under the Old Regime. What, after all, would ambitious painting be like if it were not learned and difficult, artificial and self-referential in style, aspiring to the sophistication of literary classicism and the audience that all this implied? It would have been difficult to find some available point of reference by which a care-worn merchant or apprentice clerk could genuinely participate in that culture. Everyday life, its physical imprint on the body, its costume, texture, and grit: include more than a hint of that and you have fatally compromised the desired nobility of the form. This is a period, we need to remind ourselves, when individuals and spheres of human life were rigorously distinguished and ranked on a scale of intrinsic value. The hierarchy of genres was, for the eighteenth century, a translation into cultural terms of the division of persons between *noblesse** and *roture*†. Here, for example, is one eighteenth-century art critic defending that hierarchy and then moving on to maintain that even the physical constitutions of noble persons (the overriding figural concern of history painting) were different from those of the non-noble:

> The sublimity of a simple tale is not that of an epic. The good family father, the return of the nurse, the village bride, all make charming scenes. But should you transform these humble actors into Consuls or Roman matrons, or in place of

* nobility
† commoners

the invalid grandfather suppose a dying Emperor, you will see that the malady of a hero and that of a man of the people are in no way the same, anymore than are their healthy constitutions. The majesty of a Caesar demands a character which should make itself felt in every form and movement of the body and soul.[5]

This is, to be sure, a distinction present in poetics since antiquity and in art theory since the Renaissance at least. It is telling, however, that the source of this passage is an anonymous pamphlet by a popular critic. This writer's position in cultural politics was one of liberal opposition to what he and others of his type regarded as the mendacity and sterile despotism of the academic hierarchy. Yet such critics found it difficult or impossible to imagine a democratic painting, that is, an art which did not make implicit distinctions among spectators in terms of social class. As it stood, history painting would speak through a repertoire of signs over which the typical Salon-goer would have little command.

[. . .]

NOTES

1 Eighteenth-century estimates of total Salon attendance vary from *c.* 20,000 to 100,000 or more; see Richard Wrigley, 'Censorship and Anonymity in Eighteenth-Century Art Criticism', *Oxford Art Journal*, VI, no. 2, p. 25 and note, for a discussion of these estimates. For a compact, useful survey of the history of the exhibitions, see J. J. Guiffrey, *Notes et documents inédits sur les expositions du XVIIIᵉ siècle*, Paris, 1886. A more recent account can be found in Georg Friedrich Koch, *Die Kunstausstellung*, Berlin, 1967, pp. 124–83. For a brief, well-documented discussion of the Salons between 1759 and 1781, see Udo van de Sandt, 'Le Salon de l'Académie de 1759 à 1781', in Marie-Catherine Sahut and Nathalie Volle, *Diderot et l'art de Boucher à David*, Paris, 1984, pp. 79–84.

2 Louis-Sebastien Mercier, 'Le Sallon (*sic*) de Peinture,' *Le Tableau de Paris*, Amsterdam, IV, 1782–8, pp. 203–6; anonymous, 'Entretiens sur les tableaux exposés au Sallon en 1783,' n.p., 1783, pp. 6, 12.

3 'Note extraite du *Mercure de France*', Deloynes Collection, Cabinet des Estampes, Bibliothéque Nationale, Paris, no. 3, pp. 28–9. For this and all further references to texts and documents contained in this collection, consult Georges Duplessis, *Catalogue de la collection de pièces sur les beaux-arts imprimées et manuscrites recueillie par Pierre-Jean Mariette, Charles-Nicolas Cochin et M. Deloynes, auditeur des comptes, et acquise récemment par le départment des Estampes de la Bibliothèque nationale*, Paris, 1881.

4 For a survey of the process by which some state and aristocratic collections were opened to public view in this period, see Niels von Holst, *Creators, Collectors, and Connoisseurs*, B. Battershaw, trans., London, 1967, pp. 169–214.

5 Anonymous, *Dialogues sur la peinture, seconde édition, enrichie de notes*, Paris, 1773, pp. 42–3

Section Two
The Changing Status of the Artist

The texts in this section provide sources on the changing status of the artist in the pre-modern period. In the period surveyed here the characterisation of the artist has undergone an extensive process of revision and change. The predominant way of envisaging the artist in our culture is as a special kind of person who expresses their inborn genius and talent. The way in which we see the modern artist is, however, the outcome of a long historical process. We have chosen to concentrate, in this section, on views of the pre-modern artist in order to indicate the extent of this shift in opinions. In the middle ages the work of the artist was seen by scholars to belong to the category of the Practical Arts that only required manual skill and could be learned by anyone. This situation was gradually transformed. The change in the artist's social status was not, however, either geographically even or progressively linear. Artists in different countries continued to be valued differently thoughout this period and attempts to raise the position of artists was frequently rebutted by patrons and social commentators. The sixteenth-century painter and writer on art Giorgio Vasari records a revealing anecdote in his 'Life of Giotto' concerning a man who approached Giotto to decorate his belt buckle. That this man could see Giotto as a mere craftsman, if Vasari is to be believed, provides evidence of one sense of the artist in circulation in the fourteenth century. Vasari, however, worked with a different conception of the artist: for him, this man's mistake was a testament only to his stupidity and Giotto's refusal of this request signified his real standing. Increasingly, artists and scholars claimed that the arts of painting and sculpture were Liberal Arts that had always been seen to require personal talent and were therefore accorded more social status. In this period artists claimed that their art required personal and innate talent as well as manual skill. The term that they most often used to substantiate this claim was *ingegno* or *ingenium*, meaning ingenuity. By end of the period examined here some artists were organised in Academies, and enjoyed a considerable social position, but the understanding of the artists' status still fell short of modern conceptions. Genius is a related term to *ingenium*, but it is important to stress that this concept was not applied to the artist until the Romantic period at the end of the eighteenth century.

 The first group of source texts relates to the position of Italian artists in the fifteenth and sixteenth centuries. Italian artists and scholars took the lead in raising the intellectual and imaginative status of the artist. This process was under way

in the fourteenth century, but the first evidence we present is Lorenzo Ghiberti's pioneering fifteenth-century commentary on his own life and art. Also included here is an extract from Pliny's account of ancient Greek artists. In the Renaissance it was erroneously believed that artists in ancient Greece and Rome had enjoyed the status of nobility, a view that was, in part, shaped by a misinterpretation of Pliny. Vasari's *Lives of the Artists* occupies a pivotal role in the developing conception of the artist. In adopting a biographical format for his account of art practice Vasari focused on the individual artist as a figure worthy of record alongside princes, statesmen and the practitioners of the Liberal Arts. The extract printed here is a new translation of his life of Ambrogio Lorenzetti. As we can see from Francesco del Cossa's letter to the Duke of Ferrara, the claim to the status of the Liberal Arts was not uncontested. A powerful patron could simply refuse to accept this status claim. This short letter also indicates the extent to which artists' desire to transcend the Practical Arts had an significant economic impetus. The sonnet by Michelangelo, which we include here, reveals an important artist practising a Liberal Art (poetry) and using it to confer status on his own activity of Sculpture: the extract from Cellini's autobiography, in contrast, reveals a sixteenth-century Italian artist struggling against the exclusiveness of artists to have what he saw as the high arts of jewellery, goldsmithing and dye-casting valued alongside statuary, architecture and painting. All this activity came to a head with the foundation of the first academy of design in Florence (1563). We should note that Cellini failed to insert his arts into the recognised trio of architecture, painting and sculpture.

The artists north of the Alps lagged somewhat behind the Italians in the production of texts laying claim to a higher status. Some strong texts were published in the North in the sixteenth century which claimed a position among the Liberal Arts. From this literature we include Dürer's dedication to his friend, the humanist scholar Wilibald Pirkheimer, and a poem by Lucas de Heere refuting an unfavourable view of artists who had attempted to raise their social standing. While the Northern evidence for debating status can seem weaker, it may be that explorations were taking place in fields that were merely different from that of the South. If we look at evidence of images, the tradition of self-portraiture – a key signifier of artistic status claims – was much stronger in the North, stretching from van Eyck in 1430 through Dürer and up to Rembrandt. However, it was not until the early seventeenth century that the artist Karel van Mander produced an equivalent systematic account to Vasari on the art of the Netherlands. The source texts in this section conclude with two nineteenth-century French texts that attempt to re-evaluate art of earlier periods. The first by Edmond and Jules de Goncourt reappraises eighteenth-century French art; the second by Théophile Thoré celebrates the then unknown Vermeer.

The section on critical approaches includes three texts that reflect, in very different ways, on the formation of artistic personas. The first of these texts, an extract from Kris and Kurz's *Legend, Myth and Magic in the Image of the Artist*, represents a pioneering attempt to understand the mythic structure of anecdotes and stories about artists. The second extract in this section, from Christine

Battersby's *Gender and Genius*, explores the assumptions about gender that played a formative role in shaping the new image of the artist. The final extract printed here, from Svetlana Alpers' *The Art of Describing*, suggests a fundamental distinction between the art, and by implication the artists, of the North and the South: while the former, she argues, were celebrated for their imagination and idealisation, the latter were seen in terms of science and reason. [SE/CK]

i) Giorgio Vasari, 'Life of Ambrogio Lorenzetti: Painter of Siena', from *Lives of the Most Eminent Painters, Sculptors and Architects* (1550, enlarged 1568)

The painter and architect Giorgio Vasari (1511–1574) wrote the *Lives of the Artists* between the 1540s and the 1560s, drawing on the patchy writing of artists and scholars, oral history of Tuscan artists, and, occasionally, primary documents. In addition, Vasari had seen a large number of works of art on his travels and possessed a substantial collection of drawings. His information on the sixteenth century was good, his understanding of the art of the fifteenth century was also quite well grounded, but his account of the fourteenth century must be seen as unreliable, and even positively misleading. Vasari's importance rests partly on his recording of data about Tuscan and other Italian artists. Equally significant, however, were the concepts he developed for interpreting this information and the evaluations he offered. Vasari's *Lives* was the first history of European art aiming to tell the full story of an era of art production in a geographical area. Because he offered an inclusive account, based on biographies, the *Lives* was, and still is, a highly influential model. Consequently, the fact that much of what Vasari wrote about the 'Life of Ambrogio Lorenzetti' has proved to be inaccurate, is less significant than the fact that he was determined to tell the wider story. Vasari knew little about the work of Ambrogio Lorenzetti (active 1319–1348) and his brother Pietro (active 1320–1345) and was inclined against Sienese art. He represented the history of Italian art as a triumphant development beginning in the fourteenth century with Florentine artists, building technical expertise in the realistic representation of imagined figures and knowledge of the art of Greek and Roman antiquity, and culminating in the work of Michelangelo. In this narrative Ambrogio Lorenzetti figures only as a precursor to the main story. The text was translated for this volume by Diana Norman. [CK]

Source: Giorgio Vasari, 'Life of Ambrogio Lorenzetti. Painter of Siena', from *Le vite de' più eccellenti pittori scultori e architettori*, (1550, enlarged 1568), trans. Diana Norman, Gaetano Milanesi, ed., Florence, 1906, vol. I, pp. 521–5

LIFE OF AMBROGIO LORENZETTI, PAINTER OF SIENA

If the obligation that artists of fine talent undoubtedly owe to nature is great, how much greater should ours be to them, seeing how, with great diligence, they fill

[our] cities with noble buildings and with useful and pleasing narrative composi-
tions, while usually gaining for themselves fame and riches by their works. As did
Ambrogio Lorenzetti, painter of Siena, who showed fine and prolific invention
both in his well-considered compositions and the placing of figures in his narra-
tive painting. A scene painted very gracefully by him in the cloister of the Friars
Minor offers true evidence of this, where there is represented how a youth
becomes a friar, and how he and some others go to the sultan, and there they are
beaten and sentenced to the gallows and hung from a tree, and finally beheaded,
with the unexpected appearance of a terrible storm.[1] In this painting, he simulated
with much art and skill the storminess of the air, and in the labours of the figures,
the fury of the rain and wind. From these [paintings] modern masters learned the
manner and the beginnings of this [kind of] invention for which, as it was not
used before, he deserved immense commendation.

Ambrogio was a skilled colourist in fresco, and he handled colours with great
dexterity and facility, as is still seen in the panel paintings finished by him in Siena
for the Spedaletto [little hospital] called Monna Agnese, where he painted and fin-
ished a narrative scene with a new and beautiful composition. And at the great
Spedale [hospital], on the facade, he executed, in fresco, the birth of Our Lady and
the scene when she goes with the virgins to the temple.[2] And for the friars of Saint
Augustine in the same city he painted their chapterhouse,[3] where the Apostles are
seen represented in the vault, with scrolls in their hands on which is written that
part of the Creed that each of them created; and at the foot of each a little narra-
tive scene containing the same painted subject that is signified by the writing
above. Near this, on the main wall, are three narrative scenes of Saint Catherine
the martyr, when she is disputing with the tyrant in the temple, and, in the mid-
dle, the Passion of Christ, with the thieves on the Cross, and the Maries below,
supporting the Virgin Mary who has fainted; these works were finished by him
with much grace and in a beautiful manner.

In a large room in the Palazzo della Signoria of Siena he painted the war of
Sinalunga and Peace and its events [plate viii],[4] where he also represented a map
of the world, perfect for those times; and in the same palace he executed eight,
polished, narrative scenes in terra-verde. It is said that he also sent to Volterra a
panel in tempera which was highly praised in that city. And painting a chapel in
fresco and a panel in tempera at Massa [Marittima],[5] in the company of others, he
made it known to everyone how great, both in judgement and ingenuity, was his
value in the art of painting; and in Orvieto he painted in fresco the main chapel
of Santa Maria. After these works, proceeding to Florence, he did a panel paint-
ing in San Procolo, and in a chapel he painted narrative scenes of Saint Nicholas
with small figures,[6] in order to satisfy certain of his friends, who desired to see his
way of working; and, being much practised, in a short time, he completed this
work that gained him a name and high reputation. And this work, on the predella
of which he executed his portrait, was the reason why in the year 1335 he was sum-
moned to Cortona by order of Bishop Ubertini, then ruler of that city. Here in
the church of Santa Margherita, only just built by the friars of San Francesco on

viii) Ambrogio Lorenzetti, *Allegory of Peace* (detail), 1339, Palazzo Pubblico, Siena. Photo: Scala.

the summit of the hill, he worked so well on some works, specifically half the vault and on the walls, that, although today they are almost worn out by age, there are still to be seen the most beautiful effects in the figures; and it is known that he was justly praised for them.

This work finished, Ambrogio returned to Siena, where he lived honourably the rest of his life, not only being an excellent master of painting but having devoted himself to letters in his youth – which were such a useful and sweet ornament to his life, along with painting – that they rendered him no less amiable and pleasing than the profession of painting had done. Thus he not only associated with the men of learning and of virtue, but was also employed with much honour and usefulness on the affairs of his republic. The manners of Ambrogio were, in every way, praiseworthy and rather those of a gentleman and of a philosopher than of an artist; and what most demonstrates the prudence of men, he always had a mind disposed to be content with that which the world and time brought, supporting with a quiet mind and tranquillity the good and the evil that came to him from fortune. And truly it cannot be said to what extent gentle manners and modesty, with other good habits, are an honourable companion to all the arts, and in particular to those that proceed from intellect and from noble and elevated talents; wherefore everyone should make himself no less pleasant with his manners than with the excellence of his art.

Finally, at the end of his life, Ambrogio executed a panel painting at Monteoliveto at Chiusure with great praise, and a little after, being 83 years of age, he passed happily and in Christian faith to a better life. His works date to around 1340.[7]

As it has been said, the portrait of Ambrogio, by his own hand, is seen in the predella of his panel painting in San Procolo, with a hood on his head. And what was his value in draughtsmanship is seen in our book, where there are some very good things by his hand.

END OF THE LIFE OF AMBROGIO LORENZETTI

NOTES

1 Vasari is here relying on the brief description of this painting given by the sculptor, Lorenzo Ghiberti, in his *Commentaries* of *circa* 1445–52. Executed on the walls of the cloister of San Francesco in Siena, the painting is now lost (apart from a few recently recovered fragments). [DN]

2 Vasari is again relying on Ghiberti for his description of these paintings on the façade of Siena's principal hospital of Santa Maria della Scala. From other later sources, it appears that other painters worked on the project – including Ambrogio's brother, Pietro. None of the paintings survive but their appearance may be reflected in a number of later fifteenth-century Sienese paintings. [DN]

3 Here Vasari gives a slightly fuller version of Ghiberti's description of this painted scheme for the chapterhouse of Sant'Agostino. Neither he, nor Ghiberti, refer, however, to the only surviving painting by Ambrogio in the former chapterhouse which depicts the Virgin and Christ Child with saints. [DN]

4 Here Vasari is probably referring to Ambrogio Lorenzetti's celebrated paintings on the theme of good and bad government which decorate the walls of one of the principal rooms in Siena's town hall – the Palazzo Pubblico (plate viii). [DN]

5 Here Vasari is probably referring to *The Virgin and Christ Child with Saints and Angels*, now in the Pinacoteca, Massa Marittima. [DN]

6 Here Vasari is probably referring to the *Virgin and Saints Procolo and Nicholas of Bari* and *Scenes from the Life of Saint Nicholas of Bari*, now in the Uffizi Gallery, Florence. [DN]

7 On the basis of a testamentary bequest, it now is generally believed that Ambrogio died in 1348 as a result of the great pandemic known as the Black Death. [DN]

ii) Francesco del Cossa, *Letter to the Duke of Ferrara* (1470)

Francesco del Cossa (c.1435–c.1477) was a painter and sculptor of Ferrara. The text printed here reveals the contrast in beliefs about the status of the artist in late fifteenth-century Italy. Francesco's letter relates to his commission to decorate the Palazzo Schifanoia. It is addressed to his patron, the Duke of Ferrara, but mentions the scholar in charge of the commission, Pellegrino Prisciani. The mural decoration of the palace entailed an erudite programme, invented by Pellegrino, and showing the benevolent influence of the planets on the Duke's government of Ferrara. The painter's petition makes clear, despite this scholarly scheme, that Francesco's payment was being calculated by the square foot rather than according to his intellectual acumen, pictorial skill, and imagination. Francesco protested against this, arguing that he had begun to make a name for himself and, therefore, he should be paid for the uniqueness of his acknowledged and special talent as an artist, and with regard to his studiousness and

research into his art. He refers to an appraisal (a judgement by other artists chosen by himself and his patron to adjudicate over a contested payment). But the letter ends with the patron's all powerful decision to ignore the appraisal and the plea, and to award payment by the square measure. [CK]

Source: Francesco del Cossa, *Letter to the Duke of Ferrara* (1470), Creighton E. Gilbert, ed. and trans., *Italian Art 1400–1500: Sources and Documents*, Prentice Hall, 1980, pp. 9–10

Most illustrious Prince and Excellent Lord my most particular Lord: I recently petitioned your lordship along with the other painters about the payment for the room at Schifanoia, to which your lordship answered that the account was persistent. Illustrious prince, I do not wish to be the one to annoy Pellegrino de Prisciano and others, and so I have made up my mind to turn to your lordship alone, because you may feel, or it may have been said to you, that there are some who can be happy or are overpaid with a wage of ten pennies. And to recall my petition to you, I am Francesco del Cossa, who have made by myself the three wall sections toward the anteroom. And so, illustrious lord, if your lordship wished to give me no more than ten pennies per foot, and even though I would lose forty to fifty ducats, since I have to live by my hands all the time, I would be happy and well set, but since there are other circumstances, it makes me feel pain and grief within me. Especially considering that I, when after all I have begun to have a little of a name, should be treated and judged and compared to the sorriest assistant in Ferrara. And that my having studied, and I study all the time, should not at this point have a little more reward, and especially from your lord ship, than a person gets who had avoided such study. Surely, illustrious lord, it could not be that I would not feel grief and pain. And because my work proves what I have done, and I have used gold and good colors, if they were of the same value as those who have gone ahead without such labors it would seem strange to me, and I say this, lord, because I have done almost the whole work in fresco, which is a complex and good type of work, and this is known to all the masters of the art. All the same, illustrious lord, I put myself at your lordship's feet, and I pray you, if your objection should be to say: I don't want to do it for thee because I would have to do it for the others, my lord, your lordship could always say that the appraisals were this way. And if your lordship doesn't want to follow the appraisals, I pray your lordship may wish to give me, if not all that I perhaps would be entitled to, then whatever part you may feel in your grace and kindness, and I will accept it as a gracious gift, and will so proclaim it. My compliments to your illustrious lordship. Ferrara, March 25, 1470.

[Annotated by the Duke:] Let him be content with the fee that was set, for it was set for those chosen for the individual fields.

iii) Pliny the Elder, from *Natural History* (77)

Gaius Plinius Secundus, known as Pliny the Elder (23/24–79), was a Roman encyclopaedist whose only known work is the thirty-seven volume *Natural History*,

which he dedicated to the Emperor Titus in 77. The chapters on the history of art, which dealt with ancient Greek and Roman art and artists, were included as an excursus in this work which is otherwise devoted to examining the phenomena of the natural world. Pliny's text received close attention in the Renaissance when ancient art was increasingly revered. The section on the painter Apelles (332–329 BCE) was an important source of artistic values in the fifteenth and sixteenth centuries. The life of Apelles also illustrates particularly clearly the extraordinary status some Greek artists could attain, a status aspired to in the Renaissance. Pliny's text was first translated into Italian by Landino in 1476. Although Pliny refers to a range of Greek artists, they figure here as counterpoints to Apelles and, as such, are not central to an understanding of the argument. Consequently, these historical figures have not been footnoted. (Editor's notes omitted.) [KW]

Source: *The Elder Pliny's Chapters on the History of Art*, (AD 77), trans. Katherine Jex-Blake, Ares Publishers, 1975, pp. 121–33

[. . .]

Apelles of Kos [. . .] excelled all painters who came before or after him. He of himself perhaps contributed more to painting than all the others together; he also wrote treatises on his theory of art. The grace of his genius remained quite unrivalled, although the very greatest painters were living at the time. He would admire their works, praising every beauty and yet observing that they failed in the grace [. . .], which was distinctively his own; everything else they had attained, but in this alone none equalled him. He laid claim to another merit: when admiring a work of Protogenes that betrayed immense industry and the most anxious elaboration, he said that, though Protogenes was his equal or even his superior in everything, he yet surpassed that painter in one point – namely in knowing when to take his hand from a picture; a memorable saying, showing that too much care may often be hurtful. His candour was equal to his genius: he acknowledged the superiority of Melanthios in the distribution of figures, and that of Asklepiodoros in perspective arrangement, that is in giving the accurate distances between different objects.

A neat story is told of him in connexion with Protogenes, who was living in Rhodes. Thither Apelles sailed, eager to see the works of a man only known to him by reputation, and on his arrival immediately repaired to the studio. Protogenes was not at home, but a solitary old woman was keeping watch over a large panel placed on the easel. In answer to the questions of Apelles, she said that Protogenes was out, and asked the name of the visitor: 'Here it is,' said Apelles, and snatching up a brush he drew a line of extreme delicacy across the board. On the return of Protogenes the old woman told him what had happened. When he had considered the delicate precision of the line he at once declared that his visitor had been Apelles, for no one else could have drawn anything so perfect. Then in another colour he drew a second still finer line upon the first, and went away, bidding her show it to Apelles if he came again, and add that this was the man he was seeking. It fell out as he expected; Apelles did return, and, ashamed to be beaten, drew a third line of another colour cutting the two first down their length and leaving no room for any further refinement. Protogenes owned himself beaten and

hurried down to the harbour to find his visitor; they agreed to hand down the painting just as it was to posterity, a marvel to all, but especially to artists. [. . .]

Apelles further made it an unvarying rule never to spend a day, however busy, without drawing a line by way of practice; hence the proverb. It was also his habit to exhibit his finished works to the passers-by on a balcony, and he would lie concealed behind the picture and listen to the faults that were found with it, regarding the public as more accurate critics than himself. There is a story that when found fault with by a cobbler for putting one loop too few on the inner side of a sandal, he corrected the mistake. Elated by this the cobbler next day proceeded to find fault with the leg, whereupon Apelles thrust out his head in a passion and bade the cobbler 'stick to his last,' a saying which has also passed into a proverb.

The charm of his manner had won him the regard of Alexander the Great, who was a frequent visitor to the studio, for, as we have said, he had issued an edict forbidding any one else to paint his portrait. But when the king happened to discourse at length in the studio upon things he knew nothing about, Apelles would pleasantly advise him to be silent, hinting that the assistants who ground the colours were laughing at him; such power did his personality give him over a king habitually so passionate. Yet Alexander gave him a signal mark of his regard: he commissioned Apelles to paint a nude figure of his favourite mistress Pankaspe, so much did he admire her wondrous form, but perceiving that Apelles had fallen in love with her, with great magnanimity and still greater self-control he gave her to him as a present, winning by the action as great a glory as by any of his victories. He conquered himself and sacrificed to the artist not only his mistress but his love, and was not even restrained by consideration for the woman he loved, who, once a king's mistress, was now a painter's. Some believe that she was the model for the Aphrodite rising from the sea.
[. . .]

His portraits were such perfect likenesses that, incredible as it may sound, Apio the grammarian has left it on record that a physiognomist [. . .] was able to tell from the portraits alone how long the sitter had to live or had already lived. [. . .]

He also painted a portrait of king Antigonos, who was blind of one eye, being the first to devise a means of concealing the infirmity by presenting his profile, so that the absence of the eye would be attributed merely to the position of the sitter, not to a natural defect, for he gave only the part of the face which could be shown uninjured. There are among his works some pictures of dying people, though it were difficult to say which are the best. His Aphrodite rising from the sea was dedicated by the god Augustus in the temple of his father Caesar [. . .] Apelles had begun another Aphrodite at Kos, intending to surpass even the fame of his earlier achievement, but when only a part was finished envious death interposed, and no one was found to finish the outlines already traced. He also painted in the temple of Artemis at Ephesos a portrait of Alexander holding a thunderbolt for twenty talents [. . .]: the fingers seem to stand out and the thunderbolt to project from the picture; – the reader should remember that all this was done with four colours. For this picture he was paid in gold coins, reckoned not by number but by measure. [. . .]

The Herakles with averted face, in the temple of Diana, is also attributed to Apelles; by a triumph of art the picture seems not only to suggest, but actually to give the face. He also painted a nude hero, a picture which challenges comparison with Nature herself. A horse also exists, or did exist, painted for a competition, in which he appealed from the judgement of men to that of dumb beasts. When he saw that his rivals were likely to be placed above him through intrigue, he caused some horses to be brought in and showed them each picture in turn; they neighed only at the horse of Apelles, and this was invariably the case ever afterwards, so that the test was applied purposely to afford a display of his skill. [. . .] Skilled judges of painting prefer among all his works his equestrian portrait of Antigonos and his Artemis amid a band of maidens offering sacrifice, a painting thought to have excelled the lines of Homer that describe the same scene. He also painted the unpaintable, thunder, for example, lightning and thunderbolts [. . .]

All have profited by his innovations, though one of these could never be imitated; he used to give his pictures when finished a black glazing so thin that by sending back the light it could call forth a whitish colour, while at the same time it afforded protection from dust and dirt, only becoming visible itself on the closest inspection. In using this glazing, one main purpose of his was to prevent the brilliance of the colours from offending the eyes, – the effect was as when they are looked at through talc, – and also that when seen at a distance those which were vivid to excess might be imperceptibly toned down.

[. . .]

iv) Lorenzo Ghiberti, from *Second Commentary* (c.1450)

Lorenzo Ghiberti (c.1378–1455) was a sculptor, goldsmith and architect who both trained and worked in Florence. He was awarded the prestigious commission for two sets of bronze doors for the Florence Baptistery. The conspicuous beauty of his design (Michelangelo is reported to have said that the second pair of doors were fit to be the gates of paradise), and the importance of his bronze founding workshop as a training ground put him in a powerful and respected position in the most important city in Western Christendom during the fifteenth century. Lorenzo was the first artist to write an autobiography in Western Europe, and the first since Greek antiquity to write on the history of art. He wrote the *Commentari* (Commentaries) in Italian at the end of his life in the 1450s. Lorenzo took his ideas on ancient art from Pliny the Elder and Vitruvius, and his concept of the rebirth of art after the 'middle ages' from Florentine scholars who had praised Giotto and Cimabue in the fourteenth century. His decision to write an autobiography marks a crucial stage in new ideas about the status of male artists as persons to be valued for their unique and inborn talent. Lorenzo's autobiography places him in an analogous position with poets, theologians, or philosophers, whose careers were thought worthy of record like other great men whose lives had been celebrated in antiquity by Plutarch, and in the fourteenth century by scholars like Filippo Villani. The Commentaries can be seen as Lorenzo's claim to the status of a scholar. [CK]

Source: Lorenzo Ghiberti, from *Second Commentary* (*c.*1450), Creighton E. Gilbert, ed., and trans, *Italian Art 1400–1500: Sources and Documents*, Prentice Hall, 1980, pp. 82–5

[. . .]

Now let us speak of the sculptors who were in these times. There was Giovanni, son of Master Nicola. Master Giovanni made the pulpit of Pisa, the pulpit of Siena was by his hand and the pulpit of Pistoia. These works of master Giovanni are to be seen, and the fountain of Perugia. Master Andrea of Pisa was a very good sculptor, he did very many things in Pisa at Santa Maria a Ponte, in the Bell Tower of Florence he did the seven works of mercy, seven virtues, seven sciences and seven planets. By master Andrea there are also four carved figures each eight feet high. There are also carved there a great part of those who were called inventors of the arts; Giotto is said to have carved the first two. Andrea did a bronze door for the church of St. John the Baptist in which are carved the stories of the said St. John the Baptist, and a figure of St. Stephen, which was placed in the front of Santa Reparata on the Bell Tower side. These are the works that are available by this master. He was a very great sculptor [. . .]

In Germany in the city of Cologne there was a very expert master of sculpture named Gusmin, he was of most excellent talent. He was with the Duke of Anjou, who had him do many works in gold. Among other works he did a gold panel, which he executed very finely, with every care and precision. He was perfect in his works, he was equal to the ancient Greek sculptors; he did the heads marvelously well, and all the nude parts, there was no other lack in him except that his statues were a little short. He was very fine and well versed and excellent in this art. I saw many figures cast from his. He had a very elegant air in his works, he was very learned. He saw the work he had done with such love and skill destroyed for the Duke's public requirements; he saw his labor had been vain, and cast himself to the ground on his knees, lifting his eyes and hands to heaven, and spoke, saying, O Lord, who governs the heaven and the earth and made all things, let me not in my ignorance follow any but thee, have mercy on me. And immediately he went about dividing up what he had for love of the creator of all things. He went up on a mountain where there was a great hermitage, which he entered, and was a penitent as long as he lived. [. . .]

We shall follow Theophrastus' maxim, supporting those who are well taught rather than those who put their faith in money; he who is well taught in all things is not alone nor a wanderer in the lands of others when he has lost familiar and necessary things and is in need of friends, being a citizen in every city and able to despise hardships of fortune without fear, never a prisoner in fortresses but only in bodily infirmity. And Epicurus, not differing, says that the wise set little store by fortune, and the greatest needful things are governed by thoughts of the mind and soul. So too said many philosophers, and no less did the poets, writing the ancient comedies in Greek [. . .] Whereas all gifts of fortune are given and as easily taken back, but disciplines attached to the mind never fail, but remain fixed to

the very end of life. And thus I give greatest and infinite thanks to my parents, who, proving the law of the Athenians, were careful to teach me the art, and the one that cannot be tried without the discipline of letters, and faith in all teachings. Whereas therefore through parents' care and the learning of rules I have gone far in the subject of letters or learning in philology, and love the writing of commentaries, I have furnished my mind with these possessions, of which the final fruit is this, not to need any property or riches, and most of all to desire nothing. Some who judge these things lightly might think those are wise who abound in money; they have pursued this assertion, audaciously claiming that knowledge is added with riches. And I, O excellent reader, who am not a slave to money, gave my study for the art, which from boyhood I have always followed with great study and discipline. Since I have the first teachings, I have tried to inquire how nature proceeds in it and how I can get near her, how things seen reach the eye and how the power of vision works, and how visual [word missing] works, and how visual things move, and how the theory of sculpture and painting ought to be pursued.

In my youth, in the year of Our Lord 1400, I left Florence because of both the bad air and the bad state of the country, with a fine painter whom the lord Malatesta of Pesaro had besought, who had us do a room, which we painted with the greatest diligence. My mind was largely directed to painting, on account of the works that the lord promised us, and also because the company I was with was always showing me the honor and advantage to be had from it. Nevertheless at that moment I was written to by my friends how the board of the temple of St. John the Baptist was sending for well-versed masters, of whom they wanted to see a test piece. A great many very well qualified masters came through all the lands of Italy to put themselves to this test and this battle. I asked leave of the lord and my associate. Sensing the situation, the lord gave me leave at once, and we were before the board of that temple, with the other sculptors together. Each one was given four bronze plates. As the demonstration, the board of the temple wanted each one to make a scene for the said door, and they chose that the scene should be the sacrifice of Isaac, and that each of the competitors should do the same scene. These tests were to be carried out in a year, and whoever won it should have the victory. The competitors were these: Filippo di ser Brunellesco, Simone da Colle, Niccolo D'Arezzo, Jacopo della Quercia from Siena, Francesco da Valdambrino, Nicolo Lamberti; we were six to take the test, a test which was a demonstration of a large part of the art of sculpture. The palm of victory was conceded to me by all the experts and by all those who took the test with me. The glory was conceded to me universally, without exception. Everyone felt I had gone beyond the others in that time, without a single exception, with a great consultation and examination by learned men. The board of the temple wanted to have their decision written by their own hand; they were very expert men, including painters and sculptors in gold and silver and marble. The judges were thirty-four, counting those of the city and the surrounding areas; the endorsement in my favor of the victory was given by all, and by the consuls and board and the whole body of the merchants' guild, which has the temple of St. John the Baptist in its charge. It was acknowledged as mine, and determined that I should do this bronze door

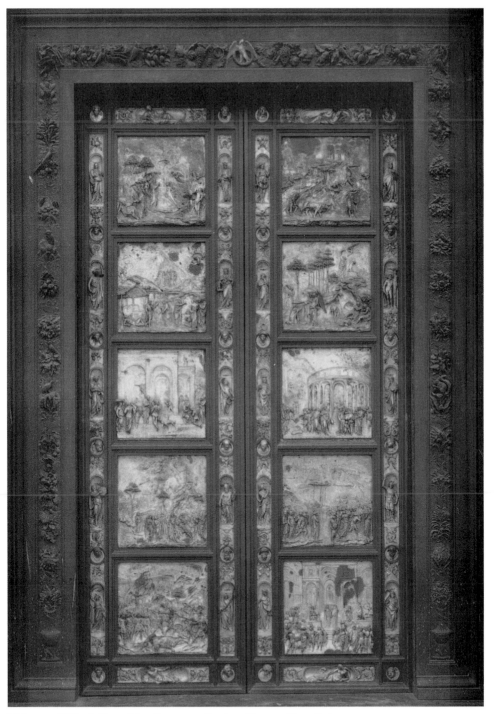

ix) Lorenzo Ghiberti, *Gates of Paradise*, 1424–52, Baptistry, Florence. Photo: Scala.

for this temple, and I executed it with great diligence. And this is the first work; with the frame around it, it added up to about twenty-two thousand florins. In that door there are also twenty-eight squares; twenty have the stories of the New Testament and at the foot are four evangelists and four doctors of the church, with a great quantity of human heads around this work; it is carried out with great love, and diligently, with cornices and ivy leaves, and the posts with a great adornment of leaves of many sorts. The weight of the work was thirty-four thousand. It was carried out with the greatest talent and discipline. At the same time the statue of Saint John the Baptist was made, which was eight feet high and over, it was installed in 1414, fine bronze.

By the city of Siena I was assigned two stories in the Baptistery, the story of how St. John baptizes Christ, the other when St. John is taken before Herod. In addition I made with my hand the statue of St. Matthew, nine feet, of bronze. I also did in bronze the tomb of messer Leonardo Dati, master general of the Dominican friars; he was a very learned man, whom I drew from life; the tomb is of slight relief, and has an epitaph at the feet. I also had the tombs of Ludovico degli Obizzi and Bartolomeo Valori carried out in marble, they are buried at the Friars Minor. In addition a bronze casket can be shown, at Santa Maria degli Angeli, where the Benedictine friars live; in that casket are the bones of three martyrs, Protus, Hyacinth and Nemesius. On the front side are sculptured two little angels, holding an olive garland in their hands, within which are written the letters of their names. At that time I mounted in gold a cornelian, the size of a nut in its hull, in which were carved three figures finely made by the hand of a most excellent ancient master. As a mount I did a dragon, with the wings a little open and the head lowered, the neck rises in the middle, the wings grasp the seal; the dragon, or snake as we would say, was between ivy leaves. Antique letters stating the name of Nero were carved by my hand around the figures, which I did with great diligence. The figures in this cornelian were an old man sitting on a rock, in a lion skin, and tied to a dry tree with his hands behind his back; at his feet was a child kneeling on one knee, and looking at a youth, who had a paper in his right hand and a zither in the left, it looked as if the child were asking the youth to teach him. These three figures were made for our three ages of life. They were certainly either by the hand of Pyrgoteles or Polyclitus; there were as perfect as anything I ever saw cut in hollow relief.
[. . .]

v) Michelangelo, 'Sonnet 151' (*c.*1535–40)

Michelangelo Buonarroti (1475–1564) trained in Florence as a painter and sculptor, before working in Rome for successive popes. He was acclaimed as a superlative artist in his lifetime by Giorgio Vasari (1550) and Ascanio Condivi (1553) and elected as president of the first academy of artists: the *Accademia del Disegno* (1563). Michelangelo's painting and sculpture are frequently seen as among the highest achievements of Western culture, and his work remained one of the central models for artists until the end of the nineteenth century. While his poetry

was unconventional, because of his lack of formal education, and circulated only in manuscript versions, the fact that he wrote poetry at all signified high intellectual ambitions. Poetry was seen as a Liberal Art, associated with scholars, and of rather higher status than painting and sculpture. Michelangelo's use of metaphors taken from the supposedly manual art of sculpture, to convey his ideas on divine and human love, signalled his belief in the high status of modelling and carving. In the neo-Platonic philosophy fashionable at the time, observing beauty in the real world (and in painting and sculpture), meant perceiving the dim reflection of God's more perfect beauties. Michelangelo, through his use of metaphor, could thus present the artist's works as rungs on the ladder to apprehending God's order which underlay appearances. [CK]

Source: Michelangelo, 'Sonnet 151' (c.1535–40), reprinted in Christopher Ryan, ed. and trans., *Michelangelo: the Poems*, J. M. Dent, 1996, pp. 139–41

The greatest artist does not have any concept which a single piece of marble does not itself contain within its excess, though only a hand that obeys the intellect can discover it.

The evil which I flee, and the good to which I aspire, gracious, noble and divine lady, lie hidden in you in just this way; but that I may not live hereafter, my art brings about the opposite of what I desire.

It is not Love, then, nor your beauty, nor harshness, nor fortune, nor haughty disdain that is to be blamed for my evil, nor my destiny nor fate,

if within your heart you carry at the same time death and mercy, and my low mind, in its burning, does not know how to draw forth from it anything but death.

Sonnet, for Vittoria Colonna

vi) Benvenuto Cellini, from *The Autobiography of Benvenuto Cellini* (written 1558–62, published 1728)

Benvenuto Cellini (1500–71) was one of the leading Florentine goldsmiths and sculptors of the sixteenth century. Among his most celebrated works is the statue of Perseus made for the Duke of Florence, which is a masterpiece of bronze casting. However, Cellini is best known for his *Autobiography* written between 1558 and 1562. This is one of the classic texts of the late Renaissance and recounts in graphic detail his love affairs, duels, escape from prison and travels around the courts of Italy and France. This book also contains long descriptions of his dealings with various patrons, especially King Francis I of France, and his battles with rivals and traducers, as well as valuable accounts of his working methods. Cellini had enormous self confidence and was deeply concerned to ensure the highest status for himself, as a creative artist, and for his fellow decorative sculptors. The extract we reproduce here reveals this concern for status in his presentation of his dealings with Francis I. [CC]

Source: Benvenuto Cellini, *The Autobiography of Benvenuto Cellini* (written 1558–62, pub. 1728), trans. George Bull, Penguin, reprinted, 1966, pp. 264, 290, 296–9.

[. . .]

First thing next morning I started work on the great salt-cellar; I pressed on very diligently with this and with my other work. By this time I had hired a large number of workmen to help either with sculpturing or with the goldsmith work. They included Frenchmen, Italians, and Germans, and sometimes I employed very many indeed, if I found them good enough. I changed them from day to day, picked out the ones who knew most, and urged them to work hard. They kept hard at it in their anxiety to keep up with me; but I had a better constitution than they did, and finding the strain too great for them they thought they could restore their strength by copious drinking and eating. Some of the Germans who were more expert than the others could not stand the strain of keeping up to my standard, and it killed them.

While I was making progress with the silver statue of Jupiter, reckoning that I had plenty of silver to spare, I put my hand without telling the King to making a large vase with two handles, about a cubit and a half tall. I also felt inclined to cast in bronze the large model I had made for the silver statue of Jupiter. [. . .]

While I was forging ahead with this work I set aside certain hours of the day to work on the salt-cellar, and others to work on the Jupiter. As there were more men working on the salt-cellar (plate x) than I could manage to employ on the Jupiter, by this time I had already finished it down to the last detail. The King had returned to Paris, and I went to find him, bringing the salt-cellar with me. [. . .] it was oval in shape, about two-thirds of a cubit high, entirely in gold, and chased by means of a chisel. [. . .] I represented the Sea and the Land, both seated, with their legs intertwined just as some branches of the sea run into the land and the land juts into the sea: so, very fittingly, that was the attitude I gave them. I had placed a trident in the right hand of the Sea, and in his left hand, to hold the salt, I had put a delicately worked ship. Below the figure were his four sea-horses: the breast and front hoofs were like a horse, all the rest, from the middle back, was like a fish; the fishes' tails were interlaced together in a charming way. Dominating the group was the Sea, in an attitude of pride and surrounded by a great variety of fish and other marine creatures. The water was represented with its waves, and then it was beautifully enamelled in its own colour.

The Land I had represented by a very handsome woman, holding her horn of plenty in her hand, and entirely naked like her male partner. In her other hand, the left, I had made a little, very delicately worked, Ionic temple that I intended for the pepper. Beneath this figure I had arranged the most beautiful animals that the earth produces; the rocks of the earth I had partly enamelled and partly left in gold. I had then given the work a foundation, setting it on a black ebony base. It was of the right depth and width and had a small bevel on which I had set four gold figures, executed in more than half relief, and representing Night, Day, Twilight, and Dawn. Besides these there were four other figures of the same size, representing the four chief winds, partly enamelled and finished off as exquisitely as can be imagined.

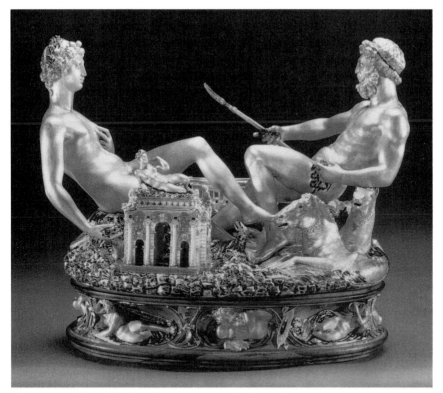

x) Benvenuto Cellini, *Salt-cellar of Francis I*, 1539–43, Kunsthistorisches Museum, Vienna.

When I set this work before the King he gasped in amazement and could not take his eyes off it. Then he instructed me to take it back to my house, and said that in due course he would let me know what I was to do with it. I took it home, and at once invited in some of my close friends; and with them I dined very cheerfully, placing the salt-cellar in the middle of the table. We were the first to make use of it. Then I set out to finish the silver Jupiter and the large vase I have mentioned before that was charmingly ornamented with a host of figures. [. . .]

Meanwhile I gave all my attention to finishing the fine silver statue of Jupiter together with its gilded base, which I had placed on a wooden plinth. Only a part of the plinth was visible and I had fixed in it four small balls, made of hard wood, more than half concealed in their sockets, like the nut in a crossbow. These were so skilfully arranged that a small child could easily, without the slightest effort, push the statue of Jupiter backwards and forwards or turn it round on itself. When I had set everything up to my satisfaction I took it to Fontainebleau, where the King was staying.

By then Bologna[1] had brought from Rome the statues I mentioned, and he had taken great pains in having them cast in bronze. I knew nothing of this, partly because he had kept his doings very secret, and partly because Fontainebleau is more

than forty miles away from Paris: so I was kept completely in the dark. When I wanted to find out from the King where to place the Jupiter, Madame d'Étampes,[2] who was present, told him that there was no place more suitable than his beautiful gallery. This is what we call in Tuscany a loggia, or more accurately, a corridor – a corridor, because a loggia is the name given to apartments open along one side.

Anyhow, this room was more than a hundred paces in length, was richly furnished, and was hung with a number of paintings from the hand of our splendid Florentine, Rosso; under the paintings were grouped a great many pieces of sculpture, some in the round and others in low relief. The room was about twelve paces across. Bologna had brought here all his antiques, beautifully cast in bronze, and had arranged them magnificently with each one raised on its own pedestal. And, as I said before, they were the most exquisite works of art, copied from the antiques of Rome. I brought in my Jupiter; and then, when I saw such a splendid spectacle with everything so skilfully set out, I said to myself:

'This is certainly running the gauntlet – now God help me.'

I put it in its place, positioning it as well as I could, and I waited for the arrival of the great King. In Jupiter's right hand I had placed his thunderbolt, so that it looked as if he were about to hurl it; and in his left I had placed a globe. Among the flames I had very neatly introduced a length of white taper.

Madame d'Étampes had managed to keep the King distracted till nightfall, with the intention of ensuring one of two unfortunate results for myself – either his not coming at all, or, because of the darkness, my work's being shown at a disadvantage: but, as God rewards those of us who trust in Him, quite the opposite happened, because seeing that it was growing dark I lit the taper that the Jupiter was holding, and as this was lifted a little way above the statue's head its light fell down from above, making the work appear much more beautiful than it would have done in daylight.

The King appeared on the scene along with his Madame d'Étampes, the Dauphin his son (today the King), the Dauphiness, his brother-in-law the King of Navarre, with Madame Marguerite his daughter, and several other great lords whom Madame d'Étampes had carefully instructed to speak against me. As soon as I saw the King come in I had my assistant, Ascanio, push the beautiful statue of Jupiter forward in his direction; he moved it very gently, and since I had done the job very skilfully and the figure was very well constructed this slight movement made the statue seem alive. The antique statues were left somewhat in the background, and so my work was the first to delight the spectators.

Straight away the King said: 'This is much more beautiful than anything that has ever been seen before: even though I'm a connoisseur I would never have come near imagining anything like this.'

As for those noblemen who were to speak against me, it seemed that they could not say enough in praise of my work.

Madame d'Étampes exclaimed fiercely: 'Have you lost your eyes? Don't you see how many beautiful bronze figures there are placed farther back? The true genius of sculpture resides in them, not in this modern rubbish.'

Then the King came forward, followed by the others. He glanced at those figures, which were not shown to any advantage since the light came from below, and he said:

'Whoever it was wanted to do this man a bad turn has done him a great favour: the comparison with these splendid works of art only serves to make it apparent that his is more impressive and beautiful by a long chalk. We must rate Benvenuto very highly indeed: his work not only rivals, it surpasses the antiques.'

At this Madame d'Étampes said that if my work were to be seen in the daylight it would not appear a thousandth part as beautiful as it did by night; besides, she added, they were to notice how I had put a veil on my statue in order to hide its faults. This, in fact, was a piece of fine gauze that I had placed with exquisite grace over the Jupiter to add to its majesty. When I heard what she said I took hold of it, lifting it from below to reveal the statue's fine genitals, and then, with evident annoyance, I tore it off completely. She thought that I had unveiled those parts in order to mock her. When the King saw how insulted she was and how I myself, overcome by passion, was trying to force out some words, like the wise man he was he said with deliberation in his own tongue:

'Benvenuto, I forbid you to say a word: keep quiet, and you'll be rewarded with a thousand times more treasure than you desire.'

Unable to say anything I writhed with fury – which made her growl even more angrily. Then the King left much sooner than he would have done, saying in a loud voice, to encourage me, that he had brought from Italy the greatest artist ever born. [. . .]

NOTES

1 Although the sculptor Giambologna (1529–1608) is frequently referred to by this name, Cellini here has in mind Francesco Primaticcio (1504/5–1570), who was sometimes called il Bologna. Primaticcio was the head of the first school of Fontainebleau but was away in Rome buying works of art for Francis I when Cellini arrived. Cellini evidently felt threatened by Primaticcio's return and records, later in his autobiography, that he threatened to kill this rival. [SE]

2 Madame d'Étampes was the mistress of the king. Cellini presents her as constantly scheming to undermine him in the king's eyes. [SE]

vii) *Contract between Tilman Riemenschneider of Würzburg and delegates of the City Council of Rothenburg* (15 April, 1501)

Tilman Riemenschneider (c. 1460–1531) was a sculptor active in Würzburg in Franconia from 1483 until his death. Among the more important products of his large and busy workshop were carved wooden altarpieces, of which the altarpiece of the Holy Blood in the St Jakobskirche, Rothenburg (plate xi), is the most significant surviving dated example. The text reproduced here is an extract from the contract between Riemenschnieder and the delegates of the town council, dated 15 April, 1501, in which the design and dimensions of the work are outlined. A separate contract was made with the joiner Erhart Harschner in 1499 for the manufacture of the altarpiece frame. [KW]

> Source: *Contract between Tilman Riemenschneider of Würzburg and delegates of the City Council of Rothenburg* (15 April, 1501), trans. M. Baxandall, reprinted in Michael Baxandall, *The Limewood Sculptors of Renaissance Germany*, Yale University Press, 1980, p. 174

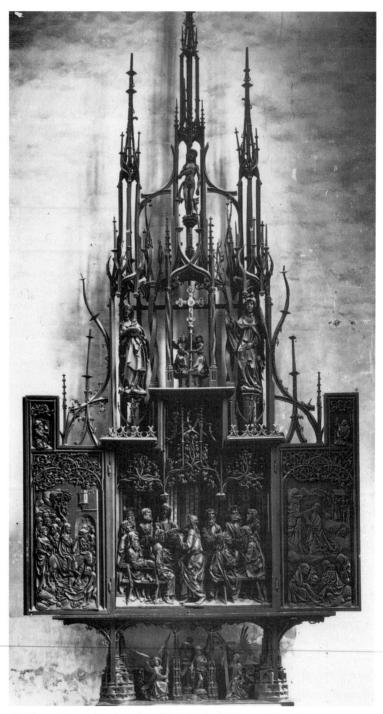

xi) Tilman Reimenschneider, *Altar of the Holy Blood*, St James's, Rothenburg, 1499–1505.
Photo © Bildarchiv Foto Marburg.

. . . in the *Sarg*[1] below next to the tabernacle two angels, each one about 1½ feet high when kneeling, one put on each side; then in the *Corpus*[2] the Last Supper of Christ, with His Apostles and what else belongs in it, the figures to be about four feet high; and on the *Flügel*[3] on the right to carve a relief scene of Palm Sunday, when Christ rode in on the ass, with its story and what belongs in it, the figures of this scene to project about three fingers deep; and on the *Flügel* on the left he shall carve also in relief the scene of Christ on the Mount of Olives with the Disciples and the arrival of the Jews, this too projecting as much as the scene of Palm Sunday; and above in the shrine in the *Auszug*[4] he shall carve in the middle two Angels kneeling opposite each other and holding the Holy Cross, and also above the Cross two gliding Angels, all of the size demanded according to the drawing; and at the sides next to the Cross, on the right the image of the Virgin Mary and on the left the Angel Gabriel of the type announcing the angelic greeting to her virgin heart; and above the Cross in the centre of the shrine an image of the Christ of Mercy, about 3 feet high.

NOTES

1 *Sarg* – *predella*, or lowest zone of the altarpiece [KW]
2 *Corpus* – the main body of the altarpiece [KW]
3 *Flügel* – altarpiece shutters [KW]
4 *Auszug* – carved structure set above the *corpus* [KW]

viii) Albrecht Dürer, 'Dedication to Herr Wilibald Pirkheimer',
 from *The Teaching of Measurement* (1525)

The painter, engraver and designer of woodcuts, Albrecht Dürer (1471–1528) was the first artist north of the Alps to adopt a theoretical position informed by humanist ideals. Accordingly, he laid the claim for the visual arts as Liberal Arts comparable to that which had been made in Italy. The treatise comprises: first, a guide to linear geometrical drawing; secondly, rules for constructing plane drawings in two dimensions; thirdly, how to design architectural solids, together with 'the just shaping of letters'; and in the fourth book, the geometry of three-dimensional bodies and the 'correct construction' for perspective. Dürer's ideas are partly indebted to the description of Roman architecture given by Vitruvius, Euclidian geometry and the writing of the Italian mathematician and friend of Leonardo da Vinci, Luca Pacioli. There are a number of points to note in the text printed here. Dürer argues that German artists have been working from experience without principle and, consequently, made mistakes in representation. He also defends well-made religious images against charges that they were idolatrous on the grounds that they represent the truth both in terms of the subject and the form of depiction. Luther had defended the use of images against Protestant iconoclasts. In this text, Dürer repeats the view, by then becoming commonplace in Italy, that classical art had been revived by Giotto (here unnamed). The treatise is seen by its author as applicable to a range of artistic activities, not merely

painting and sculpture. He regarded architecture, for example, as an exten-
sion of sculpture and goldsmithing rather than a distinct artform. From about
1513, Dürer seems to have been intending to devise a comprehensive art trea-
tise, of which *The Teaching of Measurement* would have formed a part.

The addressee, Wilibald Pirkheimer (1470–1528), was Dürer's lifelong friend
and correspondent. He devised several of Dürer's iconographic schemes,
formed a dining club for reform-minded patricians to which Dürer belonged,
and was also the centre of a group of astronomers, mathematicians and car-
tographers who published their work in Nuremberg. One of Pirkheimer's sis-
ters, the nun Eufernia, commented while they had 'a good time' with the
treatise, 'our paintress says that she can paint just as well without it'. [NW]

Source: Albrecht Dürer, 'Dedication to Herr Wilibald Pirkheimer', from *The Teach-
ing of Measurement With the Rule and Compass, In Lines and Solids, Put Together And
Brought to Print With Accompanying Figures By Albrecht Dürer, For The Use Of All
Lovers Of Art, In The Year 1525* (1525), reprinted in *The Writings of Albrecht Dürer*,
William Martin Conway, ed. and trans., Peter Owen, 1958, pp. 211–2

'To my very dear Master and friend, Herr Wilibald Pirkheimer, I, Albrecht
Dürer, wish health and happiness.

Gracious Master and friend. Heretofore many talented scholars in our German
land have been taught the art of painting, without any foundation and almost
according to mere every-day rule-of-thumb. Thus they have grown up in igno-
rance, like a wild unpruned tree.

And, though some of them have acquired a free hand by continuous practice,
so that it cannot be denied that their work has been done skilfully, yet, instead of
being grounded upon principle, it has merely been made according to their tastes.
If, however, painters of understanding and artists worthy of the name were to see
so rash a work, they would scorn the blindness of these fellows, and that not with-
out justice. For, to one who really knows, nothing is more unpleasant to see in a
picture than fundamental error, however carefully the details may be painted.
That such painters have found satisfaction in their errors is only because they have
not learnt the ART OF MEASUREMENT, without which no one can either be or
become a master of his craft. But that again has been the fault of their masters,
who themselves were ignorant of this art.

Considering, however, that this is the true foundation for all painting, I have
proposed to myself to propound the elements for the use of all eager students of
Art, and to instruct them how they may employ a system of *Measurement with
Rule and Compass*, and thereby learn to recognise the real Truth, seeing it before
their eyes. Thus they will not only acquire a delight in and love towards art, but
attain an increasingly correct understanding of it. And they will not be misled by
those now amongst us who, in our own day, revile the Art of Painting and say that
it is servant to Idolatry. For a Christian would no more be led to superstition by a
picture or effigy than an honest man to commit murder because he carries a
weapon by his side. He must indeed be an unthinking man who would worship

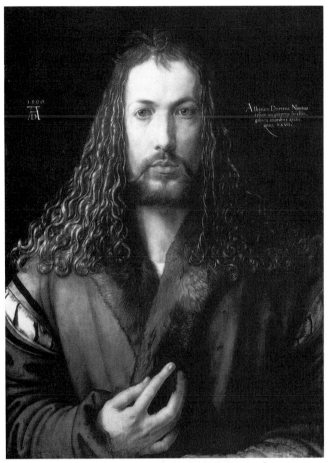

xii) Albrecht Durer, *Self-Portrait*, 1500, Alte Pinakothek, Munich.

picture, wood, or stone. A picture therefore brings more good than harm, when it is honourably, artistically, and well made.

In what honour and respect these arts were held by the Greeks and Romans the old books sufficiently prove. And, although in the course of time the arts were lost, and remained lost for more than a thousand years, they were once more brought to light by the Italians, two centuries ago. For arts very quickly disappear, but only with difficulty and after a long time can they be re-discovered.

Therefore I hope that no man of understanding will censure this project and teaching of mine, for it is well meant and will be useful to all who study art. It will not alone be serviceable to painters, but also to goldsmiths, sculptors, stone-masons, joiners, and all who require measurements. No one indeed is obliged to avail himself of this doctrine of mine, but I am sure that whosoever does adopt it will not only thereby gain a firm grounding, but, arriving by daily practice at a

better comprehension of it, will pursue the search and discover far more than I now point out.

Knowing, as I do, gracious Master and friend, that you are a lover of all the arts, and for the great affection and friendship I bear towards you, I have dedicated this book to you. Not that I think thereby to render you any great or important service, but I hope to give some evidence and measure of my good will towards you. For though I cannot benefit you with my works, my heart has none the less been always ready to render back a return for your favours and the love you cherish towards me.'

ix) Lucas de Heere, *Boomgaerd der Poësin* (1565)

Lucas de Heere (1534–after 1584) was a painter and poet of Ghent. In 1565 he compiled an anthology of poems dedicated to his patron, Admiral Adolph of Burgundy, and entitled *Den Hof en Boomgaerd der Poësin* (The Garden and Orchard of Poetry). Three years later fear of the repressive Spanish regime forced Lucas to flee the Netherlands for London. He is reputed to have died in Paris. The invective published here was not the only poem in the *Hof en Boomgaerd* in which art is discussed, but here the tone is not theoretical but personal. In this text de Heere was defending his teacher Frans Floris (1516–70) against an attack by an unnamed painter. De Heere's catalogue of insults provides important evidence of a controversy between the Italian-inspired tradition of De Heere and Floris and those who opposed it. This text was translated for this volume by Marga Emlyn-Jones. [KW]

Source: Lucas de Heere, *Boomgaerd der Poësin* (1565), trans. Marga Emlyn-Jones, printed in *Den Hof en Boomgaerd der Poësin*, Introduction and Notes, W. Water-schoot, N. V. Uitgevermaatschappij. W. E. J. Tjeenk Willink. Zwolle, 1969, pp. 88–90

AN INVECTIVE AGAINST A CERTAIN PAINTER, WHO MADE A SPITEFUL
ATTACK ON THE PAINTERS OF ANTWERP

Why injure yourself! You can see, but you are blind
Through hatred and spite, as if robbed of your senses?
Do you (who are a sloppy bungler) think to win merit for yourself
Through your contempt of those who deserve praise and honour.
5 Through their distinction? Had you swallowed your rubbish,
One might always regard you as kind of sensible – The mouth speaks from an
overflowing generosity of heart.

Not so spiteful was the scornful opinion of Momus
Who had the temerity to criticise Venus' slipper,
10 While you condemn her beauty, which the world recognises
As indescribable, front and back.
It is totally to your shame that this had to happen:
Because those who didn't know before that you were crazy,
Will realise now what a stupid moron you are.

15 The paintings of Floris and people like him
 You (sneering fool) call little sugar figures,
 because they are decorated, suitable and rich –
 Not just all over the place, but where it is right and suited.
 It's amazing you're not ashamed of yourself,
20 Because in all these aspects you're completely out or order,
 Considering you decorate your figures like carnival dolls.

 But however much you tart them up (and yourself as well),
 However much you flatter, laud, and praise yourself,
 However much you disdain everyone, and wish to belittle them,
25 The more you are held in ever smaller esteem.
 You've got a certain attractiveness that you upholster very well –
 Not like interior painters and decorators without any pretence,
 But with your rash boasts, exaggerations and lies.

 If you could sweeten and botch up your work like that,
30 So that amongst artists it could taste a bit sweet
 Because now it is even more bitter than gall –
 Then you could be something, which now you are not.
 Truly, even against the will of the King of beasts,
 Of the lion, who before you was always deemed the greatest animal,
35 This is now the honour belonging to you – and no-one else.

 Please occupy yourself with colouring in the Apostles of wallpaper painters
 Who are indeed able to draw all twelve in one unbroken stroke:
 And please use large brushes instead of pencils,
 Because fine work (how your mouth would be busy then)
40 Would be far too artistic for you – you pathetic thick-head.
 Even if you have been to Rome, it's a sad thing
 That happened, considering you remained indifferent to that extraordinary opportunity.

 One wouldn't notice that you've been to Rome
 From your paintings that are full of feeble, meaningless strokes.
45 They are neither in the Italian style, nor even antique –
 And were one to tell you your faults, it would take many weeks,
 Much paper, much ink and many nibs – would never have enough of those.
 But there would be no question of more reproaches,
 If you would only do your best to keep your mouth shut.

NOTES

Line 8 Momus: Son of Nyx, personification of ridicule. Even Jupiter was not safe in the face of his criti-
 cism. Only Venus's beauty was so perfect that he could only criticise her shoes. [trans.]
Line 15 Floris: The Antwerp painter, Frans Floris. [trans.]
Line 21 Carnival Dolls: Usually highly decorated and often elaborately dressed dolls which are for sale on
 dolls' stalls during carnival time. [trans.]
Line 36 Painters of Wallpaper: They were not artists and were not allowed to create paintings until 1463.
 Even after that they were denied the use of oil paints. [trans.]

x) Karel Van Mander, 'The Life of Pieter Brueghel, Excellent Painter
 from Brueghel', from *The Lives of the Illustrious Netherlandish and
 German Painters* (1604)

Karel Van Mander (1548–1606) was a painter and writer on art based in Haarlem
in the Northern Netherlands. His treatise on painting entitled *Het Schilderboek*
(The Painter's Book) was first published in 1604 and sold well. In addition to a
theoretical poem on the visual arts and handbooks on Ovid's *Metamorphosis* and
emblematic usage, the *Schilderboek* includes lives of ancient, Italian, and most
importantly, Northern artists after the model of Vasari's *Lives of the Artists*. In the
life of Bruegel printed here, Van Mander stresses Brueghel's peasant contacts, his
humour, his fidelity to nature, and finally the potentially controversial content of
some of his work. Although the accuracy of Van Mander's information has been
questioned, his account still forms an important source for this elusive and enig-
matic painter. The Flemish artists and connoisseurs referred to by Van Mander
have not been footnoted. [KW]

Source: Karel Van Mander, 'The Life of Pieter Brueghel, Excellent Painter from
Brueghel', from *The Lives of the Illustrious Netherlandish and German Painters*
(from the *Schilderboek*, 1604), Hessel Miedema ed., trans. Jacqueline Pennial-Boer
and Charles Ford, Davaco Publishers, 1994, pp. 190–4

The life of Pieter Brueghel, excellent painter from Brueghel.

Nature found and struck lucky wonderfully well with her man – only to be
struck by him in turn in a grand way – when she went to pick him out in Brabant
in an obscure village amidst peasants, and stimulate him toward the art of painting
so as to copy peasants with the brush: our lasting fame of the Netherlands, the very
lively and whimsical Pieter Brueghel, who was born not far from Breda in a village
called Brueghel, the name which he took himself and left to his successors. He
learned art with Pieter Koeck van Aelst whose daughter he later married – whom
he, while she was still small, had often carried in his arms when he lived with Pieter.
From there he went to work at Jeroon Kock's, thereafter travelling to France and
thence to Italy. He had practised a lot after the works of Jeroon van den Bosch and
he also made many spectres and burlesques in his manner so that he was called by
many Pier den Drol. This is why one sees few pictures by him which a spectator
can contemplate seriously and without laughing, and however straightfaced and
stately he may be, he has at least to twitch his mouth or smile. On his travels he
drew many views from life so that it is said that when he was in the Alps he swal-
lowed all those mountains and rocks which, upon returning home, he spat out
again onto canvases and panels, so faithfully was he able, in this respect and others,
to follow Nature. He chose to go and live in Antwerp and entered the guild or
chamber of painters there in the year of Our Lord 1551. He worked a great deal for
a merchant called Hans Franckert who was a man with a noble, good disposition

who liked to be with Brueghel and who daily associated with him very companionably. Brueghel often went out of town among the peasants with this Franckert, to fun-fairs and weddings, dressed in peasants' costume, and they gave presents just like the others, pretending to be family or acquaintances of the bride or the bridegroom. Here Brueghel entertained himself observing the nature of the peasants – in eating, drinking, dancing, leaping, lovemaking and other amusements – which he then most animatedly and subtly imitated with paint, in watercolour as well as oilpaints, for he was most outstanding in the handling of both techniques. He knew how to attire these men and women peasants very characteristically in Kempish or other costume[1], and how to express very naturally that simple, peasant appearance in their dancing, toing and froing and other activities. He was wonderfully sure in his poses and he had a very pure and subtle technique with the pen with which he drew many small views from life. While he still lived in Antwerp he lived together with a girl, a young woman, whom he would have married as well but for the fact that it annoyed him that she was always (so as to be economical with the truth) wont to lie. He made an agreement and undertaking with her: he would carve all her lies onto a tally stick, for which he made one that was quite long – and if in time the rally stick should be filled then marriage would be entirely off the cards and any promise invalid – and that happened before much time had passed. At last, since Pieter Koeck's widow eventually came to live in Brussels, he came to court her daughter – whom he often, as has been told, used to carry in his arms – and he married her. But the mother laid down as a stipulation that Brueghel must move from Antwerp and come to live in Brussels so that he would leave and forget that former girl; and so it came to pass. He was a very quiet and moderate man, not of many words, but quite animated in company; sometimes he gave people, as well as his own assistants, a fright by making one or other prowling or rattling. Some of his most important works are now with the Emperor, to wit a large piece with a *Tower of Babel* in which there are many handsome details to be seen; it is shown in bird's-eye view. And another of the same subject only small, or at any rate smaller. And two pieces with the *Carrying of the Cross*, very natural to look at, in which there were always some burlesque details. Then a *Massacre of the Innocents* in which many effective details can be seen, of which I have told elsewhere: how an entire family begs on behalf of a peasant child which one of the murderous soldiers has grabbed in order to kill; in which the grief and pallor of the mother and other effects are well expressed. Then a *Conversion of Paul* with very subtle rocks. It would be difficult to relate all that he made with regard to sorceries, hells, peasant scenes and other things. He made a *Temptation of Christ* in which, as in the Alps, one looks down from above onto towns and countries with clouds swirling above them, through which one sees in some places; and a *Dolle Griet*[2] carrying away plunder in the face of hell, who looks quite crazy and is weirdly kitted-out in a higgledy-piggledy way. I believe this, as well as some other pieces, to be in the Emperor's palace too. In Amsterdam with the art lover Mr Herman Pilgrims, there is a *Peasant Wedding* in oils which is most subtle; there one sees the faces and unclothed parts of the bodies of the peasants in yellow and brown as if tanned by the sun – and their skin is ugly, different from that of town dwellers. He

also made a piece in which Lent fights against Shrove Tuesday; and another in which all remedies against Death are used; and another with all manner of childrens' games, and innumerable allegories. There are also two watercolour canvases to be seen with the art lover Mr Willem Jacobsz, near the Nieuwe Kerk[3] in Amsterdam, namely a *Peasants' Fair* and a *Peasants' Wedding* in which there are many burlesque postures and the true behaviour of the peasants; for instance, bringing gifts to the bride, and there is an old peasant with his purse around his neck busy counting out the money in his hand. They are very outstanding pieces. Shortly before his death the councillors of Brussels commissioned him to make some pieces of the digging of the Brussels canal to Antwerp, but because of his death that was left undone. One sees many unusual inventions of symbolic subjects of his witty work in print; but he had still many more, neatly and carefully drawn with some captions on them, some of which he got his wife to burn when he was on his deathbed because they were too caustic or derisory, either because he was sorry or that he was afraid that on their account she would get into trouble or she might have to answer for them. In his will he left his wife a piece with a magpie on the gallows; by the magpie he meant gossiping tongues, which he committed to the gallows. He also made a picture of Truth Will Out – this (according to him) was the best he ever made. He left behind two sons who are also good painters. [. . .]

NOTES

1 A regional costume [SE]
2 A painting by Brueghel often called 'Mad Meg', c. 1562–3. It is housed in the Mayer van den Bergh museum, Antwerp. [SE]
3 New Church [SE]

xi) Edmond and Jules de Goncourt, from *French Eighteenth-Century Painters* (1859–75)

The brothers Edmond (1822–96) and Jules (1830–70) de Goncourt were wealthy novelists, playwrights, collectors and art critics. They regarded the eighteenth century as a lost paradise of wit, elegance, gallantry, sensuality and exquisite feeling and helped to create the fashion for eighteenth-century French furniture and painting. In their *L'Art du dix-huitième siècle* (*Eighteenth-Century Art*, also known as *French Eighteenth-Century Painters*), written between 1859 and 1875, they turned away from the social and artistic concerns of their own time to construct literary fantasies on the works and personalities of eighteenth-century French painters such as Jean-Antoine Watteau (1684–1721), François Boucher (1703–70), Jean-Baptiste Chardin (1699–1779), Maurice Quentin de la Tour (1704–88) Jean-Baptiste Greuze (1725–1805) and Jean-Honoré Fragonard (1732–1806). The following extracts are taken from the section on Watteau. The first uses the Romantic myth of the artist pouring his suffering into his art to construct a melancholic interpretation of Watteau's painting. The second celebrates the erotic effect of Watteau's brushwork. [LW]

Source: Edmond and Jules de Goncourt, from *French Eighteenth-Century Painters* (1859–75), trans. Robin Ironside, Phaidon, 1948, pp. 8–9, 52

[I] [. . .]

It is indeed true that in the recesses of Watteau's art, beneath the laughter of its utterance, there murmurs an indefinable harmony, slow and ambiguous; throughout his *fêtes galantes* there penetrates an indefinable sadness; and, like the enchantment of Venice, there is audible an indefinable poetry, veiled and sighing, whose soft converse captivates our spirits. The man impregnates his art; and it is an art that we are made to look upon as the pastime and the distraction of a mind that suffers, as we might look, after its death, upon the playthings of an ailing child.

The painter stands revealed in his portrait. First, that vivid portrait of his youthful appearance: a thin, anxious, nervous face; arched, feverish eyebrows; large, restless, black eyes; a long, emaciated nose; a dry, sad, sharply defined mouth – with the extremities of the nostrils extending to the corners of the lips – a long fold of flesh seeming to distort the face. And from one portrait to another, almost as from one year to another, we may observe him, always melancholy, always getting thinner, his long fingers lost in the full sleeves, the coat doubled over on his bony breast, old at thirty, his eyes sunken, tight-lipped and angular of face, only preserving his fine brow relieved by the long curls of a Louis XIV wig.

Or, rather, let us look for him in his work: that figure with the eyeglass or that flute-player – it is Watteau. His eye rests negligently upon the entwined lovers, whom he diverts with a music to whose flow of notes he gives no heed. His silent glances follow the embraces, and he listens to the love-making, listless, indifferent, morose, consumed by languor, and weary, like a violin at a marriage of the dances it directs, and deaf to the sound, to the song of his instrument.

[. . .]

[II] But let us return to that masterpiece of masterpieces, the canvas whose place has been reserved, fifty years in advance, on the walls of the Salon Carré: 'L'Embarquement de Cythère'.

Look at this foreground scarcely covered by a layer of transparent, russet oil, worked up by rapidly applied flecks of paint, skimmed by the lightest of glazes. Look at the green of these trees, pierced by auburn tones, penetrated by the windy air and watery light of autumn. Look at the plastic solidity, amid the delicate wash, as in a water-colour, of heavy oil, amid the sleek texture of the canvas, of this satchel or of this hood; look at the full impasto of the little figures, their glance and their smile visible in the drenched contours of their eyes and lips. What a fine, streaming fluidity of brushwork has produced these *décolletages*,[1] these glimpses of the naked skin, whose roseate voluptuous hue chequers the obscurity of the wood! What a neat intersection of strokes conveys the curving fullness of the nape of neck, what admirable undulating draperies with gently broken folds like the marks of the chisel in the clay of a *bozzetto*.[2] And with what wit, what a caressing dalliance in the touch, the artist's brush renders the finger-tips, the *chignons*, the ornamental details of the dress and, indeed, all that it handles! What harmony also in these sunlit distances, in the

pink snow capping these mountains, in these waters with their verdant reflections; and how fleet these sunbeams on the pink and yellow dresses, the crimson skirts, the blue hoods, the iridescent grey of the coats and on the little white lap-dogs with orange markings! No painter has expressed, as Watteau expressed, the transfiguring effect of a sunbeam on the inherent enchantments of local colour, its soft etiolation, the diffused blossoming of its brilliance under a full light. Pause a moment before this band of pilgrims hurriedly gathering, under the setting sun, around the boat of Love ready to weigh anchor; here is the most entrancing gaiety of colour caught unawares in a shaft of sunlight, and all this silk, soft and graded in the liquid radiance, will recall involuntarily those splendid insects that are sometimes found dead in a fragment of amber, but still vividly coloured beneath its gold light.

[. . .]

NOTES

1 Low neck lines [LW]
2 From the Italian, 'bozzo', meaning 'rough stone': a small three-dimensional sketch in wax or clay made
 by a sculptor in preparation for a larger and more finished work and, by extension, a rapid sketch in oil,
 made as a study for a larger picture. (Thames and Hudson *Dictionary of Art Terms*). [LW]

xii) Théophile Thoré, from *Van der Meer de Delft* (1866)

This text, in which the nineteenth-century French art critic and historian Théophile Thoré (1807–1869), writing here under his pseudonym of William Bürger, announces his 'rediscovery' of the Dutch artist Johannes Vermeer (1632–1675), was first published in the *Gazette des Beaux-Arts*, the leading French art journal of the period. It opens with a dedication to the critic Champfleury (pseudonym of Jules Husson [1828–89]), who had himself become celebrated for bringing to light three seventeenth-century painters, the Le Nain brothers. The nomenclature used here is inconsistent with the artist appearing initially as 'van der Meer' but subsequently being given the correct form of his name. This inconsistency demonstrates vividly the lack of an established reputation for Vermeer. The article seeks, on the one hand, to demonstrate that Vermeer must have studied under Rembrandt in Amsterdam and, on the other, to disentangle his work from that of other seventeenth-century Dutch painters with which it had been confused. While much of Thoré's scholarship has since been discredited, this text nevertheless represents an important step in the canonisation of Vermeer as a great artist. The artists referred to in this extract have not been footnoted. The text was translated for this volume by Emma Barker. [EB]

Source: Théophile Thoré, from *Van der Meer de Delft* (1866), trans. Emma Barker, *Gazette des Beaux-Arts*, October, pp. 297–330; November, pp. 458–70; December, pp. 542–75

To Champfleury

You are one of those who are attracted by the Unknown and Unrecognized. You are curious both about mystery and reality, about shadow and light – the two extremes of art and of life [. . .]

Given that you have yourself rescued three men who were all but dead, the Le Nain brothers, you will be interested in an original who had fallen into neglect and whom I am trying to bring to light. Reparation of an injustice which has often been committed out of ignorance in the history of our beloved Dutch school.

Van der Meer was not dead, what he had created still existed, but his name had been obliterated from his resplendent works. Van der Meer had disappeared behind Pieter de Hooch, just as Hobbema had behind Ruisdael.

Today, Hobbema has regained his individuality and taken his place alongside his friend and companion Ruisdael. It is just as fitting that van der Meer be put back alongside Pieter de Hooch and Metsu, in the circle of Rembrandt.

To you, I in turn dedicate my *sphinx* whom you will recognize as an ancestor of our artists in love with Nature, those who understand it and express it in all its appealing sincerity. [. . .]

At the museum in The Hague, a superb and utterly unique painting stops all the visitors in their tracks and makes a strong impression on artists and connoisseurs. It is a view of a town, with a quay, an old arched gate, buildings in very different architectural styles, garden walls, trees and, in the foreground, a canal, a stretch of ground and several tiny figures. The silvery grey sky and the tone of the water recall Philip[s] Koninck a little. The dazzling light, the intense colour, the thick impasto in certain areas, the utterly real and yet utterly original effect, are also somewhat reminiscent of Rembrandt.

When I visited Dutch museums for the first time, around 1842, this strange painting surprised me as much as the *Anatomy Lesson* and other Rembrandts, all of them highly distinctive, in the museum in The Hague. Not knowing to whom to attribute it, I consulted the catalogue: *View of the town of Delft*, from the canal, by Jan van der Meer of Delft.[1] 'Heavens! here's one whom we don't know in France, and who certainly ought to be known'[. . .]

Most of van der Meer's paintings reveal in some way the teaching of Rembrandt to such an extent that it could not have been communicated at second hand and with Fabritius as intermediary.[2] His pale blues, his bronze greens, like his lemon yellows and camelia reds, van der Meer derived them from Rembrandt. From Rembrandt, he took his passion for windows, through which his interiors are lit with such a precise, vivid light – and his fine Oriental carpets painted in rough layers of pigment, and his physiognomies that are so expressive and his profoundly human naivety. [. . .]

We must, if you please, accept van der Meer of Delft as one of the constellation of Dutch 'little masters' and as their equal. Like them, he is naturally original and what he does is perfect.

What does his œuvre consist of? Firstly, domestic scenes, representing the customs of his time and his country; next, views taken from within a town, mere fragments of a street, occasionally a depiction of a house; finally, landscapes in which air and light circulate as they do in nature.

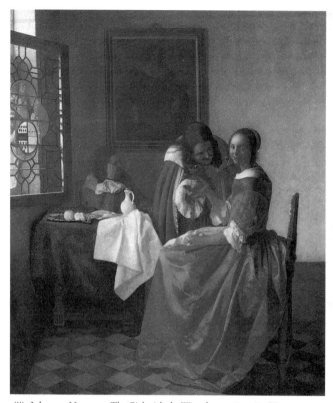

xiii) Johannes Vermeer, *The Girl with the Wineglass, c.* 1659–60, Herzog
Anton Ulrich-Museum Braunschweig. Fotonachwels: Museumsfoto B.P.
Kelser.

We are now able to identify some twenty of his figure paintings, which can be
classified alongside those of Metsu, Terburg [Ter Borch], de Hooch and Jan Steen.
But van der Meer has more emphasis than Metsu, more expression than Terburg,
more distinction than Jan Steen, more strangeness than Pieter de Hooch [. . .]

His figures are completely absorbed in what they are doing. How attentive his
reading women are to what they read! How deft his lacemaker is with her little
skeins of thread! How his woman with a guitar plays and sings! And look at the
young girl tying her necklace in front of a mirror; how charming she appears, with
her turned-up little nose and half-open mouth! And that young girl who laughs
with her soldier, and the 'Coquette' of Brunswick who laughs with her gallant
[plate xiii].[3] Here is life itself; one immediately works out the little drama that is
expressed on their physiognomies. The reading woman in the van der Hoop
museum has been put out by a piece of bad news; could it be that her lover writes
that he is leaving for the East Indies? In the painting in the Dufour collection, one
seems to hear the lady saying to her servant as she gives her the letter: 'You know
. . . it's for the young man . . . the blond one . . . Don't get the address wrong'.[4]

Often, in Vermeer, as in Jan Steen, the accessories, and especially the paintings hung on the wall, are highly revealing [. . .] In the *Woman Weighing Pearls*, the picture in the background represents the *Last Judgement*: 'Ah! You are weighing jewels? You will be weighed and judged in your turn!' In the *Young Woman at the Virginal*, what she is thinking about is indicated by a painting depicting Cupid running with a letter in his hand. Love is running through her mind. – Of course, he is coming to bring her some love letter. Naively anxious, she hopes, she strums her piano – waiting for love to come to her.[5]

All this, without any emblematic pretention. However, the trap presented by the pompous mythological paintings of Gérard de Lairesse is only just avoided! This entirely naked Cupid, leaning on his bow, could easily be by Lairesse. Fortunately, with Vermeer, one only discovers these little allegorical subtleties after having understood everything from the actual expressions of the figures. Isn't it perfectly clear why there should be proud portraits of men in the boudoir where the Brunswick 'Coquette', elegantly attired in gold brocaded silk, drinks with her rich lovers?

As for the passion for maps, I have no idea how to explain it. It could quite simply be that Vermeer found that these large brightly-coloured charts looked good against the pale, sunlit walls. In any case, maps are very common in Dutch houses, the reason being that Holland is a kind of universal nation. There is scarcely a Dutchman, regardless of the class he comes from, who has not travelled in *his* colonies and is not familiar with the geography of the world [. . .] Could it be that van der Meer was possessed by a longing to go and see the brilliant skies of Japan and Java? Perhaps he was thinking of those sunlit lands when he painted his geographers with their hand on the globe or measuring the distance with a compass.

The most prodigious quality of Vermeer, taking precedence over his physiognomic instinct, is the quality of the light. [. . .]

With Vermeer, the light is not in the least artificial but precise and wholly natural, meeting the requirements of scientific observation. The ray that enters at the edge of the frame passes through the space to the other side. The light seems to come from the painting itself, and naïve viewers might easily imagine that the light slips between the canvas and the frame. One person, on visiting M. Double where the *Soldier and Laughing Girl* was displayed on an easel, went to look behind the painting to see where the marvellous radiance at the open window came from. For this reason black frames go especially well with Vermeer's paintings [. . .]

In Vermeer, there is no black. Nor daubing, nor equivocation. Everywhere in his paintings is clear, behind a chair, a table or a virginal no less than by the window. The only variation is that each object casts just the right amount of half-shadow which mixes with the ambient light. This precision about light also accounts for the harmony of his colour. In Vermeer's painting as in nature, contrary colours such as yellow and blue (a combination that he particularly likes) do not clash with each other. A painting by Vermeer may include very different colours, ranging from the softest modulation to the most intense power. Brightness, energy, refinement, variety, surprise, strangeness, an indefinably rare and

attractive quality, he has all the gifts of the great colourists, with whom light never loses its magic.

As a painter of domestic scenes, Vermeer has his equals. As a painter of town views, he is unique [. . .] The most extraordinary work in this genre is the *Façade of a House* (Six collection): a working-class house in Delft, seen from the front, the roof cut off by the frame; scarcely a patch of sky over a courtyard; in the foreground, a sort of pavement in front of the door where a seated woman can be seen. Nothing but a wall, and a few openings without the least ornamentation. But what a colour![6]

NOTES

1 *View of Delft* (Royal Cabinet of Paintings, Mauritshuis, The Hague). [EB]
2 Carel Fabritius (1622–54), Delft artist who is often supposed to have been Vermeer's master. [EB]
3 *The Lacemaker* (Louvre Museum, Paris); *The Guitar Player* (The Iveagh Bequest, Kenwood House, London); *Woman with a Pearl Necklace* (Staatliche Museeen zu Berlin, Gemäldegalerie); *Soldier and Laughing Girl* (The Frick Collection, New York); *Girl with a Wineglass* (Herzog Anton Ulrich-Museum, Brunswick). [EB]
4 *Woman in Blue Reading a Letter* (Rijksmuseum, Amsterdam); *Lady and Maidservant* (New York, Frick Collection). [EB]
5 *Woman Holding a Balance* (National Gallery of Art, Washington); *A Lady Standing at the Virginals* (National Gallery, London). [EB]
6 *The Little Street* (Rijksmuseum, Amsterdam). [EB]

xiii) Ernst Kris & Otto Kurz, 'Introduction', from *Legend, Myth, and Magic in the Image of the Artist. A Historical Experiment* (1934)

The innovative study *Legend, Myth, and Magic in the Image of the Artist. A Historical Experiment* was published jointly by two scholars in Vienna in 1934. Ernst Kris (1900–57) worked in the department of sculpture and applied art of the Vienna Museum and went on to become a distinguished psychoanalyst. Otto Kurz (1908–75) was the librarian to the Warburg Institute in Hamburg and continued in this post when the Institute moved to London. This work, which was a product of the great Viennese art-historical culture of the nineteenth and early twentieth centuries, introduced the idea of examining artists' biographies as stories. E. H. Gombrich in his 1978 preface to this book suggests an academic division of labour existed between its authors: Kris, he argues, was responsible for the idea that stories about artists always reflect a 'universal human response to the mysterious magic of image-making', while Kurz compiled the stories and anecdotes on which this account was based. Whether or not this is true, this book represents an important early, and influential, investigation of art-historical myths about the artist. The extract reproduced here reveals a number of structural themes which frequently recur in anecdotes and biographies of artists. These anecdotes are often used, innocently, as sources in art history but their continuity and repetition, Kris and Kurz suggest, point to important mythic foundations to much thinking about art. (References omitted.) [SE]

Source: Ernst Kris & Otto Kurz, 'Introduction', from *Legend, Myth, and Magic in the Image of the Artist. A Historical Experiment*, 1934, trans. Alistair Laing & Lottie M. Newman, Yale University Press, 1979, pp. 3–12

[. . .]

Historical Accounts concerning the Artist

Traditional records concerning the life and career of an artist come into being only when it is the custom to link a work of art with the name of its creator. It is well known that this is not a universal custom. We encounter it neither among all peoples nor at all periods of time. It needs no special explanation that this custom is not found among the so-called primitive illiterate people who are supposed to have no 'history,' but we come to the heart of the problem when we are confronted by civilizations whose art we admire and whose history is familiar to us, yet we cannot name a single one of their artists. Whether or not an artist's name is recorded depends, not upon the greatness and perfection of his artistic achievement – even if this were objectively ascertainable – but upon the significance attached to the work of art [. . .]

Very generally speaking, one can say that the urge to name the creator of a work of art indicates that the work of art no longer serves exclusively a religious, ritual, or, in a wide sense, magic function, that it no longer serves a single purpose, but that its valuation has at least to some extent become independent of such connections. In other words, the perception of art as art, as an independent area of creative achievement – a perception caricatured in the extreme as 'art for art's sake' – declares itself in the articulation of the growing wish to attach the name of a master to his work. [. . .] Our thesis is that from the moment when the artist made his appearance in historical records, certain stereotyped notions were linked with his work and his person – preconceptions that have never entirely lost their significance and that still influence our view of what an artist is.

[. . .]

Their origins [of the western notions of the artist] invariably are Greek. It is exceptional for an artist to be named in the surviving records of the ancient Orient and Dynastic Egypt, and even then his name is not linked to any work. Only the Old Testament occasionally mentions artists and their works.

What we know of pre-Hellenic traditions in the Aegean has been transmitted to us by the Greeks themselves, and must be unraveled from their mythology. Even in classical Greece the special role of the artist became established rather late, and then only against considerable opposition. The signatures of Greek artists from the sixth century B.C. are the first heralds of future artistic renown; and the scattered references to artists in the literature of the archaic and classical eras are the precursors of artists' biographies, which emerged as a distinct literary category in the Hellenistic period. These were the first of their kind.

Their importance was soon so great that the enduring fame of several Greek artists – Zeuxis and Apelles, to name but two – rests on these biographies alone, without there having been any possibility of later forming an impression of their actual works. That the fame of an artist can thus outlive any of his productions is

in itself a striking affirmation of the potent influence of the Greek biography of the artist. The knowledge of such biographies has never been entirely lost since antiquity, having been kept alive at least in Byzantium throughout the Middle Ages.

The image of the artist documented in the Greek biography of the artist must be regarded as an acquisition of Greek culture; even Roman connoisseurs – save for a few exceptions in the Republican era – knew only the names of Greek artists.

The anonymity of Roman artists extended beyond the Empire and persisted among those peoples who attempted to enter the European cultural community. The rare instances of an artist's fame in the early Middle Ages always hark back to antiquity; wherever in the Romanesque and Gothic periods a breach in the tradition of artistic anonymity occurs – beginning, as before, with the appearance of artists' signatures – the formal characteristics of the work of art are borrowed from classical sources. Finally, in the late Middle Ages, in the fourteenth and fifteenth centuries, when the figure of the artist emerges on the historical scene and gains independent stature in every way, biography of the artist as an independent entity emerges as well. This happened first on classical soil, but soon spread north of the Alps; nonetheless, in every case, as the documentation that we have amassed amply demonstrates, it is always directly inspired by those same original accounts of the Greek artists.

From this time on an unbroken sequence of literary accounts referring to artists extends right up to the present. The sociological view they offer is most diverse: from the world of the guild and the masons' lodge they take us to the studios of the Renaissance masters who were inspired by humanism: from the patronage of the Church and of merchants to that of princes; from the constraints of being a craftsman to those of the academic tradition; but they also show the ultimate attainment of individual self-expression and the highest esteem of creativity in the *divino artista*. In each phase of this historical development new social types appear alongside the old, without ever entirely displacing them. The revolutionary innovator stands next to the head of an academic school, and the artist as a universal genius or gentleman stands side by side with the unrecognized and solitary figures. This diversity of social background appears among the artists of the nineteenth century whose world embraced the fêted darling of his prince and country just as much as the slouch-hatted Bohemian living out his conception of genius on the social periphery, in Schwabing, Montmartre, or Greenwich Village – a vanishing world which, where it still survives, belongs to yesteryear. In this world, however, the artist does not stand alone: he is a member of the great 'community of geniuses.'
[. . .]

Anecdotes about Artists, and Some Biographical Motifs
In the numerous accounts of the lives of painters and sculptors that have come down to us from the Renaissance onward one repeatedly encounters typical leitmotifs – themes that recur in numerous biographies with little or no variation.

These relate either to the career of the artist – particularly to his childhood – or to the effect of his works upon his public.

Several biographies tell of how the master first gave evidence of his gifts by sketching the animals he herded as a shepherd. Then a connoisseur happened to pass by, recognized the extraordinary talent in these first artistic endeavors, and watched over the proper training of this young shepherd, who later emerged as this or that far-famed genius. This account has a number of variants, in some of which all the episodes are retained, or several are merely modified, whereas in others only the central theme is retained – that the artist's gifts were already evident in his childhood.

Another narrative formula is designed to leave no doubt as to the artist's capabilities: the master painted a bit of nature so skillfully that observers mistook it for the real thing, for example, a spider poised to scuttle across the picture. His accomplishments were especially noteworthy when he succeeded in deceiving his fellow artists. There are simply untold numbers of the same or similar stories. Whatever else may be modified, the setting, the atmosphere of the artist's studio, rarely varies, but the core of the episode never does: that the artist's work is taken for nature's own.

We have singled out these two basic examples, [. . .] in order to raise the initial question: what can we conclude from such consistent accounts? In the case of the first, the tale of the artist's youth, one might be inclined to say that the account emphasizes a typical element in the development of an artist; that the vocation of shepherd or cowherd is said to be particularly apt to stimulate latent artistic talent; and that, generally speaking, it is of the greatest significance that the artist's talent already is evident in childhood. One could even take these traditional accounts concerning the life of great artists as the basis for psychological speculation. We could then try to understand the second group of stories analogously: great artists are apparently capable of deceptively imitating nature. In this case it is hardly surprising that their biographers should stress precisely these abilities.

Such explanations – which may be termed rationalistic – can barely be maintained with regard to the first group of stories, especially if one considers the remarkable number of exactly identical accounts; in the case of the second group, they are untenable. For in answer to the question, 'How far does the ability to imitate nature extend?' we can be perfectly confident of our reply, 'Not that far.' We would neither take a portrait of the Emperor Charles V painted by Titian for the Emperor himself (as it is related that his son Philip II did), nor would we take for a real insect a spider such as the one that Dürer is reputed to have painted on a picture by Michelangelo. It was long ago realized that different explanations must be found. In this endeavor the tools of textual criticism proved to be successful. This method showed that the shared elements in stories relating to quite different people were explicable in terms of their common derivation from the same source. The take of the artist as shepherd boy stemmed from a popular story about Giotto's youth, an oral tradition that began to take shape in Florence about a century after the master's death; the other went right back to classical antiquity, being modeled on the famous competition between the two Greek painters,

Zeuxis and Parrhasios, as recorded in the *Encyclopedia* of Pliny the Younger. Eventually, it became the custom to label these stereotyped episodes, and others like them; they became known as 'artist anecdotes.'

In order to circumscribe the meaning of this label, it is necessary to say something about the nature of these anecdotes, insofar as this has a bearing on our further considerations.

At present we are inclined to associate the anecdote with jokes. The difference between the two, though real, is slight and not easy to define, but their structure is the same. An anecdote, like a joke, has a 'point' that is tied to the pleasure gain. (This aspect will not be elaborated here because in this context we are interested in the content of the anecdote.) As a rule the anecdote deals with a prominent person or a hero – or it substitutes a particular social type – who is brought closer to our understanding, so that we can identify with him more easily. Hence what is related about the hero is mostly to be regarded as a gloss upon his 'official' biography, and presents the great man as one with human foibles, or else shows his adroitness in a new and unexpected light. One could call the anecdote an episode from the secret life of the hero.

[. . .]

We regard the hero of these typical anecdotes as depicting the typical artist – as *the image of the artist* which the historian had in mind. The question whether statements contained in an anecdote in this or that particular case are true then becomes irrelevant. The only significant factor is that an anecdote recurs, that it is recounted so frequently as to warrant the conclusion that it represents a typical image of the artist. This approach compels us to expand the existing concept of the 'artist anecdote.' Speaking in the most general terms, we can say that we seek to understand *the meaning of fixed biographical themes.* In this sense the anecdote can be viewed as the 'primitive cell' of biography. While this is obviously valid of biography in general, it is particularly true and historically proven in the case of the biography of artists.

One of the first texts in the literature of art of which we have some knowledge – it was written in the late fourth century B.C. by Duris, the Tyrant of Samos and a knowledgeable adherent of the Peripatetic school – already contains the germs of the most important anecdotes that we shall discuss. In Duris's work, which textual research reconstructed with rare circumspection, the anecdote is used throughout as a literary device.

At the same time, however, the anecdote is intimately linked with the legendary past, in which the image of the artist originated. For historians have learned to recognize that the anecdote in its wider sense taps the realms of myth and saga, from which it carries a wealth of imaginative material into recorded history.

Thus, even in the histories of comparatively modern artists we find biographical themes that can be traced back, point by point, to the god- and hero-filled world before the dawn of history. These themes can be demonstrated to occur again and again even outside of the orbit that links our Western tradition with ancient Greece; this is, in fact, the significance of the oriental, and especially the Far Eastern, parallels [. . .]

xiv) Christine Battersby, 'The Clouded Mirror', from *Gender and Genius: Towards a Feminist Aesthetics* (1989)

Christine Battersby lectures in Philosophy at the University of Warwick. In her book, *Gender and Genius: Towards a Feminist Aesthetic*, published in 1989, she examined the genealogy of the notion of genius in Western thought. Battersby argues that the idea of the genius as a special kind of person has been central to art, philosophy and literature. She contends that this category is fundamentally structured around assumptions about gender differences. Genius, she argues, is a category exclusively applied to males and is seen to stem from a virile masculine sexuality. In contrast, the tradition of Western aesthetic thought has represented women as incapable of genius. The extract we publish here addresses the issues of gender and genius in Vasari's *Lives of the Artists*. Battersby argues that Vasari does not use the term genius but the Italian word *ingegno* (ingeniousness) and that the modern concept of artistic genius only developed after the Renaissance. [SE]

> Source: Christine Battersby, 'The Clouded Mirror', from *Gender and Genius: Towards a Feminist Aesthetics*, The Womens Press, 1989, pp. 32–40

[. . .] Our present criteria for artistic excellence have their origins in theories that specifically and explicitly denied women genius. We still associate the great artist with certain (male) personality-types, certain (male) social roles, and certain kinds of (male) energies. And, since getting one's creative output to be taken seriously involves (in part) becoming accepted as a serious artist, the consequences of this bias towards male creators are profound. Women who want to create must still manipulate aesthetic concepts taken from a mythology and biology that were profoundly anti-female. Similarly, the achievements of women who have managed to create are obscured by an ideology that associates cultural achievement with the activities of males.

Although I am arguing that the particular problems that creative women face *now* are ones that derive from a Romantic inheritance, it is not part of my thesis that there was no previous history of linguistic harassment of women in the arts. What the nineteenth century did was re-work and amplify an older rhetoric of sexual exclusion that has its roots in Renaissance theories of art and of sexual difference. And, since the Renaissance writers themselves explicitly re-cycled theories taken from the ancient Greeks and Romans, nineteenth-century cultural misogyny turns out to have a very ancient pedigree indeed. What gives the Romantic contribution to the anti-female traditions a distinctively new feel is that women continued to be represented as artistic inferiors . . . even though qualities previously downgraded as 'feminine' had become valuable as a consequence of radical changes in aesthetic taste and aesthetic theory. What I will be exploring in this book is the way that cultural misogyny remained (and even intensified) despite a reversal in attitudes towards emotionality, sensitivity and imaginative self-expression. [. . .]

European conceptions of the artist's task were inherited from the ancient Greeks, who did not even have a term that meant 'creation' in our sense. How could something come from nothing? The Greek gods shaped pre-existent matter in the manner of an architect (Plato), or by the processes of giving birth. The artist's only task was to imitate nature as it had been patterned by the gods. The Greeks lacked the words for concepts that we now take for granted in discussing the arts: 'originality', 'inspiration', 'genius', 'create', 'creative'. Although some scholars think they can find rough verbal equivalents to our modern vocabulary of art, these are at best approximations. Most of the supposed parallels are to be found in early discussions of poets and poetry. But [. . .] the ancient Greeks did not think of poetry as an art. Instead the poet was seen as a kind of prophet, a rhapsodic bard who delivered messages from the gods. [. . .]

When the Greeks judged painting and sculpture what they were looking for was beauty of form and truthfulness to nature. Once the perfect form had been discovered (not invented), it was to be repeated without any deviation. Progress in the arts was a matter of increased accuracy in mimicking the beauty shaped by the gods. Art on this model was essentially *mimetic*: nothing more than imitation. And that was how art remained throughout the Middle Ages. Within the monasteries the artist's task was to reproduce divine truth and Christian teaching as faithfully as possible. Authenticity, individuality or self-expression were values alien to the didacticism of the medieval artist. Received wisdom and orthodoxy had to be absorbed, and then passed on to others. [. . .]

Unlike the Greeks, the men of the Middle Ages had a word for creation out of nothing. But they insisted that it was solely an attribute of God. The artist was not god-like; he did not create the new; he was an imitator who reproduces what is visible to the eye of faith. Originality was not a virtue. Creativity was a theological and not an aesthetic concept. Thus we often do not even know the names of many of those who produced icons, illuminated manuscripts and other artefacts. *Who* was the workman mattered hardly at all; *what* was produced was the important thing. Although the term 'masterpiece' comes to us from the arts of that time, it has nothing at all to do with genius, creativity or early Christian art theory. Its origins are instead in the medieval craft traditions.

The Latin word *magister* (master) was a legal term meaning 'one who possesses authority over others'. The word 'masterpiece' was first used by the medieval craft guilds to denote the piece of work produced by an apprentice which showed sufficient skill or competence to permit admission to the privileges of the guild. Then, in the twelfth century, the term *magister* became used as part of the title of the elected head of a craft guild. The 'master' was a kind of trade-union leader. As feminist scholarship is beginning to show, women were active in these guilds – despite the need to prove their merit with a 'masterpiece'. Hostility towards women in the arts only increased when the status of the artist began to be distinguished from that of the craftsman, and the arts in general represented as activities suitable for only the most perfect (male) specimens of humanity.

This change in the status of the arts and the artist started during the Renais-

sance. Private and court patronage meant that wealth and power were beginning to flow into their hands. Painting and sculpture began to be occupations for well-bred men, instead of manual crafts. Their practitioners began to puff up the status of these arts, by talking about them in a way previously reserved for music and poetry. Patronage also meant that art could begin to free itself from the domination of the Church. [. . .]

In the Renaissance, however, art was still seen as *mimetic*. The artist was an *imitator* . . . whether of previous art-works, or the most perfect and most universal natural forms. For the neoplatonist art theorists these 'forms' or 'types' were *Ideas* which existed in the artist's mind. But they did not exist solely in the artist's mind. His task remained that of mirroring Truth, Beauty and Goodness, not creating an alternative reality. Not even the greatest of all artists was an inventor in our modern sense of the word. His task was not to express his feelings, nor his own individuality – only to copy. 'Originality' began to be valued. But there was no contradiction in talking about an 'original imitation', which might be a more perfect version of some historical event or person, or even a re-working of an old story, myth or piece of art.

We can see a lot of this in Vasari's *Lives of the Artists* [1550 and 1568] which records the ever-increasing esteem, power and social position allocated to individual artists during the Renaissance period. Giotto (1266/7–1337) was the son of a peasant; Michelangelo (1475–1564) was said to be 'related to the most noble and ancient family of the counts of Canossa'. Vasari's *Lives* is often credited with having invented the modern concept of genius, celebrating as it does the lives and powers of individual artists. But although the term 'genius' is sprinkled liberally through modern English translations of Vasari's text, I have been unable to locate the Italian term *genio* in corresponding passages in the original. The English 'genius' translates a number of Italian phrases, most commonly including the Italian word *ingegno* – perhaps best rendered as 'ingeniousness'.

Italian, like Latin, had two terms, the history of which has been thoroughly confused. The Italian *genio* was like the Latin *genius* in starting out as a word referring to the divine forces associated with, and protective of, male fertility. *Ingegno*, like the Latin *ingenium*, was associated with good judgement and knowledge; but also with talent, and with the dexterity and facility essential to the great artist working in the mimetic traditions. Without such skills an artist might conceive perfect beauty, but he would be unable to reproduce it. Being able to execute one's design without sweating over it became one of the qualities most valued in an artist. It harmonised well with the class pretensions of the new group of painters and sculptors, who were anxious to play down the manual work involved in their professions. Similar values spread to the literary arts.
[. . .]

In fact [. . .] the Roman *genius* involved the divine aspects of male procreativity which ensured the continuance of property belonging to the *gens* or male clan. It involved the fertility of the land, as well as the fertility of the man. Here we find the roots of the second sense of 'genius' during the Renaissance. 'Genii' were male protective spirits and divinities attached to places, people and natural objects.

This is the sense of the word that we find illustrated in the most important dictionary of symbolic meaning of the seventeenth century. In his *Iconologia*, Cesare Ripa represents 'Genius' ('*Genio*') by a small, naked, smiling child wearing a garland of poppies, and carrying in his hands corn and grapes. The symbols of the fertility of the harvest (poppies, corn and grapes) were themselves metaphors for the father's seed. To us this seems extremely odd. Although we carry on using the term 'Genius' in the sense of a spirit-Genius, we certainly wouldn't think of symbolising genius as a chubby little boy. But Ripa was not being simply eccentric. Modern dictionaries of the 'lost' language of symbolic meaning point out that in Renaissance art often what we take to be little cupids were little genii. In Ripa's dictionary of symbols it was 'Ingenuity' ('*Ingegno*') that was represented by a winged male youth 'of a vehement, daring Aspect' wearing a helmet with an eagle's crest on it, and carrying in his hand a bow and arrow. His unageing intellect, his strength, vigour, generosity, loftiness, inquisitiveness and acuteness were qualities that later were all transferred from 'ingenuity' to 'genius' itself.

The senses and symbols of genius have changed dramatically. This was a process that started when, sometime during the seventeenth century, the two different words 'genius' and 'ingenuity' (Latin *ingenium*; Italian *ingegno*) collapsed into each other. It is not easy to put an exact date on the blending of the two concepts since modern histories of ideas also conflate the two terms. But certainly by the start of the eighteenth century the two Latin words and the two corresponding English words were no longer sharply distinguished. [. . .] It is only in the eighteenth century that the term 'genius' begins to be in general use in anything like its modern sense. It is only when the two Latin terms *genius* and *ingenium* merge that our modern concept of genius emerges.

The Renaissance artist was great not in so far as he possessed great *genius*, but in so far as he had a superior *ingenium*. In the Renaissance our modern concept of the genius simply did not exist. Of course, when Vasari wrote his *Lives* he often wrote in a way that seems to prefigure our modern conception of artistic creativity. [. . .] Vasari's *Lives* reveals the direction that art criticism and theory would move in. He presented Michelangelo and Raphael as sublime heroes and, as such, it is tempting to read into Vasari our modern understanding of genius. But, during the Renaissance period, the artist possessed *genius* only in so far as he was a fertile male in a patrilineal culture, and in so far as his goods, lands and powers were watched over (and guided) by spirit-genii.

Renaissance women lacked *genius*. But it is not this, as such, which was supposed to make them artistic inferiors. This was put down to a deficiency in *ingenium*: those inherited mental and physical talents that helped an artist conceive and execute his projects. Women, apparently, were fated to lack wit, judgement and skill simply by virtue of the fact that they were born female. Hence, unsurprisingly, cultural inferiority became linked with a lack of *genius* as such . . . a lack of that aspect of maleness that made men divine. We can see why the concepts of *genius* and *ingenium* should eventually have collapsed into each other to form that of the modern (male) genius. Even in the Renaissance what made a human being great was what made him distinctively *not-female*. There is nothing accidental about the way that

the Romantic concept of genius is gendered: the term was forged at the point where two modes of misogyny meet . . . the creative and the procreative.
[. . .]

xv) Svetlana Alpers, 'Introduction', from *The Art of Describing:*
 Dutch Art in the Seventeenth Century (1989)

Svetlana Alpers is a distinguished historian of Northern art, whose books include: *Rembrandt's Enterprise. The Studio and the Market* (1988), *The Making of Rubens* (1995); and *The Art of Describing. Dutch Art in the Seventeenth Century* (1983), from which the present extract is taken. In this text Professor Alpers distinguishes between an Italian tradition of art which, she argues, was based on textual sources, and a Northern tradition which involved an intense and careful observation of the natural world. Alpers proceeds to set up a fundamental distinction between Italian narrative painting and a Northern practice of description and explores these issues in the context of seventeenth-century Dutch art, map making and optical science. This is a controversial account, but one which has lead to much rethinking and debate among historians of both Italian and Northern art. (Notes omitted and re-ordered.) [SE]

> Source: Svetlana Alpers, 'Introduction', from *The Art of Describing: Dutch Art in*
> *the Seventeenth Century*, Penguin, 1989, pp. xix–xxvi

[. . .]
To a remarkable extent the study of art and its history has been determined by the art of Italy and its study. This is a truth that art historians are in danger of ignoring in the present rush to diversify the objects and the nature of their studies. Italian art and the rhetorical evocation of it has not only defined the practice of the central tradition of Western artists, it has also determined the study of their works. In referring to the notion of art in the Italian Renaissance, I have in mind the Albertian definition of the picture: a framed surface or pane situated at a certain distance from a viewer who looks through it at a second or substitute world. In the Renaissance this world was a stage on which human figures performed significant actions based on the texts of the poets. It is a narrative art. And the ubiquitous doctrine *ut pictura poesis* was invoked in order to explain and legitimize images through their relationship to prior and hallowed texts. Despite the well-known fact that few Italian pictures were executed precisely according to Alberti's perspective specifications, I think it just to say that this general definition of the picture that I have summarily presented was that internalized by artists and finally installed in the program of the Academy. By Albertian, then, I do not mean to invoke a particular fifteenth-century type of picture, but rather to designate a general and lasting model. It was the basis of that tradition that painters felt they had to equal (or to dispute) well into the nineteenth century. It was the tradition, furthermore, that produced Vasari, the first art historian and the first writer to formulate an autonomous history for art. A notable sequence of artists in the West

and a central body of writing on art can be understood in these Italian terms. Since the institutionalization of art history as an academic discipline, the major analytic strategies by which we have been taught to look at and to interpret images – style as proposed by Wölfflin and iconography by Panofsky – were developed in reference to the Italian tradition.

The definitive place of Italian art in both our tradition of art and our tradition of writing about it means that it has proved difficult to find appropriate language to deal with images that do not fit this model. Indeed, some innovative work and writing on images has come out of a recognition of this difficulty. It has been done on what might be called nonclassical, non-Renaissance images that would otherwise have been seen from the perspective of the Italian accomplishment. [. . .] And if in the pages that follow I chart this art partly through its *difference* from the art of Italy, it is not to argue an unique polarity between north and south, between Holland and Italy, but to stress what I believe to be the condition of our study of all non-Albertian images.

[. . .] A major theme of this book is that central aspects of seventeenth-century Dutch art – and indeed of the northern tradition of which it is part – can best be understood as being an art of describing as distinguished from the narrative art of Italy. This distinction is not an absolute one. Numerous variations and even exceptions can doubtless be found. And one must leave the geographic boundaries of the distinction flexible: some French or Spanish works, even some Italian ones can fruitfully be seen as partaking of the descriptive mode, while the works of Rubens, a northerner steeped in the art of Italy, can be seen in terms of the ways in which on various occasions he variously engages both these modes. The value of the distinction lies in what it can help us to see. The relationship between these two modes within European art itself has a history. In the seventeenth century and again in the nineteenth some of the most innovative and accomplished artists in Europe – Caravaggio and Velázquez and Vermeer, later Courbet and Manet – embrace an essentially descriptive pictorial mode. 'Descriptive' is indeed one way of characterizing many of those works that we are accustomed to refer to casually as *realistic* – among which is included, as I suggest at various points in my text, the pictorial mode of photographs. In Caravaggio's *Crucifixion of St. Peter*, Velázquez's *Water-seller*, Vermeer's *Woman with Scales*, and Manet's *Déjeuner sur l'Herbe* figures are suspended in action to be portrayed. The stilled or arrested quality of these works is a symptom of a certain tension between the narrative assumptions of the art and an attentiveness to descriptive presence. There seems to be an inverse proportion between attentive description and action: attention to the surface of the world described is achieved at the expense of the representation of narrative action. [. . .]

Although it might appear that painting by its very nature is descriptive – an art of space, not of time, with still life as its basic theme – it was essential to the Renaissance aesthetic that imitative skills were bound to narrative ends. The *istoria*, as Alberti wrote, will move the soul of the beholder when each man painted there clearly shows the movement of his soul. The biblical story of the massacre of the innocents, with its hordes of angry soldiers, dying children, and mourning moth-

ers, was the epitome of what, in this view, pictorial narration and hence painting should be. Because of this point of view there is a long tradition of disparaging descriptive works. They have been considered either meaningless (since no text is narrated) or inferior by nature. This aesthetic view has a social and cultural basis. Time and again the hierarchy of mind over sense and of educated viewers over ignorant ones has been summoned to round out the argument for narration with a blast at an art that delights the eyes. Narration has had its defenders and its explicators but the problem remains how to defend and define description.

Dutch pictures are rich and various in their observation of the world, dazzling in their display of craft, domestic and domesticating in their concerns. The portraits, still lifes, landscapes, and the presentation of daily life represent pleasures taken in a world full of pleasures: the pleasures of familial bonds, pleasures in possessions, pleasure in the towns, the churches, the land. In these images the seventeenth century appears to be one long Sunday, as a recent Dutch writer has put it, after the troubled times of the previous century.[1] Dutch art offers a delight to the eyes and as such seems perhaps to place fewer demands on us than does the art of Italy. [...]

Part and parcel of the difference felt between the art of Italy and that of the north was a sense of Italian superiority and Netherlandish inferiority. The Italian assumption about the rational authority and power of their art is made clear in the famous critique of the art of the Netherlanders attributed by Francisco de Hollanda to none other than Michelangelo himself:

> Flemish painting ... will ... please the devout better than any painting of Italy. It will appeal to women, especially to the very old and the very young, and also to monks and nuns and to certain noblemen who have no sense of true harmony. In Flanders they paint with a view to external exactness or such things as may cheer you and of which you cannot speak ill, as for example saints and prophets. They paint stuffs and masonry, the green grass of the fields, the shadow of trees, and rivers and bridges, which they call landscapes, with many figures on this side and many figures on that. And all this, though it pleases some persons, is done without reason or art, without symmetry or proportion, without skilful choice or boldness and, finally, without substance or vigour.[2]

The passage immediately following this one (one that has understandably not been quoted in studies devoted to northern art) seals and further grounds Michelangelo's severe judgment: 'It is practically only the work done in Italy we can call true painting, and that is why we call good painting Italian.' [...] I want to note that while reason and art and the difficulty involved with copying the perfections of God are on the side of Italy, only landscape, external exactness, and the attempt to do too many things well belong to the north. The contrast is between the central and definitive Italian concern with the representation of the human body (what Michelangelo engages when he speaks of the *difficultà* of art) and the northern concern with representing everything else in nature exactly and unselectively. The Netherlanders for their part did not really disagree. On those rare occasions when northerners attempt to state the special nature of their native art,

they characteristically concur with the Italian distinction by laying claim to nature, rather than art, as the source of their artistic accomplishment.[3]
[. . .]

The Dutch present their pictures as describing the world seen rather than as imitations of significant human actions. Already established pictorial and craft traditions, broadly reinforced by the new experimental science and technology, confirmed pictures as the way to new and certain knowledge of the world. A number of characteristics of the images seem to depend on this: the frequent absence of a positioned viewer, as if the world came first (where we are situated as viewers is a question that one is hard put to answer in looking at a panoramic landscape by Ruisdael); a play with great contrasts in scale (when man is not providing the measure a huge bull or cow can be amusingly played off against a tiny distant church tower); the absence of a prior frame (the world depicted in Dutch pictures often seems cut off by the edges of the work or, conversely, seems to extend beyond its bounds as if the frame were an afterthought and not a prior defining device); a formidable sense of the picture as a surface (like a mirror or a map, but not a window) on which words along with objects can be replicated or inscribed; an insistence on the craft of representation (extravagantly displayed by a Kalf who repeatedly recrafts in paint the porcelain, silver, or glass of the craftsman along side the lemons of Nature herself). It is, finally, hard to trace stylistic development, as we are trained to call it, in the work of Dutch artists. Even the most naive viewer can see much continuity in northern art from Van Eyck to Vermeer, and I shall often look back from the seventeenth century to similar phenomena in earlier northern works. But no history on the developmental model of Vasari has ever been written, nor do I think it could be. This is because the art did not constitute itself as a progressive tradition. It did not make a history in the sense that art did in Italy. For art to have a history in this Italian sense is the exception, not the rule.
[. . .]

NOTES

1 J. Q. van Regteren Altena, 'The Drawings by Pieter Saenredam,' in *Catalogue Raisonné of the Works of Pieter Jansz. Saenredam* (Utrecht: Centraal Museum, 1961) p. 18. Though the reference to Sunday might be owed to Hegel, Van Regteren Altena's short essay contains some of the most original and acute writing ever done on the nature of Dutch art. For the 'Sunday of life' characterization in Hegel, see G. W. F. Hegel, *Aesthetics: Lectures on Fine Art*, trans. T. M. Knox (Oxford: Clarendon Press, 1975), 1: 8 8 7.
2 Francisco de Hollanda, *Four Dialogues on Painting*, trans. Aubrey F. G. Bell (London: Oxford University Press, 1928), pp. 15–16.
3 The famous epitaph written by Abraham Ortelius for his friend Pieter Bruegel refers to 'works I used to speak [of] as hardly works of art, but as of works of Nature' ('picturas ego minime artificiosas, at naturales appellare soleam'). See Wolfgang Stechow, ed., *Northern Renaissance Art 1400–1600*, Sources and Documents in the History of Art (Englewood Cliffs, N.J., Prentice Hall, 1966), p. 37.

Section Three
Gender and Art

The texts included in this section have been selected to support an introductory examination of the ways in which issues of gender difference have informed the study of art and art history. Over recent years feminist art history has emerged as an influential – if controversial – branch of art history which has significantly contributed to the contemporary re-evaluation of the role and nature of a western canon of art. By foregrounding problems of difference (cultural, sexual, social) in our understanding of representation, it has helped to shift the terms of the debate around issues of aesthetic value and historical status. The following source texts from the eighteenth and nineteenth centuries (extracts from criticism of Vigée-Lebrun in the 1783 French Salon and from the English designer Mrs Haweis's *The Art of Decoration*) are included as original examples of writings which reveal gendered assumptions about the practice or meaning of art and design. As the work of a woman designer in a field dominated by men, the assumptions betrayed in the Haweis extract are particularly pertinent in this respect. The third source text in this section is taken from Judy Chicago's account of the genesis, nature and content of her important installation, *The Dinner Party* of 1979, a work which has subsequently become a focus of on-going debate around the function of gender issues within art theory and practice, and which has itself become both an icon of feminist consciousness and a target of modernist criticism.

The critical approaches section of this part has been selected to provide a range of material on the constantly evolving debates which have characterised the development of feminist art history (itself a relatively recent category of art history) and the study of gender difference. An extract from Linda Nochlin's seminal essay 'Why have there been No Great Women Artists?' of 1971, marks an important stage in the exploration of the ideological, historical and gendered assumptions behind the idea of the 'artist'. Psychoanalytic theory has had an important impact on the evolution of the discipline, informing our understanding of the unconscious desires at play in the processes of looking at and representing the objects of art. The ways in which such desires affect the construction of sexual difference are central concerns of Laura Mulvey's famous article 'Fears, Fantasies and the Male Unconscious', written in response to an exhibition of the work of Allen Jones held in 1970. A later, and equally influential, essay which deploys psychoanalytic theory to understand the construction of sexual difference in the process of 'looking' is Jacqueline Rose's 'Sexuality in the Field of

Vision' of 1984. As Rose's text suggests, psychoanalytic models have also influenced recent critical approaches which emphasise the instability of gender relations, acknowledging that our identities as masculine and feminine are constantly being redefined within a network of shifting associations.

Building on Judy Chicago's contribution to the documented history of *The Dinner Party*, we have included Amelia Jones's critical overview of the theoretical impact of this work, published in *Sexual Politics: Judy Chicago's* Dinner Party *in Feminist Art History* in 1996. This essay represents some of the feminist debates raised by Chicago's work in relation to critical positions associated with modernist art history, thus engaging with another important strand within feminist art history: the problematic relationship between the concerns of modernist theory and interest in the representation of gender difference. The work of the British feminist art historian Griselda Pollock has unquestionably helped to reshape the discipline, and her many influential articles, as well as extracts from her books, have been widely reproduced in anthologies of art historical texts. We have selected an extract from her book *Differencing the Canon*, in which she represents and analyses some of the different approaches which have dominated the evolution of feminist art history. The emergence of this critical overview is itself, perhaps, symptomatic of a period of reflection and 'stocktaking' within a branch of art history which has become increasingly significant. We conclude this section with an extract from an essay by Whitney Davis which deals with art history's silence with regard to homosexuality in order to give some indication of the ways in which a concern with the issues of gender have developed beyond feminism. [GP]

i) Anon., 'Vigée-Lebrun at the Salon of 1783', *Memoires secrets* (1784)

In 1783 the French painter Elisabeth-Louise Vigée-Lebrun (1755–1842) exhibited for the first time at the Paris Salon, having become eligible to do so on her acceptance as a member of the *Académie Royale de Peinture et Sculpture* earlier in the same year. The Salon review extracted here provides testimony of the sensation made by Vigée-Lebrun, not least because it begins with a discussion of her début instead of an account of paintings by more senior (male) academicians, as was normal practice. While this critic praises Vigée-Lebrun's work, even suggesting that she deserves to be accepted by the academy as a history painter (which would have been entirely unprecedented for a woman artist had this proposal been accepted), the text also reveals something of the ways in which women artists were denigrated and marginalised in the late eighteenth-century French art world. It is notable, for instance, that this writer feels it necessary to rebut suggestions that this work was actually produced by a male admirer. (Translated for this volume by Emma Barker.) [EB]

Source: Anon., 'Vigée-Lebrun at the Salon of 1783', *Memoires Secrets pour servir à l'histoire de la république des lettres en France depuis 1762 jusqu'à nos jours,* vol. 24, 1784, trans. Emma Barker, pp. 4–12

Today, for example, despite the history paintings that are to be found in this place in greater abundance than ever before, despite the excellence of the numerous masters battling in the arena of the *grand genre* – who would believe it and would it not be a kind of blasphemy to say that the sceptre of Apollo seems to have dwindled into a distaff, and that it is a woman who carries off the victor's palm. Let me explain: this is not to say that there is more genius in a painting of two or three three-quarter length figures than in a vast composition of ten or twelve life-size figures; in a picture that expresses a simple idea than in one so complex in conception that it would require a whole poem to explain it. It only means that the works of the modern Minerva are the first to attract the eyes of the spectator, calls him back repeatedly, captivates and obsesses him and elicits those exclamations of pleasure and admiration which artists long to hear, and which are usually the sign of superior works of art. The paintings in question are also the most highly praised; they're the ones that people are talking about, that they're discussing both at court and in the city, at supper parties, in clubs, even in the studios. When anyone says that they have just come from the Salon, he is immediately asked, have you seen Madame le Brun? What do you think of Madame le Brun? Before he has time to reply, the questioners continue: Isn't she truly an astonishing woman, this Madame Le Brun? Such is the name, Monsieur, of the woman of whom I am speaking, who has become so famous in such a short time. After all, it is only a few months since she was received as an academician, by-passing the usual procedures, in accordance with the privilege of her sex, and given one of the four places which are specially set aside for women alone.

Besides, what has contributed more than just a little to the spread of Madame Le Brun's reputation is the fact that she is a young and pretty woman, witty and graceful, quite charming, who frequents the best company of Paris and Versailles, invites artists, writers and people of quality to her supper parties. It helps that her house is the refuge where the likes of Polignac, Vaudreuil and Polastron, the most favoured and fastidious courtiers, come in search of relief from the tedium of the court, and enjoy themselves in a way they never can elsewhere. Nothing less than such powerful patronage was required to enable her to break through the barriers of the Academy to which, despite her merit, she would never have been admitted because her husband degrades art with his activities as a dealer, something that would disqualify anyone from membership.

I don't know how the Academy has ranked Madame Le Brun, whether as a history painter, genre painter or portraitist, but she is not in the least unworthy of any category, even the highest. In my view, her reception piece would certainly justify granting her this rank. It depicts *Peace Bringing Back Abundance* [plate xiv], an allegory that is both natural and ingenious; it fits the occasion perfectly. The first figure, noble, decent and modest as the peace that France has just concluded,[1] can be identified from the olive branch, her characteristic plant, which she holds in her right hand; she gently embraces the second figure who looks at her with docility and seems to submit without effort to her lead. The latter is characterized by the sheaves of wheat that she holds tightly in her left hand and which she is ready to scatter. [. . .]

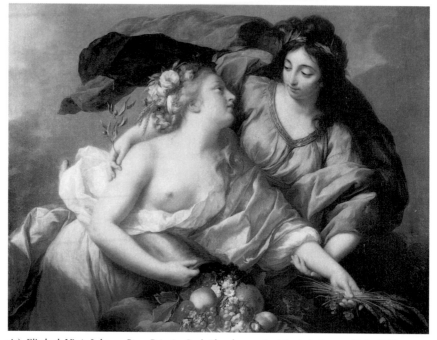

xiv) Elisabeth Vigée-Lebrun, *Peace Bringing Back Abundance*, 1780, Musée du Louvre, Paris. © Photo RMN.

Let us now consider these figures from an artist's point of view. The opinion is that they are grouped in a superior fashion; the broad forms, soft contours and picturesque attitude of Abundance – who is expertly posed – have all been praised. By comparison, Peace, daughter of heaven, is drawn with greater precision; her whole figure is imbued with the gentleness, calm and repose of the inhabitants of Olympus; her simple and severe garment forms a marvellous contrast to the brilliant draperies that are allowed to float loosely about her entirely earthbound companion. The latter has her hair stylishly arranged, with innumerable flowers adorning her head, while the other is crowned only with olive leaves. These various oppositions produce a pictorial harmony which causes the spectator to feel a delight of which the vulgar have no inkling but which is swiftly apprehended by connoisseurs.

If this composition, Monsieur, could not quite qualify Mme Lebrun for the honour of taking her place alongside the history painters, there is another which would make it difficult to deny her the rank. The subject, taken from Homer, proves that she can, like the artists she admires, be enthused by the divine works of the prince of poets and painters, so-called because the latter endlessly take him for their inspiration. The subject is Juno coming to borrow the belt of Venus. There are three figures in this scene, the other one being Cupid who amuses himself by playing with the belt . . . there is no art lover who would not, for once, prefer Juno to Venus. The first is a brunette combining the majesty of the throne

with all the piquancy of beauty; the latter, a blonde without any of the nobility of a goddess; she even looks a bit common, a bit faded and consequently not at all seductive. To compensate for the weakness of the head, a serious defect in a history painting, the body is full of charms; it is a nude in the manner of Boucher, most seductively painted in his characteristic colours [. . .]

Besides these three paintings, Mme Lebrun has exhibited three portraits of the royal family, one of the queen, one of monsieur and one of madame.[2] The two princesses are *en chemise*,[3] a fashion that women have recently come up with. Many people have thought it inappropriate that such august personages should be put on public view clad in garments that they would only wear in the privacy of their palace; it can only be assumed that the artist has been authorized to do so. [. . .]

As for the portrait of the prince, he looks as if he is enjoying himself, something which is most unusual in portraits and which gives the impression that he wasn't bored while sitting for it. This one can well believe when one sees the portait of Mme Lebrun painted by herself. And yet she has been less concerned to display her charms there than to deploy her talents as an artist. She wears a broad-brimmed hat, which casts a shadow – expertly painted – over her face, thereby partially obscuring her gaze, though this is slightly absurd given that, as can be seen from the palette and brushes in her hands, she is engaged in an activity that requires that she should be able to see clearly. Moreover, the shawl around her shoulders certainly doesn't allow her arms and hands the free play that she would need at such a moment. All this, so artists tell me, is more picturesque and, they insist, it's a question not of practicality but of artistic virtuosity. [. . .]

In concluding this account of Mme Lebrun – whom I would not have gone on about at such length, Monsieur, if I did not know your taste for the fair sex and if she wasn't truly a phenomenon worthy of note – I will not conceal a rumour that has been taken seriously among her colleagues. It is insinuated that she does not paint her own pictures or at least that it is not she who adds the final touches and that an artist who is enamoured of her,[4] gives her his assistance. I will admit that the proximity of the latter, who lodges under the same roof, gives support to this suspicion; it must be added that painters tend to be extremely envious and that sometimes this can lead them into calumny. Envy could play an important part in this anecdote and indeed be wholly responsible for it. Be that as it may, Mme Lebrun's paintings are hers so long as a genuine collaborator does set himself up against her; it is up to her to defend herself by painting new masterpieces, if possible surpassing the existing ones, and thus justify her reputation and give the lie to these unworthy rumours.

What brings Mme Le Brun's triumph to its peak, Monsieur, is that impartial art-lovers, who are in agreement as to her merits, begin to disagree when it comes to selecting the foremost among the rival history painters; they divide into as many parties as there are paintings in this genre. Some are for M. Vien, others for M. de la Grénée; there are those who opt for M. Menageot and those for M. Berthélemy; M. Vincent has his admirers; M. David also . . . To start with a general point, true connoisseurs are pleased to observe that the School of Boucher is

manifestly dying out; and his precious and mannered style, with which the French
school has so long been infected, is now finally giving way to the correct taste in
painting and the imitation, however remote still, of the antique.

NOTES

1 The Treaty of Versailles, marking the end of the American War of Independence. [EB]
2 The king's brother and sister-in-law. [EB]
3 Since this was written, the authorities have apparently become conscious of the indecency of the dress,
 especially for a queen, and the order has been issued to withdraw the painting.
4 M. Menageot.

ii) Mrs H. R. Haweis, 'On the Beauty of Freedom', from *The Art of Decoration* (1881)

Mary Eliza Haweis (1848–189?) supplemented her income by honing her child-
hood artistic skills in drawing book illustrations and subsequently in writing
about dress and decoration. She developed a scholarly approach that was based
on a thorough study of the history of the decorative arts (largely through visits to
the South Kensington Museum, now the Victoria & Albert Museum) and argued
for individual taste rather than obedience to supposedly objective rules. This was
different from previous primers of taste such as Eastlake's *Hints on Household
Taste* (1869). Marrying a fashionable London preacher helped to give her work
respectability. *The Art of Decoration* was the second and most important of
Haweis's books dealing with interior design and furnishing. [CC]

Source: Mrs H. R. Haweis, 'On the Beauty of Freedom', from *The Art of
Decoration*, London, 1881, pp. 361–3

As I near the end of my book, I am prepared for the inevitable cry: 'We have not
been told what to do. There is not a word about the drawing-room – nor the bed-
room – nor the kitchen – not a hint what colour is proper for this room, or what
material for that!'

 Would not such dogmatism be in total contradiction to my first principles,
most indolent lambs? It is the upholsterer's, the penny-a-liner's, the tyro's business
to frame laws as of the Medes and Persians about that which is independent of
small shackles – it is mine to emancipate you from their ignorant tyranny. There
is no *ought* in beauty, save your own feeling of delight, and it is only the pleasure
of the majority which determines art rules; and the more capable you are of com-
paring one sensation with another, in fact, the more you cultivate your eyes and
minds, and the more fastidious you become in arranging pleasant accessories, the
higher is the form of beauty resultant from your efforts. A very little, any bright
scrap, pleases the uneducated man, and to him it is beauty. As his brain develops
by study of its impressions and its favourite associations, he is less easily satisfied;
demands change; relief from the intensity of this or that sensation of pleasure or
pain. But comfort, pleasantness, propriety, on which beauty depends, can only be
determined by the nerves themselves, and as the faculties of individuals differ, like

their figures, the blatant customs of consecrating this wood to the dining-room, that to the boudoir – this fabric to the chair, that to the curtain – deprive our homes of all character, and English art of all vigour.

When beauty is tied down in a trap, she has the faculty of evading it; like the lark in the Chinese palace, wherein she could not sing as in the wild free woods.

Art is long, though life and its laws are brief. I have tried to show how the broad principles enunciated in my first chapters have been borne out by all the schools of art furniture.

In the fourteenth-century room, the mass of monotone necessary to relieve the bright frescoes, tapestries, and costumes was provided – perhaps by dirt – certainly by the broad shadows inseparable from low-pitched rooms with thick walls and small windows. In a Louis XIV, room, the necessary monotone was sought by the artificially chequered glow of Boule furniture, lighted up at certain points artistically by metal mounts; the Stuart room had its dark oak wainscot and furniture, the Georgian had its mottled wood-marquetry, and damask walls; the Louis Seize room provided plenteous grey by means of its blended opal tints. Against a monotone all bright objects look doubly effective; but the monotone must not be monotonous, it must be *broken up* discreetly; not by small contrasting objects which have a spotty effect, but by carefully regulated tones of similar tint. A shady room requires no mass of monotone from the decorator, it has it by nature.

No artist allows a large unbroken mass of one colour in his picture, but he as carefully avoids patchiness and spots. It is far more difficult to blend bright colours beautifully than dull ones; but the bright colours are best, after all; the sunny fields are fairer than the gloomy ones, though of both we may say, 'behold, it is very good.'

If there were a fixed law that only one kind of art had a sound basis – what would have become of all the schools, all fresh effort, and honest ambition? we should have had no choice offered us from this land or that. We are free: let us use our freedom with discretion and kindliness.

[. . .]

iii) Judy Chicago, from *The Dinner Party* (1996)

Judy Chicago (b. 1939) is an American artist and writer whose work has had a significant impact on the development of feminist art practice. Her large installation, *The Dinner Party*, was first exhibited in 1979 at the San Francisco Museum of Art, and has since become a controversial landmark within feminist art history. This collaborative multi-media work (it was made by about 400 women ceramicists, china painters and embroiderers) consisted of an open triangular table covered with thirty-nine place settings, each commemorating a goddess or important woman from Western history. She described the installation as 'a symbolic history of women in Western Civilisation' and a work of art which would 'convey the long struggle for freedom and justice that women have waged since the advent of male-dominated societies. In 1978 and 1980 Chicago published two

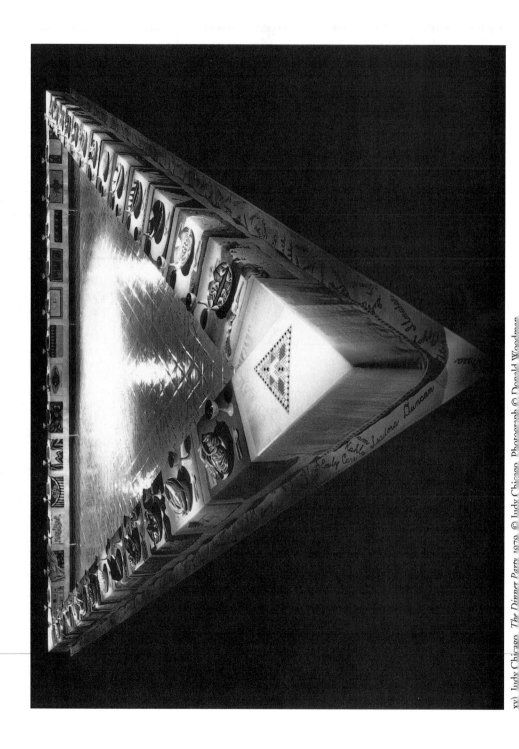

xv) Judy Chicago, *The Dinner Party*, 1979 © Judy Chicago. Photograph © Donald Woodman

volumes describing the genesis and content of the installation. The following extract is taken from the revised edition which she prepared to accompany a commemorative showing of The Dinner Party at the University of California at Los Angeles Armand Hammer Museum in 1996. [GP]

Source: Judy Chicago, from *The Dinner Party*, Penguin Books, 1996, pp. 3–4

[. . .]

The Dinner Party (plate xv) is a work of art, triangular in configuration, that employs numerous media, including ceramics, china-painting, and needlework, to honor women's achievements. An immense open table covered with fine white cloths is set with thirty-nine place settings, thirteen on a side, each commemorating a goddess, historic personage, or important woman. Though most are largely unknown, their names should, in my estimation, be as familiar to us as the male heroes whose exploits we absorb from childhood through art, myth, literature, history, and popular entertainment. *The Dinner Party* suggests that these female heroes are equally worthy of commemoration, as are those hundreds of others whose names are inscribed upon the *Heritage Floor*. This lustred porcelain surface serves as the foundation for *The Dinner Party* table and the many important human accomplishments it symbolizes.

The Dinner Party visually describes the historic struggle of women to participate in all aspects of society; its aim is to end the ongoing cycle of omission in which women's hard-earned achievements are repeatedly written out of the historic record, sometimes within years of their attainments. This process results in generation after generation of women struggling for insights and freedoms that, even when fiercely won, are too often quickly forgotten or erased once again.

My idea for *The Dinner Party* grew out of the research into women's history that I had begun at the end of the 1960s. I had undertaken this study in an effort to discover whether women before me had faced and recorded their efforts to surmount obstacles similar to those I was encountering as a woman artist. When I started my investigation, there were no women's studies courses, and the prevailing attitudes toward women's history can best be summed up by the following story. While an undergraduate at UCLA, I took a course titled the Intellectual History of Europe. The professor, a respected historian, promised that at the last class he would discuss women's contributions to Western thought. I waited eagerly all semester, and at the final meeting, the instructor strode in and announced: 'Women's contributions to European intellectual history? They made none.'

I was devastated by his judgment, and when my later studies demonstrated that my professor's assessment did not stand up to intellectual scrutiny, I became convinced that the idea that women had no history – and the companion belief that there had never been any great women artists – was simply prejudice elevated to intellectual dogma. I suspected that many people accepted these notions primarily because they had never been exposed to a different perspective.

As I began to uncover what turned out to be a treasure trove of information about women's history, I became both empowered and inspired. My intense interest in sharing these discoveries through my art led me to wonder whether

visual images might play a role in changing the prevailing views regarding women and women's history. I had always been attracted to medieval art, which taught history, myth, and values to the populace through easily understandable visual symbols. Though contrary to the tenets of modern art, which promote a visual language that is far from accessible to most people, this earlier model appeared particularly appealing, primarily because it suggested a way of reaching a broad audience, an objective that seemed essential if I were to contribute to any meaningful transformation of consciousness. This ideal appeared eminently possible in the climate of the early 1970s, when the women's movement was at its height, a time when no dream – even one so vast as influencing the world through art – seemed impossible. [. . .]

iv) Amelia Jones, 'The Sexual Politics of *The Dinner Party*: A Critical Context' (1996)

Amelia Jones is a feminist art historian who teaches at the University of California, Riverside. In 1996 she curated an exhibition entitled *Sexual Politics: Judy Chicago's Dinner Party in Feminist Art History* at the University of California, Los Angeles Armand Hammer Museum. Although *The Dinner Party* was the focus of the exhibition, it included over one hundred works by fifty-five feminist artists, covering the period from the 1960s onwards. By placing Chicago's installation alongside other feminist works, including many more recent pieces, Jones sought to demonstrate the range of issues and questions raised by Chicago's work which have continued to be of interest to feminist art practice and theory. The following extract is taken from Jones's essay in the exhibition catalogue entitled 'The Sexual Politics of *The Dinner Party*: A Critical Context'. In this text she highlights some of the debates, conflicts and critical strategies within both feminist and modernist art history for which *The Dinner Party* has become 'a central icon'. (Notes omitted and re-ordered.) [GP]

> Source: Amelia Jones, 'The Sexual Politics of *The Dinner Party*: A Critical Context', in Amelia Jones, ed., *Sexual Politics: Judy Chicago's Dinner Party in Feminist Art History*, University of California Press, 1996, pp. 84–9

Since its premier at the San Francisco Museum of Modern Art in 1979, Judy Chicago's *Dinner Party* has engendered vehement responses, both positive and negative. In 1980 John Perreault described the piece as 'magnificent,' stating: 'It is an important work; it is a key work. Certain conservative journalistic critics may call it kitsch to their dying day, may puritanically rage against its sexual imagery, may imply over and over again that it can't be good art because it's too popular; but I know it's great. I was profoundly moved.'[1] Kay Larson, conversely, insisted that *The Dinner Party* 'manages to be brutal, baroque, and banal all at once,' and Hilton Kramer intoned, notoriously, that "The Dinner Party" reiterates its theme . . . with an insistence and vulgarity more appropriate . . . to an advertising campaign than to a work of art.'[2]

 In spite of these conflicted readings – or perhaps because of them – *The Dinner Party*, which has been in storage since its last exhibition in Melbourne,

Australia, in 1988, has come to be seen as a central icon of a certain period of feminist art. It has been positively viewed, by Perreault and populist feminists such as Lucy Lippard, as paradigmatic of feminism's triumphant and uplifting celebration of female artistic expression. It has been negatively evaluated by modernist critics such as Kramer as epitomizing a loss of 'artistic standards.'[3] Feminist commentators have criticized it as exemplary of 1970s feminism's supposed naïveté, essentialism, universalism, and failure to establish collaborative alternatives to the unified (and masculinist) authorial structures of modernist art production. Indeed, the very intensity of these responses to *The Dinner Party* and the extreme polarization of opinion seen in evaluations of the piece testify to its importance as a cultural monument with which all historians of contemporary art, and perhaps especially feminist art historians, must come to terms. *The Dinner Party* and the issues it raises are central to an understanding of the politics of modernist, postmodernist, and feminist art theory and art history.

The reception of *The Dinner Party* highlights unexpected intersections among critical models thought to be opposed: for example, some feminist responses to the piece converge uncomfortably with conventional modernist evaluations. Here I would like first to outline the parameters of modernist critiques of the piece and then to explore its position within feminist arguments in order to highlight what it can teach us about the ideological assumptions motivating critical thought about contemporary art. The history of *The Dinner Party* reception can tell us a great deal about the politics of art criticism and of feminism itself, foregrounding, in particular, the complexity of the feminist project, which attempts [. . .] both to construct a coalition of women and to contest the exclusions that such a unification of subjects entails.

Returning *The Dinner Party* to a complex historical and political matrix is a crucial step in attempting to understand the 'sexual politics' of feminist art theory and practice and, by extension, the politics of identity in the 1990s. Today there appears to be little understanding of the complexities of 1970s feminism and its historical context. The results of this loss of history are damaging: younger generations of feminists have little access to the wealth of insights that were painfully developed in the art and theory of this period and waste time reinventing what has already been extensively theorized,[4] and writers such as Camille Paglia and Katie Roiphe have capitalized on this lost history by dismissing earlier feminisms in order to pose themselves as the avatars of a 'postfeminist' (and, I would argue, misogynist) viewpoint.[5] Furthermore, this erasure has encouraged the tendency of mainstream, non-feminist historical accounts of the 1970s to ignore the feminist advances that took place during this period; to emphasize male movements and conceptions of radicality over the explosively disruptive effects of feminist art, theory, and activism.[6] The charged reception of *The Dinner Party* has much to teach us about the complexities of feminist and contemporary art history.
[. . .]

The goal of this essay is to consider these diverse responses, returning to *The Dinner Party* with an analytical but respectful eye; its basic assumption is that, whether one likes the piece or not, it is a crucially important work that has

catalyzed volatile but extremely important discussion. As David Evett argued in a 1981 review that is unusual within *Dinner Party* criticism for its measured tone, the piece 'is among the most important later twentieth-century American works of art, not necessarily because it is a better work than others of a comparable form and scale, but because, like *Nude Descending a Staircase* or *Guernica*, it has been able to force a great many viewers to consider and reconsider their basic assumptions about what art can and ought to do.' Among other things, then, *The Dinner Party* can enable us to take seriously our own feminist art history, as much as we may not like its fledgling assumptions. Celebrated and excoriated at once by writers with vastly different ideological perspectives, the piece has become a central – if often invisible – monument within the history of contemporary art. For the moment, as Evett put it, 'we have to deal with *The Dinner Party*.'[7]

CRITICAL RESPONSES TO THE ÐINNER PARTY: MODERNIST ART HISTORY

Hilton Kramer's account of *The Dinner Party*, which sticks obsessively on its populism, confirms the transgressiveness of the piece within the conservative codes of modernist art discourse. The hysteria with which modernist art critics have accused *The Dinner Party* of being kitsch testifies to its enormous threat to these ostensibly disinterested discourses, which take their authority from the assumed inherence of artistic value. Through its overt celebration of craft and its explicit politicization of the history of Western culture, the piece blatantly subverts modernist value systems, which privilege the 'pure' aesthetic object over the debased sentimentality of the domestic and popular arts.

The Dinner Party revises the history of Western culture by naming and symbolizing in visual form 1,038 women from various historical periods. Nine hundred and ninety-nine of them are named on luminous porcelain floor tiles, and the thirty-nine honorees at the dinner table itself are symbolically represented through elaborate needlepoint runners, in large part worked in techniques drawn from the period in which each woman lived, and ceramic plates with centralized motifs and vulvar imagery[8] Chicago's integration of media associated with women's labor in the domestic sphere (needlework, ceramics, and china painting) into this monumental artwork produces an explosive collision between aesthetics (the public domain of the high-art museum) and domestic kitsch (the private domain of women's space, the home).[9]

The judgments of modernist art criticism in its hegemonic form, as epitomized by the later writings of Clement Greenberg, are predicated on the notion that visual art must, in Greenberg's words, 'confine itself to what is given in visual experience and make no reference to any other orders of experience.'[10] From the perspective of Chicago and other feminist artists and artists of color working in the 1960s and 1970s, Greenberg's insistence on the autonomy of art (especially as his more complex arguments were reductively deployed by writers such as Kramer) was perceived as motivated by a reactionary apoliticism that supported the status quo, excluding from the privileged domain of 'high art' elements of popular culture and work by women and other groups of people marginalized by elitist institutions of high art.

Greenberg's formalism came to be seen as synonymous with modernism's conservative privileging of masculine values and white, male artists.

In Greenberg's late, formulaic view of high art, the 'essence' of modernism lies in the artwork's 'purity' and 'self-definition,' its truthfulness to its medium; from the mid-nineteenth century onward, 'all ambitious tendencies in painting were converging . . . in an antisculptural direction.' The modernist work of art must 'exclude the representational or the 'literary,' must be abstract, must be 'a question of purely optical experience.'[11] This formalist argument developed out of Greenberg's much earlier, and well-known, formulation of a dichotomous view of culture that posed a pure modernism in opposition to degraded 'kitsch.' In a 1939 essay he demanded that a strict boundary be maintained between 'avant-garde' (high modernist) art and low culture, or 'kitsch.' Kitsch, for Greenberg, is 'debased and academicized' culture; it is 'ersatz culture,' the 'epitome of all that is spurious in the life of our time.' Kitsch is all that formalist, modernist art is not: it is popular, loved by the masses; it is literary; it is associated with women's tastes and with domestic crafts.[12]

Clearly Greenberg's seemingly 'disinterested' criteria for judging works of art – inherited by Kramer – has a distinct gender bias. Kramer's response to *The Dinner Party* is paradigmatic of a modernist, and still masculinist, mode of critical evaluation that could view the piece only as a threat to post-Enlightenment definitions of artistic 'quality.' Notions of 'quality' and 'greatness,' as 1970s feminist artists and art theorists had already begun to argue when *The Dinner Party* appeared on the scene, always harbor ideological investments.[13] Thus, Kramer's histrionic rejection of *The Dinner Party* – as displaying a vulgarity 'more appropriate . . . to an advertising campaign than to a work of art,' as associated with the 'abysmal taste' of 'kitsch' – can be seen as the response of a critic whose system of values is being threatened. *The Dinner Party* is a blast in the face of modernist criticism: it is literary; it is aggressively handmade using 'feminine' crafts techniques; it is painting and embroidery made blatantly sculptural. Through its flamboyant activation of kitsch – the prohibited desire of modernism – *The Dinner Party* explodes the boundaries of aesthetic value so carefully policed by modernist criticism. (One can thus imagine the source of Kramer's anxiety as he contemplated the sickly-sweet, pastrylike lace lips of the Emily Dickinson plate, beckoning him unabashedly.)

It is difficult, however, to align *The Dinner Party* with the radical feminist goal of merging high and low so as to collapse the masculinist hierarchy of value that dichotomizes 'avant-garde' and 'kitsch,' especially if one reads the piece through Chicago's own public statements about her introduction of craft into the high-art realm.[14] She has made it clear, in fact, that she wants *The Dinner Party* to be viewed as high art, that she still subscribes to this structure of value: 'I'm not willing to say a painting and a pot are the same thing,' she has stated. 'It has to do with intent. I want to make art.'[15] Chicago was ambivalent about whether china painting could be considered an aesthetic pursuit. She wrote that the women in her china-painting class were 'primarily housewives interested in filling their spare time,' whereas she herself had been a "serious" art student' from the time she was young.[16] Rather than attempting to break down the distinction between high and

low, Chicago has openly acknowledged her continued investment in upholding such an opposition.

Here again, *The Dinner Party* teaches us something about conflicts endemic to feminist art theory: Chicago is by no means the only feminist to have maintained a desire to have her work exhibited and discussed within high art institutions and discourses while attempting to critique them at the same time. In fact, as I have argued elsewhere, this contradiction is common to almost all feminist practice from 1970 to the present.[17] At the same time it is clear from Kramer's response that, in spite of Chicago's investment in a hierarchical and ultimately masculinist modernist conception of 'high' art, *The Dinner Party* clearly disrupted modernist value systems.

Kramer's opinion was echoed in the evaluations of other conservative writers. Robert Hughes wrote in *Time* magazine that *The Dinner Party* is 'mainly cliché, . . . with colors worthy of a Taiwanese souvenir factory. In terms of taste, *The Dinner Party* is no better than mass devotional art.' Hughes alludes here to both kitsch and the presumably stupid devotion of the uneducated masses. Maureen Mullarkey, writing in *Commonweal,* excoriated the 'vapid prettiness of the imagery,' which in her view aligned *The Dinner Party* with *Playboy* and *Penthouse.* Chicago's plates, she argued, are the 'Hummel figurines of the feminist movement.'[18] Both Hughes's Taiwanese souvenirs and Mullarkey's Hummel figurines represent degraded kitsch culture (and, especially in the latter case, are linked to feminine tastes). Suzanne Muchnic of the *Los Angeles Times* was even more direct, labeling the piece 'the ultimate in 1970s kitsch.'[19]

It is clear that Chicago's decision to use many different techniques and styles of needlework as well as china painting to 'call . . . attention to women's unrecognized heritage' challenged the prevailing modernist structures of critical judgment. For it is precisely its use of women's crafts, combined with its style and content, that aligned *The Dinner Party* with kitsch in the eyes of conservative critics. A photograph accompanying a *People* magazine article headlined 'Sassy Judy Chicago Throws a Dinner Party, but the Art World Mostly Sends Regrets' depicts the artist sitting in front of the piece and sticking out her tongue (presumably at Kramer, who is cited in the article); this is a particularly apt visualization of her self-defined, contradictory position – both at odds with and on top of the modernist critical system.

[. . .]

NOTES

1 John Perreault, 'No Reservation,' *The Soho News,* 22 October 1980, 19.
2 Kay Larson, 'Under the Table: Duplicity, Alienation,' *Village Voice,* 11 June 1979, 51; Hilton Kramer, 'Judy Chicago's "Dinner Party" Comes to Brooklyn Museum,' *The New York Times,* 17 October 1980.
3 See Hilton Kramer, 'Does Feminism Conflict with Artistic Standards?' *The New York Times,* 27 January 1980, sec. 2, in which he implies, of course, that it does.
4 As Lucy Lippard has pointed out, in much of the new feminist work from the 1990s, 'it feels as though the wheel is being reinvented by those who don't know the feminist art history of "transgression"' ('Moving Targets/Concentric Circles: Notes from the Radical Whirlwind,' introduction to Lippard's

The Pink Glass Swan: Selected Feminist Essays on Art [New York: New Press, 1995], 3–28). I am indebted to Lippard, who has been the single most consistent champion of 1970s feminist art for the last two decades, for sharing her thoughts and an early version of this text with me.

5 For Paglia's offensive 'postfeminist' views (such as her dismissal of 'endlessly complaining feminists' [9]), see her essays in *Sex, Art, and American Culture* (New York: Vintage Books, 1992). Roiphe, a twenty-something postfeminist, most clearly demonstrates the dangers of this lost history in her excoriation of what she calls 'fashionable feminists' and 'rape crisis feminists'; see her disturbing *The Morning After: Sex, Fear, and Feminism on Campus* (Boston: Little, Brown, 1993). Given the striking parallels between their positions and those of traditional patriarchy, it is no surprise that both women have been given enormous media attention.

6 A perfect example of this erasure is the revisionist accounts of the history of the California Institute of the Arts, Valencia (known as CalArts), as a site for the development of radical postmodern practice in the early 1970s – accounts that completely ignore the motivating presence of the Feminist Art Program run by Chicago and Miriam Schapiro in the early 1970s. The 1987 exhibition *CalArts: Skeptical Belief(s)* epitomized this. Only one passing reference is made to the Feminist Art Program in the seven essays in the catalogue, and none of the artists from the program was included in the exhibition (see *CalArts: Skeptical Belief(s)* [Chicago: Renaissance Society, University of Chicago; Newport, California: Newport Harbor Art Museum, 1987]). See also Mira Schor's 'Amnesiac Return,' *Tema Celeste*, no. 37–38 (Autumn 1992): 16–17. Schor, who participated in the CalArts Feminist Art Program, is an active feminist artist and art writer who has been an important voice in the documentation of this partial history.

7 David Evett, 'Moveable Feast,' *Northern Ohio Live*, 4–17 May 1981, 27, 29. I am indebted to Rosalind Bickell for sharing with me her provocative paper examining the controversial position of *The Dinner Party* in art discourse, 'Intervention on the Sacred; The Politics and Poetics of *The Dinner Party*' (1991).

8 The thirty-nine embrroidered runners for each of the honored 'guests' at the party have been seen as particularly successful elements of the piece even by those who are repelled by the plates. Kramer, for example, allows that in the runners 'we occasionally encounter some details of real artistic interest' ('Judy Chicago's "Dinner Party"'). A notable exception to the appreciation of the runners is Tamar Garb's acerbic evaluation of them as exemplary of *The Dinner Party*'s hypocritical attempt to pose a subversive, alternative female tradition to modernism through the use of traditional female skills while at the same time 'satisfying Modernism's hunger for innovation' and presenting the work within conditions of viewing 'in keeping with the notion of the art museum as shrine' ('Engaging Embroidery,' *Art History* 9 [March 1986]: 132).

9 The needlework loft was run by Susan Hill, who cowrote (with Chicago) the second Dinner Party book, *Embroidering Our Heritage: The Dinner Party Needlework* (New York: Anchor Press/Doubleday, 1980).

10 Clement Greenberg, 'Modernist Painting' (1965), in *The New Art: A Critical Anthology*, ed. Gregory Battcock (New York: Dutton, 1966), 74. See also Mary Kelly's important critique of Greenberg, 'Re-Viewing Mudernist Criticism' (1981), in which she cites this essay, in *Art after Modernism: Rethinking Representation*, ed. Brian Wallis (New York: New Museum of Contemporary Art; Boston: David R. Godine, 1984), 92.

11 Greenberg, 'Modernist Painting,' 68–69, 70, 71.

12 Clement Greenberg, 'Avant-Garde and Kitsch' (1939), in *Art and Culture: Critical Essays* (Boston: Bcacon Press, 1961), 10. Greenberg specifically notes that the appreciator of kitsch culture is 'more usually' a woman, in 'Present Prospects in American Painting' (1947), in *Clement Greenberg: The Collected Essays and Criticism*, vol. 2. *Arrogant Purpose, 1945–1949*, ed. John O'Brian (Chicago: University of Chicago Press, 1986), 161. Greenberg's polemic, of course, has its own specific historical subtext, one that explains the vehemence with which he justifies his oppositional framing of kitsch as the 'bad' other of avant-garde practice. Writing in 1939, he was responding to the overwhelming effects of fascist totalitarianism in Europe. His excoriation of kitsch, then, was motivated by a desire to theorize the ways in which bourgeois capitalism, with its debasement (or 'kitschification') of culture, contributed to the kind of political totalitarianism (with its consumerist strategies of mass manipulation) that supported Germany's fascist regime during this period. On these issues, see Francis Frascina's 'Introduction,' T.J. Clark's 'Clement Greenberg's Theory of Art,' and Michael Fried's 'How Modernism Works,' in *Pollock and After: The Critical Debate*, ed. Francis Frascina (New York: Harper and Row, 1985), 3–20, 47–79. I am grateful to Anne Wagner for encouraging me to look again at these analyses of Greenberg. While this historical context is crucial to understanding the bases of Greenberg's argument, I am interested here, rather, in the way in which this argument is articulated, i.e., in the fact that, like many theorists of culture throughout the modernist period (from

Nietzsche to Adorno), Greenberg posited a dichotomous model of culture that defined debased, unsuccessful, or otherwise 'bad' art in feminine terms. See my discussion of this phenomenon in *Postmodernism and the EnGendering of Marcel Duchamp* (New York and Cambridge: Cambridge University Press, 1994), 16–21.

13 See Carol Duncan, 'When Greatness is a Box of Wheaties' (1975), in *The Aesthetics of Power Essays in Critical Art History* (Cambridge: Cambridge University Press, 1993), 121–32.

14 On the use of craft to 'feminize' art practice and subvert modernism, see Norma Broude, 'Miriam Schapiro and "Femmage": Reflections on the Conflict between Decoration and Abstraction in Twentieth-Century Art' (1980), in *Feminism and An Issue: Questioning the Litany*, ed. Norma Broude and Mary D. Garrard (New York: Harper and Row, 1982), 315–29; and idem, 'The Pattern and Decoration Movement,' in *The Power of Feminist Art: The American Movement of the 1970s, History and Impact*, ed. Norma Broude and Mary D. Garrard (New York: Harry N. Abrams, 1994), 208–25.

15 Cited in Lucy Lippard, 'Judy Chicago's "Dinner Party," ' *Art in America* 68 (April 1980): 124. See also Chicago's privileging of art over craft in 'Judy Chicago,' interview with Dinah Dosser (1983), in *Visibly Female: Feminism and Art Today*, ed. Hilary Robinson (New York: Universe Books, 1988), 44; and in Caroline Seebohm, '*The Dinner Party*: Turning Women's Crafts into Art,' *House and Garden*, April 1981, 199. Diana Ketcham comments that, while Chicago uses traditional crafts, she 'makes a rigid distinction between fine arts and crafts, and places her own career on the fine arts side of the fence' ('On the Table: Joyous Celebration,' *Village Voice*, 11 June 1979, 49). Laura Meyer examines Chicago's ambivalence about her use of crafts in 'The "Essential" Judy Chicago: Central Core Imagery vs. the Language of Fetishism in Womanhouse and *The Dinner Party* (M.A. thesis, University of California, Riverside, 1994); see also her essay in this catalogue.

16 Judy Chicago, *The Dinner Party; A Symbol of Our Heritage* (Garden City, N.Y.: Doubleday, 1979), 8–9.

17 For example, see my critique of the contradictory privileging and heroizing of artists such as Barbara Kruger for their supposed deconstruction of conceptions of artistic genius in my book review, 'Modernist Logic in Feminist Histories of Art,' *Camera Obscura* 27 (1991–92): 149–65.

18 Robert Hughes, 'An Obsessive Feminist Pantheon: Judy Chicago's *Dinner Party* Turns History into Agitprop,' *Time*, 15 December 1980, 85; Maureen Mullarkey. 'Dishing It Out: Judy Chicago's "Dinner Party," ' *Commonweal* 108 (April 1981): 210–11. Interestingly Mullarkey, like Hughes, associates the piece with religious imagery (another connection that implicitly feminizes and, within modernist logic, devalues it): 'The combination of opportunism, evangelical intent, and entrepreneurial drive and technique . . . make it as American as Billy Sunday' (210). One way of looking at this particular critique is that it helps these critics explain away the enormous popularity of the piece: dismissing its appeal by linking it to the blind devotion inspired by religious zealots, they downplay questions of their own elitism (for feminists, perhaps especially important questions).

19 Suzanne Muchnic, 'An Intellectual Famine at Judy Chicago's Feast, *Los Angeles Times*, 15 April 1979. For mostly outraged responses to Muchnic's diatribe, see the letters to the editor published in the April 29th issue and the unpublished letter by Suzanne Lacy in the Judy Chicago archives.

v) Linda Nochlin, from 'Why Have There Been No Great Women Artists?' (1975)

Linda Nochlin is the Lila Acheson Wallace Professor of Modern Art at the Institute of Fine Arts, New York University, and her work in feminist art history has had an important influence on the discipline. Nochlin wrote this essay 'during the heady days of the birth of the Womens' Liberation Movement' in 1970, and it first appeared in *Art News* in January 1971 (Vol. 69) as part of an edition which addressed women and art. It has since come to be seen as a seminal text which helped to form the ideological agenda of feminist art history. In this extract (the first part of the essay) Nochlin argues that the question: 'why have there been no great women artists?' is itself based on a set of uncritical assumptions about what

'great art' is. She shows that before we can adequately answer the question we need to unpick some of the gendered assumptions which underpin it. Later sections of the essay (not reproduced here) go on to explore 'The Question of the Nude', and the idea of art as 'The Lady's Accomplishment', demonstrating the historical and cultural nature of the idea of the (male) artist, rooted in social, educational and aesthetic conventions. (Notes omitted and re-ordered.) [GP]

Source: Linda Nochlin, 'Why Have There Been No Great Women Artists?' (1975), in Linda Nochlin, *Women, Art, and Power and Other Essays*, Thames and Hudson, 1989, pp. 145–58

While the recent upsurge of feminist activity in this country has indeed been a liberating one, its force has been chiefly emotional – personal, psychological, and subjective – centered, like the other radical movements to which it is related, on the present and its immediate needs, rather than on historical analysis of the basic intellectual issues which the feminist attack on the status quo automatically raises.[1] Like any revolution, however, the feminist one ultimately must come to grips with the intellectual and ideological basis of the various intellectual or scholarly disciplines – history, philosophy, sociology, psychology, etc. – in the same way that it questions the ideologies of present social institutions. If, as John Stuart Mill suggested, we tend to accept whatever *is* as natural, this is just as true in the realm of academic investigation as it is in our social arrangements. In the former, too, 'natural' assumptions must be questioned and the mythic basis of much so-called fact brought to light. And it is here that the very position of woman as an acknowledged outsider, the maverick 'she' instead of the presumably neutral 'one' – in reality the white-male-position-accepted-as-natural, or the hidden 'he' as the subject of all scholarly predicates – is a decided advantage, rather than merely a hindrance or a subjective distortion.

In the field of art history, the white Western male viewpoint, unconsciously accepted as *the* viewpoint of the art historian, may – and does – prove to be inadequate not merely on moral and ethical grounds, or because it is elitist, but on purely intellectual ones. In revealing the failure of much academic art history, and a great deal of history in general, to take account of the unacknowledged value system, the very *presence* of an intruding subject in historical investigation, the feminist critique at the same time lays bare its conceptual smugness, its meta-historical naïveté. At a moment when all disciplines are becoming more self-conscious, more aware of the nature of their presuppositions as exhibited in the very languages and structures of the various fields of scholarship, such uncritical acceptance of 'what is' as 'natural' may be intellectually fatal. Just as Mill saw male domination as one of a long series of social injustices that had to be overcome if a truly just social order were to be created, so we may see the unstated domination of white male subjectivity as one in a series of intellectual distortions which must be corrected in order to achieve a more adequate and accurate view of historical situations.[2]

It is the engaged feminist intellect (like John Stuart Mill's) that can pierce through the cultural-ideological limitations of the time and its specific

'professionalism' to reveal biases and inadequacies not merely in dealing with the question of women, but in the very way of formulating the crucial questions of the discipline as a whole. Thus, the so-called woman question, far from being a minor, peripheral, and laughably provincial sub-issue grafted on to a serious, established discipline, can become a catalyst, an intellectual instrument, probing basic and 'natural' assumptions, providing a paradigm for other kinds of internal questioning, and in turn providing links with paradigms established by radical approaches in other fields. Even a simple question like 'Why have there been no great women artists?' can, if answered adequately, create a sort of chain reaction, expanding not merely to encompass the accepted assumptions of the single field, but outward to embrace history and the social sciences, or even psychology and literature, and thereby, from the outset, can challenge the assumption that the traditional divisions of intellectual inquiry are still adequate to deal with the meaningful questions of our time, rather than the merely convenient or self-generated ones. [. . .]

'Why have there been no great women artists?' The question tolls reproachfully in the background of most discussions of the so-called woman problem. But like so many other so-called questions involved in the feminist 'controversy,' it falsifies the nature of the issue at the same time that it insidiously supplies its own answer: 'There are no great women artists because women are incapable of greatness.'

The assumptions behind such a question are varied in range and sophistication, running anywhere from 'scientifically proven' demonstrations of the inability of human beings with wombs rather than penises to create anything significant, to relatively open-minded wonderment that women, despite so many years of near-equality – and after all, a lot of men have had their disadvantages too – have still not achieved anything of exceptional significance in the visual arts.

The feminist's first reaction is to swallow the bait, hook, line and sinker, and to attempt to answer the question as it is put: that is, to dig up examples of worthy or insufficiently appreciated women artists throughout history; to rehabilitate rather modest, if interesting and productive careers; to 'rediscover' forgotten flower painters or David followers and make out a case for them; to demonstrate that Berthe Morisot was really less dependent upon Manet than one had been led to think – in other words, to engage in the normal activity of the specialist scholar who makes a case for the importance of his very own neglected or minor master. Such attempts, whether undertaken from a feminist point of view, like the ambitious article on women artists which appeared in the 1858 *Westminster Review*,[3] or more recent scholarly studies on such artists as Angelica Kauffmann and Artemisia Gentileschi,[4] are certainly worth the effort, both in adding to our knowledge of women's achievement and of art history generally. But they do nothing to question the assumptions lying behind the question 'Why have there been no great women artists?' On the contrary, by attempting to answer it, they tacitly reinforce its negative implications.

Another attempt to answer the question involves shifting the ground slightly and asserting, as some contemporary feminists do, that there is a different kind of 'greatness' for women's art than for men's, thereby postulating the existence of a distinc-

tive and recognizable feminine style, different both in its formal and its expressive qualities and based on the special character of women's situation and experience.

This, on the surface of it, seems reasonable enough: in general, women's experience and situation in society, and hence as artists, is different from men's, and certainly the art produced by a group of consciously united and purposefully articulate women intent on bodying forth a group consciousness of feminine experience might indeed be stylistically identifiable as feminist, if not feminine, art. Unfortunately, though this remains within the realm of possibility it has so far not occurred. While the members of the Danube School, the followers of Caravaggio, the painters gathered around Gauguin at Pont-Aven, the Blue Rider, or the Cubists may be recognized by certain clearly defined stylistic or expressive qualities, no such common qualities of 'femininity' would seem to link the styles of women artists generally [. . .]

Women artists are more inward-looking, more delicate and nuanced in their treatment of their medium, it may be asserted. But which of the women artists cited above is more inward-turning than Redon, more subtle and nuanced in the handling of pigment than Corot? Is Fragonard more or less feminine than Mme Vigée-Lebrun? Or is it not more a question of the whole Rococo style of eighteenth-century France being 'feminine,' if judged in terms of a binary scale of 'masculinity' versus 'femininity'? Certainly, if daintiness, delicacy, and preciousness are to be counted as earmarks of a feminine style, there is nothing fragile about Rosa Bonheur's *Horse Fair*, nor dainty and introverted about Helen Frankenthaler's giant canvases. If women have turned to scenes of domestic life, or of children, so did Jan Steen, Chardin, and the Impressionists – Renoir and Monet as well as Morisot and Cassatt. In any case, the mere choice of a certain realm of subject matter, or the restriction to certain subjects, is not to be equated with a style, much less with some sort of quintessentially feminine style.

The problem lies not so much with some feminists' concept of what femininity is, but rather with their misconception – shared with the public at large – of what art is: with the naïve idea that art is the direct, personal expression of individual emotional experience, a translation of personal life into visual terms. Art is almost never that, great art never is. The making of art involves a self-consistent language of form, more or less dependent upon, or free from, given temporally defined conventions, schemata, or systems of notation, which have to be learned or worked out, either through teaching, apprenticeship, or a long period of individual experimentation. The language of art is, more materially, embodied in paint and line on canvas or paper, in stone or clay or plastic or metal – it is neither a sob story nor a confidential whisper.

The fact of the matter is that there have been no supremely great women artists, as far as we know, although there have been many interesting and very good ones who remain insufficiently investigated or appreciated; nor have there been any great Lithuanian jazz pianists, nor Eskimo tennis players, no matter how much we might wish there had been. That this should be the case is regrettable, but no amount of manipulating the historical or critical evidence will alter the situation; nor will accusations of male-chauvinist distortion of history. There *are* no women

equivalents for Michelangelo or Rembrandt, Delacroix or Cézanne, Picasso or Matisse, or even, in very recent times, for de Kooning or Warhol, any more than there are black American equivalents for the same. If there actually were large numbers of 'hidden' great women artists, or if there really should be different standards for women's art as opposed to men's – and one can't have it both ways – then what are feminists fighting for? If women have in fact achieved the same status as men in the arts, then the status quo is fine as it is.

But in actuality, as we all know, things as they are and as they have been, in the arts as in a hundred other areas, are stultifying, oppressive, and discouraging to all those, women among them, who did not have the good fortune to be born white, preferably middle class and, above all, male. The fault lies not in our stars, our hormones, our menstrual cycles, or our empty internal spaces, but in our institutions and our education–education understood to include everything that happens to us from the moment we enter this world of meaningful symbols, signs, and signals. The miracle is, in fact, that given the overwhelming odds against women, or blacks, that so many of both have managed to achieve so much sheer excellence, in those bailiwicks of white masculine prerogative like science, politics, or the arts.

It is when one really starts thinking about the implications of 'Why have there been no great women artists?' that one begins to realize to what extent our consciousness of how things are in the world has been conditioned – and often falsified – by the way the most important questions are posed. We tend to take it for granted that there really is an East Asian Problem, a Poverty Problem, a Black Problem – and a Woman Problem. But first we must ask ourselves who is formulating these 'questions,' and then, what purposes such formulations may serve. (We may, of course, refresh our memories with the connotations of the Nazis' 'Jewish Problem.') Indeed, in our time of instant communication, 'problems' are rapidly formulated to rationalize the bad conscience of those with power: thus the problem posed by Americans in Vietnam and Cambodia is referred to by Americans as the 'East Asian Problem,' whereas East Asians may view it, more realistically, as the 'American Problem'; the so-called Poverty Problem might more directly be viewed as the 'Wealth Problem' by denizens of urban ghettos or rural wastelands; the same irony twists the White Problem into its opposite, a Black Problem; and the same inverse logic turns up in the formulation of our own present state of affairs as the 'Woman Problem.'
[. . .]

The question 'Why have there been no great women artists?' is simply the top tenth of an iceberg of misinterpretation and misconception; beneath lies a vast dark bulk of shaky *idées reçues* about the nature of art and its situational concomitants, about the nature of human abilities in general and of human excellence in particular, and the role that the social order plays in all of this. While the 'woman problem' as such may be a pseudo-issue, the misconceptions involved in the question 'Why have there been no great women artists?' points to major areas of intellectual obfuscation beyond the specific political and ideological issues involved in the subjection of women. Basic to the question are many naïve, dis-

torted, uncritical assumptions about the making of art in general, as well as the making of great art. These assumptions, conscious or unconscious, link together such unlikely superstars as Michelangelo and van Gogh, Raphael and Jackson Pollock under the rubric of 'Great' – an honorific attested to by the number of scholarly monographs devoted to the artist in question – and the Great Artist is, of course, conceived of as one who has 'Genius'; Genius, in turn, is thought of as an atemporal and mysterious power somehow embedded in the person of the Great Artist.[5] Such ideas are related to unquestioned, often unconscious, meta-historical premises that make Hippolyte Taine's race-milieu-moment formulation of the dimensions of historical thought seem a model of sophistication. But these assumptions are intrinsic to a great deal of art-historical writing. It is no accident that the crucial question of the conditions *generally* productive of great art has so rarely been investigated, or that attempts to investigate such general problems have, until fairly recently, been dismissed as unscholarly, too broad, or the province of some other discipline, like sociology. To encourage a dispassionate, impersonal, sociological, and institutionally oriented approach would reveal the entire romantic, elitist, individual-glorifying, and monograph-producing substructure upon which the profession of art history is based, and which has only recently been called into question by a group of younger dissidents.

Underlying the question about woman as artist, then, we find the myth of the Great Artist – subject of a hundred monographs, unique, godlike – bearing within his person since birth a mysterious essence, rather like the golden nugget in Mrs. Grass's chicken soup, called Genius or Talent, which, like murder, must always out, no matter how unlikely or unpromising the circumstances.

The magical aura surrounding the representational arts and their creators has, of course, given birth to myths since the earliest times. Interestingly enough, the same magical abilities attributed by Pliny to the Greek sculptor Lysippos in antiquity – the mysterious inner call in early youth, the lack of any teacher but Nature herself – is repeated as late as the nineteenth century by Max Buchon in his biography of Courbet. The supernatural powers of the artist as imitator, his control of strong, possibly dangerous powers, have functioned historically to set him off from others as a godlike creator, one who creates Being out of nothing. The fairy tale of the discovery by an older artist or discerning patron of the Boy Wonder, usually in the guise of a lowly shepherd boy, has been a stock-in-trade of artistic mythology ever since Vasari immortalized the young Giotto, discovered by the great Cimabue while the lad was guarding his flocks, drawing sheep on a stone; Cimabue, overcome with admiration for the realism of the drawing, immediately invited the humble youth to be his pupil.[6] [. . .]

As is so often the case, such stories, which probably have some truth in them, tend both to reflect and perpetuate the attitudes they subsume. Even when based on fact, these myths about the early manifestations of genius are misleading. It is no doubt true, for example, that the young Picasso passed all the examinations for entrance to the Barcelona, and later to the Madrid, Academy of Art at the age of fifteen in but a single day, a feat of such difficulty that most candidates required a month of preparation. But one would like to find out more about similar precocious qualifiers for

art academies who then went on to achieve nothing but mediocrity or failure – in whom, of course, art historians are uninterested – or to study in greater detail the role played by Picasso's art-professor father in the pictorial precocity of his son. What if Picasso had been born a girl? Would Señor Ruiz have paid as much attention or stimulated as much ambition for achievement in a little Pablita?

What is stressed in all these stories is the apparently miraculous, nondeter-mined, and asocial nature of artistic achievement; this semi-religious conception of the artist's role is elevated to hagiography in the nineteenth century, when art historians, critics, and, not least, some of the artists themselves tended to elevate the making of art into a substitute religion, the last bulwark of higher values in a materialistic world. The artist, in the nineteenth-century Saints' Legend, struggles against the most determined parental and social opposition, suffering the slings and arrows of social opprobrium like any Christian martyr, and ultimately suc-ceeds against all odds – generally, alas, after his death – because from deep within himself radiates that mysterious, holy effulgence: Genius. Here we have the mad van Gogh, spinning out sunflowers despite epileptic seizures and near-starvation; Cézanne, braving paternal rejection and public scorn in order to revolutionize painting; Gauguin throwing away respectability and financial security with a single existential gesture to pursue his calling in the tropics; or Toulouse-Lautrec, dwarfed, crippled, and alcoholic, sacrificing his aristocratic birthright in favor of the squalid surroundings that provided him with inspiration.

Now no serious contemporary art historian takes such obvious fairy tales at their face value. Yet it is this sort of mythology about artistic achievement and its concomitants which forms the unconscious or unquestioned assumptions of scholars, no matter how many crumbs are thrown to social influences, ideas of the times, economic crises, and so on. Behind the most sophisticated investigations of great artists – more specifically, the art-historical monograph, which accepts the notion of the great artist as primary, and the social and institutional structures within which he lived and worked as mere secondary 'influences' or 'background' – lurks the golden-nugget theory of genius and the free-enterprise conception of individual achievement. On this basis, women's lack of major achievement in art may be formulated as a syllogism: If women had the golden nugget of artistic genius then it would reveal itself. But it has never revealed itself. Q.E.D. Women do not have the golden nugget of artistic genius. If Giotto, the obscure shepherd boy, and van Gogh with his fits could make it, why not women?

Yet as soon as one leaves behind the world of fairy tale and self-fulfilling prophecy and, instead, casts a dispassionate eye on the actual situations in which important art production has existed, in the total range of its social and institu-tional structures throughout history, one finds that the very questions which are fruitful or relevant for the historian to ask shape up rather differently. One would like to ask, for instance, from what social classes artists were most likely to come at different periods of art history, from what castes and subgroup. What proportion of painters and sculptors, or more specifically, of major painters and sculptors, came from families in which their fathers or other close relatives were painters and sculptors or engaged in related professions? As Nikolaus Pevsner

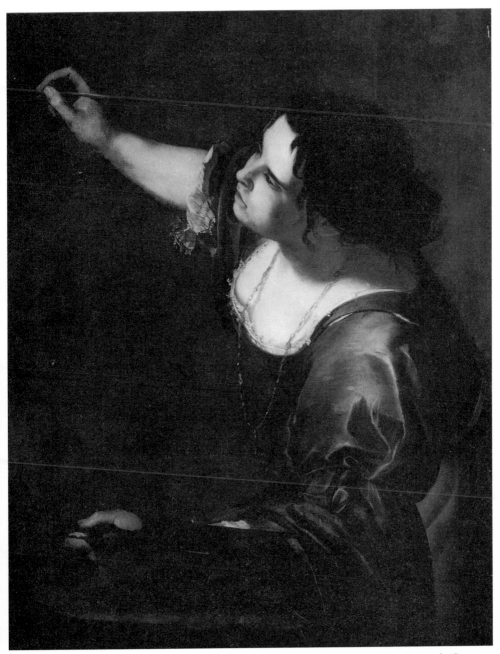

xvi) Artemesia Gentileschi, *Self-Portrait as La Pittura*, oil on canvas, The Royal Collection © Her Majesty the Queen.

points out in his discussion of the French Academy in the seventeenth and eighteenth centuries, the transmission of the artistic profession from father to son was considered a matter of course (as it was with the Coypels, the Coustous, the Van Loos, etc.); indeed, sons of academicians were exempted from the customary fees for lessons.[7] Despite the noteworthy and dramatically satisfying cases of the great father-rejecting *révoltés* of the nineteenth century, one might be forced to admit that a large proportion of artists, great and not-so-great, in the days when it was normal for sons to follow in their fathers' footsteps, had artist fathers. In the rank of major artists, the names of Holbein and Dürer, Raphael and Bernini, immediately spring to mind; even in our own times, one can cite the names of Picasso, Calder, Giacometti, and Wyeth as members of artist-families.

As far as the relationship of artistic occupation and social class is concerned, an interesting paradigm for the question 'Why have there been no great women artists?' might well be provided by trying to answer the question 'Why have there been no great artists from the aristocracy?' One can scarcely think, before the anti-traditional nineteenth century at least, of any artist who sprang from the ranks of any more elevated class than the upper bourgeoisie; even in the nineteenth century, Degas came from the lower nobility – more like the haute bourgeoisie, in fact – and only Toulouse-Lautrec, metamorphosed into the ranks of the marginal by accidental deformity, could be said to have come from the loftier reaches of the upper classes. While the aristocracy has always provided the lion's share of the patronage and the audience for art – as, indeed, the aristocracy of wealth does even in our more democratic days – it has contributed little beyond amateurish efforts to the creation of art itself, despite the fact that aristocrats (like many women) have had more than their share of educational advantages, plenty of leisure and, indeed, like women, were often encouraged to dabble in the arts and even develop into respectable amateurs, like Napoleon III's cousin, the Princess Mathilde, who exhibited at the official Salons, or Queen Victoria, who, with Prince Albert, studied art with no less a figure than Landseer himself. Could it be that the little golden nugget – genius – is missing from the aristocratic makeup in the same way that it is from the feminine psyche? Or rather, is it not that the kinds of demands and expectations placed before both aristocrats and women – the amount of time necessarily devoted to social functions, the very kinds of activities demanded – simply made total devotion to professional art production out of the question, indeed unthinkable, both for upper-class males and for women generally, rather than its being a question of genius and talent?

When the right questions are asked about the conditions for producing art, of which the production of great art is a subtopic, there will no doubt have to be some discussion of the situational concomitants of intelligence and talent generally, not merely of artistic genius. Piaget and others have stressed in their genetic epistemology that in the development of reason and in the unfolding of imagination in young children, intelligence – or, by implication, what we choose to call genius – is a dynamic activity rather than a static essence, and an activity of a subject *in a situation*. As further investigations in the field of child development imply, these abilities, or this intelligence, are built up minutely, step by step, from infancy onward, and the

patterns of adaptation-accommodation may be established so early within the sub-ject-in-an-environment that they may indeed *appear* to be innate to the unsophisti-cated observer. Such investigations imply that, even aside from meta-historical reasons, scholars will have to abandon the notion, consciously articulated or not, of individual genius as innate, and as primary to the creation of art.[8]

The question 'Why have there been no great women artists?' has led us to the conclusion, so far, that art is not a free, autonomous activity of a super-endowed individual, 'influenced' by previous artists, and, more vaguely and superficially, by 'social forces,' but rather, that the total situation of art making, both in terms of the development of the art maker and in the nature and quality of the work of art itself, occur in a social situation, are integral elements of this social structure, and are mediated and determined by specific and definable social institutions, be they art academies, systems of patronage, mythologies of the divine creator, artist as he-man or social outcast.

[. . .]

NOTES

1 Kate Millett's *Sexual Politics*, New York, 1970, and Mary Ellman's *Thinking About Women*. New York, 1968, provide notable exceptions.
2 John Stuart Mill, *The Subjection of Women* (1869) in *Three Essays by John Stuart Mill*, World's Classics Series, London, 1966.
3 'Women Artists.' Review of *Die Frauen in die Kunstgeschichte* by Ernst Guhl in *The Westminster Review* (American Edition), LXX, July 1858, pp. 91–104. I am grateful to Elaine Showalter for having brought this review to my attention.
4 See, for example, Peter S. Walch's excellent studies of Angelica Kauffmann or his unpublished doctoral dissertation, 'Angelica Kauffmann,' Princeton University, 1968, on the subject; for Artemisia Gen-tileschi, see R. Ward Bissell, 'Artemisia Gentileschi – A New Documented Chronology.' *Art Bulletin*, L (June 1968): 153–68.
5 For the relatively recent genesis of the emphasis on the artist as the nexus of esthetic experience, see M. H. Abrams, *The Mirror and the Lamp: Romantic Theory and the Critical Tradition*, New York, 1953, and Mau-rice Z. Shroder, *Icarus: The Image of the Artist in French Romanticism*, Cambridge, Massachusetts, 1961.
6 A comparison with the parallel myth for women, the Cinderella story, is revealing: Cinderella gains higher status on the basis of a passive, 'sex-object' attribute – small feet – whereas the Boy Wonder always proves himself through active accomplishment. For a thorough study of myths about artists, see Ernst Kris and Otto Kurz. *Die Legende vom Künstler: Ein Geschichtlicher Versuch*, Vienna, 1934.
7 Nikolaus Pevsner, *Academies of Art, Past and Present*. Cambridge, 1940, p. 961.
8 Contemporary directions – earthworks, conceptual art, art as information, etc. – certainly point away from emphasis on the individual genius and his salable products; in art history, Harrison C. and Cyn-thia A. White's *Canvases and Careers: Institutional Change in the French Painting World*, New York, 1965, opens up a fruitful new direction of investigation, as did Nikolaus Pevsner's pioneering *Academies of Art*. Ernst Gombrich and Pierre Francastel, in their very different ways, always have tended to view art and the artist as part of a total situation rather than in lofty isolation.

vi) Griselda Pollock, 'Differencing, Feminism and the Canon', from *Differencing the Canon: Feminist Desire and the Writing of Art's Histories* (1999)

Griselda Pollock is Professor of Social and Critical Histories of Art, and the Direc-tor of the Centre for Cultural Studies, at the University of Leeds. Professor Pollock

is an art historian and feminist theorist who, through both her writings and teaching, has played a major role in placing questions of gender at the forefront of modern art history. Her books include: *Old Mistresses: Women, Art & Ideology* (1981); *Framing Feminism, Art and the Women's Movement 1970–1985.* (1987) (both co-written with Rozsika Parker); and *Vision & Difference, Femininity, Feminism and the Histories of Art* (1988). Pollock has forcefully rejected the idea that gender roles are natural. Instead she sees gender (as opposed to biological sex) as a powerfully constraining social and psychic process constructed and maintained by patriarchal capitalist discourses. As an alternative to previous feminist approaches, her project involves drawing on theories of discourse and psychoanalysis to problematise art history itself. By revealing the extent to which the fundamental assumptions of the discipline are built on structures of gender inequality Pollock seeks radically to reshape the questions that we ask about art and artists. In the process she places the construction of sexuality and desire at the centre of the discipline. The text we publish here is from Pollock's book: *Differencing the Canon: Feminist Desire and the Writing of Art's Histories* published by Routledge in 1999. In this extract she surveys three different feminist approaches to art history and assesses their advantages and drawbacks. This extract appears here without footnotes. [SE]

Source: Griselda Pollock, 'Differencing, Feminism and the Canon', from *Differencing the Canon: Feminist Desire and the Writing of Art's Histories*, Routledge, 1999

I FEMINISM'S HISTORIC ENCOUNTER WITH THE CANON

Feminism's encounter with the canon has been complex and many levelled: ideological, discursive, mythological, psychoanalytical. Now I want to identify and schematically lay out a number of different strategies which correspond to the related but also contradictory positions of feminism's encounter with the canon historically, that is since the formation of a women's movement in the early 1970s. These different positions represent tactical moments, each as necessary as they are contradictory, while the accumulation of our practices and thoughts is beginning to produce a critical and strategic dissonance from art history that allows us to imagine other ways of seeing and reading art than those locked into the canonical formation.

POSITION ONE:
Feminism encountered the canon as a structure of exclusion.
The immediate task after 1970 was the absolute need to rectify the gaps in historical knowledge created by the consistent omission of women of all cultures from the history of art. Standard text books of the institutionalised establishment in art history had, since the early years of the twentieth century, consistently and completely obliterated women from the History of Art. The only place a woman artist might be glimpsed was in the basement or storeroom of a national gallery. The

first article I ever wrote as a 'feminist' in 1972 was a study of the paintings by women artists in the open basement galleries of the National Gallery in London. I entered a correspondence with Michael Levy, the then Director, as to why all the paintings by women were kept below stairs. This included Rosa Bonheur's *The Horse Fair*, the first painting by a living artist to be admitted to the National Collection. Admittedly it is not the original version, now in the Metropolitan Museum of Art in New York. Admittedly, Rosa Bonheur was assisted by Natalie Micas in making this painting for Ernest Gambart, the dealer, who was to make an engraving of the work. These reasons were used against the public showing of the only painting of this major, decorated nineteenth century painter. A large pastel portrait, *The Man in Grey*, by Rosalba Carriera was also downstairs and a Berthe Morisot, part of the Lane Collection, was in Dublin at the time. Michael Levy felt I would be misrepresenting the gallery if I did not take all these factors into account.

As the phrase, first used in 1972 by Ann Gabhart and Elizabeth Broun, 'Old Mistress,' so tellingly suggested, the exclusions were, however, more than mere oversights. There is no equivalent term of value and respect for great *mistresses* of art comparable to the old *masters* who form the very substance of the canon. Structurally, it would be impossible to re-admit excluded women artists like Artemisia Gentileschi or Mary Cassatt to an expanded canon without either radical misunderstanding of their artistic legacy or radical change to the very concept of the canon as the discourse which sanctions the art we should study. The canon is 'in the masculine' as well as 'of the masculine'. This statement does not in any way belittle the vitally important work that has been done in producing the research, documentation and analysis of women artists in anthologies, monographs and comprehensive surveys, culminating in the historic moment when the popular but academically used *World of Art* series produced by Thames and Hudson published Whitney Chadwick's double volume *Women, Art and Society* in 1990. The recurring shock of discovery that there have been women artists at all, and so many and such interesting ones, which we as teachers, lecturers and writers regularly witness with each new class of students or new audience for our lectures on women artists, is proof of the reiterating need for this basic research of revelatory information. Evidence of women's uninterrupted involvement in the fine arts is still the fundamental step in exposing the canon's selectivity and ideological bias. But the very fact that this great project has, of necessity, to be accomplished by special books on women artists and that any survey of museum and other art bookshops will still reveal a terrible scarcity of monographs on women artists by comparison with numerous possibilities on offer for the major masters, confirms the problem we face.

The tradition remains *the* tradition with the women in their own special, separated compartments, or added as politically correct supplements. It is a great thing that books on women artists are increasingly available. But I doubt there are many survey courses using Whitney Chadwick, or Nochlin and Sutherland Harris or Parker and Pollock as the backbone for their study of Western art to the exclusion

of Janson or Gardiner whereas there are plenty of cases of the other way round, where no women are mentioned at all. The purposes of giving students a sense of what has happened in the history of Western art through successions of styles, interests, issues, can be done using women artists just as well as the usual cast. Issues about social production of art, patronage, iconography, cultural transformation, theological, philosophical or political determinations and resources, issues of class, sexuality, colonialism and race: these can equally be addressed by the study of artists who are women. I regularly do it in my own introductory lectures. What is missing are the great heroes who are, I suggest, the real subject of the survey course in art history as heroic epic of western Man. In that story of art, women artists are an incomprehensible addition, available for those women disposed to be interested to read about, but the real history of art remains fundamentally unaffected because its mythological and psychic is not fundamentally or exclusively to do with art and its histories, but the western masculine subject, its mythic supports and psychic needs. It is the story of Man. To that end it needs constantly to create a negated femininity as the other that alone allows the slippage into synonymity of man and artist. Artist is implicitly but unstatedly man artist; woman artist has the qualifying adjective precisely in order to disqualify 'her.'

Furthermore I suspect even those art historians sympathetic to a feminist critique of selectivity are not sure how to change this situation in any profound or long term way. [. . .] So, after over twenty years of feminist work rectifying the gaps in the archive, we still face the question: how can we make the cultural work of women an effective presence in cultural discourse which both changes the order of discourse and the hierarchy of gender in one and the same deconstructive move?

POSITION TWO:
Feminism encounters the canon as a structure of subordination and domination which marginalizes and relativizes all women according to their place in the contradictory structurations of power – race, gender, class and sexuality.
In response to not only exclusion but systematic devaluation of anything aesthetic associated with women, feminists have tried to valorise practices and procedures particularly practised by or connected with women that are without status in the canon, and which, therefore, cannot be spoken of in canonical terms, for instance textiles and ceramics.
[. . .]

Work on quilting, weaving and embroidery by Western women has exposed the troubled nature of the Western canon's attempt to valorise its culture above all others by a hierarchy of means and materials. It has become more culturally advanced to make art with pigment and canvas, stone or bronze than with linen and thread, wool, or clay and pigment. Feminists, however, have argued that textiles are both the site of profound cultural value beyond mere utilitarian usage and the site of the production of meanings that traverse culture as a whole: religious, political, moral, ideological. Thus the canonical division between intellectual and

manual art forms, truly creative and merely decorative practices has been challenged. By showing the ways in which the art of embroidery, once the most valued cultural form of medieval ecclesiastical culture, was progressively deprofessionalised, domesticated and feminised, feminist art historians have exposed both the relativity of cultural valuations and the intimacy between value and gender.

The specificity of such cultural practices that are typically downgraded because they are (mis)identified with the domestic, the decorative, the utilitarian, the dexterous, that is with what patriarchal logic calls the feminine, what is negatively assessed as quintessentially feminine, appear as merely instances of difference, and paradoxically confirm, rather than afflict the canonical – normative – status of other practices by men. This is a prime instance of being trapped in a binary where reverse valuation of what has hitherto been devalued does not ultimately breach the value system at all. None the less, feminist discourse on and from the position of marginalisation, interrupting art history by a political voice challenging hierarchies of value between, for instance, painting and art made with textiles, does have some subversive force. It gets entangled with the underlying structure I insist on drawing out: art is often a debate in disguised form about gender. So the basis of the revaluation of patchwork quilts and weaving is the shifted appreciation of the work and creativity of the domestic sphere, or of traditions of female aesthetic choices and challenges. Inside the categorical division of the genders, there is a realignment of what is aesthetically valued through determining more complex relations between art and the social experiences of women.

The difficulty remains, however, that in speaking of and as women, feminism confirms the notion that woman is the sex, the sign of gender, perpetually the particular and sexualized Other to the universal sign Man, who appears to transcend his sex to represent Humanity. [. . .] The more we insist upon the specificity of women's involvement in the arts in all its forms, the more we confirm the very difference which is the basis of our subordination and marginalisation. To speak of the repressed question of gender is to confirm the dominant culture's worst suspicions, that if women are allowed to speak, all they can speak of is (their) sex.

POSITION THREE:
Feminism encounters the canon as a discursive strategy in the production and reproduction of sexual difference and its complex configurations with other modes of power. Deconstructing discursive formations leads to the production of radically new knowledges which contaminate the seemingly 'ungendered' domains of art and art history by insisting that sex is everywhere. The canon is named as an instance of Western masculinity, itself saturated by its own traumatised sexual formation. The key difference from position two is this. In the same gesture as we confirm that sexual difference structures women's social positions, cultural practices and aesthetic representations, we also sexualise the masculine, demanding that the canon be recognised as a gendered and an *en-gendering* discourse. Not a matter of reverse sexism, this third strategy overcomes sexism and its straight inversion by naming the structures which implicate both men and women because they produce mas-

culinity and femininity relatively, suppressing, in the same move, the complexity of sexualities that defy this model of sex and gender. The feminist interruption of the naturalised (hetero)sexual division identifies the structures of difference on which the canon is erected by examining its mechanisms for maintaining only *that* difference – woman as Other, sex, lack, metaphor, sign, etc., *the* difference that sustains the very illusions of masculine narcissism that are invested in the idealised images of the artist and the domain of art, represented according to the fantasies, desires and anxieties of historic, classed and raced masculine subjectivities.

This third position no longer operates within art history as an internal contestant or corrective to the discipline. Its purposes are not equity. It does not aim at just more women in the art history books or better coverage for decorative as well as fine arts (position one). Nor, however, does it operate outside, or in the margins, a voice for women's absolute difference, valorising the feminine sphere (position two). It implies a shift from the narrowly bounded spaces of art history as a disciplinary formation into an emergent and oppositional signifying space we call the women's movement which is not a place apart, but a movement across the fields of discourse and its institutional bases, across the texts of culture and its psychic foundations.

This play on the word 'movement' allows us to keep in mind the political collectivity in which feminist work must be founded and, at the same time, it enables us to refuse containment in a category called feminism. Feminism will not just be one more approach in the chaotic pluralisation to which a threatened art history desperately turns in the hope of maintaining its hegemony by tactical incorporation. The notion of movement is also associated with that of the eye as it reads a text: re-vision, in Adrienne Rich's terms. Reading has become a charged signifer of a new kind of critical practice, re-reading the texts of our culture symptomatically as much for what is not said as for what is. Meaning is produced in the spaces between, and that is what we are moving across canons, disciplines and texts to hear, see and understand anew. It is precisely through these movements between disciplinary formations, between academe and street, between social and cultural, between intellectual and political, between semiotic and psychic, that women were able to grasp the interrelations between the dominant formations around sexuality and power which inform but are mystified by the outward and visible signs of a discipline's or practice's particular habits and professional procedures. Thus from the novel space and connections between women practising in many fields created by the formation of the women's movement, feminists intervene in art history to generate expanded forms for art's histories. [. . .] Thus, art history is not merely to be understood as the study of the artistic artefacts and documents left deposited in the present by time. Art History is a discourse in so far as it creates its object: art and the artist. From the 'space off' of feminism, I do not confirm the mystical status of the object nor the theological concept of the artist that are the central projects of art historical discourse. The terrain I explore is the socio-symbolic process of sexuality and the constitution of the subject in [sexual] difference, itself within the field of history, as it shapes and is shaped in a history of aesthetically crafted visual representations.

vii) Jacqueline Rose, 'Sexuality in the Field of Vision', from *Sexuality in the Field of Vision* (1986)

In this essay, which has played a seminal role in the development of feminist theory, Jacqueline Rose criticises some conventional accounts of the relationship between viewer and image. Drawing on psychoanalytic models developed by Sigmund Freud and Jacques Lacan, she explores the contingent and unstable character of sexual difference and some of the unconscious fantasies involved in the construction of sexual identity as male and female. Focusing on the encounter between psychoanalysis and artistic practice, she explores what she calls 'the problem of seeing', arguing that representation and sexuality are locked together through language. The essay was first published in the catalogue for the exhibition 'Difference: On Representation and Sexuality' at the Museum of Contemporary Art, New York, December 1984–February 1985. The exhibition included work by Ray Barrie, Victor Burgin, Hans Haacke, Mary Kelly, Silvia Kolbowski, Barbara Kruger, Sherrie Levine, Yve Lomax, Jeff Wall and Marie Yates. Jacqueline Rose is Professor of English at Queen Mary and Westfield College, University of London. (Author's notes have not been completed.) [GP]

Source: Jacqueline Rose, 'Sexuality in the Field of Vision', from *Sexuality in the Field of Vision*, Verso, 1986, pp. 225–33

SEXUALITY IN THE FIELD OF VISION

In an untypical moment Freud accuses Leonardo of being unable to draw.[1] A drawing done in anatomical section of the sexual act is inaccurate [plate xvi]. What is more it is lacking in pleasure: the man's expression is one of disgust, the position is uncomfortable, the woman's breast is unbeautiful (she does not have a head). The depiction is inaccurate, uncomfortable, undesirable and without desire. It is also inverted: the man's head looks like that of a woman, and the feet are the wrong way around according to the plane of the picture – the man's foot pointing outwards where the woman's foot should be, and her foot in his place. In fact, most of Freud's monograph on Leonardo is addressed to the artist's *failure*, that is, to the restrictions and limitations which Leonardo himself apparently experienced in relation to his potential achievement. Freud takes failure very seriously, even when it refers to someone who, to the gaze of the outside world, represents the supreme form of artistic success. But in this footnote on the sexual drawing, Freud goes beyond the brief of the largely psychobiographical forms of interpretation that he brings to Leonardo's case. He relates – quite explicitly – a failure to depict the sexual act to bisexuality and to a problem of representational space. The uncertain sexual identity muddles the plane of the image so that the spectator does not know where she or he stands in relationship to the picture. A confusion at the level of sexuality brings with it a disturbance of the visual field.

An artistic practice which sets itself the dual task of disrupting visual form and questioning the sexual certainties and stereotypes of our culture can fairly return

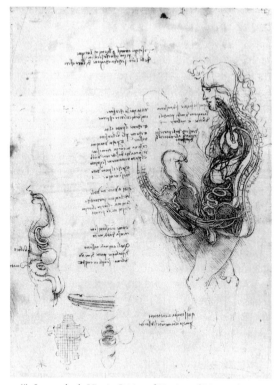

xvii) Leonardo da Vinci, *Coition of Hemisected Man and
 Woman*, c. 1492–4, The Royal Collection © Her Majesty
 the Queen.

to this historical moment (historical analytically as well as artistically, since the
reference to Leonardo is now overlaid with the reference to the beginnings of
psychoanalysis itself). Not for authority (authority is one of the things being ques-
tioned here), but for its suggestiveness in pointing up a possible relation between
sexuality and the image. We know that Freud's writing runs parallel to the emer-
gence of 'modern' art; he himself used such art as a comparison for the blurred
fields of the unconscious psychic processes which were the object of his analytic
work.[2] But in this footnote on Leonardo's failure in the visual act, we can already
see traced out a specific movement or logic: that there can be no work on the
image, no challenge to its powers of illusion and address, which does not simul-
taneously challenge the fact of sexual difference, whose self-evidence Leonardo's
drawing had momentarily allowed to crumble.[3]

 The rest of Freud's writing shows that sexual difference is indeed such a hesi-
tant and imperfect construction. Men and women take up positions of symbolic
and polarised opposition against the grain of a multifarious and bisexual
disposition, which Freud first identified in the symptom (and genius . . .) before
recognising its continuing and barely concealed presence across the range of nor-
mal adult sexual life. The lines of that division are fragile in exact proportion to

the rigid insistence with which our culture lays them down; they constantly con-
verge and threaten to coalesce. Psychoanalysis itself can therefore explain the
absence of that clear and accomplished form of sexuality that Freud himself had
unsuccessfully searched for in the picture.

Freud often related the question of sexuality to that of visual representation.
Describing the child's difficult journey into adult sexual life, he would take as his
model little scenarios, or the staging of events, which demonstrated the complex-
ity of an essentially visual space, moments in which perception *founders* (the boy
child refuses to believe the anatomical difference that he sees)[4] or in which
pleasure in looking tips over into the register of *excess* (witness to a sexual act in
which he reads his own destiny, the child tries to interrupt by calling attention to
his presence).[5] Each time the stress falls on a problem of seeing. The sexuality lies
less in the content of what is seen than in the subjectivity of the viewer, in the rela-
tionship between what is looked at and the developing sexual knowledge of the
child. The relationship between viewer and scene is always one of fracture, partial
identification, pleasure and distrust. As if Freud found the aptest analogy for the
problem of our identity as human subjects in failures of vision or in the violence
which can be done to an image as it offers itself to view. For Freud, with an empha-
sis that has been picked up and placed at the centre of the work of Jacques Lacan,
our sexual identities as male or female, our confidence in language as true or false,
and our security in the image we judge as perfect or flawed, are fantasies.[6] And
these archaic moments of disturbed visual representation, these troubled scenes,
which expressed and unsettled our groping knowledge in the past, can now be
used as theoretical prototypes to unsettle our certainties once again. Hence one of
the chief drives of an art which today addresses the presence of the sexual in rep-
resentation – to expose the fixed nature of sexual identity as a fantasy and, in the
same gesture, to trouble, break up, or rupture the visual field before our eyes.

The encounter between psychoanalysis and artistic practice is therefore *staged*,
but only in so far as that staging has *already taken place*. It is an encounter which
draws its strength from that repetition, working like a memory trace of something
we have been through before. It gives back to repetition its proper meaning and
status: not lack of originality or something merely derived (the commonest
reproach to the work of art), nor the more recent practice of appropriating
artistic and photographic images in order to undermine their previous status; but
repetition as insistence, that is, as the constant pressure of something hidden but
not forgotten – something that can only come into focus now by blurring the field
of representation where our normal forms of self-recognition take place.

The affinity between representation and sexuality is not confined to the visual
image. In fact, in relation to other areas of theoretical analysis and activity, recog-
nition of this affinity in the domain of the artistic image could be said to manifest
something of a lag.[7] In one of his most important self-criticisms,[8] Barthes
underlined the importance of psychoanalysis in pushing his earlier exposé of
ideological meanings into a critique of the possibility of meaning itself. In his case
studies Freud had increasingly demonstrated that the history of the patient did
not consist of some truth to be deciphered behind the chain of associations which

emerged in the analytic setting; it resided within that chain and in the process of emergence which the analysis brought into effect. Lacan immediately read in this the chain of language which slides from unit to unit, producing meaning out of the relationship between terms; its truth belongs to that movement and not to some prior reference existing outside its domain. The divisions of language are in themselves arbitrary and shifting: language rests on a continuum which gets locked into discrete units of which sexual difference is only the most strongly marked. The fixing of language and the fixing of sexual identity go hand in hand; they rely on each other and share the same forms of instability and risk. Lacan read Freud through language, but he also brought out, by implication, the sexuality at work in all practices of the sign. Modernist literary writing could certainly demonstrate, alongside the syntactic and narrative shifts for which it is best known, oscillations in the domain of sexuality, a type of murking of the sexual proprieties on which the politer world of nineteenth-century realist fiction had been based. Although the opposition between the two forms of writing has often been overstated, it is no coincidence that, in order to illustrate this tension between 'readerly' and 'writerly' fiction, Barthes chose a story in which the narrative enigma turns on a castrato (Balzac's *Sarrasine*).[9] The indecipherable sexuality of the character makes for the trouble and the joy of the text.

It is worth pausing over the implications of this for a modernist and postmodernist artistic practice which is increasingly understood in terms of a problematic of reading and a theory of the sign. Again, the historical links are important. Freud takes modern painting as the image of the unconscious. But the modernist suspension of the referent, with its stress on the purity of the visual signifier, belongs equally with Saussure who, at the same time, was criticising the conception of language as reference and underlining the arbitrary nature of the sign (primacy to the signifier instead of language as a nomenclature of the world). Lacan's move then simply completes the circuit by linking Saussure back to Freud. The unconscious reveals that the normal divisions of language and sexuality obey the dictates of an arbitrary law undermining the very possibility of reference for the subject since the 'I' can no longer be seen to correspond to some pre-given and permanent identity of psycho-sexual life. The problem of psychic identity is therefore immanent to the problem of the sign.

The same link (of language and the unconscious) can be made to that transition to postmodernism which has been read as a return of the referent, but the referent as a problem, not as a given.[10] Piles of cultural artefacts bring back something we recognise but in a form which refuses any logic of the same. The objects before the spectator's eyes cannot be ordered: in their disjunctive relation, they produce an acuter problem of vision than the one which had resulted when reference was simply dropped from the frame. Above all – to return to the analogy with the analytic scene – these images require a reading which neither coheres them into a unity, nor struggles to get behind them into a realm of truth. The only possible reading is one which repeats their fragmentation of a cultural world they both echo and refuse.

At each point of these transitions – artistic and theoretical – something is called into question at the most fundamental level of the way we recognise and respond to our own subjectivity and to a world with which we are assumed to be familiar,

a world we both do and do not know. Yet in each of these instances, it is precisely the psychoanalytic concepts of the unconscious and sexuality, specifically in their relationship to language, which seem to be lost.

Thus the modernist stress on the purity of the visual signifier easily dissolves into an almost mystic contemplation. Language can be used to rupture the smoothness of the visual image but it is language as pure mark uninformed by the psychoanalytic apprehension of the sign. Cultural artefacts are presented as images within images to rob them of the values they seem naturally to embody, but the fundamental sexual polarity of that culture is not called into account. Finally, meaning is seen to reside in these images as supplement, allegory or fragment, but with no sexual residue or trace – the concept of textuality is lifted out of psycho-analytic and literary theory but without the sexual definition that was its chief impetus and support.

Across a range of instances, language, sexuality and the unconscious *in their mutual relation* appear as a present-absence which all these moments seem to brush against, or elicit, before falling away. The elisions can be summarised schematically:

- purity of the visual signifier and the unconscious as mystique (no language);
- language as rupture of the iconicity of the visual sign (no unconscious);
- cultural artefacts as indictment of the stereotype (no sexual difference);
- reading as supplement, process or fragment (no sexual determinacy of the signifier or of visual space).

Artists engaged in sexual representation (representation *as* sexual) come in at precisely this point, calling up the sexual component of the image, drawing out an emphasis that exists *in potentia* in the various instances they inherit and of which they form a part.[11] Their move is not therefore one of (moral) corrective. They draw on the tendencies they also seek to displace, and clearly belong, for example, within the context of that postmodernism which demands that refer-ence, in its problematised form, re-enter the frame. But the emphasis on sexuality produces specific effects. First, it adds to the concept of cultural artefact or stereo-type the political imperative of feminism which holds the image accountable for the reproduction of norms. Secondly, to this feminist demand for scrutiny of the image, it adds the idea of a sexuality which goes beyond the issue of content to take in the parameters of visual form (not just what we see but how we see – visual space as more than the domain of simple recognition). The image therefore sub-mits to the sexual reference, but only in so far as reference itself is questioned by the work of the image. And the aesthetics of pure form are implicated in the less pure pleasures of looking, but these in turn are part of an aesthetically extraneous political space. The arena is simultaneously that of aesthetics and sexuality, and art and sexual politics. The link between sexuality and the image produces a particu-lar dialogue which cannot be covered adequately by the familiar opposition between the formal operations of the image and a politics exerted from outside.

The engagement with the image therefore belongs to a political intention. It is an intention which has also inflected the psychoanalytic and literary theories on which such artist[s] draw. The model is not one of applying psychoanalysis to the

work of art (what application could there finally be which does not reduce one field to the other or inhibit by interpretation the potential meaning of both?). Psychoanalysis offers a specific account of sexual difference but its value (and also its difficulty) for feminism, lies in the place assigned to the woman in that differentiation. In his essay on Leonardo, Freud himself says that once the boy child sees what it is to be a woman, he will 'tremble for his masculinity' henceforth.[12] If meaning oscillates when a castrato comes onto the scene, our sense must be that it is in the normal image of the man that our certainties are invested and, by implication, in that of the woman that they constantly threaten collapse.

A feminism concerned with the question of looking can therefore turn this theory around and stress the particular and limiting opposition of male and female which any image seen to be flawless is serving to hold in place. More simply, we know that women are meant to *look* perfect, presenting a seamless image to the world so that the man, in that confrontation with difference, can avoid any apprehension of lack. The position of woman as fantasy therefore depends on a particular economy of vision (the importance of 'images of women' might take on its fullest meaning from this).[13] Perhaps this is also why only a project which comes via feminism can demand so unequivocally of the image that it renounce all pretensions to a narcissistic perfection of form.

At the extreme edge of this investigation, we might argue that the fantasy of absolute sexual difference, in its present guise, could be upheld only from the point when painting restricted the human body to the eye.[14] That would be to give the history of the image in Western culture a particularly heavy weight to bear. For, even if the visual image has indeed been one of the chief vehicles through which such a restriction has been enforced, it could only operate like a law which always produces the terms of its own violation. It is often forgotten that psychoanalysis describes the psychic law to which we are subject, but only in terms of its *failing*. This is important for a feminist (or any radical) practice which has often felt it necessary to claim for itself a wholly other psychic and representational domain. Therefore, if the visual image in its aesthetically acclaimed form serves to maintain a particular and oppressive mode of sexual recognition, it does so only partially and at a cost. Our previous history is not the petrified block of a singular visual space since, looked at obliquely, it can always be seen to contain its moments of unease.[15] We can surely relinquish the monolithic view of that history, if doing so allows us a form of resistance which can be articulated *on this side of* (rather than beyond) the world against which it protests.

Among Leonardo's early sketches, Freud discovers the heads of laughing women, images of exuberance which then fall out of the great canon of his art. Like Leonardo's picture of the sexual act, these images appear to unsettle Freud as if their pleasure somehow correlated with the discomfort of the sexual drawing (the sexual drawing through its failure, the heads of laughing women for their excess). These images, not well known in Leonardo's canon, now have the status of fragments, but they indicate a truth about the tradition which excludes them, revealing the presence of something strangely insistent to which these artists return. '*Teste di femmine, che ridono*'[16] – laughter is not the emphasis here, but the

urgent engagement with the question of sexuality persists now, as it did then. It can no more be seen as the beginning, than it should be the end, of the matter.

NOTES

1 Sigmund Freud, 'Leonardo da Vinci and a Memory of his Childhood', p. 70n; p. 159n. [. . .] Only part of the drawing discussed here is now attributed to Leonardo, see 'Leonardo da Vinci', PF 11, p. 161n.

2 Freud, 'The Dissection of the Psychical Personality', p. 79; p. 112 (passage retranslated by Samuel Weber in *The Legend of Freud*, p. 1).

3 Peter Wollen makes a similar point on the relationship between perceptual and sexual contradiction in Manet's Olympia in 'Manet – Modernism and Avant-Garde', *Screen* 21: 2, Summer 1980, p. 21.

4 Freud, 'Some Psychical Consequences of the Anatomical Distinction between the Sexes', p. 252, pp. 335–336.

5 Freud, *From the History of an Infantile Neurosis*, pp. 29–47; pp. 80–81.

6 On the centrality of the visual image in Lacan's topography of psychic life, and on enunciation and the lying subject see 'The Imaginary' and 'Dora – Fragment of an Analysis', note 24.

7 For discussion of these issues in relation to film, see Laura Mulvey's crucial article, 'Visual Pleasure and Narrative Cinema', and also Jane Weinstock's article in *Difference: On Representation and Sexuality*.

8 Roland Barthes. 'Change the Object Itself'.

9 Barthes, *S/Z*.

10 Leo Steinberg defined postmodernism as the transition from nature to culture; this is reinterpreted by Craig Owens, 'The Allegorical Impulse – Towards a Theory of Postmodernism', *October* 12–13, Spring and Summer 1980, esp. pp. 79–80, and also Douglas Crimp, 'On the Museum's Ruins', *October* 13, Summer 1980. Craig Owens has recently used Freud's account of the creative impulse in a critical appraisal of the Expressionist revival, 'Honor, Power and the Love of Women', *Art and Artists*, January 1983.

11 For a discussion of some of these issues in relation to feminist art, see Mary Kelly, 'Re-viewing Modernist Criticism', *Screen* 22: 3, Autumn 1981.

12 'Leonardo da Vinci and a Memory of his Childhood', p. 95; pp. 186–187.

13 The status of the woman as fantasy in relation to the desire of the man was a central concern of Lacan's later writing; see *Encore*, especially 'God and the Jouissance of Woman' and 'A Love Letter' in *Feminine Sexuality*, and the commentary, 'Feminine Sexuality – Jacques Lacan and the *école freudienne*', in this collection.

14 Norman Bryson describes post-Albertian perspective in terms of such a restriction in *Vision and Painting: The Logic of the Gaze*, London 1983.

15 See Lacan on death in Holbein's 'The Ambassadors', *The Four Fundamental Concepts* pp. 85–90.

16 'Leonardo da Vinci and a Memory of his Childhood', p. 111; p. 203. An exhibition entitled *The Revolutionary Power of Women's Laughter*, including works by Barbara Kruger and Mary Kelly was held at Protetch McNeil, New York, January 1983.

viii) Laura Mulvey, 'Fears, Fantasies and the Male Unconscious *or* "You Don't Know What is Happening, Do You, Mr Jones?" ' (1972)

Laura Mulvey is a feminist film-maker and Professor of Film at Birkbeck College, London. She is probably best known for her highly influential and polemical article 'Visual Pleasure and Narrative Cinema', first published in 1975, in which she uses psychoanalytic theory to explore the social and psychic processes involved in the 'male gaze'. The essay 'Fears, Fantasies and the Male Unconscious' was written in 1972 and first published in the popular feminist magazine *Spare Rib* in 1973 as a response to an exhibition of the work of Allen Jones held in Tooth's Gallery in 1970. Utilising Freudian accounts of castration anxiety, Mulvey explores

the fetishistic nature of Jones's work, arguing that by drawing on imagery from the whole of the mass media, Jones calls attention to the all-pervasive nature of fetishistic images of women in our culture. [GP]

Source: Laura Mulvey, 'Fears, Fantasies and the Male Unconscious or 'You Don't Know What is Happening, Do You, Mr Jones?' (1972), printed in Laura Mulvey, *Visual and Other Pleasures*, Macmillan, 1989, pp. 6–13

To decapitate equals to castrate. The terror of the Medusa is thus a terror of castration that is linked to the sight of something. The hair upon the Medusa's head is frequently represented in works of art in the form of snakes, and these once again are derived from the castration complex. It is a remarkable fact that, however frightening they may be in themselves, they nevertheless serve actually as a mitigation of the horror, for they replace the penis, the absence of which is the cause of the horror. This is a confirmation of the technical rule according to which a multiplication of penis symbols signifies castration. (Freud, 'The Medusa's Head')

In 1970 Tooth's Gallery in London held a one-man show of sculptures by Allen Jones which gained him the notoriety he now enjoys throughout the Women's Movement. The sculptures formed a series, called 'Women as Furniture', in which life-size effigies of women, slave-like and sexually provocative, double as hat-stands, tables and chairs. The original of *Chair* is now in the Düsseldorf home of a West German tycoon, whose complacent form was recently photographed for a *Sunday Times* article, sitting comfortably on the upturned and upholstered female figure. Not surprisingly, members of Women's Liberation noticed the exhibition and denounced it as supremely exploitative of women's already exploited image. Women used, women subjugated, women on display: Allen Jones did not miss a trick. [. . .]

At first glance Allen Jones seems simply to reproduce the familiar formulas which have been so successfully systematised by the mass media. His women exist in a state of suspended animation, without depth or context, withdrawn from any meaning other than the message imprinted by their clothes, stance and gesture. The interaction between his images and those of the mass media is made quite explicit by the collection of source material which he has published. *Figures*[1] is a scrapbook of cuttings out of magazines, both respectable (*Nova, Harper's Bazaar, Life, Vogue, Sunday Times* supplement and so on) and non-respectable (*Exotique, Female Mimics, Bound, Bizarre* and so on). There are also postcards, publicity material, packaging designs and film stills (*Gentlemen Prefer Blondes, Barbarella, What's New, Pussycat?*). *Projects*,[2] his second book, records sketches and concepts (some unfinished) for stage, film and TV shows, among them *Oh Calcutta!* and Kubrick's *A Clockwork Orange* and includes more source material as an indication of the way his ideas developed.

By publishing these clippings Allen Jones gives vital clues, not only to the way he sees women, but to the place they occupy in the male unconscious in general.

He has chosen images which clearly form a definite pattern, which have their own visual vocabulary and grammar. The popular visuals he produces go beyond an obvious play on the exhibitionism of women and the voyeurism of men. Their imagery is that of a fetishism. Although every single image is a female form, not one shows the actual female genitals. Not one is naked. The female genitals are always concealed, disguised or supplemented in ways which alter the significance of female sexuality. The achievement of Allen Jones is to throw an unusually vivid spotlight on the contradiction between woman's fantasy presence and real absence from the male unconscious world. The language which he speaks is the language of fetishism, which speaks to all of us every day, but whose exact grammar and syntax we are usually only dimly aware of. Fetishistic obsession reveals the meaning behind popular images of women.

It is Allen Jones's mastery of the language of 'basic fetishism' that makes his work so rich and compelling. His use of popular media is important not because he echoes them stylistically (pop art) but because he gets to the heart of the way in which the female image has been requisitioned, to be recreated in the image of man. The fetishist image of women has three aspects, all of which come across clearly in his books and art objects. First: woman plus phallic substitute. Second: woman minus phallus, punished and humiliated, often by woman plus phallus. Third: woman as phallus. Women are displayed for men as figures in an amazing masquerade, which expresses a strange male underworld of fear and desire.

THE LANGUAGE OF CASTRATION ANXIETY

The nearer the female figure is to genital nakedness, the more flamboyant the phallic distraction. The only example of frontal nudity in his work, a sketch for *Oh Calcutta!*, is a history of knickers, well-worn fetishist items, in which the moment of nakedness is further retrieved by the fact that the girls are carrying billiard cues and an enormous phallus is incorporated into the scenery. In the source material, a girl from *Playboy* caresses a dog's head on her lap; another, on the cover of a movie magazine, clutches an enormous boa constrictor as it completely and discreetly entwines her. Otherwise there is an array of well-known phallic extensions to divert the eye: guns, cigarettes, erect nipples, a tail, whips, strategically placed brooches (Marilyn Monroe and Jane Russell in *Gentlemen Prefer Blondes*), a parasol, and so on, and some, more subtle, which depend on the visual effect of shadows or silhouettes.

Women without a phallus have to undergo punishment by torture and fetish objects ranging from tight shoes and corsetry, through rubber goods to leather. Here we can see the *sadistic* aspect of male fetishism, but it still remains fixated on objects with phallic significance. An ambiguous tension is introduced within the symbolism. For instance, a whip can be simultaneously a substitute phallus and an instrument of punishment. Similarly, the high heel on high-heeled shoes, a classic fetishist image, is both a phallic extension and a means of discomfort and constriction. Belts and necklaces, with buckles and pendants, are both phallic

symbols and suggest bondage and punishment. The theme of *woman bound* is one of the most consistent in Allen Jones's source material: at its most vestigial, the limbs of pin-up girls are bound with shiny tape, a fashion model is loaded with chains, underwear advertisements, especially for corsets, proliferate, as do rubber garments from fetishistic magazines. Waists are constricted by tight belts, necks by tight bands, feet by the ubiquitous high-heeled shoes. For the television show illustrated in *Projects* Allen Jones exploits a kind of evolved garter of black shiny material round the girls' thighs, which doubles, openly in one case, as a fetter. The most effective fetish both constricts and uplifts, binds and raises, particularly high-heeled shoes, corsets or bras and, as a trimming, high neck bands holding the head erect.

[. . .]

THE FETISHIST'S COLLECTION OF SIGNS

To understand the paradoxes of fetishism, it is essential to go back to Freud. Fetishism, Freud first pointed out, involves displacing the sight of woman's imaginary castration onto a variety of reassuring but often surprising objects – shoes, corsets, rubber gloves, belts, knickers and so on – which serve as *signs* for the lost penis but have no direct connection with it. For the fetishist, the sign itself becomes the source of fantasy (whether actual fetish objects or else pictures or descriptions of them) and in every case the sign is the sign of the phallus. It is man's narcissistic fear of losing his own phallus, his most precious possession, which causes shock at the sight of the female genitals and the subsequent fetishistic attempt to disguise or divert attention from them.

A world which revolves on a phallic axis constructs its fears and fantasies in its own phallic image. In the drama of the male castration complex, as Freud discovered, women are no more than puppets; their significance lies first and foremost in their lack of a penis and their star turn is to symbolise the castration which men fear. Women may seem to be the subjects of an endless parade of pornographic fantasies, jokes, day-dreams and so on, but fundamentally most male fantasy is a closed-loop dialogue with itself, as Freud conveys so well in the quotation about the Medusa's head. Far from being a woman, even a monstrous woman, the Medusa is the sign of a male castration anxiety. Freud's analysis of the male unconscious is crucial for any understanding of the myriad ways in which the female form has been used as a mould into which meanings have been poured by a male-dominated culture.

Man and his phallus are the real subject of Allen Jones's paintings and sculptures, even though they deal exclusively with images of women on display. From his scrapbooks we see how the mass media provide material for a 'harem cult' (as Wilhelm Stekel describes the fetishist's penchant for collections and scrapbooks in his classic psychoanalytic study) in which the spectre of the castrated female, using a phallic substitute to conceal or distract attention from her wound, haunts the male unconscious. The presence of the female form by no means ensures that the message of pictures or photographs or posters is about women. We could say that

the image of woman comes to be used as a sign, which does not necessarily signify the meaning 'woman' any more than does the Medusa's head. The harem cult which dominates our culture springs from the male unconscious and woman becomes its narcissistic projection.

Freud saw the fetish object itself as phallic replacement so that a shoe, for instance, could become the object on which the scandalised denial of female castration was fixated. But, on a more obvious level, we could say with Freud in 'The Medusa's Head' that a *proliferation* of phallic symbols must symbolise castration. This is the meaning of the parade of phallic insignia borne by Allen Jones's harem, ranging from precisely poised thighs, suggestive of flesh and erection, through to enormous robots and turrets. Castration itself is only rarely alluded to in even indirect terms. In one clipping an oriental girl brandishes a large pair of scissors, about to cut the hair of a man holding a large cigar. In another, a chocolate biscuit is described in three consecutive pictures: *c'est comme un doigt* (erect female finger), *avec du chocolat autour* (ditto plus chocolate), *ça disparaît très vite* (empty frame), then larger frame and triumphal return, *c'est un biscuit: Finger de Cadbury* (erect biscuit held by fingers).

There is one exception to this: the increasingly insistent theme of women balancing. Female figures hang suspended, on the point of coming down (the phallic reference is obvious). Anything balanced upright – a woman walking a tightrope or balancing a tray or poised on the balls of her feet – implies a possible catastrophe that may befall. The sculptures of women as furniture, especially the hat-stand, freeze the body in time as the erect pose seems to capture a moment, and also they are suspended, cut off from any context, to hang in space. In addition, the formal structure of some of Jones's earlier paintings – three-dimensional flights of steps leading steeply up to two-dimensional paintings of women's legs poised on high heels – describe an ascension: erect posture and suspension and balance are fused into one illusionistic image.

In his most recent paintings, exhibited this summer at the Marlborough Galleries, Allen Jones develops the theme of balance much further. A number of the paintings are of women circus performers, objects of display and of balance. Here the equation 'woman = phallus' is taken a step further, almost as if to illustrate Freud's dictum that 'the remarkable phenomenon of erection which constantly occupies the human phantasy, cannot fail to be impressive as an apparent suspension of the laws of gravity (of the winged phalli of the ancients)'. In *Bare Me*, for example, the phallic woman, rigid and pointing upwards, holding her breasts erect with her hands, is standing in high heels on a tray-like board balanced on two spheres. She is on the way up, not down. Loss of balance is possible, but is not immediate.

But in other paintings this confidence is undercut. The defiance of gravity is more flamboyant than convincing. The same devices – high heels, walking on spheres – which compel an upright, erect posture can also point to its precariousness. The painting *Whip* is derived from a brilliant Eneg drawing of two women, castrator and castrated: a woman lassoed by a whipcord is slipping off a three-legged stool. In the painting, we can see only the toppling stool, but there can be

no doubt from comparison with the Eneg source that the real absence – symbolic castration – is intended. In another painting, *Slip*, both figures from the same Eneg drawing are combined into one and loss of balance becomes the explicit theme. Dancers on points, waitresses carrying trays, women acrobats teetering on high heels or walking the tightrope – all are forced to be erect and to thrust vertically upwards. But this phallic deportment carries the threat of its own undoing: the further you strive up, the further you may fall.

[. . .]

Most people think of fetishism as the private taste of an odd minority, nurtured in secret. By revealing the way in which fetishistic images pervade not just specialised publications but the *whole of the mass media*, Allen Jones throws a new light on woman as spectacle. The message of fetishism concerns not woman, but the narcissistic wound she represents for man. Women are constantly confronted with their own image in one form or another, but what they see bears little relation or relevance to their own unconscious fantasies, their own hidden fears and desires. They are being turned all the time into objects of display, to be looked at and gazed at and stared at by men. Yet, in a real sense, women are not there at all. The parade has nothing to do with woman, everything to do with man. The true exhibit is always the phallus. Women are simply the scenery onto which men project their narcissistic fantasies. The time has come for us to take over the show and exhibit our own fears and desires.

NOTES

1 Allen Jones, *Figures* (Berlin: Galerie Mikro, and Milan: Edizioni O, 1969).
2 Allen Jones, *Projects* (London: Matheus Miller Dunbar, and Milan: Edizioni O, 1971).

ix) Whitney Davis, from 'Founding the Closet: Sexuality and the Creation of Art History' (1992)

Whitney Davis teaches art history at Northwestern University, Chicago. His books include: *The Canonical Tradition in Ancient Egyptian Art* (1990); *Masking the Blow: The Scene of Representation in Late Prehistoric Egyptian Art* (1992); and *Latent Images; Homosexuality and Visual Interpretation of Freud's 'Wolf Man Case'* (1995). In 1994 he wrote the introduction to the *Journal of Homosexuality* special issue on art history. As is apparent from this list of publications Davis writes on both ancient Egyptian art and on gay art history. As part of the questioning of art history to questions of gender and spectatorship a number of writers, among whom Davis has been prominent, have explored the patterns of same sex identification and desire in art and its histories. In the text published here he considers the significance of homoerotic experience in shaping one of the founding works of modern art history, Winckelmann's *History of Ancient Art* (1764). Davis argues that Winckelmann's interest in classical culture stemmed from its availability as a

model of sexual freedom and that the circuit of classical scholarship operated as an understood part of a homosexual subculture. He suggests that it was a condition of existence for this subculture that it functioned clandestinely. Winckelmann, he points out, therefore sublimated his desire into a series of formal judgements about beauty. While it is understandable, Davis argues, that Winckelmann's desires were written in euphemistic form, subsequent art history has been only too happy to continue in this mode and to place homosexuality in the 'closet'. In the section of the text not included here the author recounts the difficulty he encountered in attempting to find accounts and published images with which to teach a component 'on the homosocial or homosexual elite male social life in classical Athens' for a course on 'Greek Civilisation in the Classical Period'. Davis suggests that the lack, or inaccessibility, of appropriate material for this subject indicates art history's sanitisation of sexual diversity. The context for this essay is provided by recent attempts by the State in the USA to censor a number of art exhibitions including the work of gay photographer Robert Mapplethorpe. Davis concludes that art history needs to think carefully about its own repression and censorship of homosexuality. (Notes omitted and re-ordered.) [SE]

Source: Whitney Davis, from 'Founding the Closet: Sexuality and the Creation of Art History', *Art Documentation. Bulletin of the Art Libraries Society of North America*, vol. 11, no. 4, Winter 1992, pp. 171–5

In 1992, it might appear that calls for censorship of the arts have become increasingly common. The recent efforts of authorities in Cincinnati to police Dennis Barrie's exhibition of Robert Mapplethorpe's photographs sparked a controversy that was intense in its own right and also came to stand for the larger problems facing artists, art historians, art curators, art archivists, and art librarians today. We have, of course, won some important battles. To take one notorious example, Senator Jesse Helms's proposed amendments to congressional appropriations bills would have changed the accepted way in which the National Endowment for the Arts disburses grants to artists through peer review processes standard throughout the scientific and academic world – but they were beaten back.[1]

In a war, as another recent experience has shown, it is very easy to represent the other side according to convenient stereotype and to overlook the extent of one's own hypocrisy, opportunism, or responsibility for the very situation one claims to oppose. Art scholarship is no exception. Today it finds itself fighting intervention or censorship from the outside, at the same time as it has experienced and practiced various forms of internal censorship dating from the 1750s or 1760s, when modern techniques of collecting art objects, exhibiting and cataloging them, acquiring and storing information about them, and analyzing them were formalized in what we now call art history.[2] I have no intention of arguing here that art history's contemporary efforts to combat censorship and ensure wide access to art and the knowledge about it are totally vitiated by its own long-standing implication in techniques of policing art and art historical knowledge. (No doubt,

however, there is some truth in the old saw about the mote in your brother's eye). Instead, in this brief essay I want to notice something more complex in the particular case of art history's relationship with homosexual artists, collectors, critics, and scholars, among whom Robert Mapplethorpe must be counted. Since its beginning in the 1760s, the scholarly study of art has involved a displacement of questions of sexuality, especially homosexuality. This displacement has so profoundly affected the very methods, theories, and resources of art history that art history, over 200 years later, is not in the best position to do the job in contexts like the Cincinnati struggle. Crudely, in Cincinnati, art history was forced to lie when it should have been speaking the truth.

I have space to comment on this matter in only two ways. First, I want to remark – mostly through personal observation, since systematic studies are lacking – on the gap between what kind of resources art history needs to fight its battles today and the actual state of these resources in existing museums, libraries, and scholarly databases. My point here will be that art history's own history has not provided what is needed today. Second, I want to identify briefly some of the psychological, social, and historical forces – they must be deep, persisting, and pervasive ones – that might explain this resource gap. There are many ways to examine this question, but I will do so by going to the historical origins of the problem.
[. . .]

Although there are important roots for modern art history in the archaeology and antiquarianism of the Renaissance, for my purposes the main episode to consider is the crafting of what is generally accepted as the first true history of art, Winckelmann's *History of Ancient Art*, first published in Dresden in 1764.[3] Winckelmann is an enigmatic figure. Serious study of his achievement is hampered by the very closeting of essential resources [. . .]. Intimate letters detailing his erotic interests and sexual escapades, for example, still remain partly untranslated.[4] Winckelmann's same-sex erotics were recognized by his acutest commentator, Goethe, to motivate much of his conceptual labor;[5] but what those erotics actually involved remains uncertain, although we have at least one possibly reliable document in Casanova's report of discovering Winckelmann relaxing with one of the young Roman castrati he favored, as well as Winckelmann's own testimonies to his infatuations with noble German boys he was hired to tutor or guide. Late in his life, before his murder in 1768, Winckelmann was a valued member of the Papal Court, the personal librarian to the great collector Cardinal Alessandro Albani, as well as Albani's advisor and confidant.[6] But he was born to a poor family in Prussia, studying and finding his first secretarial jobs in a state with some of the most repressive laws against sodomy, harshly enforced for the lower classes by Frederick the Great.[7] Although he seems to have had a long affair in the 1740s with his first private student, a modern psychologist might say that through Winckelmann's early middle age he ferociously sublimated both his sexual appetite and his political views, which turned toward republicanism and anticlericalism. His self-censorship was not only in the interest of personal security, however. As he moved up in the world and especially after he moved to Italy with his patron Cardinal Albani, in 1755, he was freer to move in the sexually permissive world of the upper classes.[8] He also behaved

opportunistically. Recognizing, for example, that nominal Catholicism was a paper credential for employment in Rome, he converted. The threads are tangled: he converted in order to get to Rome, for Rome was where he could best pursue classical studies, but Rome, as well as Greek art, already signified sexual freedom to any worldly European.[9] It is safe to suppose that Winckelmann, both socially and personally defined as a sodomite interested in sexual activity with others of his own sex, participated in the sodomitical subculture of his day, a subculture that revolved, like some 20th-century urban homosexual subcultures, around certain cafés, theaters, and drinking establishments, as well as open-air strolling in various quarters of the city and suburbs. It is entirely relevant to remember that one of Winckelmann's chief employments as papal antiquarian was to guide British, German, and other northern gentlemen on their tour through the ruins of Rome, an activity that by the late 18th century already clearly signified, at least for many participants, the availability of sex with local working boys, liaisons that tended to be frustrated or proscribed in the Anglo-German states. That Winckelmann's apartment in Rome was graced with a bust of a faun, which he published and described in his treatise, was not, then, merely a manifestation of his antiquarian scholarship in the questions of Greco-Roman art history. It also was fully consistent with, and probably functioned partly as, his self-definition and representation in the contemporary subculture to which he belonged.

Winckelmann raised art history from the chronicle of artists' lives and commissions to a higher level that includes systematic stylistic analysis, historical contextualization, and even iconographical analysis, especially if we include writings like his publications of gems and other antiquities and his treatise on visual allegory. Of course, Winckelmann also helped to forge one of the essential tools of general criticism: in his essays on the *Belvedere Torso* and *Apollo* and on the *Laokoön*, the latter included in the *History*,[10] he produced lengthy focused descriptions of the individual artwork as it appears to us, an appearance that can be turned either to aesthetic-ethical or to historical analysis. Winckelmann's *History* has to be read carefully to identify his strange separation between the known meaning of ancient Greek sculptures, revolving partly around the sexualized cult of masculinity noted earlier, and the history of Greek style. Essentially, Winckelmann focused his attention, and that of the entire tradition of art history which inherits its twinned methods of 'formalism' and 'historicism' from him, on the *form* of Greek art and on the facts of technique, use, and the like, going all the way back to such factors as climate, which he deemed to be relevant to explaining form historically. But major aspects of the art's *content*, its frequent depiction of or allusion to the social practices of ancient Greek masculinity, homosociality, and homosexuality, were not usually acknowledged. When meaning absolutely *had* to be addressed in the formal or historical analysis, Winckelmann employed an elaborate euphemism. For him, Greek art is formally about and historically depends on 'freedom,' although the freedom to be or to do exactly what is left somewhat undefined. It would certainly be a misreading of German Enlightenment discourse to suppose that Winckelmann's *Freiheit* means political freedom alone: as in Kant, freedom is a cognitive condition or capability.[11]

At points, Winckelmann's understanding of the freedom of Greek art does shine forth, but always in code. For example, the naturalistic beauty of a Greek statue came, for Winckelmann, from the Greek sculptors' close observation of inherently beautiful boys naked in the gymnasium. But exactly why the boys are inherently beautiful is not represented as a personal attitude of the historian-observer, which it must be; instead, it is said to result from the favorable Greek climate and social context of training men for war, factors which must somehow determine particular forms of beauty or of art. In general, throughout Winckelmann's writing on the history of art, as opposed, in some cases, to his more philosophical meditations on questions of aesthetics, such objective histori-cist explanation overrides the subjective aesthetic, political-sexual response that motivated it in the first place.

An alert reading can catch Winckelmann's contradictions in his systematic trans-position of subjective personal erotics and politics into objectivizing formalist and historicist analysis. One striking contradiction creeps in almost as if he could not help it. According to the explicit standards of Winckelmann's analysis, the Hel-lenistic hermaphrodites, let alone the Roman portraits of Hadrian's young lover Antinous, were contemporary with the total decline of general freedom in Greece and thus could not embody the essence of Greek art. But Winckelmann nonetheless cites them as great Classical works: which just goes to show that the real denotation of freedom, for Winckelmann, is not, or not only, in civic politics at all but rather in species of social-sexual license possible in a monarchic or impe-rial society as much as in a democratic one.[12] Winckelmann's very definition of classicism can only be established in implicit relation to the various formal and his-torical precursors of classicism itself – the Egyptian, archaic Greek, Etruscan, and late Roman (Byzantine) arts which Winckelmann, although bound by his own his-toricist reasoning, cannot quite disentangle from a classicism that is supposedly the autonomous formal expression of historical factors peculiar to the 5th century and late 4th century Greek city-states. For example, because Greece in the 6th century possessed the same climate and roughly the same militarized competitiveness as Greece in the 5th century, according to Winckelmann's historicism, its art should be classically beautiful. What archaic Greece supposedly lacked, of course, was poli-tical freedom; but if Winckelmann is willing to admit the unfree, if Hellenized, art of Hadrianic Rome or Justinian's Ravenna as producing great classicism, on what grounds can he exclude the 6th-century *kouroi*, the remarkable but frequently unnaturalistic standing statues of naked youths. Obviously, the real point of distinction must lie in other aesthetic or ethical responses to the *kouroi* and natu-ralism respectively, but Winckelmann does not directly produce his criteria. Instead, the objective formal-historical chronology, with its statement of causes and sequences and classification of species of the beautiful, is supposed in itself to render the distinction intelligible to us *ex post facto*. Despite their lack of freedom, Rome or Ravenna preserve enough of a memory of Greek classicism to engender a Classical art, while archaic Greece, although causally and chronologically closer to the zenith, did not. As Winckelmann's logic here implies, one of his criteria for the presence of the Classical turns on the play of memory and retrospective allusion, a

condition foreclosed in advance for all forerunners of the Classical Greeks, who cannot remember and allude to what has not yet happened. Thus Egyptian art remains aesthetically inert for Winckelmann even though he makes some penetrating observations about its formal organization and historical meaning. Significantly, however, Etruscan art gives Winckelmann trouble: it is neither really a forerunner nor quite an inheritor of 5th-century Greek art but rather a parallel cultural development. A reader of Winckelmann's book can be forgiven for not being able to work out these tangles even though they have interested historians today: the general point is that the *History of Ancient Art* largely manages the erotic – the wish for and memory of what is subjectively witnessed as beautiful and desirable in sexual, political, and ethical terms – almost entirely off stage.

'Off stage,' that is, from the point of view of the reader. From the point of view of Winckelmann, however, it is possible that he was having things both ways. Exploring his sexual and ethical attractions, actively filling them out with images, information, and a social and historical reality, both through and in the very doing of his research, he finally transposes them all into another narrative for others. In the process, the resource gap I noted in the first part of this essay opens up. What seems, from the point of view of a reader hunting for information, to be the *primary* data base, the collection of visual and archaeological facts with basic formal and historical analysis attached to them, is actually already *secondary*. The ostensibly primary data is a selection from and euphemization or substitution of those data that are *truly* primary – namely, on the one hand, the sexual-political responses of researchers to their own desires and to the social world in which they find themselves and, on the other, the particular knowledge they gather to understand and control these responses. Art history is a *discipline*, as has been pointed out many times; but what it disciplines are not the facts of art history, or only secondarily the facts of art history. What it primarily and inaugurally disciplines is itself.

We can readily fault Jesse Helms for trying to censor art and its exhibition, publication, and discussion, for the external intervention in the disciplines of art history, curatorship, or archiving. But I do not blame art historians for the internal closeting I have been indicating here. Winckelmann's complex personal and textual self-discipline is not exactly the same thing as social censorship, especially if it is undertaken, as might have been or still be the case, to avoid or survive an external, imposed censorship or suppression. And I do not just mean to refer to the historical suppression of homoeroticism, pederasty, and sodomy or, latterly, of homosexuality. The repressions requiring the self-discipline or self-censorship of art history include much broader, more diffuse attempts to contain human variety and its multiple ways of immediately engaging the world. At what might be the most general level of all, art history has consistently sited visual meaning in the fully abstract, derealized domains of optics and of signs and the salient historical context of this meaning in the domain of articulated, rationally managed disputes about ideas in institutional policies and in wider social affairs. Optics, signs, and historical contexts so defined are, of course, objectively describable using one or another of the many scientific, or, more properly, scientistic, techniques of art theory, semiology, or sociology; but in each case, to carry out the objective

analysis, one must be transported, or transposed, out of the actual bodily and mental realities involved, namely, for optics, looking; for signs, sense; and for social context, subjectivity. And as the examples of Winckelmann and Mapplethorpe show, this transposition is not a full translation of the erotically interesting into the objectively known; certain realities drop out.

One of the ironies of Dennis Barrie's trial in Cincinnati, for me, was the argument, successful, it turned out, of the curators and scholars. In reviewing the transcripts, one finds that Barrie's defenders said very little about the content or meaning of Mapplethorpe's 'X' pictures, about B&D and the leather world, rubber, or water sports, and Mapplethorpe's intriguing, problematic images as particular historical versions of the affective or aesthetic realities of those worlds.[13] Their argument was, as it were, *falsely* affective and aesthetic: they went on about the striking compositions, superb lighting, and general formal beauty of the photos, and about Mapplethorpe's historical place in the development of modern photography. The jury, of course, was reassured to hear this voice from the closet, for it actually implied that the images are more closeted, less disruptive, than they really are – art, not representation, beauty, not freedom. In this particular case, the closet did the job against censorship without needing to put into evidence anything other than tried-and-true aesthetic and art historical banalities it could parade in hundreds of other situations as well. But one wonders how long this device is going to work before outsiders see it for the deflection and euphemism the historians already know it to be.

NOTES

1　After this paper was delivered, the situation changed for the worse. Reports have circulated that the peer review process has been compromised, prompting the president of the College Art Association, Larry Silver, to complain to the acting chairperson of the National Endowment for the Arts (see the *CAA Newsletter*, May 1992). As is widely known, the previous chairperson. John Frohnmayer, was forced out of his job when the administration caved in to pressure from the far-right wing of the Republican party.

2　The full history of the formation of art history remains to be written: for two views, see Heinrich Dilly, *Kunstgeschichte als Institution – Studien zur Geschichter einer Disciplin* (Frankfurt: Suhrkamp, 1979), and Donald Preziosi, *Rethinking Art History, Meditations on a Gay Science* (New Haven: Yale University Press 1989). For collecting practices at the end of the 18th century, see especially Krzysztol Pomian, *Collectors and Curiosities: Paris and Venice, 1500–1800*, trans. Elizabeth Wiles-Porter (*Cambridge*: Polity Press, 1990).

3　The only English translation, by G. H. Lodge (4 vols. Boston: Little, Brown, 1880), is unsatisfactory in several respects; a new rendition is long overdue. The French translation (supposedly by Hubert, but not credited in the publication) is worth consulting for its more subtle representation of Winckelmann's nuanced prose (*Histoire de l'art chez les anciens, par Winckelmann, avec des notes historiques et critiques de differens auteurs* [Paris: Bossange, Masson et Besson, 1802–3]).

4　The best (but still incomplete) edition is J. J. Winckelmann, *Briefe*, ed. Walter Rehm. 4 vols. (Berlin: De Gruyter, 1952–55); selections can be found in the standard, still unsurpassed biography: Carl Justi, *Winckelmann und seine Zeitgenossen*, 3 vols. 2nd ed. (Leipzig: F. C. W. Voegl, 1898).

5　J. W. von Goethe, *Winckelmann und sein Jahrhundert in Briefen und Aufsätzen*, ed. H. Holtzhauer (Leipzig: Seeman Verlag, 1969). Although there have been numerous subtle studies of Winckelmann's art historical writing and aesthetic theory, only a handful have attempted to integrate them with an account of his sexuality. The most successful, although still problematic or idiosyncratic in one way or another, are Leopold D. Ettlinger. 'Winckelmann, or Marble Boys are Better,' in *Art the Ape of Nature, Studies in Honor of H. W. Janson*, ed. Moshe Barasch and Lucy Freeman Sandler. (Englewood Cliffs. N.J.: Prentice Hall, 1981). 505–11; Hans Mayer, 'Winckelmann's Death and the

Discovery of a Double Life,' in *Outsiders. A Study in Life and Letters*, trans. Denis M. Sweet (Cambridge, Mass.: MIT Press, 1982). 167–74; Denis M. Sweet, 'The Personal, the Political, and the Aesturin: Johann Joachim Winckelmann's German Enlightenmant Life,' in *Journal of Homosexuality* (special double issue subtitled 'The Pursuit of Sodomy: Male Homosexuality in Renaissance and Englightenment Europe') 16,00, 1/2 (1988); 147–61.

6 See W. O. Collier, 'The Villa of Cardinal Alessandro Albani. Hon F.S.A.,' *Antiquaries Journal* 67 (1987): 338–17. According to G. S. Rousseau, "The villa of Cardinal Albani in Rome . . . was an unrivaled nervecenter for combined antiquarian and homosocial activity. In the unique atmosphere of this Roman villa many homosexual aesthetes, in addition to Winckelmann, the bisexual [Anton] Mengs, and the homosocial Richard Payne Knight, discovered their artistic and erotic sides conjoined.' ('The Pursuit of Homosexuality in the Eighteenth Century: 'Utterly Confused Category' and/or Rich Repository?,' *Eighteenth Century Life* (special issue subtitled 'Unauthorized Sexual Behavior in the Enlightenment') 9 (May 1985): 155).

7 James D. Steakley. 'Sodomy in Englightenment Prussia: From Execution to Suicide,' *Journal of Homosexuality* 16, no. 1/2 (1988): 163–74.

8 Much remains to be done in reconstructing the social and cultural history of male-male and female-female sexuality in the Ancien Regime, the German courts, the Papal Court, and elsewhere, but solid beginnings have been made by Maccubbin, ed., 'Unauthorized Sexual Behavior in the Englightenment' (see note 6); Gerard and Hekma, eds., 'The Pursuit of Sodomy' (see note 5); and G. S. Rousseau and Roy Porter, eds. *Sexual Underworlds of the Enlightenment* (Chapel Hill, N.C.: University of North Carolina Press, 1988). In addition to his homoerotic or pederastic involvements with young men, Winckelmann was interested in castrati and hermaphrodites. Although the former had a major role in 18th-century cultural life and the latter a well-defined place in the 18th-century topography of gender, hard information about their participation in 'sexual underworlds' of the 18th century is still very scattered.

9 See especially G. S. Rousseau, 'The Sorrows of Priapus: Anticlericalism, Homosocial Desire, and Richard Payne Knight,' Rousseau and Porter, eds. *Sexual Underworlds of the Enlightenment*, 101–53.

10 For Winckelmann's publications of gems and other antiquities, see, J. J. Winckelmann, *Description des Pierres gravées du feu Baron de Stosch* (Florence, 1760); *Monumenti Antichi Inediti* (Rome, 1767). For his treatise on allegory, see *Versuch einer Alleggorie, besonders für die Kunst* (Dresden, 1766). For his general aesthetic ideas, see especially *Gedanken über die Nachahmung der griechischen Werke in der Mahlerei und Bildhauerkunst* (Dresden, 1755). A good English translation of the last, Winckelmann's early but extraordinarily influential call for the 'imitation' of ancient art by modern artists, is *Reflections on the Imitation of Greek Works in Painting and Sculpture*, trans. Elfriede Heyer and Roger C. Norton (La Salle. Ill.: Open Court, 1987).

11 See especially Peter D. Fenves, *A Peculiar Fate: Metaphysics and World-History in Kant* (Ithaca, N.Y.: Cornell University Press, 1991). The most overt (although not wholly intelligible) connection between Winckelmann's idealization of freedom and the principles of political republicanism was made by his French readers at the end of the 18th century: see Alex Potts. 'Political Attitudes and the Rise of Historicism in Art Theory,' *Art History* 1 (1978): 191–213; id., 'Beautiful Bodies and Dying Heroes: Images of Ideal Manhood in the French Revolution,' *History Workshop Journal* 30 (1990): 1–21; Edouard Pommier, 'Winckelmann et la vision de l'Antiquité classique dans la France des Lumières et de la Révolution,' *Revue de l'Art* 83 (1989): 9–21. In German-speaking countries, Winckelmann's thought provoked other responses altogether: see especially Henry C. Hatfield. *Aesthetic Paganism in German Literature from Winckelmann to the Death of Goethe* (Cambridge, Mass: Harvard University Press, 1948), and Michael Embach, 'Kunstgeschichte und Literatur: zur Winckelmann-Rezeption des Deutschen Idealismus,' in *Ars et Ecclesia: Festschrift für Franz J. Ronig zum 60. Geburtstag*, ed. Hans-Walter Stork (Trier: Paulinus, 1989), 97–113. This and the following paragraphs are considerably amplified in my 'Winckelmann Divided,' in *Outlooks: Lesbian and Gay Studies in Art History*, ed. Whitney Davis (Binghamton. N. Y.: Haworth Press, 1993), forthcoming.

12 Various other disjunctions in Winckelmann's *History* are explored in the essays by Potts and Davis noted above (note 11): see also Alex Potts, 'Winckelmann's Construction of History', *Art History, 5* (1982): 377–407; Barbara Maria Stafford, 'Beauty of the Invisible: Winckelmann and the Aesthetics of Imperceptibility,' *Zeitschrift für Kunstgeschichte* 43 (1980): 63–78; Wolf Lepenies. 'Der andere Fanatiker: Historisierung und Verwissenschaftlichung der Kunstauffassung bei Johann Joachim Winckelmann,' in *Ideal und Wirkhichkeit der bildenden Kunst im spätem 18. Jahrhundert*, ed. Herbert Beck, Peter C. Bol. and Eva Maek-Gerard (Berlin: Gebr. Mann, 1984). 19–29; Michael Fried, 'Antiquity Now: Reading Winckelmann on Imitation,' *October* 37 (1986): 87–97. In each case, I believe, one could relate the turmoil in Winckelmann's texts – not only his contradictions and inconsistencies but also his explicit commitments, and ambitions – to the real and imagined dimensions of his

sexuality and eroticism, broadly conceived. This reading would not be an alternative to more stan-
dard histories of ideas or to a social history of art history but would supplement them by grounding
Winckelmann's representations in his actual experience within his social milieux.

13 It is well worth reading these trnscripts in comparison with Goethe's reflections on the life, work,
ethics, and eroticism of Winckelmann (see above, note 5). In both cases, although the commentators
know something about the reality of the artist's or the writer's interests, they do not directly name
them. Actually, to be fair, Goethe was more honest than some of Mapplethorpe's defenders.

Section Four
The Challenge of the Avant-Garde

The following section presents a selection of readings in support of the book *The Challenge of the Avant-Garde*.* The first nine selections are documentary in nature. They range from the first statement of the concept of the avant-garde, through various examples of art criticism, to statements of early twentieth-century artistic vanguardism in practice. The final three texts offer examples of critical debate about the concept of an artistic avant-garde from modernist and postmodernist points of view.

The concept of the 'avant-garde' has been widely used in discussion of modern art, particularly in the decades after the Second World War. However, the term is not neutral or value-free; it does not have one single meaning. As a key notion of artistic modernism it has become synonymous with the evolving modern movement in art, that succession of objects and practices extending from the mid-nineteenth century to the mid twentieth century which is commonly thought of in terms of artistic 'autonomy', 'independence', 'abstraction' and so forth. Although 'art for art's sake' is a term which is not often used in a positive sense these days, this modernist sense of the 'avant-garde' relates to that tradition insofar as art is not seen to require any external justification – ethical or political – for its products.

Historically, however, the idea of an 'avant-garde' has a very different provenance. It emerged in the third decade of the nineteenth century, not in debate about art as such, but in the early socialist tradition as left-wing intellectuals and politicians tried to think through concepts of progress and freedom in emerging modern societies. Art was seen by figures such as Henri de Saint-Simon and Charles Fourier to play a potentially leading role in this process of emancipation – as a kind of 'advance guard' for social progress as a whole. To that extent, then, the idea of a socially and politically committed 'avant-garde' originally stood opposed to the idea of *l'art pour l'art* ('art for art's sake') which emerged in France at about the same time.

It is one of those odd twists of history that the dominant understanding of the term 'avant-garde' in the years after 1945 should in effect have come to signify the opposite of what was originally intended. This is not because of any sleight of hand on the part of critics and intellectuals, so much as a result of the way art itself evolved in modern western bourgeois societies. These societies have experienced what is widely understood as a 'separation of the spheres': for example,

the separation of political practices from economic, or ethical, and of course artistic activity ('keep politics out of sport'; 'what has art to do with politics?'; 'trade unions should not become involved in politics', etc. etc.). It has been as part of this widespread social and historical process that modern art has evolved a set of procedures, and references, techniques and assumptions, which add up to something like its own characteristic 'language'. And it has, further, been as part of this history of development that the notion of being 'in advance' came to denote not so much modern art's relationship to society at large, as certain kinds of art's relationship to other, more conventional kinds of art.

There is however a further twist to this story of historical twists, for in the 1960s this modernist understanding of the idea of an artistic 'avant-garde' came under challenge. From what has come to be seen as a constellation of postmodernist points of view, the importance of art's active and explicit relationship to the wider culture beyond art has once more been widely canvassed. As part of this process, the appellation 'avant-garde' has been withdrawn by many writers and critics from those 'autonomous' art movements with which it was for long identified. Instead, the idea of an avant-garde has been returned to those art practices which explictly sought to overcome the separation of art from life, the separation of aesthetics from politics.

The extracts reprinted here are no more than fragments from an immensely complex and wide-ranging corpus of debate. They do however provide some insight into the issues at stake in the changing history of what it has been to be 'avant-garde'. [PW]

* *The Challenge of the Avant-Garde*, Paul Wood ed., Yale University Press, 1999.

i) Henri de Saint-Simon, from *Opinions litteraires, philosophiques et industrielles* (1825)

Historians believe that the French Utopian socialist philosopher Henri de Saint-Simon (1760–1825) in his book, *Opinions litteraires, philosophiques et industrielles*, was the first writer to use the term 'avant-grade' in relation to art. The term avant-grade was originally a military term meaning advanced guard, or the first troops into battle. Saint-Simon used the idea of an avant-garde in this book in an imaginary debate between an artist, a '*Savant*' (a kind of scientific or technical intellectual) and an industrialist. The speaker in the section reproduced here is 'The Artist', who proposes that, rather than relying on the ruling classes to exercise leadership in society, the three characters in Saint-Simon's dialogue should join together to ensure social progress. In this manner, Saint-Simon places the artist along with the industrialist and the technical specialist in the leadership of the attempt to build the new society. All three of these characters are seen as the bearers of progress in the face of a predominantly parasitic and idle élite. [PW/SE]

Source: Henri de Saint-Simon, from *Opinions litteraires, philosophiques et industrielles* (1825), trans. Jonathan Murphy, printed in Charles Harrison, Paul Wood and Jason Gaiger, eds., *Art in Theory 1815–1900*, Blackwells, 1998, pp. 39–41

[. . .]

European society is no longer composed of children who must, in their own interest, be governed by a firm and active intervention; it is made up of mature men, whose education is complete, and who need naught but instruction. Politics should now be the science of procuring for the greatest number the greatest possible sum of material goods and moral pleasures. The ruling classes, although in the sway of ancient prejudices, and living a life of delusion, do none the less pay homage, through their actions, to public opinion. They are beginning to demonstrate, if not by their actions, then at least by the form in which they present them, that they have begun to realize that they are dealing with reasonable men who do not wish to live in order that they may be governed, but who consent to be governed in order that they may live more comfortably. One may grant that, to the best of their abilities given the present state of affairs, they honour the Arts, the Sciences and Industry with their favours, but what need have these three great powers of such favour, when they are already so capable in themselves, and so indispensable to society? Those of us who oversee them might well ask the ruling classes what, in the final analysis, they have in common with us. How is it that we are at their mercy? To whom does the nation owe its well-being? Who offers the greater service to the throne? Everything which is useful to Society emerges from our minds, from our studies, from our workshops, from our factories and not from their offices or dining-rooms. [. . .]

Yet, rather than a happy concord reigning amongst us, there is, on the contrary, between Savants, Industrialists and Artists, a state of permanent hostility. I do not pretend that the blame is to be found on one side: we all bear some responsibility.

The Savant, influenced by the nature of his work and his natural talent, respects only rigorous reasoning and positive results, and considers the Artist a somewhat wild spirit. He believes neither in the utility or the power of the arts. But he of course forgets that reasoning merely convinces on an intellectual level, while the arts persuade by touching men's sensibilities.

Neither does the Industrialist, in general, do the Artist the justice that he deserves, but forms instead a false picture of him. He sets little store by the talents of men of letters, poets, painters and musicians, regarding them as untrustworthy, dangerous outsiders. Normally cold and calculating in matters pertaining to material production, Industrialists look down upon any intellectual work which produces no facts amongst its results. Others seem inspired by some distant feudal associations, and forget all too often both their own plebeian origins, and the hard work which is the honourable source of their riches, and open the doors of their brilliant salons only to people whose great name or large fortune outweighs their usefulness. Doubtless they would be afraid to treat as equals men who regard as obsolete the sort of respect conferred by titles and nobility. In short, all Industrialists regard the superiority of their social position over that of Artists as being quite evident and incontestable.

We Artists – and here I speak with the same frankness – are perhaps even more exclusive and unjust. The ideal sphere which we inhabit often inclines us to cast a glance filled with pity and scorn at this earthly world. The imagination, which

provides us with the sweetest pleasures and the purest consolations, seems to us the sole human faculty deserving of respect and praise, and hence we attach no great value to the work of Savants, whose importance we constantly underestimate, and we make almost nothing of their company, which seems to provide so little food for our souls. Their conversation seems too dull, and their work, to our eyes, is too purely material. We feel even more strongly about the men of industry. The low opinion that many of us have of a class of men who are both honourable and necessary is made worse by the conviction that all Industrialists are ruled exclusively by a raging passion for money. Such an eminently earthly passion is hated by poets, painters and musicians, for whom money has neither dignity nor value; since time immemorial, Artists have excelled only at spending it.

Evidently, I have spoken frankly here on behalf of all of us, and if I speak as a man who would hide nothing, it is because I desire fervently that these times were behind us. Let us change our attitude and change direction: instead of fixing our attention on the faults of one another, let us instead set about praising our qualities. Let us be filled with one great idea: the well-being of society as a whole depends entirely on the potential of the three groups which we represent. Let us always bear in mind that each of us contributes in equal measure to this good, and that if a single one of the three classes to which we belong were to disappear, society would pass into a time of great hardship and danger. Deprived of Science, Art or Industry, society would topple like a palace in an earthquake.

Let us be conscious of our mutual value, and in this way we will achieve the dignity befitting our position. Let us combine our forces, that the mediocrity of the present, which triumphs over our disarray, will be recognized for what it is, and forever banished to its proper place below. The pacific power of our triple crown will triumph over a world in transformation.

Let us unite. To achieve our one single goal, a separate task will fall to each of us.

We, the artists, will serve as the avant-garde: for amongst all the arms at our disposal, the power of the Arts is the swiftest and most expeditious. When we wish to spread new ideas amongst men, we use, in turn, the lyre, ode or song, story or novel; we inscribe those ideas on marble or canvas, and we popularize them in poetry and in song. We also make use of the stage, and it is there above all that our influence is most electric and triumphant. We aim for the heart and imagination, and hence our effect is the most vivid and the most decisive. If today our role seems limited or of secondary importance, it is for a simple reason: the Arts at present lack those elements most essential to their success – a common impulse and a general scheme.

[. . .]

ii) Marie-Camille de G., from the 'Salon of 1834', *Tribune des femmes* (1834)

Marie-Camille de G. (dates unknown) published the present Salon review in the utopian socialist journal *Tribune des femmes* in 1834. Women authors withheld their surnames in order to avoid having to use the patriarchal names of husbands

or fathers. The very anonymity of this critic seems to speak of the condition of the women and workers she wrote about in a culture dominated by middle-class men. *Tribune des femmes* was closed down later in 1834 as part of the government's repression of a wave of working-class unrest. In this text the author argues that contemporary artists have a social responsibility both to criticise the powers that be and to produce positive representations of women and the working class. It is notable, however, that the artist she singles out for praise is Jean-Auguste-Dominique Ingres (1780–1867) who was a key proponent of the academic tradition. She opposes Ingres to the Romantic painter Eugène Delacroix (1798–1863) who is usually seen as an avant-grade figure, but who is presented here as an eclectic artist. In this text, then, there is no neat fit between social radicalism and artistic experimentation. [PW/SE]

> Source: Marie-Camille de G., from the 'Salon of 1834', *Tribune des Femmes* (1834), trans. Jonathan Murphy, printed in Charles Harrison, Paul Wood and Jason Gaiger, eds., *Art in Theory 1815–1900*, Blackwells, 1998, pp. 156–9

[. . .]

In the same way that humanity tires of walking an arid path where no feeling of happiness blossoms, and of having no thoughts with which its broken soul might repose, the arts, when classical periods draw to a close, and centuries like that of Augustus or Louis XIV draw their last breath, having uttered their final words in Virgil or Racine, and merit is no longer to be found but in imitation or pastiche, the arts strive to return to life, and seek out a new form of originality. The rules of rhetoric are broken, and liberty, art and *romanticism* spring forth. Soon to come the intermediaries, eclectic men in the fields of art, philosophy, and politics; men with vision, marching towards a visionary future. [. . .]

These principles should help us to understand this year's Salon and the attitudes that people are taking towards it. Why is it that a crowd of artists and amateurs throngs around two pictures by Delaroche and Ingres in particular? For one good reason: the eclectic talent of Delaroche and the original genius of Ingres bear witness to all the problems that are currently besetting art.

The subject of Delaroche's painting is Lady Jane Gray, at the moment when the executioner is about to follow the orders of Queen Mary and bring down his axe upon her neck. She fills us with pity: she is about to die for a dream, for wanting to be dressed in royal robes, and for wanting to see her own eyes sparkle beneath a diamond crown. Mary has forced her from the throne to the Tower, and for her crown, has given her a blindfold to hide her eyes, and for a cushion to rest her head, an executioner's block. [. . .] The colour of the painting is striking in its truthfulness, the drawing unexceptional, the poses natural, but it is with some disappointment that one notes that the artist was too concerned with individual detail, and that the carpet is carefully laid out, the folds of Lady Jane's dress fall too regularly, and that nothing, not the tiniest stroke, is missing. Delaroche takes up a particular idea, meticulously researches all the necessary details, and repeats them with great care, but he lacks originality. He is merely a man of great talent.

Anyone who cannot conceive of unity in variety should examine Ingre's contribution to the Salon this year. The subject is Saint-Symphorien, in prison, where he has suffered thirst, hunger and all the tortures known to man. His flesh may have bled and been lacerated into strips by the blows of the lictor, his body may be broken, but his soul stands fast. Ingres is a man of genius.

According to the distinction that we have made between eclectic artists and original artists, with Delaroche we would place Delacroix and Vernet; with Ingres we place Granet, Decamps and the elder Scheffer.

[. . .]

On coming out of the museum one is struck by a sad thought. We see battles, shipwrecks, scaffolds, landscapes, portraits, thousands of pictures, but so few pictures with any vision. We see extraordinary attempts at drawing and colour, a prodigious expenditure of talent, but the resulting paintings are nothing more than hackneyed, sterile scenes.

Painters represent women in a multitude of styles. They turn them into flowers with which they furnish exquisite boudoirs; they intoxicate them with perfumes and honeyed words; they show them at elegant society balls where you could mistake them for priestesses in their rich robes; and in interior scenes they stretch them out voluptuously, dreaming on sumptuous divans. Now they are painted like blooms in the sun, blossoming beneath the sweet breath of their lover, now, with scant regard for their modesty, their beautiful bodies are desecrated as they are dragged before the executioner. Surely, Gentlemen, we have had our fill of perfumes and beautiful clothes, passionate embraces and scaffolds: the time has come to grant women a place worthy of them, the due place they deserve! We have seen again this year yet another Eve picking the forbidden fruit. The painter in question would be well advised to go and look closely at a picture by Jules Laure, an artist of our acquaintance, who we can thank for faithfully portraying the thoughts of a great woman. He will see Lélia kneeling beside the body of Sténio; a world of suffering weighs down on the shoulders of the young woman, and cruel disappointments have caused her beautiful face to pale. Perhaps it will occur to him that for long enough now the daughters of Eve have torn at their flesh and sacrificed their hearts for the sons of Adam, for long enough they have watered the paths of the earth with their tears: it is time a new Eden appeared. Artists! If you love *women*, if some time their beauty has filled your soul with poetry, and lent delicacy and inspiration to your brush to fix your dreams and joys on canvas, show her growing in liberty. Imagine the progression. First, crushed beneath shields, walking like a worker, suffering under the weight of her chains; her body, her thoughts, her desires, all her existence broken by the hand of her tyrant; then, beginning to look more resolutely at her master and transforming her slavery into a tutelage, which in turn she hopes to surpass. For women wish to be free, as God has breathed a love of liberty into their souls. But free to pour balm on the wounds of humanity, like a holy dove descending from the skies; free to quell the bellicose urges of man, and lead him back to God, back to the path of peace and happiness; free to embrace the universe with the intelligence of a savant, and to embrace it with love; free to serve as the bond not simply between individuals but between

entire peoples. Women yearn for a pedestal in the temple, to preach to the world the sacred words that inspire hearts and show men the path into the future.

The working classes only entered the pictures of the salon with weapons in their hands, stained with mud and blood, with hate in their hearts and cruelty in their eyes. Artists! If you really feel solidarity with the people, if you have felt the strength and grandeur beneath that surface of rude ignorance, show too their weeping wounds, that those who have the power to tend to such suffering are moved to action! If you love drama, paint those awful scenes which are played out every day before your eyes, paint an unhappy father dying in a pauper's bed, filled with agony and misery. Paint his numerous children who beg for bread with their cries and their tears, paint his daughter whose income cannot possibly meet the needs of her father and her brothers, and further off, in the background, paint the rich man offering her the gold she needs to minister to her father and save his life . . . but at a terrible price! Let your canvas cry out in despair so that the world can see the anguish, the torture and the terrible sacrifices which civilization veils with a deceptive smile: let the terrible cries of hunger and the awful spectre of prostitution be seen! Let your pictures be a mirror which reflects the pain of the poor, let them seize that poverty and distill it so strong that the rich catch their breath and are brought to their senses. In Anvers, they say, a Rubens picture of Christ is veiled, as the very sight of it sends electric shocks through spectators; let your works be so, that the privileged are ashamed of their happiness, while thousands of others agonize in misery.

If you are filled with enthusiasm, enlarge your canvas so that all humanity can play out its giant drama there. Let your canvas be an elemental maelstrom, water and earth, and air and fire; – fill it with the hopes of the world. Let it transport us a thousand leagues over the seas; fill it with mountains and forests and pyramids and temples; let it take the world in its hands, and forge it anew, let it listen to that gathering storm of progress, as the mighty voice of God calls out and urges us on to new worlds of ideas, achievements and inventions. For we march on inexorably, to a temple of joys which we dimly perceive on the horizon, whose marble columns and eternal towers we will one day see standing tall before us.

A great mission awaits the artists of today!

iii) Charles Baudelaire, 'On the Heroism of Modern Life' (1846)

Charles Baudelaire (1821–67) was a French poet and critic whose verse and writing on art had a significant impact on the development of modern art and theories of modernism. His volume of poems *Les Fleurs du mal* (Flowers of evil) was published in 1857 and was heavily criticised as 'immoral'. Baudelaire's most extended discussion of his concept of 'modernity' occurs in his essay 'The Painter of Modern Life', published in 1863. Several years earlier, however, he had outlined his views in his review of the Salon of 1846. In particular he is concerned to emphasise the role in art of two contrasting elements, the 'eternal' and the 'transitory'. Baudelaire believed it was the transitory which characterised the experience of

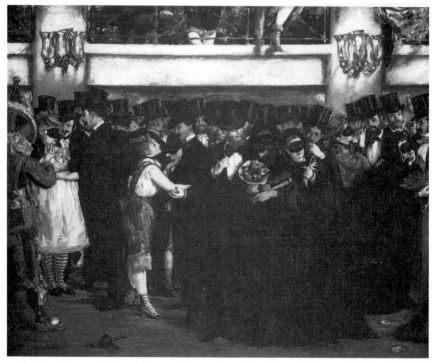

xviii) Edouard Manet, *The Masked Ball at the Opéra*, 1873, © 1998 Board of Trustees, National Gallery of Art, Washington DC.

modernity, and that artists would have to distill any eternal properties of their work from it. (Notes have been omitted.) [PW/SE]

Source: Charles Baudelaire, 'On the Heroism of Modern Life' (1846), trans. Jonathan Mayne, *Art in Paris 1845–1862. Salons and Other Exhibitions, Reviewed by Charles Baudelaire*, Phaidon, 1965, pp. 116–20

ON THE HEROISM OF MODERN LIFE

Many people will attribute the present decadence in painting to our decadence in behaviour. This dogma of the studios, which has gained currency among the public, is a poor excuse of the artists. For they had a vested interest in ceaselessly depicting the past; it is an easier task, and one that could be turned to good account by the lazy.

It is true that the great tradition has been lost, and that the new one is not yet established.

But what *was* this great tradition, if not a habitual, everyday idealization of ancient life – a robust and martial form of life, a state of readiness on the part of each indivi-

dual, which gave him a habit of gravity in his movements, and of majesty, or violence, in his attitudes? To this should be added a public splendour which found its reflection in private life. Ancient life was a great *parade*. It ministered above all to the pleasure of the eye, and this day-to-day paganism has marvellously served the arts.

Before trying to distinguish the epic side of modern life, and before bringing examples to prove that our age is no less fertile in sublime themes than past ages, we may assert that since all centuries and all peoples have had their own form of beauty, so inevitably we have ours. That is in the order of things.

All forms of beauty, like all possible phenomena, contain an element of the eternal and an element of the transitory – of the absolute and of the particular. Absolute and eternal beauty does not exist, or rather it is only an abstraction skimmed from the general surface of different beauties. The particular element in each manifestation comes from the emotions: and just as we have our own particular emotions, so we have our own beauty.

[. . .]

As for the garb, the outer husk, of the modern hero, although the time is past when every little artist dressed up as a grand panjandrum and smoked pipes as long as duck-rifles, nevertheless the studios and the world at large are still full of people who would like to poeticize *Antony* with a Greek cloak and a parti-coloured vesture.[1]

But all the same, has not this much-abused garb its own beauty and its native charm? Is it not the necessary garb of our suffering age, which wears the symbol of a perpetual mourning even upon its thin black shoulders? Note, too, that the dress-coat and the frock-coat not only possess their political beauty, which is an expression of universal equality, but also their poetic beauty, which is an expression of the public soul – an immense cortège of undertaker's mutes (mutes in love, political mutes, bourgeois mutes . . .). We are each of us celebrating some funeral.

A uniform livery of affliction bears witness to equality; and as for the eccentrics, whose violent and contrasting colours used easily to betray them to the eye, today they are satisfied with slight nuances in design, in cut, much more than in colour. Look at those grinning creases which play like serpents around mortified flesh – have they not their own mysterious grace?

[. . .]

Let not the tribe of colourists be too indignant. For if it is more difficult, their task is thereby only the more glorious. Great colourists know how to create colour with a black coat, a white cravat and a grey background.

But to return to our principal and essential problem, which is to discover whether we possess a specific beauty, intrinsic to our new emotions, I observe that the majority of artists who have attacked modern life have contented themselves with public and official subjects – with our victories and our political heroism. Even so, they do it with an ill grace, and only because they are commissioned by the government which pays them. However there are private subjects which are very much more heroic than these.

The pageant of fashionable life and the thousands of floating existences – criminals and kept women – which drift about in the underworld of a great city; the

Gazette des Tribunaux and the *Moniteur* all prove to us that we have only to open our eyes to recognize our heroism.

[. . .]

The life of our city is rich in poetic and marvellous subjects. We are enveloped and steeped as though in an atmosphere of the marvellous; but we do not notice it.

[. . .]

NOTES

1 Dumas the elder's prose-drama *Antony* was produced in 1831. The central character became a powerful hero-figure of the times, and young men who cast themselves for this rôle in real life were popularly known as 'Antonys'.

iv) Seven reviews of Gustave Caillebotte's work in the Impressionist Exhibition of 1876

Reproduced here are extracts from a range of reviews of the second Impressionist exhibition which either bear upon or directly discuss the work of the painter Gustave Caillebotte (1848–1894). Caillebotte shared the subject matter of modern life with the Impressionists and regularly exhibited in their collective exhibitions, but his works were much more highly finished than the paintings of those who are now seen to form the nucleus of the group. In the extracts printed here, Duranty brings out the naturalism of the new art in relation to traditional emphases on drawing and colour. The other critics variously celebrate or reject Caillebotte's naturalism, particularly his radical treatment of conventions of perspective. [PW/SE]

Sources: a) Edmond Duranty, *The New Painting, Concerning the Group of Artists Exhibited at the Durand-Ruel Galleries* (1876), printed in Charles S. Moffat, *The New Painting. Impressionism 1874–86*, Fine Art Museum of San Francisco, 1986, pp. 42–4. b) Emile Porcheron, 'Promenades d'un flaneur – Les Impressionistes', *Le Soleil*, 4 April, 1876. c) Maurice Chaumelin, 'Actualités: L'Exposition des Impressionistes', *La Gazette (des Etrangers)*, 8 April, 1876. d) Louis Enault, 'Mouvement Artistique – L'Exposition des Intransigeants dans les Galeries de Durand-Ruel', *Le Constitutionnel*, 10 April, 1876. e) Philippe Burty, 'Fine Art: The Exhibition of the Intransigeants', *The Academy*, 15 April, 1876. f) Bertall, 'Exposition des Impressionistes, Rue Lepeletier, *Le Soir*, April, 1876. g) Emile Zola, 'Deux Expositions d'Art en Mai', *Le Messager de l'Europe*, June, 1876. Texts b–g reprinted in Kirk Varnedoe, *Gustave Caillebotte*, Yale University Press, 1987, pp. 185–7.

a) Edmond Duranty 'The New Painting. Concerning the Group of Artists Exhibiting at the Durand-Ruel Galleries', 1876

I am less concerned with the present exhibition than its *cause* and *idea*. What then do this cause and idea bring us? What does the movement contribute? And consequently, what do these artists contribute, these artists who wrestle with

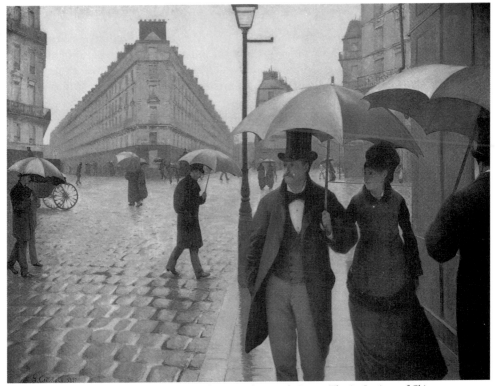

xix) Gustave Caillebotte, *Paris Street; Rainy Weather*, 1877. Photograph © 1998, The Art Institute of Chicago.

tradition, admire it and simultaneously want to destroy it, these artists who acknowledge that tradition is great and powerful and who attack it for that very reason. Why, then, are people interested in them? Why are they forgiven for too often producing – and with a touch of laziness – nothing but sketches, abbreviated summaries of works?

The real reason is that in an age like ours, when there seems nothing left to discover, when previous ages have been analysed so much, and when we suffocate under the weight of the creations of past centuries, it is a great surprise to see new ideas and original creations suddenly burst forth . . . What, then, do these painters contribute? A new method of colour, of drawing, and a gamut of original points of view.

Some of them limit themselves to transforming tradition, striving to translate the modern world without deviating too far from the superannuated and magnificent formulas that served earlier eras. Others cast aside the techniques of the past without another thought.

In the field of colour they made a genuine discovery for which no precedent can be found, not in the Dutch masters, not in the clear, pale tones of fresco painting, nor in the soft tonalities of the 18th century.

They are not merely preoccupied by the refined and subtle play of colour that emerges when they observe the way the most delicate ranges of tone either contrast or intermingle with each other. Rather, the real discovery of these painters lies in their realisation that strong light mitigates colour, and that sunlight reflected by objects tends, by its very brightness, to restore that luminous unity that merges all seven prismatic rays into one single colourless beam – light itself.

Proceeding by intuition, they little by little succeeded in splitting sunlight into its rays, and then re-establishing its unity in the general harmony of the iridescent colour that they scatter over their canvases. With regard to visual subtleties and delicate blending of colours, the result is utterly extraordinary . . .

Turning to drawing, it is well understood that among these new painters as elsewhere, the inevitable differences between colourists and draughtsmen persist. Thus when I speak of colour, you should only think of those who primarily are colourists. And when I refer to drawing, you should only envision those who are primarily draughtsmen . . .

[. . .] what drawing wants in terms of its current goals is just to know nature intensely and to embrace nature with such strength that it can render faultlessly the relation between forms, and reflect the inexhaustible diversity of character. Farewell to the human body treated like a vase, with an eye for the decorative curve. Farewell to the uniform monotony of bone structure, to the anatomical model beneath the nude. What we need are the special characteristics of the modern individual – in his clothing, in social situations, at home, or on the street. The fundamental idea gains sharpness of focus. This is the joining of torch to pencil, the study of states of mind reflected by physiognomy and clothing. It is the study of the relationship of a man to his home, or the particular influence of his profession on him, as reflected in the gestures he makes: the observation of all aspects of the environment in which he evolves and develops.

b) *Emile Porcheron, 'Promenades d'un flaneur – Les Impressionistes'* (Promenades of a flaneur – The Impressionists), *Le Soleil, 4 April 1876*

In the second room let us stop before the canvases of Monsieur Caillebotte, the least bad of the exhibition. One of the missions that Impressionism seems to have set for itself is to torture perspective: you see here what results can be attained.

Two canvases, representing the *Floorscrapers*, are excessively original, in one of them, one of the men has stopped his work to undertake on his person a hunt that cleanliness would have rendered unnecessary: this is in dubious taste.

The *Luncheon* is insane, one finds there none of the virtues we saw above; this is the height of Impressionism. Imagine the top of a table actually round but inordinately elongated by a perspective so misunderstood that the table seems to be at least twelve meters long; the frame cuts the plate of one of the three diners in two, and the other two people placed at the far end of the table are so far away that one no longer takes them in.

c) Maurice Chaumelin, 'Actualités: L'Exposition des Impressionistes' (Latest News: The Impressionists' Exhibition), La Gazette (des Etrangers), *8 April 1876*

All I know is that Monsieur Caillebotte is one of the most original painters who has come to light for several years, and I don't fear compromising myself by predicting that he will be famous before too long.

In his *Floor-scrapers*, Monsieur Caillebotte shows himself a realist just as raw, but much more witty, than Courbet, just as violent, but altogether more precise, than Manet . . . If intransigence consists of painting this way, I would advise our young school to become intransigent.

d) Louis Enault, 'Mouvement artistique – L'Exposition des Intransigeants dans la Galerie de Durand-Ruel' (Artistic Developments – The Intransigeants' Exhibition in the Galerie Durand-Ruel), Le Constitutionnel, *10 April 1876*

That Monsieur Caillebotte knows his profession, no one will want to dispute. There is certainly an adroit enough execution in the two pictures that he has just dedicated to the glory of the floorplaners, who, perhaps, were not expecting such an honour. The subject is surely vulgar, but we can understand how it might tempt a painter. All those who have had the pleasure or the bother of having a house built know the way these robust fellows work unabashedly putting aside any encumbering outfit, leaving only the most dispensable clothing, and thus offering to the artist who wants to make a study of the nude, a torso and a bust that other trades do not expose as freely.

Monsieur Caillebotte's planers are certainly not at all badly painted and the effects of perspective have been studied by an eye that sees correctly. I only regret that the artist did not choose his types better, or, once he accepted what reality offered him, that he did not give himself the right, which I can assure him no one would have denied him, to interpret them more freely. The arms of the planers are too thin, and their chests too narrow. Do the nude, gentlemen, if the nude suits you; I'm not prudish, and I won't be so wrong-headed as to find it bad. But may your nude be handsome or don't get involved with it!

e) Philippe Burty, 'Fine Art: the Exhibition of the Intransigeants', The Academy, *15 April 1876*

A young man, Caillebotte by name, who makes his first appearance in this exhibition, has attracted a (great) deal of attention. His pictures are original in their composition, but, more than that, are so energetic as to drawing that they resemble the early Florentines. These pictures would create a scandal in an official Salon amid the false and sinewless figures of the school, and we applaud the jury's wisdom in keeping them out. Here it is a different matter. Their success is fair and honest and due to their faithful representation of life as it expresses itself in the working functions, and of the members as they come to look when modified by the constant pursuit of some one particular occupation. M. Caillebotte has sent *Des racleurs de parquet* [The Floorscrapers], joiners bare to the waist scraping the parquet floor of a room with iron blades.

f) Bertall, 'Exposition des Impressionistes, Rue Lepeletier' (The Impressionists'
Exhibition, Rue Lepeletier), *Le Soir, April 1876*

Monsieur Caillebotte, so remarkable in his profound scorn for perspective, could,
if he wanted to, handle perspective as well as anyone. But his originality would
lose something thereby. He will not make this mistake. In his *Luncheon,* his *Floor-
scrapers,* and his *Young Pianist,* the intention is clear; he knows this is how he will
make a name for himself, and then he can show that he has a certain talent, as is
demonstrated by the little floor-scraper seated in the background of his picture
No. 27

g) Emile Zola, 'Deux Expositions d'Art en Mai' (Two Art Exhibitions in May),
Le Messager de l'Europe, June 1876

Caillebotte exhibited the *Floorscrapers* and *A Young Man at his Window,* which are
of an extraordinary three-dimensionality. However, it is anti-artistic painting,
painting as neat as glass, bourgeois painting, because of the exactitude of the copy-
ing. Photography of reality which is not stamped with the original seal of the
painter's talent – that's a pitiful thing.

v) Paul Signac, from 'Impressionists and Revolutionaries', *La Révolte* (1891)

Paul Signac (1863–1935) was a leading figure in the 'Neo-Impressionist' or 'Divi-
sionist' group which formed around Georges Seurat (1859–91) in the second half
of the 1880s. Like Camille Pissarro (1830–1903), one of the original Impressionists
who became involved with the younger group, Signac espoused anarchist
political convictions. In the text printed here, rather than advocate an overtly
politicised subject matter which modern techniques could be used to illustrate,
he attempts to establish a connection between progressive politics and what he
sees as the radicalism of Divisionist artistic techniques. Signac's essay was origi-
nally published anonymously in 1891 over the signature of 'un camarade
impressioniste' (an impressionist comrade) in the communist-anarchist journal
La Révolte. [PW/SE]

> Source: Paul Signac, from 'Impressionists and Revolutionaries' from *La Révolte*
> (1891), trans. Christopher Miller, reprinted from *Art in Theory 1815–1900,* Charles
> Harrison, Paul Wood and Jason Gaiger, eds., Blackwells, 1998, pp. 795–7

Some weeks ago, at the Exhibition of Independent Artists, faced with the pictures
of the Independent and impressionist painters, there were those who exclaimed
against them; a poor sort of fellow, whose inveterate vulgarity has been perfectly
captured by the ironist Forain.[1] On Sunday, by contrast, some proletarians were
rather intrigued by what they saw.
 The revolutionary tendency of the impressionist painters explains both the
raucous malice of the former and the reserved sympathy of the latter. In the mat-

ter of technique, these painters are innovators; by a more logical and scientific arrangement of tones and colours they are replacing outdated procedures: the financial mixtures made on the palette, the scumbles so long in fashion, the heavy impasto expressive of an ardour generally factitious. In moral terms, the example they set for our sensual generation is all too rare: faithful to their idea of art, convinced of the superiority of their methods, they remain poor at a time when they might, as so many others have done, at the cost of a few compromises enjoy the favour of the standard, influential critics, whose stale prose translates for the artist into gold, honours and decorations.

Were it only for these reasons, the impressionist artists, expelled from the community of art like revolutionaries from society, would deserve a sympathetic greeting from those who applaud the breakdown of all prejudice and all routine. But they have a more important claim on such sympathies. Their works, the products of a purely aesthetic emotion elicited by the picturesque aspect of things and beings, have that unconsciously social character that is the stamp of contemporary literature. Certain novels by Flaubert, the Goncourt brothers, Zola and their disciples, written from purely literary preoccupations on the basis of lived experience, have served the revolutionary cause far more powerfully than any novel in which political preoccupations took precedence over the literary.

[. . .]

If we turn from the literary document to the witness of art, we find a similar state of affairs. Millet remained a peasant; completely absorbed by his art, he produced a corpus whose social tendency is much clearer than the intendedly philosophical paintings of Courbet, painter and thinker – to cite an artist of similar tendency in art.

At this very time, at the *Exposition Nationale des Beaux-Arts*, one can see a little water-colour by Meissonnier, *The Barricade (1848)*, which is a terrible indictment of the social conditions established over the last hundred years by the Bourgeoisie. The riot has been quelled; in a desolate street, bodies lie mutilated amid pavés and splintered barrels, their features contracted by their death-agonies, the shirt of the insurgent touching the soldier's red breeches. Before this scene – summarily outlined with a few strokes of the pen and a little colour – the heart bleeds. For one feels it is a thing seen and rendered in all its sincerity by an artist simply attracted by the strangeness of the scene and the colour effects to which it gave rise – Note that Meissonnier was a bourgeois who took his hatred of socialists to the lengths of banning Courbet from the official *Salon* because he had taken part in the Insurrection of 18 March [i.e. the Commune].

It would therefore be an error – an error into which the best informed revolutionaries, such as Proudhon, have too often fallen – systematically to require a precise socialist tendency in works of art; this tendency will be found much stronger and more eloquent in pure aesthetes – revolutionaries by temperament, who, departing from the beaten track, paint what they see, as they feel it, and, often unconsciously, give a solid pick blow to the old social edifice, which, wormeaten, cracks and crumbles like some abandoned cathedral.

This can easily be seen in the works that the impressionist painters sent to the *Exposition des Indépendants*. By their new technique, which runs counter to the

standard rules, they showed the futility of unchanging procedures. By their picturesque studies of working-class housing of Saint-Ouen and Montrouge, sordid and overwhelmingly real, by reproducing the broad and strangely vivid gestures of a navvy working by a pile of sand, of a blacksmith in the incandescent light of the forge – or better still by synthetically representing the pleasures of decadence, balls, riotous dances, and circuses, as did the painter Seurat, who had such a strong sense of the debasement of our epoch of transition – they have contributed their witness to the great social process which pits the workers against Capital. [. . .]

NOTES

1 Forain was a painter who satirised the bourgeoisie. He exhibited in four of the Impressionist exhibitions. [PW]

vi) Four Reviews of Adolph von Menzel

The career of the German artist Adolph von Menzel (1815–1905) spanned the second half of the nineteenth century. His case is a puzzling one for art historians, who have tended to assume a categorical distinction between an 'Academic' approach to art and the emerging 'avant-garde' tradition. In Menzel's œuvre, relatively conventional, public-oriented, historical representations of the Prussian court of the Enlightenment period contrast with more privately-motivated naturalistic depictions of contemporary life, many of them of a marked technical radicalism. These different aspects of his work tended to be celebrated by traditionalist and Modernist critics respectively. We reproduce four extracts on Menzel here. Two from the 1880s demonstrate the diversity of approaches to Menzel. For the German Pecht, he is an icon of cultural nationalism, for the Frenchman Duranty his work matches the search for visual truth embodied in the contemporary French school. The two later examples celebrate Menzel's work from a modern point of view, calling attention to his naturalism and technical freedom. These texts were translated for this volume by Jason Gaiger. [PW/SE]

Sources: a) Friedrich Pecht, 'Weihnachts-Bücherschau' (Christmas Book Review), trans. Jason Gaiger, *Die Kunst für Alle*, vol. 3, Part 5, 1st December, 1887, p. 73. b) Hugo von Tschudi, 'Aus Menzels Jungen Jahren' (Menzel's Early Years), trans. Jason Gaiger, *Jahrbuch der königlich Preuzichen Kunstammlung*, 26 Band, Berlin, 1905, pp. 225–6. c) Julius Meier-Graefe, from 'Der Maler' (The Painter), *Der junge Menzel*, Insel Verlag, 1906, pp. 86–7, 92–3, 99. d) Edmond Duranty, 'Adolph Menzel'. Part II, trans. Jason Gaiger, *Gazette des Beaux-Arts*, vol. XXII, 2 periode, 1880, pp. 110, 123.

a) Friedrich Pecht, 'Weihnachts-Bücherschau' (Christmas Book Review). Die Kunst für Alle, vol. 3, 1887–8, p.73

[. . .] We have in Menzel a master the like of which no nation has possessed since

Rembrandt [. . .] Wherein does his greatness reside? Therein, that since the time of the Dutch artist, to whom he is so closely related, no artist has succeeded in embodying the ruling spirit of his nation, its temperment, its innermost feelings, its entire essence, as Menzel the spirit of the Prussian Volk. To the extent to which the Prussian-German race has had a more powerful influence on the history of the world than Holland, so Menzel's art is superior to that of Rembrandt. It is, from the outset, infinitely richer because it reflects its basis in a powerful state, accompanying the latter from its earliest development in the midst of needy nature, from which everything had first to be wrung through inexhaustible labour, to its present world status, rendering the latter fully comprehensible. [. . .]

b) *Hugo von Tschudi. 'Aus Menzels jungen Jahren'* (Menzel's early years), Jahrbuch der Königlich Preuszichen Kunstsammlung, *26 Band, Berlin, 1905, pp. 225–6*

[. . .] In 1845 Menzel began producing oil paintings, apparently very modest, in a form not common in Germany at that time, at first in quick succession and in large number (with the joy of a discoverer), later more intermittently. What he discovered was the beauty, or rather the painterly relevance of his immediate environment and his own time. In a single word, he painted for the first time after nature. Common to all the paintings is that they were not shown in public. They remained in the painter's house and were either forgotten or disregarded by the artist. Even in the appreciation of his work on the occasion of his eightieth birthday, this aspect of his activity was not taken into account. Thus it was that Menzel's most vivid creations slumbered in the dust of his studio, until in the last few years of Menzel's life a resourceful art dealer gradually brought them to the light of day and displayed them before an astonished public. In these modest things one discovered and admired a painterly quality which was not to be found in the same degree of strength and purity in Menzel's large and famous works.

The very first of these paintings, the *Balcony Room* of 1845 in the Nationalgalerie, has almost the same affect upon us now after half a century as the freshest contemporary art. A simple, sparsely furnished room, something which he (and most of his contemporaries) would earlier not even have considered worthy as a stage for his beautifully costumed figures. Nor is it a stage, not even for the most unassuming goings on. But perhaps after all it is a stage; a stage for things which delight the painterly sensitive eye, an eye which communicates artistic sensations to the soul, even though they are not romantically rooted or sugared with sentiment; a stage for an eye which delights directly (though not naively!) in the beauty of the room filled with light, in the soft line of the curtain moved by the wind, in the harmony formed by the brown-red mahogany tone with the fine green of the wall and the white of the curtain, in the almost undetectable delicate nuance with which the colours appear in the mirror image. These and many other wonders which the crude word cannot capture play upon the unassuming stage of the balcony room. [. . .]

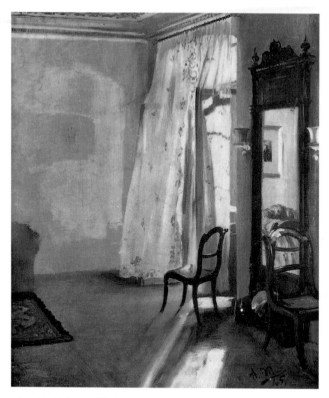

xx) Adolph Menzel, *The Balcony Room*, 1845. Nationalgalerie, Staatliche
Museen Preussicher Kulturbesitz, Berlin.

c) Julius Meier-Graefe, Der junge Menzel (Young Menzel), *Leipzig: Insel Verlag,*
1906

[. . .] Constable taught the painter, who until then had seen colour as a medium
of shading, the value of colour as building material and pointed out to him the
significance of contrast. That is to say, he revealed to him nothing less than the
entire essence of painting. [. . .]

[. . .] The painted interiors reveal once again Constable's influence. But here the
influence is far less literal and for this reason of greater advantage. The mere fact that
Menzel transports the experience he had gathered studying the Englishman's
landscapes into a domain that Constable never touched, gave his successor greater
freedom. The influence – or, rather, influx – was directed into a bed which was suited
to receive it. The best of the interiors are exclusively of rooms in which Menzel lived,
or knew well. [. . .] The majority are small in format and painted in virtually the same
colours. The foundation is formed by a chocolate brown warmed with red which,
through the gradation of light and dark, often suffices for all the artist's needs. The
very economy of the materials produces the harmony of the small sketches. Nowhere
are we disturbed by the harsh, arbitrary contrasts of the late paintings. [. . .]

It is impossible to reveal the beauty of the *Balcony Room* to a proper Menzel enthusiast. If the mature Menzel did not value this painting, how should someone else who stands close to him think differently. Yet whoever comes to this painting not from Menzel but from art itself, experiences a rare delight. Here one arrives for the first time in Germany in the first half of the nineteenth century at real pleasure without having to make one's comparisons relative and without being disturbed by recollecting greater works of the same sort. [. . .]

d) Edmund Duranty, 'Adolph Menzel' II, Gazette des Beaux-Arts, vol. xxii, 2 periode, 1880

[. . .] In a word, [Menzel] is always independent, sincere, with a steady gaze and a resolute tone which is at times a little brutal. He views the world, past or present, as it is, without ever altering or distorting it, rendering it with great vigour through gesture, movement, expression and an implacable exactitude. While he enjoys good health, he is *neurotic* about the truth [*il a la névrose du vrai*]. One senses in his works the nervous shock, the excitement, which nature produces in him. I know of no one else who gives so much of *nature*, and for this reason he may offend those who desire only an arrangement, a ragout, a tidy ordering. He makes nature trivial and banal, when that is how she is; passionate and violent, when that is how she is; strange and delicate, when that is how she is. [. . .]

The cut, the points of view, the angles, the subjects, the expression – everything which our new generation and our new school of art, rightly or wrongly, has established as its programme, as a desiderata, M. Menzel has realised, even though he knows neither our ideas nor our researches in France, confirming at least the appropriateness and accord which reigns amongst those who occupy the terrain of reality.

In due time, and despite what might be said, it will be realised that certain people have rendered great services to their age. I speak of those who have savoured and expressed the taste of life, its gaiety, its light, its movement, of those who have taken pleasure in *seeing* life, in its daily play, with its wheels and cogs, taken pleasure in counting the beat of our collective pulse and of our heart, who have accustomed others to take in the prodigious interest of the hundred thousand elements of this astonishing spectacle; in short, those who regard man not with pity or horror, but with curiosity. [. . .]

vii) Filippo Tommaso Marinetti, from 'Foundation and Manifesto of Futurism' (1909)

The poet Filippo Tommaso Marinetti (1876–1944) was the intellectual force and impresario of the Italian Futurism movement which flourished immediately prior to the First World War. The Futurists celebrated modernity in art and life and opposed all tendencies which they saw as passé. Marinetti published his two-part 'Foundation and Manifesto of Futurism' in the Parisian newspaper *Le Figaro* on

20 February, 1909. The first part of the text consists of a prose narrative in which the author and his friends break out of a decadent Symbolist soirée and embark on a violent race through the night in motor cars. The author's car crashes in a factory ditch, and he rises from the polluted waters in effect re-baptised as a new kind of modern man, a 'Futurist'. The second part of the text consists of the Manifesto of Marinetti's Futurism. [PW/SE]

Source: Filippo Tommaso Marinetti, from 'Foundation and Manifesto of Futurism', (1909), trans. R. W. Flint & Arthur A. Coppotelli, printed in *Marinetti. Selected Writings*, R.W. Flint, ed., Secker and Warburg, 1972, pp. 41–3

MANIFESTO OF FUTURISM

1. We intend to sing the love of danger, the habit of energy and fearlessness.
2. Courage, audacity, and revolt will be essential elements of our poetry.
3. Up to now literature has exalted a pensive immobility, ecstasy, and sleep. We intend to exalt aggressive action, a feverish insomnia, the racer's stride, the mortal leap, the punch and the slap.
4. We say that the world's magnificence has been enriched by a new beauty; the beauty of speed. A racing car whose hood is adorned with great pipes, like serpents of explosive breath – a roaring car that seems to ride on grapeshot – is more beautiful than the *Victory of Samothrace*[1]
5. We want to hymn the man at the wheel, who hurls the lance of his spirit across the Earth, along the circle of its orbit.
6. The poet must spend himself with ardor, splendor, and generosity, to swell the enthusiastic fervor of the primordial elements.
7. Except in struggle, there is no more beauty. No work without an aggressive character can be a masterpiece. Poetry must be conceived as a violent attack on unknown forces, to reduce and prostrate them before man.
8. We stand on the last promontory of the centuries! ... Why should we look back, when what we want is to break down the mysterious doors of the Impossible? Time and Space died yesterday. We already live in the absolute, because we have created eternal, omnipresent speed.
9. We will glorify war – the world's only hygiene – militarism, patriotism, the destructive gesture of freedom-bringers, beautiful ideas worth dying for, and scorn for woman.
10. We will destroy the museums, libraries, academies of every kind, will fight moralism, feminism, every opportunistic or utilitarian cowardice.
11. We will sing of great crowds excited by work, by pleasure, and by riot; we will sing of the multicolored, polyphonic tides of revolution in the modern capitals; we will sing of the vibrant nightly fervor of arsenals and shipyards blazing with violent electric moons; greedy railway stations that devour smoke-plumed serpents; factories hung on clouds by the crooked lines of their smoke; bridges that stride the rivers like giant gymnasts, flashing in the sun with a glitter of knives; adventurous steamers that sniff the horizon; deep-chested locomotives whose

wheels paw the tracks like the hooves of enormous steel horses bridled by tubing; and the sleek flight of planes whose propellers chatter in the wind like banners and seem to cheer like an enthusiastic crowd.

It is from Italy that we launch through the world this violently upsetting, incendiary manifesto of ours. With it, today, we establish *Futurism* because we want to free this land from its smelly gangrene of professors, archaeologists, ciceroni, and antiquarians. For too long has Italy been a dealer in secondhand clothes. We mean to free her from the numberless museums that cover her like so many graveyards.

Museums: cemeteries! . . . Identical, surely, in the sinister promiscuity of so many bodies unknown to one another. Museums: public dormitories where one lies forever beside hated or unknown beings. Museums; absurd abattoirs of painters and sculptors ferociously macerating each other with color-blows and line-blows, the length of the fought-over walls!

[. . .]

In truth I tell you that daily visits to museums, libraries, and academies (cemeteries of empty exertion, calvaries of crucified dreams, registries of aborted beginnings!) is, for artists, as damaging as the prolonged supervision by parents of certain young people drunk with their talent and their ambitious wills. When the future is barred to them, the admirable past may be a solace for the ills of the moribund, the sickly, the prisoner. . . . But we want no part of it, the past, we the young and strong *Futurists!*

So let them come, the gay incendiaries with charred fingers! Here they are! Here they are! . . . Come on! set fire to the library shelves! Turn aside the canals to flood the museums! . . . Oh, the joy of seeing the glorious old canvases bobbing adrift on those waters, discolored and shredded! . . . Take up your pickaxes, your axes and hammers, and wreck, wreck the venerable cities, pitilessly!

[. . .]

NOTES

1 The *Victory of Samothrace* (*c.* 200 BCE) is a large Greek marble statue thought to be from the prow of a ship. It was discovered on the Aegean Island of Samothrace in 1863 and taken to Paris were it was installed in the Louvre in 1867. For Marinetti this sculpture epitomised the classical tradition. [SE]

viii) *LEF*, 'Declaration: Comrades, Organisers of Life' (1923)

The LEF (Left Front of the Arts) group was formed by revolutionary artists and writers in the Soviet Union in 1923. Leading figures included the poet Vladimir Mayakovsky (1893–1930), the artist and photographer Alexander Rodchenko (1891–1956), the critic Osip Brik (1888–1945), and the theatre director Sergei Tretyakov (1892–1939). A journal was published in two phases: initially as *LEF* between 1923 and 1925, and then again as *Novyi Lef* (New *LEF*) between 1927 and 1928. *LEF*'s basic platform entailed the rejection of 'bourgeois' art forms and the

active involvement of artists and writers in building the new, post-revolutionary socialist society. For these revolutionary artists and intellectuals the construction of a new society demanded new forms of representation in order to represent the new reality. These concerns are presented, in the text printed here, in the declamatory style of political agitation. [PW/SE]

> Source: *LEF*, 'Declaration: Comrades, Organisers of Life' (1923), reprinted in *Russian Art of the Avant Garde. Theory and Criticism 1902–1934*, John E. Bowlt, ed. and trans., Thames and Hudson, 1988, pp. 199–202

[. . .]

Today, the *First of May*, the workers of the world will demonstrate in their millions with song and festivity.
Five years of attainments, ever increasing.
Five years of slogans renewed and realized daily.
Five years of victory.
And–
Five years of monotonous designs for celebrations.
Five years of languishing art.

So-called Stage Managers!
How much longer will you and other rats continue to gnaw at this theatrical sham?
Organize according to real life!
Plan the victorious procession of the Revolution!

So called Poets!
When will you throw away your sickly lyrics?
Will you ever understand that to sing praises of a tempest according to newspaper information is not to sing praises about a tempest?
Give us a new *Marseillaise* and let the *Internationale* thunder the march of the victorious Revolution!

So called Artists!
Stop making patches of color on moth-eaten canvases.
Stop decorating the easy life of the bourgeoisie.
Exercise your artistic strength to engirdle cities until you are able to take part in the whole of global construction!
Give the world new colors and outlines!
We know that the 'priests of art' have neither strength nor desire to meet these tasks: they keep to the aesthetic confines of their studios.

On this day of demonstration, the First of May, when proletarians are gathered on a united front, we summon you, organizers of the world:
Break down the barriers of 'beauty for beauty's sake'; break down the barriers of those nice little artistic schools!

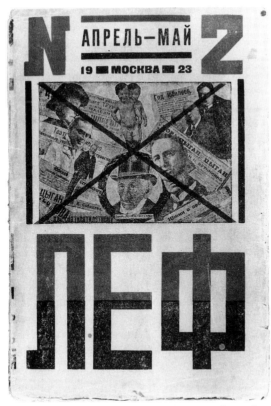

xxi) Alexander Rodchenko and Varvara Stepanova, Cover of
LEF, no. 2, 1923. V&A Picture Library. © DACS 1998.

Add your strength to the united energy of the collective!

We know that the aesthetics of the old artists, whom we have branded 'rightists,' revive monasticism and await the holy spirit of inspiration, but they will not respond to out call.

We summon the 'leftists', the revolutionary *futurists,* who have given the streets and squares their art; the *productivists,* who have squared accounts with inspiration by relying on the inspiration of factory dynamos; the *constructivists,* who have substituted the processing of material for the mysticism of creation.

Leftists of the world!

We know few of your names, or the names of your schools, but this we do know – wherever revolution is beginning, there you are advancing.

We summon you to establish a single front of leftist art – the 'Red Art International.'

Comrades!

Split leftist art from rightist everywhere!

With leftist art prepare the European Revolution; in the U.S.S.R. strengthen it.

[. . .]

Not by accident did we choose the First of May as the day of our call

Only in conjunction with the Workers' Revolution can we see the dawn of future art.
We, who have worked for five years in a land of revolution, know:
That only October has given us new, tremendous ideas that demand new artistic
organization.
That the October Revolution, which liberated art from bourgeois enslavement,
has given real freedom to art.
Down with the boundaries of countries and of studios!
Down with the monks of rightist art!
Long live the single front of the leftists!
Long live the art of the Proletarian Revolution!

ix) Bureau of Surrealist Research, 'Declaration of 27 January, 1925' (1925)

The Surrealist group was constituted in 1924 and its first Manifesto, by the poet
André Breton (1896–1966), was published in Paris that same year. A journal, *La
Revolution Surréaliste*, also commenced publication. Although Surrealism is best
known for its visual art, particularly the production of 'dream images', the major-
ity of early adherents to the group were literary figures. However, Surrealism
always aspired to more than just artistic activity. As the historian Maurice Nadeau
wrote, 'what was at stake was not writing but revolution'. This stance is made
explicit in the Declaration published in January 1925. Though signed by twenty-
six individuals, it appeared under the collective imprimatur of the 'Bureau de
Recherches Surréalistes' (Bureau of Surrealist Research). In it Surrealism, it was
claimed, was not a manifestation of culture, but an instrument of human libera-
tion. This liberation is 'of the mind', but the Surrealists see its achievement as
requiring more than mental exertion: 'material hammers, if need be'. In short,
the Surrealists, in uniting the ideas of Karl Marx and Sigmund Freud, conceived
their work to be part of bringing about revolution, the destabilisation of bour-
geois culture and consciousness as a counterpart to revolutionary political
struggle. [PW/SE]

Source: Bureau of Surrealist Research, 'Declaration of 27 January, 1925' (1925),
trans. Robert Howard, reprinted in Maurice Nadeau, *The History of Surrealism*,
Penguin, 1978, pp. 262–3

With regard to a false interpretation of our enterprise, stupidly circulated among
the public,
 We declare as follows to the entire braying literary, dramatic, philosophical,
exegetical and even theological body of contemporary criticism:
 1) We have nothing to do with literature;
 But we are quite capable, when necessary, of making use of it like anyone else.
 2) *Surrealism* is not a new means of expression, or an easier one, nor even a
 metaphysic of poetry.

It is a means of total liberation of the mind *and of all that resembles it.*

3) We are determined to make a Revolution.

4) We have joined the word *surrealism* to the word *revolution* solely to show the disinterested, detached, and even entirely desperate character of this revolution.

5) We make no claim to change the *mores* of mankind, but we intend to show the fragility of thought, and on what shifting foundations, what caverns we have built our trembling houses.

6) We hurl this formal warning to Society: Beware of your deviations and *faux-pas*, we shall not miss a single one.

7) At each turn of its thought, Society will find us waiting.

8) We are specialists in Revolt.
There is no means of action which we are not capable, when necessary, of employing.

9) We say in particular to the Western world: *surrealism* exists. And what is this new ism that is fastened to us? Surrealism is not a poetic form. It is a cry of the mind turning back on itself, and it is determined to break apart its fetters, even if it must be by material hammers!

Bureau de Recherches Surréalistes,
15, Rue de Grenelle:

LOUIS ARAGON	MICHEL LEIRIS
ANTONIN ARTAUD	GEORGES LIMBOUR
JACQUES BARON	MATHIAS LÜBECK
JOË BOUSQUET	GEORGES MALKINE
J.-A. BOIFFARD	ANDRÉ MASSON
ANDRÉ BRETON	MAX MORISE
JEAN CARRIVE	PIERRE NAVILLE
RENÉ CREVEL	MARCEL NOLL
ROBERT DESNOS	BENJAMIN PÉRET
PAUL ÉLUARD	RAYMOND QUENEAU
MAX ERNST	PHILIPPE SOUPAULT
T. FRANKEL	DÉDÉ SUNBEAM
FRANCIS GÉRARD	ROLAND TUAL

x) Clement Greenberg, from 'Avant Garde and Kitsch' (1939)

Clement Greenberg (1909–94) became the leading figure in modernist criticism in the years from the end of the Second World War to the late 1960s. In this post-war period Greenberg's writing was understood as advocating an intimate appreciation of works of art that dispensed altogether with social determinants of artistic production and interpretation. His first major essay, 'Avant Garde and Kitsch' was, however, published in the New York based left-wing magazine *Partisan Review*. In this text, Greenberg employs, the term 'avant-garde' as the name for what was

more commonly referred to as the 'modern movement': the increasingly autonomous artistic tradition which traced its own origins to French art of the mid-nineteenth century, and which, by the outbreak of the Second World War, seemed to have culminated in the abstract work of artists such as Mondrian and Miró. In this essay Greenberg saw kitsch (a kind of cheap item of entertainment) as the product of bourgeois culture in profound and terminal crisis. He believed, at this time, that avant-garde art was necessary to keep culture alive until a genuine socialism could create a new culture. (One note omitted.) [PW/SE]

Source: Clement Greenberg, from 'Avant Garde and Kitsch' (1939), reprinted in *Clement Greenberg. The Collected Essays and Criticism, vol. I, Perceptions and Judgements 1939–1944*, John O'Brian, ed., University of Chicago Press, 1986, pp. 6–11

[. . .]

A society, as it becomes less and less able, in the course of its development, to justify the inevitability of its particular forms, breaks up the accepted notions upon which artists and writers must depend in large part for communication with their audiences. It becomes difficult to assume anything. All the verities involved by religion, authority, tradition, style, are thrown into question, and the writer or artist is no longer able to estimate the response of his audience to the symbols and references with which he works. In the past such a state of affairs has usually resolved itself into a motionless Alexandrianism, an academicism in which the really important issues are left untouched because they involve controversy, and in which creative activity dwindles to virtuosity in the small details of form, all larger questions being decided by the precedent of the old masters. The same themes are mechanically varied in a hundred different works, and yet nothing new is produced: Statius, mandarin verse, Roman sculpture, Beaux-Arts painting, neo-republican architecture.

It is among the hopeful signs in the midst of the decay of our present society that we – some of us – have been unwilling to accept this last phase for our own culture. In seeking to go beyond Alexandrianism, a part of Western bourgeois society has produced something unheard of heretofore: – avant-garde culture. A superior consciousness of history – more precisely, the appearance of a new kind of criticism of society, an historical criticism – made this possible. This criticism has not confronted our present society with timeless utopias, but has soberly examined in the terms of history and of cause and effect the antecedents, justifications and functions of the forms that lie at the heart of every society. Thus our present bourgeois social order was shown to be, not an eternal, 'natural' condition of life, but simply the latest term in a succession of social orders. New perspectives of this kind, becoming a part of the advanced intellectual conscience of the fifth and sixth decades of the nineteenth century, soon were absorbed by artists and poets, even if unconsciously for the most part. It was no accident, therefore, that the birth of the avant-garde coincided chronologically – and geographically, too – with the first bold development of scientific revolutionary thought in Europe.

True, the first settlers of bohemia – which was then identical with the avant-garde – turned out soon to be demonstratively uninterested in politics. Nevertheless, with-

out the circulation of revolutionary ideas in the air about them, they would never have been able to isolate their concept of the 'bourgeois' in order to define what they were *not*. Nor, without the moral aid of revolutionary political attitudes would they have had the courage to assert themselves as aggressively as they did against the prevailing standards of society. Courage indeed was needed for this, because the avant-garde's emigration from bourgeois society to bohemia meant also an emigration from the markets of capitalism, upon which artists and writers had been thrown by the falling away of aristocratic patronage. (Ostensibly, at least, it meant this – meant starving in a garret – although, as we will be shown later, the avant-garde remained attached to bourgeois society precisely because it needed its money.)

Yet it is true that once the avant-garde had succeeded in 'detaching' itself from society, it proceeded to turn around and repudiate revolutionary as well as bourgeois politics. The revolution was left inside society, a part of that welter of ideological struggle which art and poetry find so unpropitious as soon as it begins to involve those 'precious' axiomatic beliefs upon which culture thus far has had to rest. Hence it developed that the true and most important function of the avant-garde was not to 'experiment,' but to find a path along which it would be possible to keep culture *moving* in the midst of ideological confusion and violence. Retiring from public altogether, the avant-garde poet or artist sought to maintain the high level of his art by both narrowing and raising it to the expression of an absolute in which all relativities and contradictions would be either resolved or beside the point. 'Art for art's sake' and 'pure poetry' appear, and subject matter or content becomes something to be avoided like a plague.

It has been in search of the absolute that the avant-garde has arrived at 'abstract' or 'nonobjective' art – and poetry, too. The avant-garde poet or artist tries in effect to imitate God by creating something valid solely on its own terms, in the way nature itself is valid, in the way a landscape – not its picture – is aesthetically valid; something *given*, increate, independent of meanings, similars or originals. Content is to be dissolved so completely into form that the work of art or literature cannot be reduced in whole or in part to anything not itself.

But the absolute is absolute, and the poet or artist, being what he is, cherishes certain relative values more than others. The very values in the name of which he invokes the absolute are relative values, the values of aesthetics. And so he turns out to be imitating, not God – and here I use 'imitate' in its Aristotelian sense – but the disciplines and processes of art and literature themselves. This is the genesis of the 'abstract.'[1] In turning his attention away from subject matter of common experience, the poet or artist turns it in upon the medium of his own craft. The nonrepresentational or 'abstract,' if it is to have aesthetic validity, cannot be arbitrary and accidental, but must stem from obedience to some worthy constraint or original. This constraint, once the world of common, extroverted experience has been renounced, can only be found in the very processes or disciplines by which art and literature have already imitated the former. These themselves become the subject matter of art and literature. If, to continue with Aristotle, all art and literature are imitation, then what we have here is the imitation of imitating. To quote Yeats:

Nor is there singing school but studying
Monuments of its own magnificence.

Picasso, Braque, Mondrian, Miró, Kandinsky, Brancusi, even Klee, Matisse and
Cézanne derive their chief inspiration from the medium they work in.[2] The
excitement of their art seems to lie most of all in its pure preoccupation with the
invention and arrangement of spaces, surfaces, shapes, colors, etc., to the exclu-
sion of whatever is not necessarily implicated in these factors. The attention of
poets like Rimbaud, Mallarmé, Valéry, Éluard, Pound, Hart Crane, Stevens, even
Rilke and Yeats, appears to be centered on the effort to create poetry and on the
'moments' themselves of poetic conversion, rather than on experience to be con-
verted into poetry. Of course, this cannot exclude other preoccupations in their
work, for poetry must deal with words, and words must communicate. Certain
poets, such as Mallarmé and Valéry, are more radical in this respect than others –
leaving aside those poets who have tried to compose poetry in pure sound alone.
However, if it were easier to define poetry, modern poetry would be much more
'pure' and 'abstract.' As for the other fields of literature – the definition of avant-
garde aesthetics advanced here is no Procrustean bed. But aside from the fact that
most of our best contemporary novelists have gone to school with the avant-garde,
it is significant that Gide's most ambitious book is a novel about the writing of a
novel, and that Joyce's *Ulysses* and *Finnegans Wake* seem to be, above all, as one
French critic says, the reduction of experience to expression for the sake of expres-
sion, the expression mattering more than what is being expressed.

That avant-garde culture is the imitation of imitating – the fact itself – calls for
neither approval nor disapproval. It is true that this culture contains within itself
some of the very Alexandrianism it seeks to overcome. The lines quoted from
Yeats referred to Byzantium, which is very close to Alexandria; and in a sense this
imitation of imitating is a superior sort of Alexandrianism. But there is one most
important difference: the avant-garde moves, while Alexandrianism stands still.
And this, precisely, is what justifies the avant-garde's methods and makes them
necessary. The necessity lies in the fact that by no other means is it possible today
to create art and literature of a high order. To quarrel with necessity by throwing
about terms like 'formalism,' 'purism,' 'ivory tower' and so forth is either dull or
dishonest. This is not to say, however, that it is to the *social* advantage of the avant-
garde that it is what it is. Quite the opposite.

The avant-garde's specialization of itself, the fact that its best artists are artists'
artists, its best poets, poets' poets, has estranged a great many of those who were
capable formerly of enjoying and appreciating ambitious art and literature, but
who are now unwilling or unable to acquire an initiation into their craft secrets.
The masses have always remained more or less indifferent to culture in the process
of development. But today such culture is being abandoned by those to whom it
actually belongs – our ruling class. For it is to the latter that the avant-garde
belongs. No culture can develop without a social basis, without a source of stable
income. And in the case of the avant-garde, this was provided by an elite among
the ruling class of that society from which it assumed itself to be cut off, but to

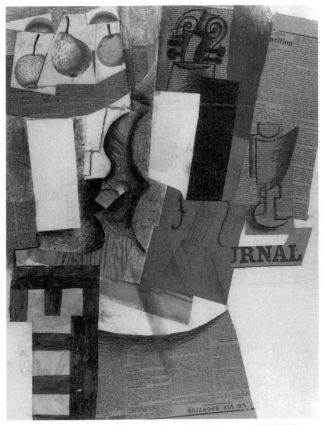

xxii) Pablo Picasso, *Bowl of Fruit, Violin and Wineglass*, 1912, Philadelphia
 Museum of Modern Art, the A.E. Gallotin Collection. © Succession
 Picasso DACS 1998.

which it has always remained attached by an umbilical cord of gold. The paradox
is real. And now this elite is rapidly shrinking. Since the avant-garde forms the
only living culture we now have, the survival in the near future of culture in gen-
eral is thus threatened.

 We must not be deceived by superficial phenomena and local successes.
Picasso's shows still draw crowds, and T. S. Eliot is taught in the universities; the
dealers in modernist art are still in business, and the publishers still publish some
'difficult' poetry. But the avant-garde itself, already sensing the danger, is becom-
ing more and more timid every day that passes. Academicism and commercialism
are appearing in the strangest places. This can mean only one thing; that the
avant-garde is becoming unsure of the audience it depends on – the rich and the
cultivated.

[. . .]

NOTES

1 The example of music, which has long been an abstract art, and which avant-garde poetry has tried so much to emulate, is interesting. Music, Aristotle said curiously enough, is the most imitative and vivid of all arts because it imitates its original – the state of the soul – with the greatest immediacy. Today this strikes us as the exact opposite of the truth, because no art seems to us to have less reference to something outside itself than music. However, aside from the fact that in a sense Aristotle may still be right, it must be explained that ancient Greek music was closely associated with poetry, and depended upon its character as an accessory to verse to make its imitative meaning clear. Plato, speaking of music, says: 'For when there are no words, it is very difficult to recognize the meaning of the harmony and rhythm, or to see that any worthy object is imitated by them.' As far as we know, all music originally served such an accessory function. Once, however, it was abandoned, music was forced to withdraw into itself to find a constraint or original. This is found in the various means of its own composition and performance.

2 I owe this formulation to a remark made by Hans Hofmann, the art teacher, in one of his lectures. From the point of view of this formulation, Surrealism in plastic art is a reactionary tendency which is attempting to restore 'outside' subject matter. The chief concern of a painter like Dali is to represent the processes and concepts of his consciousness, not the processes of his medium.

xi) Peter Bürger, from *Theory of the Avant-Garde* (1974)

In the wake of the political and intellectual changes of the late 1960s, Peter Bürger (b. 1936) was among those critics who sought to remove the definition of 'avant-garde' from its identification with an aesthetically autonomous artistic modernism, and to return it to its original use within the socialist tradition. To this end Bürger reserves the term 'avant-garde' for those groups who, in response to the First World War and the Russian Revolution, sought to overcome the separation of art from life. The foremost of these 'classic avant-gardes' were Dada, Constructivism and Surrealism, though Bürger also acknowledges the avant-garde status of related movements such as Expressionism, Futurism and Cubism. By his own account, Bürger's book evolved out of discussions in German universities 'that emerged after the events of May 1968 and the failure of the student movement in the early seventies.' It was eventually translated into English in 1984, since when it has been influential in re-evaluations of twentieth-century art. (Footnotes omitted.) [PW/SE]

Source: Peter Bürger, from *Theory of the Avant-Garde* (1974), trans. Michael Shaw, University of Minnesota Press, 1984, pp. 16–17, 47–54

[. . .] 'The example of labor,' Marx writes, 'shows strikingly how even the most abstract categories, despite their validity – precisely because of their abstractness – for all epochs, are nevertheless, in the specific character of this abstraction, themselves likewise a product of historic relations, and possess their full validity only for and within these relations.' The idea is difficult to grasp because Marx maintains on the one hand that certain simple categories are always valid, yet also states that their generality is due to specific historical conditions. The decisive distinction here is between 'validity for all epochs' and the *perception* of this general validity (in Marx's terms, 'the specific character of this abstraction'). It is Marx's contention that conditions must have unfolded historically for that per-

ception to become possible. In the monetary system, he says, wealth is still interpreted to be money, which means that the connection between labor and wealth is not seen. Only in the theory of the physiocrats is labor discovered to be the source of wealth, though it is not labor in general but only a particular form of it, namely, agriculture. In classical English economics, in Adam Smith, it is no longer a particular kind of labor but labor in general that is recognized as the source of wealth. For Marx, this development is not merely one in economic theory. Rather, he feels that the possibility of a progress in knowledge is a function of the development of the object toward which insight directs itself. When the physiocrats developed their theory (in France, during the second half of the eighteenth century), agriculture was still the economically dominant sector on which all others depended. Only in the economically much more advanced England, where the industrial revolution had already set in and where the dominance of agriculture over all other sectors of social production would therefore be eventually eliminated, was Smith's insight possible that it was not a specific form of labor but labor as such that created wealth. [. . .]

It is my thesis that the connection between the insight into the general validity of a category and the actual historical development of the field to which this category pertains and which Marx demonstrated through the example of the category of labor also applies to objectifications in the arts. Here also, the full unfolding of the constituent elements of a field is the condition for the possibility of an adequate cognition of that field. In bourgeois society, it is only with aestheticism that the full unfolding of the phenomenon of art became a fact, and it is to aestheticism that the historical avant-garde movements respond.[1]
[. . .]

THE NEGATION OF THE AUTONOMY OF ART BY THE AVANT-GARDE

In scholarly discussion up to now, the category 'autonomy' has suffered from the imprecision of the various subcategories thought of as constituting a unity in the concept of the autonomous work of art. Since the development of the individual subcategories is not synchronous, it may happen that sometimes courtly art seems already autonomous, while at other times only bourgeois art appears to have that characteristic. To make clear that the contradictions between the various interpretations result from the nature of the case, we will sketch a historical typology that is deliberately reduced to three elements (purpose or function, production, reception), because the point here is to have the nonsynchronism in the development of individual categories emerge with clarity.

A. Sacral Art (example: the art of the High Middle Ages) serves as cult object. It is wholly integrated into the social institution 'religion.' It is produced collectively, as a craft. The mode of reception also is institutionalized as collective.

B. Courtly Art (example: the art at the court of Louis XIV) also has a precisely defined function. It is representational and serves the glory of the prince and the self-portrayal of courtly society. Courtly art is part of the life praxis of courtly society, just as sacral art is part of the life praxis of the faithful. Yet the detachment

from the sacral tie is a first step in the emancipation of art. ('Emancipation' is being used here as a descriptive term, as referring to the process by which art constitutes itself as a distinct social subsystem.) The difference from sacral art becomes particularly apparent in the realm of production: the artist produces as an individual and develops a consciousness of the uniqueness of his activity. Reception, on the other hand, remains collective. But the content of the collective performance is no longer sacral, it is sociability.

C. Only to the extent that the bourgeoisie adopts concepts of value held by the aristocracy does bourgeois art have a representational function. When it is genuinely bourgeois, this art is the objectification of the self-understanding of the bourgeois class. Production and reception of the self-understanding as articulated in art are no longer tied to the praxis of life. Habermas calls this the satisfaction of residual needs, that is, of needs that have become submerged in the life praxis of bourgeois society. Not only production but reception also are now individual acts. The solitary absorption in the work is the adequate mode of appropriation of creations removed from the life praxis of the bourgeois, even though they still claim to interpret that praxis. In Aestheticism, finally, where bourgeois art reaches the stage of self-reflection, this claim is no longer made. Apartness from the praxis of life, which had always been the condition that characterized the way art functioned in bourgeois society, now becomes its content. The typology we have sketched here can be represented in the accompanying tabulation (the vertical lines in boldface refer to a decisive change in the development, the broken ones to a less decisive one).

	Sacral Art	Courtly Art	Bourgeois Art
Purpose or function	cult object	representational object	portrayal of bourgeois self-understanding
Production	collective craft	individual	individual
Reception	collective (sacral)	collective (sociable)	individual

[. . .]

Seen in this fashion, the separation of art from the praxis of life becomes the decisive characteristic of the autonomy of bourgeois art (a fact that the tabulation does not bring out adequately). To avoid misunderstandings, it must be emphasized once again that autonomy in this sense defines the status of art in bourgeois society but that no assertions concerning the contents of works are involved. Although art as an institution may be considered fully formed toward the end of the eighteenth century, the development of the contents of works is subject to a historical dynamics, whose terminal point is reached in Aestheticism, where art becomes the content of art.

The European avant-garde movements can be defined as an attack on the status of art in bourgeois society. What is negated is not an earlier form of art (a style) but art as an institution that is unassociated with the life praxis of men. When the

avant-gardistes demand that art become practical once again, they do not mean that the contents of works of art should be socially significant. The demand is not raised at the level of the contents of individual works. Rather, it directs itself to the way art functions in society, a process that does as much to determine the effect that works have as does the particular content.

The avant-gardistes view its dissociation from the praxis of life as the dominant characteristic of art in bourgeois society. One of the reasons this dissociation was possible is that Aestheticism had made the element that defines art as an institution the essential content of works. Institution and work contents had to coincide to make it logically possible for the avant-garde to call art into question. The avant-gardistes proposed the sublation of art – sublation in the Hegelian sense of the term: art was not to be simply destroyed, but transferred to the praxis of life where it would be preserved, albeit in a changed form. The avant-gardistes thus adopted an essential element of Aestheticism. Aestheticism had made the distance from the praxis of life the content of works. The praxis of life to which Aestheticism refers and which it negates is the means-ends rationality of the bourgeois everyday. Now, it is not the aim of the avant-gardistes to integrate art into *this* praxis. On the contrary, they assent to the aestheticists' rejection of the world and its means-ends rationality. What distinguishes them from the latter is the attempt to organize a new life praxis from a basis in art. In this respect also, Aestheticism turns out to have been the necessary precondition of the avant-gardiste intent. [. . .]

In the aestheticist work of art, the disjointure of the work and the praxis of life characteristic of the status of art in bourgeois society has become the work's essential content. It is only as a consequence of this fact that the work of art becomes its own end in the full meaning of the term. In Aestheticism, the social functionlessness of art becomes manifest. The avant-gardiste artists counter such functionlessness not by an art that would have consequences within the existing society, but rather by the principle of the sublation of art in the praxis of life. But such a conception makes it impossible to define the intended purpose of art. For an art that has been reintegrated into the praxis of life, not even the absence of a social purpose can be indicated, as was still possible in Aestheticism. When art and the praxis of life are one, when the praxis is aesthetic and art is practical, art's purpose can no longer be discovered, because the existence of two distinct spheres (art and the praxis of life) that is constitutive of the concept of purpose or intended use has come to an end.

We have seen that the *production* of the autonomous work of art is the act of an individual. The artist produces as individual, individuality not being understood as the expression of something but as radically different. The concept of genius testifies to this. [. . .] In its most extreme manifestations, the avant-garde's reply to this is not the collective as the subject of production but the radical negation of the category of individual creation. When Duchamp signs mass-produced objects (a urinal, bottle drier) and sends them to art exhibits, he negates the category of individual production. The signature, whose very purpose it is to mark what is individual in the work, that it owes its existence to this particular artist, is

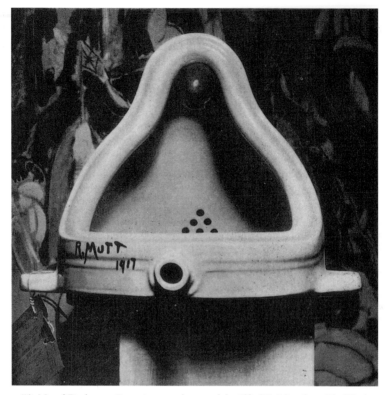

xxiii) Marcel Duchamp, *Fountain*, 1917, photograph by Alfred Steiglitz, from *The Blind Man* no. 2, May, 1917, Philadelphia Museum of Art, Louise and Walter Arensberg Archives. © Succession Marcel Duchamp DACS 1998.

inscribed on an arbitrarily chosen mass product, because all claims to individual creativity are to be mocked. Duchamp's provocation not only unmasks the art market where the signature means more than the quality of the work: it radically questions the very principle of art in bourgeois society according to which the individual is considered the creator of the work of art. Duchamp's Ready-Mades are not works of art but manifestations. Not from the form-content totality of the individual object Duchamp signs can one infer the meaning, but only from the contrast between mass produced object on the one hand, and signature and art exhibit on the other. [. . .]

The avant-garde not only negates the category of individual production but also that of individual *reception*. The reactions of the public during a dada manifestation where it has been mobilized by provocation, and which can range from shouting to fisticuffs, are certainly collective in nature. True, these remain reactions, responses to a preceding provocation. Producer and recipient remain clearly distinct, however active the public may become. Given the avant-gardist intention to do away with art as a sphere that is separate from the praxis of life, it is logical to eliminate the antithesis between producer and recipient. [. . .]

In summary, we note that the historical avant-garde movements negate those determinations that are essential in autonomous art: the disjunction of art and the praxis of life, individual production, and individual reception as distinct from the former. The avant-garde intends the abolition of autonomous art by which it means that art is to be integrated into the praxis of life. This has not occurred, and presumably cannot occur, in bourgeois society unless it be as a false sublation of autonomous art. Pulp fiction and commodity aesthetics prove that such a false sublation exists. [. . .]

NOTES

1 The concept of the historical avant-garde movements used here applies primarily to Dadaism and early Surrealism but also and equally to the Russian avant-garde after the October revolution. Partly significant differences between them notwithstanding, a common feature of all these movements is that they do not reject individual artistic techniques and procedures of earlier art but reject that art in its entirety, thus bringing about a radical break with tradition. In their most extreme manifestations, their primary target is art as an institution such as it has developed in bourgeois society. With certain limitations that would have to be determined through concrete analyses, this is also true of Italian Futurism and German Expressionism.

 Although cubism does not pursue the same intent, it calls into question the system of representation with its linear perspective that had prevailed since the Renaissance. For this reason, it is part of the historic avant-garde movements, although it does not share their basic tendency (sublation of art in the praxis of life). [. . .]

xii) Andreas Huyssen from 'Introduction', *After The Great Divide. Modernism, Mass Culture, Post Modernism* (1986)

Andreas Huyssen's text represents an intervention in the debate between modernist and postmodernist senses of avant-gardism, which may be identified, respectively, with the writings of Clement Greenberg and Peter Bürger. The former asserts a categorical distinction between, on the one hand, an independent art centred on the production of aesthetic effects, and on the other the world of 'kitsch', which encompasses both the remnants of the Academic tradition and a whole range of popular cultural forms. For Bürger however, the real 'avant-gardes' were those artistic tendencies which sought to overcome the modernist separation of art from life. Huyssen discusses the relation between modernism and mass culture in terms of a 'Great Divide'. He regards the attempt by various historical avant-gardes to overcome that distinction as precursors to the postmodern perspective from which he himself writes. In the words of another postmodern critic, Hal Foster, the postmodernist artist is not so much a 'producer of objects' as a 'manipulator of signs'. By the same token, postmodernist art is less a matter for aesthetic contemplation than an attempt to heighten critical awareness of the widespread cultural conventions in which contemporary subjectivities are formed. It follows, therefore, that the relation of such art to mass culture is very different from that of the modernist avant-garde. In the text Huyssen refers to artists, composers and writers who have been central figures in European high culture of the last two hundred years. [PW/SE]

Source: Andreas Huyssen from 'Introduction', *After The Great Divide, Modernism, Mass Culture, Post Modernism*, Macmillan Press, 1986, pp. vii–x

Ever since the mid-19th century, the culture of modernity has been characterized by a volatile relationship between high art and mass culture. Indeed, the emergence of early modernism in writers such as Flaubert and Baudelaire cannot be adequately understood on the basis of an assumed logic, of 'high' literary evolution alone. Modernism constituted itself through a conscious strategy of exclusion, an anxiety of contamination by its other: an increasingly consuming and engulfing mass culture. Both the strengths and the weaknesses of modernism as an adversary culture derive from that fact. Not surprisingly, this anxiety of contamination has appeared in the guise of an irreconcilable opposition, especially in the l'art pour l'art movements of the turn of the century (symbolism, aestheticism, art nouveau) and again in the post-World War II era in abstract expressionism in painting, in the privileging of experimental writing, and in the official canonization of 'high modernism' in literature and literary criticism, in critical theory and the museum.

However, modernism's insistence on the autonomy of the art work, its obsessive hostility to mass culture, its radical separation from the culture of everyday life, and its programmatic distance from political, economic, and social concerns was always challenged as soon as it arose. From Courbet's appropriation of popular iconography to the collages of cubism, from naturalism's attack on l'art pour l'art to Brecht's immersion in the vernacular of popular culture, from Madison Avenue's conscious exploitation of modernist pictorial strategies to postmodernism's uninhibited learning from Las Vegas, there has been a plethora of strategic moves tending to destabilize the high/low opposition from within. [. . .]

The most sustained attack on aestheticist notions of the self-sufficiency of high culture in this century resulted from the clash of the early modernist autonomy aesthetic with the revolutionary politics arising in Russia and Germany out of World War I, and with the rapidly accelerating modernization of life in the big cities of the early 20th century. This attack goes by the name of historical avantgarde, which clearly represented a new stage in the trajectory of the modern. Its most salient manifestations were expressionism and Berlin Dada in Germany; Russian constructivism, futurism, and the proletcult in the years following the Russian Revolution; and French surrealism, especially in its earlier phase. Of course, this historical avantgarde was soon liquidated or driven into exile by fascism and Stalinism, and its remnants were later retrospectively absorbed by modernist high culture even to the extent that 'modernism' and 'avantgarde' became synonymous terms in the critical discourse. My point of departure, however, is that despite its ultimate and perhaps inevitable failure, the historical avantgarde aimed at developing an alternative relationship between high art and mass culture and thus should be distinguished from modernism, which for the most part insisted on the inherent hostility between high and low. Such a distinction is not meant to account for each and every individual case: there are modernists whose aesthetic practice was close to the spirit of avantgardism, and

one could point to avantgardists who shared modernism's aversion to any form of mass culture. But even though the boundaries between modernism and avant-gardism remained fluid, the distinction I am suggesting permits us to focus on sufficiently discernible trends within the culture of modernity. More specifically, it allows us to distinguish the historical avantgarde from late-19th century modernism as well as from the high modernism of the interwar years [. . .]

What I am calling the Great Divide is the kind of discourse which insists on the categorical distinction between high art and mass culture. In my view, this divide is much more important for a theoretical and historical understanding of modernism and its aftermath than the alleged historical break which, in the eyes of so many critics, separates postmodernism from modernism. The discourse of the Great Divide has been dominant primarily in two periods, first in the last decades of the 19th century and the first few years of the 20th, and then again in the two decades or so following World War II. The belief in the Great Divide, with its aesthetic, moral, and political implications, is still dominant in the academy today (witness the almost total institutional separation of literary studies, including the new literary theory, from mass culture research, or the widespread insistence on excluding ethical or political questions from the discourse on literature and art). But it is increasingly challenged by recent developments in the arts, film, literature, architecture, and criticism. This second major challenge in this century to the canonized high/low dichotomy goes by the name of postmodernism; and like the historical avantgarde though in very different ways, postmodernism rejects the theories and practices of the Great Divide. Indeed, the birth of the postmodern out of the spirit of an adversary avantgardism cannot be adequately understood unless modernism's and postmodernism's different relationship to mass culture is grasped. [. . .]

After all, both modernism and the avantgarde always defined their identity in relation to two cultural phenomena: traditional bourgeois high culture (especially the traditions of romantic idealism and of enlightened realism and representation), but also vernacular and popular culture as it was increasingly transformed into modern commercial mass culture. Most discussions of modernism, the avantgarde, and even postmodernism, however, valorize the former at the expense of the latter. If mass culture enters in at all, it is usually only as negative, as the homogeneously sinister background on which the achievements of modernism can shine in their glory. [. . .]

Adorno[1], of course, was the theorist par excellence of the Great Divide, that presumably necessary and insurmountable barrier separating high art from popular culture in modern capitalist societies. He developed his theory, which I see as a theory of modernism, for music, literature, and film in the late 1930s, not coincidentally at the same time that Clement Greenberg articulated similar views to describe the history of modernist painting and to envision its future. Broadly speaking it can be argued that both men had good reasons at the time to insist on the categorical separation of high art and mass culture. The political impulse behind their work was to save the dignity and autonomy of the art work from the totalitarian pressures of fascist mass spectacles, socialist realism, and an ever more

degraded commercial mass culture in the West. That project was culturally and politically valid at the time, and it contributed in a major way to our understanding of the trajectory of modernism from Manet to the New York School, from Richard Wagner to the Second Vienna School, from Baudelaire and Flaubert to Samuel Beckett. It found its theoretically more limited expression in the New Criticism (the basic premises of which Adorno clearly would have rejected), and even today some of its basic assumptions continue to assert themselves, even though in altered form, in French poststructuralism and its American progeny. My argument, however, is that this project has run its course and is being replaced by a new paradigm, the paradigm of the postmodern, which is itself as diverse and multifaceted as modernism had once been before it ossified into dogma. By 'new paradigm' I do not mean to suggest that there is a total break or rupture between modernism and postmodernism, but rather that modernism, avantgarde, and mass culture have entered into a new set of mutual relations and discursive configurations which we call 'postmodern' and which is clearly distinct from the paradigm of 'high modernism.' As the word 'postmodernism' already indicates, what is at stake is a constant, even obsessive negotiation with the terms of the modern itself. [. . .]

NOTE

1 Theodor Wiesengrund Adorno (1903–69) was a German philosopher and musicologist who was influenced by the Marxist tradition. He argued, in a series of highly acclaimed books, that genuine culture was threatened by capitalism, and was in danger of being replaced by a degraded and instrumental mass media. For Adorno it was the most difficult works of modern art or music, rather than anti-capitalist propaganda, which represented the true resistance to this atrophy of critical reason. [SE]

Section Five
Views of Difference: Different Views of Art

A number of recent studies have investigated the way Europeans sought to control the cultural as well as the economic productions of their subjects, and continue to do so despite the fact that most areas previously under colonial rule have achieved at least nominal political independence. Historians trace the presence of dissent from imperialist interpretations at many points in the past. We reproduce here the viewpoints of the sculptor Edmonia Lewis in the mid nineteenth century, and of the scholar Ananda Kentish Coomaraswamy in the early twentieth century on his native Sri Lankan art (texts ii, iv). However the majority of documents and interpretations included in this section date from the 1960s onwards, and represent the joint impetus of the achievement of political independence for many areas and of movements for civil rights. From the 1960s onwards new ways of looking at imperial cultural systems in a broad sense have been proposed within academic fields such as Cultural Studies and Post-colonial Studies. These place the histories of the colonisers and the colonised together.

One of the key scholars in this field has been Edward Said (b. 1935) who has analysed the manner in which colonisers used stereotypes of the exotic 'East' and the timeless 'Orient' to create concepts of themselves as 'Western'. Within such stereotypes 'Western' indicated decorousness and normality (rather than exoticism) and the 'progressive' and 'modern' (rather than unchanging) (text vi). Said emphasised that a new look at the myths of European imperialism about the arts of colonised peoples entailed fresh scrutiny of canonical European art works. As an historian of comparative literature he aimed at a fuller understanding of texts like Jane Austen's *Mansfield Park*, but others have transposed this approach to the history of art. David Dabydeen, for example, in *Hogarth's Blacks* (1987) pointed to the imperialist meanings at the heart of famous paintings by the man considered the founder of the English school of painters, William Hogarth (see text vii).

As well as reconsidering the canonical works of the empire builders, scholars and artists from the 1960s onwards have been investigating the subordinate roles within the European canons of art played by a variety of artists, whether they were colonial subjects, slaves, descendants of slaves, or peoples whose lands have been taken. Such histories had frequently been disregarded on the grounds that the artists had had no influence on mainstream European artistic developments. However, a new wave of scholars, critics and artists proposed that those who had shown their inventiveness in making art 'against the grain' had

demonstrated independence of thought, imagination and intellect of the highest order. Such an enterprise was initiated, for instance, in 1965 when the African-American artist Romane Bearden was asked by students to give a talk on African-American artists. Finding a paucity of studies, he collaborated over the next twenty years with the scholar Harry Henderson to produce *A History of African-American Artists from 1792 to the Present* (1993). The painters and sculptors whose biographies they retrieved could be seen as forming an alternative canon in a tradition of resistance (see text v).

During the 1970s historians sought to unpick the sets of interlocking assumptions or discourses which placed canons of resistance at permanent disadvantage. The assumption that 'significant' artists were exclusively those who practised the high arts in the 'Western' tradition of painting, sculpture and architecture, with its accompanying notion of genius, was an important focus for critical analysis. African-American women, for example, had made many quilts displaying abstract and figurative designs. Could these too belong to the canon of resistance and survival? The 'Western' discourse developing from the sixteenth century onwards had treated textile making as a minor art, requiring routine manual operations by craftspeople. Such distinctions between high arts and the useful and decorative crafts were questioned.

During and soon after the period when many areas achieved independence, interest intensified in the way colonisers had interpreted the pre-colonial arts produced by the societies which they had colonised. For instance, Partha Mitter has surveyed the historiography of Indian art by Europeans in *Much Maligned Monsters: History of European Reactions to Indian Art* (1977) (see text viii). Mitter traced the application of theories of racial superiority to the evaluation and categorisation of pre-colonial Indian art in writings like those of James Fergusson in the mid nineteenth century (see text i). Mitter noted Fergusson's unfavourable comparisons between Indian pre-colonial art and the traditions of Classical Greek and Roman art. He also analysed the evaluations of the followers of John Ruskin, William Morris and the Arts and Crafts Movement who enthused about pre-colonial Indian art as being similar to that of Medieval Europe. These medievalists demolished the canonical status of Classical and Renaissance styles and proposed that concepts of the Fine Arts and of 'genius' developed in the Italian Renaissance were robbing everyone of their share in the pleasures of making and using art. Instead, they put forward as canonical exemplars of excellence the secular and ecclesiastical buildings of the Romanesque and Gothic period in Europe. The study entitled *Medieval Sinhalese Art* (1908) by Ananda Kentish Coomaraswamy is an example of this new evaluation (text ii).

Mitter regarded both approaches as blinkered, since neither set of viewers was willing to treat Indian art independently of 'Western' canons – be they medieval or Classical. He also uncovered the work of Indian scholars who had sought, before the achievement of independence, to enable Indian art to be studied in Indian terms of reference. For instance, he described the importance of Ram Raz in publishing critical editions of the *Śilpa Śāstras* (1834) (see text viii). Indeed, Mitter looked forward to a time when scholars would study and evaluate pre-eighteenth-

century Indian works of art in the light of what could be reconstructed of the purposes and standards of the artists and the erudite patrons who had made them. Indian artists could also be seen as operating canons of excellence in the sense of making and responding to exemplary solutions to the demands of specific art forms. For example, a succession of sculptures like the images of Shiva and of the Buddha in their different guises, show artists contributing to a sequence of solutions judged worthy of imitation – in other words, to a canonical tradition.

Artists and scholars have also taken issue with imperialist approaches to evaluating modern art produced by colonial subjects and their heirs. In societies which have achieved political independence, such as Nigeria, as well as ones where they have not, as in the position of First Australians, groups of artists have created agendas for themselves which aim to avoid notions of 'Western' leadership (texts iv, ix). Such communities see themselves as having arrived at their modern art practices by their own routes developing from a strong base in their own traditions rather than having been given modern art by 'Western' inventors.

'Western' historians have tended to see their cultures as possessing long and continually changing traditions from which modern art with a capital 'M' has developed and whose modernity has then been given to 'developing' countries. These 'developing' peoples are supposed to have made unchanging traditional 'ethnic' art – which is considered to be authentic (text ix). Modern art produced by 'ethnic' communities may be thought of as alienated from its heritage rather than as having been produced as a critique of this heritage. One alternative is to consider that 'Western' art also represents its own 'ethnic' particularities and that 'non-Western' artistic traditions have always changed and developed – including developing their views of modern art. For example, Ikem Stanley Okoye has recently proposed that artists working within the tradition of sculpture in West Africa were developing modern ways of working around 1890 using found industrial materials (see text x).

The tendency for some 'Western' critics to treat modern art by those identified as 'non-Western' differently from the way they would approach modern art produced by 'Western' artists can be sampled in the critical response to the paintings of Rabindranath Tagore in 1930 (text iii), the exhibition *The Other Story* (text xi) and attitudes to the modern art being made by First Australians (text ix). The colonised and their heirs may be treated as if they trail behind the modernity of 'Western' art. Their works may be complimented as being very 'Indian', 'African' or 'Aboriginal', as if there were something unalterable in being Indian, African or First Australian – unlike the ever-inventive and developing identities claimed for being 'Western'. Critics may also compare artists' works with that of leading 'Western' exponents, rather as Partha Mitter noted that European historians had compared pre-colonial art and architecture with the stylistic traditions of Europe (see text viii). The issue here seems to be about whether there is only one, 'Western', agenda for the making of modern art which counts, or whether there may be a fruitful debate between exponents of high calibre about varieties of different but equally subtle and challenging works of art. [CK]

i) James Fergusson, from *The History of Indian and Eastern
 Architecture* (1876)

James Fergusson (1808–86) was born in Scotland and educated at Edinburgh High
School. While he was a teenager, he was sent to India. He had made a substan-
tial fortune as an indigo trader by his early twenties, and used this to travel exten-
sively around the subcontinent, studying its sites and buildings. Returning to
England by 1845, he spent the rest of his life as a writer and advisor on architec-
tural matters. His works covered both Classical and other styles in the West and
Indian and oriental architecture. He published *An Illustrated History of Architecture
of all Ages and Countries* in 1855, but his *Handbook of Indian and Eastern Architecture*
did not appear until 1876. In writing he was able to rely on the new science of
photography, supplementing his field notes of the 1830s with his own and other
collections of photographic images. Fergusson's text exemplifies the way that
notions of 'race' provided European colonisers with a framework of judgements
about the products of the indigenous peoples. In a climate of opinion that
increasingly saw different 'races' in terms of distinct species with separate origins,
Fergusson explained Indian architecture in terms of 'racial difference'. He argued
that it had been Aryans ('Indo Europeans') who had produced great art at an
early period on the subcontinent in the earliest Buddhist architecture. Following
the theories of Joseph Arthur Gobineau (1853–5) he asserted that the subsequent
decline from this cultural peak was the result of intermarrying with inferior
Dasyus or 'natives'. According to Fergusson, this 'racial' degeneration was
responsible for the subsequent production of what was, according to him,
inferior Hindu architecture. (Notes omitted.)[CC/CK]

Source: James Fergusson, from *The History of Indian and Eastern Architecture*, John
Murray, 1876, pp. 9–14

[. . .]

ARYANS

At some very remote period in the world's history – for reasons stated in the
Appendix I believe it to have been at about the epoch called by the Hindus the
Kali Yug, or B.C. 3101–the Aryans, a Sanscrit-speaking people, entered India across
the Upper Indus, coming from Central Asia. For a long time they remained set-
tled in the Punjab, or on the banks of the Sarasvati, then a more important stream
than now, the main body, however, still remaining to the westward of the Indus.
If, however, we may trust our chronology, we find them settled 2000 years before
the Christian Era, in Ayodhya, and then in the plenitude of their power. It was
about that time apparently that the event took place which formed the ground-
work of the far more modern poem known as the 'Ramayana.' The pure Aryans,
still uncontaminated by admixture with the blood of the natives, then seem to
have attained the height of their prosperity in India, and to have carried their vic-
torious arms, it may be, as far south as Ceylon.

There is, however, no reason to suppose that they at that time formed any permanent settlements in the Deccan, but it was at all events opened to their missionaries, and by slow degrees imbibed that amount of Brahmanism which eventually pervaded the whole of the south. Seven or eight hundred years after that time, or it may be about or before B.C. 1200, took place those events which form the theme of the more ancient epic known as the 'Mahabharata,' which opens up an entirely new view of Indian social life. If the heroes of that poem were Aryans at all, they were of a much less pure type than those who composed the songs of the Vedas, or are depicted in the verses of the 'Ramayana.' Their polyandry, their drinking bouts, their gambling tastes, and love of fighting, mark them as a very different race from the peaceful shepherd immigrants of the earlier age, and point much more distinctly towards a Tartar, trans-Himalayan origin, than to the cradle of the Aryan stock in Central Asia. As if to mark the difference of which they themselves felt the existence, they distinguished themselves, by name, as belonging to a Lunar race, distinct from, and generally antagonistic to, the Solar race, which was the proud distinction of the purer and earlier Aryan settlers in India.

Five or six hundred years after this, or about BC 700, we again find a totally different state of affairs in India. The Aryans no longer exist as a separate nationality, and neither the Solar nor the Lunar race are the rulers of the earth. The Brahmans have become a priestly caste, and share the power with the Kshatriyas, a race of far less purity of descent. The Vaisyas, as merchants and husbandmen, have become a power, and even the Sudras are acknowledged as a part of the body politic; and, though not mentioned in the Scriptures, the Nagas, or Snake people, had become a most influential part of the population. They are first mentioned in the 'Mahabharata,' where they play a most important part in causing the death of Parikshit, which led to the great sacrifice for the destruction of the Nagas by Janemajaya, which practically closes the history of the time. Destroyed, however, they were not, as it was under a Naga dynasty that ascended the throne of Magadha, in 691, that Buddha was born, BC 623, and the Nagas were the people whose conversion placed Buddhism on a secure basis in India, and led to its ultimate adoption by Asoka (BC 250) as the religion of the State.

Although Buddhism was first taught by a prince of the Solar race, and consequently of purely Aryan blood, and though its first disciples were Brahmans, it had as little affinity with the religion of the Vedas as Christianity had with the Pentateuch, and its fate was the same. The one religion was taught by one of Jewish extraction to the Jews and for the Jews; but it was ultimately rejected by them, and adopted by the Gentiles, who had no affinity of race or religion with the inhabitants of Judæa. Though meant originally, no doubt, for Aryans, the Buddhist religion was ultimately rejected by the Brahmans, who were consequently utterly eclipsed and superseded by it for nearly a thousand years; and we hear little or nothing of them and their religion till they reappeared at the court of the great Vicramaditya (490–530), when their religion began to assume that strange shape which it now still retains in India. In its new form it is as unlike the pure religion of the Vedas as it is possible to conceive one religion being to

another; unlike that, also, of the older portions of the 'Mahabharata'; but a confused mess of local superstitions and imported myths, covering up and hiding the Vedantic and Buddhist doctrines, which may sometimes be detected as underlying it. Whatever it be, however, it cannot be the religion of an Aryan, or even of a purely Turanian people, because it was invented by and for as mixed a population as probably were ever gathered together into one country – a people whose feelings and superstitions it only too truly represents.

DRAVIDIANS

Although, therefore, as was hinted above, there might be no great difficulty in recovering all the main incidents and leading features of the history of the Aryans, from their first entry into India till they were entirely absorbed into the mass of the population some time before the Christian Era, there could be no greater mistake than to suppose that their history would fully represent the ancient history of the country. The Dravidians are a people who, in historical times, seem to have been probably as numerous as the pure Aryans; and at the present day from one-fifth of the whole population of India. As Turanians, which they seem certainly to be, they belong, it is true, to a lower intellectual status than the Aryans, but they have preserved their nationality pure and unmixed, and such as they were at the dawn of history, so they seem to be now.

Their settlement in India extends to such remote pre-historic times, that we cannot feel even sure that we should regard them as immigrants, or, at least, as either conquerors or colonists on a large scale, but rather as aboriginal in the sense in which that term is usually understood. Generally it is assumed that they entered India across the Lower Indus, leaving the cognate Brahui in Belochistan as a mark of the road by which they came, and as the affinities of their language seem to be with the Ugrians and northern Turanian tongues, this view seems probable. But they have certainly left no trace of their migrations anywhere between the Indus and the Nerbudda, and all the facts of their history, so far as they are known, would seem to lead to an opposite conclusion. The hypothesis that would represent what we know of their history most correctly would place their original seat in the extreme south, somewhere probably not far from Madura or Tanjore, and thence spreading fan-like towards the north, till they met the Aryans on the Vindhya mountains. The question, again, is not of much importance for our present purposes, as they do not seem to have reached that degree of civilization at any period anterior to the Christian Era which would enable them to practise any of the arts of civilized life with success, so as to bring them within the scope of a work devoted to the history of art.

It may be that at some future period, when we know more of the ancient arts of these Dravidians than we now do, and have become familiar with the remains of the Accadians or early Turanian inhabitants of Babylonia, we may detect affinities which may throw some light on this very obscure part of history. At present, however, the indications are much too hazy to be at all relied upon. Geographically, however, one thing seems tolerably clear. If the Dravidians came into India

in historical times, it was not from Central Asia that they migrated, but from Babylonia, or some such southern region of the Asiatic continent.

DASYUS

In addition to these two great distinct and opposite nationalities, there exists in India a third, which, in pre-Buddhist times, was as numerous, perhaps even more so, than either the Aryans or Dravidians, but of whose history we know even less than we do of the two others. Ethnologists have not yet been able to agree on a name by which to call them. I have suggested Dasyus, a slave people, as that is the name by which the Aryans designated them when they found them there on their first entrance into India, and subjected them to their sway. Whoever they were, they seem to have been a people of a very inferior intellectual capacity to either the Aryans or Dravidians, and it is by no means clear that they would ever of themselves have risen to such a status as either to form a great community capable of governing themselves, and consequently having a history, or whether they must always have remained in the low and barbarous position in which we now find some of their branches. When the Aryans first entered India they seem to have found them occupying the whole valley of the Ganges – the whole country in fact between the Vindhya and the Himalayan mountains. At present they are only found in anything like purity in the mountain ranges that bound that great plain. There they are known as Bhîls, Coles, Sontals, Nagas, and other mountain tribes. But they certainly form the lowest underlying stratum of the population over the whole of the Gangetic plain. So far as their affinities have been ascertained they are with the trans-Himalayan population, and it either is that they entered India through the passes of that great mountain range, or it might be more correct to say that the Thibetans are a fragment of a great population that occupied both the northern and southern slope of that great chain of hills at some very remote pre-historic time.

Whoever they were, they were the people who, in remote times, were apparently the worshippers of Trees and Serpents, but what interests us more in them, and makes the inquiry into their history more desirable, is that they were the people who first adopted Buddhism in India, and they, or their congeners, are the only people who, in historic times, as now, adhered, or still adhere to, that form of faith. No purely Aryan people ever were, or ever could be, Buddhist, nor, so far as I know, were any Dravidian community ever converted to that faith. But in Bengal, in Ceylon, in Thibet, Burmah, Siam, and China, wherever a Thibetan people exists, or a people allied to them, there Buddhism flourished and now prevails. But in India the Dravidians resisted it in the south, and a revival of Aryanism abolished it in the north.

Architecturally, there is no difficulty in defining the limits of the Dasyu province: wherever a square tower-like temple exists with a perpendicular base, but a curvilinear outline above such as that shown in the woodcut on the following page, then we may feel certain of the existence, past or present of a people of Dasyu extraction retaining their purity very nearly in the direct ratio to the number of

these temples found in the district. Were it not consequently for the difficulty of introducing new names and obtaining acceptance to what is unfamiliar, the proper names and obtaining acceptance to what is unfamiliar, the proper names for the style prevailing in northern India would be Dasyu style, instead of Indo-Aryan or Dasyu-Aryan which I have felt constrained to adopt. No one can accuse the pure Aryans of introducing this form in India, or of building temples at all, or of worshipping images of Siva or Vishnu, with which these temples are filled, and they consequently have little title to confer their name on the style. The Aryans had, however, become so impure in blood before these temples were erected, and were so mixed up with the Dasyus, and had so influenced their religion and the arts, that it may be better to retain a name which sounds familiar, and does not too sharply prejudge the question. Be this as it may, one thing seems tolerably clear, that the regions occupied by the Aryans in India were conterminous with those of the Dasyus, or in other words, that the Aryans conquered the whole of the aboriginal or native tribes who occupied the plains of northern India, and ruled over them to such an extent as materially to influence their religion and their arts, and also very materially to modify even their language. So much so, indeed, that after some four or five thousand years of domination we should not be surprised if we have some difficulty in recovering traces of the original population, and could probably not do so, if some fragments of the people had not sought refuge in the hills on the north and south of the great Gangetic plain, and there have remained fossilised, or at least sufficiently permanent for purposes of investigation. [. . .]

ii) Ananda Kentish Coomaraswamy, from *Medieval Sinhalese Art* (1908)

It has been an important task in post-colonial accounts of culture to consider the work of those historians who rejected the colonisers' narratives and identified, instead, with the colonised. The art history written by Coomaraswamy (1877–1945) is an example of this kind of ideological resistance to colonialism. Coomaraswamy was educated in his mother's country – England, but identified with the religion of his father, affiliating himself to Hinduism in 1907. He fought to preserve the art and architecture of his father's country, present-day Sri Lanka (called Ceylon by Portuguese and British colonial map makers) and supported the fight for the independence of the Indian subcontinent from British rule. Contrary to colonising views Coomaraswamy argued that Indian and Sri Lankan art had begun to decline only when the European invaders had arrived and had destroyed systems of patronage as well as having introduced industrialisation. He asserted that Indian and Sri Lankan art should be compared to the art of Medieval Europe both in its spiritual aims, its preference for the symbolic over the realistic, and in its use of corporate workshop organisation. In making this argument Coomaraswamy was able to draw on the increasing dislike of the Classical aesthetic tradition in British artistic circles typified by the writings of John Ruskin (1819–1900) and later the work of the Arts and Crafts Movement (of which he became a member). [CK]

Source: Ananda Kentish Coomaraswamy, *Medieval Sinhalese Art*, Broad Campden, 1908, pp. v–vi, 54, 63–4

This book is a record of the work and the life of the craftsman in a feudal society not unlike that of Early Mediæval Europe. It deals, not with a period of great attainment in fine art, but with a beautiful and dignified scheme of peasant decoration, based upon the traditions of Indian art and craft. Sinhalese art is essentially Indian, but possesses this especial interest, that it is in many ways of an earlier character, and more truly Hindu – though Buddhist in intention, – than any Indian art surviving on the mainland so late as the beginning of the nineteenth century. The minor arts, and the painting, are such as we might expect to have been associated with the culture of Aśoka's time, and the builders of Barāhat.

The period dealt with I have called Mediæval; but it must be understood that changes of style in decorative art take place comparatively slowly, and that it is generally impossible to say at a glance whether a given piece of work be of the sixteenth, seventeenth, eighteenth century, or even older or later. Most of the specimens here figured or described date from the latter part of the eighteenth century. Mediæval conditions survived in full force until the British occupation of Kandy in 1815, and what is actually described in this book is the work of Sinhalese craftsmen under mediæval conditions, mainly as these survived in the eighteenth century, and, in a less degree, even to the present day.

Mediæval Sinhalese Art was the art of a people for whom husbandry was the most honourable of all occupations, amongst whom the landless man was a nobody, and whose ploughmen spoke as elegantly as courtiers. It was a religious art, and so a popular art. It was also essentially a national art; the craftsmen, forming an integral part of the Civil Service, were rewarded with grants of State land, no less than soldiers or husbandmen. It was the art of a people whose kings were 'one with the religion and the people,' – perhaps the most significant phrase in the whole of that magnificent chronicle, the Mahāvamsa[1] from which I have so often quoted, – a phrase embodying an ideal hopeless of attainment by a foreign ruler.

It was the art of a poor people, the annual income of whose kings did not in the eighteenth century exceed £2000 in money, beside revenue in kind. It was very different from the sumptuary art of the great courts and wealthy cities of India, of which we trace but a faint reflection here and there in the use of Indian materials, and the importation of Indian craftsmen. But it is the only true art discoverable in Ceylon to-day. In a few years it may be gone for ever. I have tried to make a picture of it, before it was too late.

If we would understand the significance and the history of the arts and crafts in India, it will be needful to begin with such survivals of them as we can study readily, and work back from these to earlier times. Hence, even from a wider point of view, I make no apology for writing a large book about a time when the traditions of fine art were stereotyped, and even the traditions of the crafts intensely formalised and rigid. Such an art is, as it were, an outlier, left by long continued

denudation, in extent severely limited, yet evidence unmistakeable of a former continuity which it helps us to understand. Even so considered, the intrinsic value of the art is great; the capacity for certain types of designing survives even to this day amongst a few craftsmen almost perfectly developed; and whatever limitations even late Sinhalese art possessed, it is at least immeasurably superior to anything produced by any would-be-modern Sinhalese artists of the present day. An eighteenth century *jātaka* painting[2] is as much superior to a modern Low-country book[3] illustration, as a Kandyan jewel is to a modern imitation of a design borrowed from a Birmingham catalogue, or a Kandyan temple to a modern structure [. . .]

This book is not primarily intended as a work of scholarship, but is written first of all for the Sinhalese people, as a memorial of a period which at present they are not willing to understand. The 'educated' Sinhalese of to-day, after, on the one hand, a century of foreign government, and of education in which the national culture has been completely ignored, and, on the other hand, an equal period of subservient and obsequious imitation of foreign manners, have little reason to be proud of their present achievement in the Art of Living. Evidence of shallow thought is everywhere to be seen in an exaltation of the present age at the expense of the past. It is, however, only in an effort to realise the ideals of this very past, and of the past of India, that there lies the possibility of a true regeneration and revitalising of the national life of the Sinhalese people. This book, then, is written first of all as a contribution to the understanding of this past.

Secondly, it is meant for those in East or West who are interested in the reorganization of life, and especially of the arts and crafts under modern conditions. Thirdly, an endeavour has been made to render it as far as possible of value to the anthropologist, and to students of sociology and folk-lore. Criticism, only too easy from several points of view, should take into account the actual purpose of the book, and the fact that such a detailed account of the arts and crafts of a small area in the East, is really pioneer work.

[. . .]

A more particular account of the *Ācāri*, *Navandannō*, or caste or guild of artificers proper, will be necessary. The subdivisions of the caste, according to Valentyn[4], are eleven in number, viz., *ācāri*, blacksmiths; *baḍallu*, silversmiths; *vaḍuvō*, carpenters; *liyana vaḍuvō*, turners; *ridikẹtayankārayō*, damasceners; *ẹtdatkẹtayankārayō*, ivory carvers and cabinet makers; *galvaḍuvo*, stone cutters; *ratne endra kāyarō* (?), jewellers; *ivaḍuvō*, arrow makers (lac workers); *sittaru*, painters; *lokuruvō*, founders. But Valentyn's divisions are rather a list of names given to men who follow particular branches of their craft, than actual caste divisions. The Janavamsa[5] merely distinguishes two principal divisions of the caste, viz., (1) *kamburō, navandanno* or *ācāri*, divided into *lokaruvō*, workers in copper, bronze and brass; *sittaru*, painters; and *svarṇakārayō*, goldsmiths; and including also turners and blacksmiths: and, (2) *vaḍuvō*, carpenters, blacksmiths and masons, including housebuilders, agricultural implement makers (who are also mentioned in the first section) and arrow makers (*ivaḍuvo*, including all lac workers). The existence of a confusion between the two classes is admitted, and

appears to have been inevitable as the work of the two to some extent overlapped. It seems likely that the *kamburō* (also spoken of in the Janavamsa as *Kammāra Brahmans*) were strictly speaking the imported *kammālar* workmen from the coast, who did fine work as goldsmiths, painters, etc., and that the *vaḍuvō*, were the indigenous artificers accustomed only to the ordinary work of building, tool making, etc. Just in the same way there were two groups of weavers, the *beravāyō* who made country cloth (home-spun, so to say) and the 'chalias' (*salāgamayō*) who were brought over from South India to make fine and gold-woven cloths. Confusion also results from the use of terms in a particular as well as in a general sense. At the present day two main divisions, corresponding in the main with those of the *Janavamsa* form the only real caste division. Those in the higher division (architects, painters, gold and silversmiths, brass repoussers, ivory and wood carvers) called *galladdō*, do not eat or intermarry with those in the lower division, called *vaḍuvō* (ordinary carpenters and turners of wood and ivory, blacksmiths, damasceners, stone carvers and lac workers). The term *vaḍuvā* now has the general meaning of 'carpenter,' and would hardly be used in speaking of a blacksmith, still less of a goldsmith, but is used in the *Māyāmataya* in the sense of 'architect,' and together with *sittaruva*, 'painter,' refers to men of the superior division. The tailors and embroiderers (*hannāli*) and leather workers (*hommarayō*), potters (*baḍahelayō*), weavers of country cloth (*beravāyō*), mat-makers (*kinnarayō*), and makers of whips, cords, and preparers of hides (*roḍiyō*) were of other and inferior caste. These last are only incidentally referred to in the present chapter.

[. . .]

The greatest interest attaches to the system of apprenticeship and instruction found amongst the Kandyan craftsmen. From the social and guild point of view, the same method may be said to be characteristic of all the craftsmen, both of the artificers' caste and also potters and weavers, etc. That is, the trade was hereditary, and the sons are brought up to it as a matter of course, and trained in the actual workshop, being given easy or monotonous work at first (as grinding colours) and little by little picking up a knowledge of the craft by precept, example, and practice; and so the tradition was perpetuated. Thus from the very beginning, the disciple absorbed together, technique, tradition and metaphysic. No technical education of the future can replace the workshop training of the old craftsmen; for technical education supplies only technique, and that inferior; the imagination it takes no account at all! When the son married and set up for himself, he would be given tools, but would still very probably continue to work with and for his father. We see here the working of the joint family system. Very often also the craftsman trained up with his own sons those of other men of the same caste. In either case the relation between master and pupil was one of lasting reverence and affection; especially where the period of instruction was prolonged, and the information imparted of great value, as amongst the higher craftsmen.

Such was the general type of apprenticeship amongst the craftsmen; but the teaching of drawing and design was confined to the superior division of the artificer's caste, the *galladdō* from whom the *pattal-hatara* men were drawn. The

lower division of craftsmen had also some knowledge of design, but in the main relied upon the others to set out their work.

[. . .]

NOTES

1 *The Great Chronicle. The History of Ceylon*, written in Pali in the 5th century – continued up to 1815. [CK]
2 A painting of an episode from the story of the incarnation of Buddha. [CK]
3 The plains on the coast of Ceylon (present day Sri Lanka) away from the mountainous capital of the Kingdom. [CK]
4 According to Coomaraswamy his source was the Reverend F. Valentyn. [CK]
5 *The History of Mankind*, composed in the fifteenth century in Sinhalese by Simha of Kessellena. [CK]
6 A work treating of building sites translated into Sinhalese from Sanskrit in 1837. [CK]
7 The court workshop in the original capital – Kandy. [CK]

iii) Three Reviews of an Exhibition of Work by Rabindranath Tagore (1930)

During the late nineteenth century and early twentieth century Indian painters explored ways of working which they considered suited to fostering national identity and the goal of national independence: whether in terms of developing techniques and subjects employed by Rajput and Mughal painters; or of inter-pretations of the realistic conventions derived from European art; or of European modern art; or admiration for art forms made outside Europe. In 1930 an exhibi-tion of 300 paintings by the Nobel Prize-winning poet Rabindranath Tagore (1861–1941) toured Europe to great acclaim. Tagore adopted approaches parallel to those used by modern European artists including surrender to the unconscious; reliance on feeling and introspection; and a prioritisation of abstract qualities. He also looked to models of abstraction in non-European art. While the critics were enthusiastic about Tagore's paintings, few showed the openness to new images evidenced by a Mr Kaines-Smith in the *Birmingham Mail*, who avoided seeing the paintings as either typically Indian or 'Oriental' or trying to derive them from other artists. In contrast, the other reviewers published here presented this work as possessing the calmness 'characteristic' of 'the Indian'; they were perceived to be eclectically derivative; the colour was seen as 'typical of the innate tastes of an ancient civilization'; and the exhibition was thought to prove the necessity for modern European artists to 'revert to primitive sources'.

Source: from *Paintings by Rabindranath Tagore, Foreign Comments*, Art Press, 1932, pp. 2–4, 11–12. a) Mr. Kaines-Smith, *Birmingham Mail* from *Paintings by Rabindranath Tagore: Foreign Comments*, Art Press, Calcutta, 1932, pp. 2–4. b) 'My Pictures are Verses'. Rabindranath Tagore's Exhibition at Charlottenburg', *Berlingske Tidende* (Denmark), August 9th, 1930, p. 12. c) 'Exhibition at the Moeller Gallery', *Vossische Zeitung*, (Berlin), 17th July 1930, p. 11

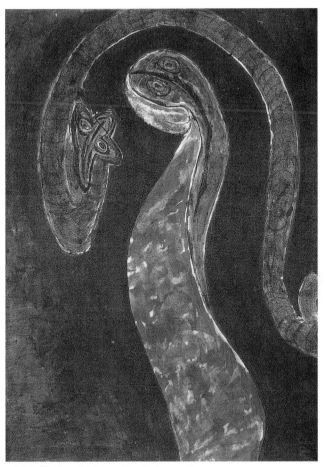

xxiv) Rabindranath Tagore, *The Snake*, c. 1928

a) Mr Kaines-Smith writing in the Birmingham Mail

It is impossible to apply the ordinary standards of artistic criticism to the draw-
ings by Rabindranath Tagore on exhibition at the Birmingham City Art Gallery.
Their classification according to the date of their production – the whole falls
within the last three years – is a sufficient indication of the fact that they are
intended to be regarded as evidence of the evolution of the poet's mind, as a new
means of self-expression, rather than as a progressive development of technique.
Indeed, it is noticeable that the latest drawings of the group are apparently less
spontaneous than the earliest – that to some extent they have become tinged with
the deliberate intent towards representation which is so conspicuously absent
from the work of 1928.

The first exhibit of all, a page of manuscript in which the erasures are linked together into a harmonious whole, gives the clue to the form taken by the original impulse which brought all the drawings into being, and their author has himself pointed out that there is in them no primary intention of representation, but they are rather an almost automatic submission to a rhythmical impulse.

That this rhythmical impulse should almost immediately link itself up with visual experiences in the material world, is a perfectly natural thing, but if we compare the second exhibit with some others of the 1928 drawings, which definitely suggest human figures in movement, we see how very sure and natural is the step from the one, a design entirely devoid of material representation, to the others, in which reminiscence of natural forms is so strongly marked. There is no essential difference between the two, for in both rhythm is the commanding feature.

When we come to the group of masks in the early part of the 1929 series we are immediately struck by the fact that he has become a representational artist, and the human face is the dominant factor of these masks.

Later on we come to a very interesting development, that in which the design is a deliberate aberration from natural forms, approaching in some instances the deliberately grotesque. There is an immense amount of enjoyment in this group of drawings, but again the artist has started from what may be called a fortuitous germ of design and has taken an animal form exactly as he took the accidental form of his erasures as the beginning of an entirely fanciful development of design. In one or two instances we have exquisite handling of line and form in which human figures derive their beauty and their value as a design, not from direct resemblance to human figures, but rather from the quality of the line by which those figures are expressed.

These are seen as their best when the line is extremely fine, and very formal, and enhanced by no colour whatever, and the range of artistic preception is very strongly emphasized when we come to the designs which depend wholly for their visual satisfaction on the colour.

Some of these latter are of astounding power, their very deep tones and wonderfully harmonious sequence produce exactly the same effect of rhythm as that which is to be observed in purely linear work, and we might sum up the whole of this exhibition as being a marvellous example of the sense of balance and of harmony, even in the most fortuitous of its forms.

b) Anon., ' *"My Pictures are Verses", Rabindranath Tagore's, Exhibition at Charlottenberg'*, Berlingske Tidende *(Denmark), August 9th, 1930*

The impression one gets when one today is passing through the Galleries at Charlottenburg, where Tagore's pictures are exhibited, is something out of the ordinary.

The Indian Poet draws more than he paints. He uses ink, Indian ink and watercolours, and he has developed a special technique. He uses his pen both normally and with the back-side and also his fingers. Only recently has this Poet-thinker ventured to enter into the field of painting. He thinks himself that he has reached

the rhythm of the lines through the rhythm of thoughts and music. And he says: 'My pictures are verses in lines.'

It is, however, difficult to discover a similarity between the Poet's poems and his paintings. As a poet he possesses that inner contemplative calmness of mind characteristic of the Indian, a philosophic inward turning, which in nature finds the symbols of the living poems within him. But out of his pictures a certain strange decorative art is developed, the form of which does not so much mirror the contemplation thinker as the man who has travelled all over the globe and investigated the various cultures of the East and the West. In this exhibition there are elements which remind us about things from Egyptian monuments, from modern German Graphic art, from Japanese wood cuts, from English Water-colour paintings and from primitive decorative art. There are elements which possess certain likeness to the antique orient and elements which remind us about the Scandinavian Drake style and the Gauguin Exoticism.

And just as the corrections in his neatly written manuscripts are transformed into decorative forms by his beauty-loving hand almost as the 'Illuminations' in the old manuscripts of the middle-ages – so also by looking at a few of his pictures one may be made to think of the primitive mystic drawings and shapes which in our child-hood during a school lesson at times were created when we drew forms and shapes on our blotting paper making use of the blots. This decorative art, where it is best, reminds us in this country mostly of the art of Johannes Holbeck and Jens Lund. Also they might at times draw forms which remind us strangely of something in-between an insect and a woman, a blue fairy bird and a poetic nameless flower.

c) Anon., 'Rabindranath Tagore Takes to Painting. Exhibition at the Moeller Gallery', Vossische Zeitung, (Berlin), July 17th 1930

One of the exhibits in the Moeller Gallery shows how Tagore, only a few years ago, came to take up painting. The correction of the manuscripts produced all kinds of curious scrawls, nebular and flowing shapes. To Tagore they suggested drawings as yet unborn. He proceeded to introduce order in the vague confusion, or, as he says so aptly in the introduction to his catalogue: 'I feel that the solution of the 'Unemployment problem' in this haphazard conglomeration of lines – namely by the fulfilment of their inherent purpose – is the essence of creative art.'

At the outset the process gave rise to arabesques and ornamental designs until the brush was substituted for the pen and the artist's imaginative faculty suddenly took wing.

For his next subject he chose those mental visions which have their origin deep in our innermost being and of which everyday reality is but the mere reflection. Animals play a prominent part here; but not the animals we see in the zoological garden, but the monsters which terrify us in our nightmares. The coloring employed in the illustration of monkeys, tigers, swans, vultures and other beasts of prey is typical of innate tastes of an ancient civilization: against a black back-ground – the night enveloping the dreamer – there stand out designs in shades of red, brown and yellow, rich and vivid to a degree. Deep mysterious c[h]ords are struck, serving as a background for some clearly outlined object.

There is a remarkable similarity between Tagore's manner of piercing through outer reality and that of modern European and particularly of German artists. Some of his animals may be taken as representative of Christian Morgenstern's art. They are shadowy outlines of the human figure suggestive of Munch. There are groups and heads forcibly reminding one of Nolde: the head of an Indian done in black and white resembles an early woodcut by that artist. Then again Tagore allows his fancy free play in the manner of Paul Klee. Occasionally a delicate note of fun is struck, as for instance in the calligraphic sketch showing the birds doing homage to man upon his learning to fly. How universal is the fundamental spiritual trend of this present day is borne out once again. Simultaneously one realizes how necessary it was to revert to primitive sources of inspiration in order that imaginative fertility might be renewed and the hateful routine of cut-and-dried realism be abandoned.

iv) Two Nigerian Manifestos of Modern Art

In areas that had achieved independence from colonial rule after the 1939–45 war, groups of artists debated how they could create a modern art to express that independence in cultural terms. A central theme in this project was the development of a concept of nationhood (colonial rule had often gathered together groups of people as putative 'nations' who in pre-colonial times had seen themselves as unconnected or merely allied). It was in the context of these debates that, in 1960, eight art students gathered to write an artistic manifesto at Ahmadu Bello University, Zaria, in Nigeria on the eve of independence. Among the authors were: Bruce Onobrakpeya, Demas Nwoko, Uche Okeke, Yusuf Grillo and Simon Okeke. They aimed at a new art for a new society – an art that would synthesise the functional with art for its own sake and which would neither imitate neither European nor old African heritages. In the decades following independence nationalist hopes have waned or been modified. In 1989, again at Ahmadu Bello University, Zaria, another manifesto was published by five artists: Jacob Jari, Jerry Buhari, Gani Odutokun, Matt Ehizele, and Tonie Okpe. In this changed context these artists presented nationalist concerns as too narrow in shutting artists off from belonging to the international scope of 'developments of mankind'. The Eye society, which authored this manifesto, founded a journal, *The Eye: A Journal of Contemporary African Art*, in the same year. [CK]

Sources: a) Uche Okeke, *Natural Synthesis* (1960), *Seven Stories*, Whitechapel Art Gallery, London, 1995, pp. 208–9. b) Jacob Jari, *The Eye Manifesto* (1989), *Seven Stories*, p. 210

a) Uche Okeke, *Natural Synthesis*, (1960)

Young artists in a new nation, that is what we are! We must grow with the new Nigeria and work to satisfy her traditional love for art or perish with our colonial past. Our new nation places huge responsibilities upon men and women in all

walks of life and places, much heavier burden on the shoulders of contemporary artists. I have strong belief that with dedication of our very beings to the cause of art and with hard work, we shall finally triumph. But the time of triumph is not near, for it demands great change of mind and attitude toward cultural and social problems that beset our entire continent today. The very fabric of our social life is deeply affected by this inevitable change. Therefore the great work of building up new art culture for a new society in the second half of this century must be tackled by us in a very realistic manner.

This is our age of enquiries and reassessment of our cultural values. This is our renaissance era! In our quest for truth we must be firm, confident and joyful because of our newly won freedom. We must not allow others to think for us in our artistic life, because art is life itself and our physical and spiritual experiences of the world. It is our work as artists to select and render in pictorial or plastic media our reactions to objects and events. The art of creation is not merely physical, it is also a solemn act. In our old special order the artist had a very important function to perform. Religious and social problems were masterly resolved by him with equal religious ardour. The artist was a special member of his community and in places performed priestly functions because his noble act of creation was looked upon as inspired.

Nigeria needs a virile school of art with new philosophy of the new age – our renaissance period. Whether our African writers call the new realisation Negritude, or our politicians talk about the African Personality, they both stand for the awareness and yearning for freedom of black people all over the world. Contemporary Nigerian artists could and should champion the cause of this movement. With great humility I beg to quote part of my verse, *Okolobia*, which essayed to resolve our present social and cultural chaos. The key work is synthesis, and I am often tempted to describe it as *natural synthesis*, for it should be unconscious not forced.

Okolobia's sons shall learn to live
from father's failing;
blending diverse culture types,
the cream of native kind
adaptable alien type;
the dawn of an age –
the season of salvation.

The artist is essentially an individual working within a particular social background and guided by the philosophy of life of his society. I do not agree with those who advocate international art philosophy; I disagree with those who live in Africa and ape European artists. Future generations of Africans will scorn their efforts. Our new society calls for a synthesis of old and new, of functional art and art for its own sake. That the greatest works of art ever fashioned by men were for their religious beliefs go a long way to prove that functionality could constitute the base line of most rewarding creative experience.

Western art today is generally in confusion. Most of the artists have failed to

realise the artists' mission to mankind. Their art has ceased to be human. The machine, symbol of science, material wealth and of the space age has since been enthroned. What form of feelings, human feelings, can void space inspire in a machine artist? It is equally futile copying our old art heritages, for they stand for our old order. Culture lives by change. Today's social problems are different from yesterday's, and we shall be doing grave disservice to Africa and mankind by living in our fathers' achievements. For this is like living in an entirely alien cultural background.

b) Jacob Jari, *The Eye Manifesto* (1989)

The Society believes in the freedom of the artist to use his varying experiences for the benefit of mankind. Such experiences embrace the whole of human imagination – deriving, for example, from such phenomena as nature, tradition, science and technology.

While it acknowledges the presence of tradition in all societies it is aware, however, that every society is affected by cultural changes. These changes may be brought about or are influenced by the culture of others. It is insincere, therefore, for an artist to pretend not to notice these changes and to insist on portraying his society as if it were static. The Eye believes that the visual arts provide the forum whereby the dynamism of culture can be appreciated. Thus the Society does not expect artists to be tied down to mere local expectations to the detriment of other dynamic cultural developments of mankind through art. It identifies the seeming absence of progress in most developing nations as a resultant effect of such self-limiting methods that usually are propagated by those who often wish that artists chart a direction purportedly national in appearance but essentially parochial. In the present African and Nigerian circumstance, the Society believes that the artist should not be seen to propagate artistic narrow-mindedness.

Objectives

The projection of the visual arts as an instrument of development of the society.
The documentation and analysis of developments and history in the visual arts.
The promotion of community projects in the area of environmental aesthetics, arts and crafts through workshops and other activities involving members and selected communities from time to time.
The organisation and promotion of exhibitions, workshops and symposia.

v) Romane Bearden and Harry Henderson, 'Edmonia Lewis' from *A History of African–American Artists from 1792 to the Present* (1993)

Romane Bearden and Harry Henderson spent two decades researching a pioneering study of African-American artists. The emphasis in their book on retrieving the biographies of artists typifies the priorities of the first, large-scale

wave of alternative art history of the 1970s. In the preface to the book Henderson (Bearden died before publication) explained that this study resulted from Bearden's realisation, when asked to speak on the topic by students at the Museum of Modern Art in New York, that there was a dearth of material available. The extract printed here on Edmonia Lewis (1845–?) typifies the method of this book. Lewis's family experienced discrimination as indigenous Americans and as Africans imported as slave labour. This continued even after slave emancipation (1862). She was educated at Oberlin College, Cleveland, but was accused of poisoning girls of European descent, and although she was cleared of these charges, she was beaten without redress and not allowed to graduate. Subsequently, she obtained tuition in sculpture from the abolitionist artist Edward Brackett in 1863. Lewis continued her studies in Italy in 1865 and managed to make a living as a sculptor there until her death. Her life-size statue of Cleopatra Queen of Egypt relates to contemporary debates about the 'racial identity' of the ancient Egyptians. While some European scholars considered that these people were Africans, others believed they must have been 'pure' Aryans and that the 'weakening' effects of intermarrying with Arabs and Africans must have produced the 'degenerated' society of modern Egypt. As a descendant of Africans and of 'mixed' parentage Lewis had much at stake in creating a noble image of this Queen. The critic, cited in this text, who considered her image looked 'Jewish' was noting that it appeared 'not-Ayran'. (Notes re-ordered). [CK]

Source: Romane Bearden and Harry Henderson, 'Edmonia Lewis', from *A History of African-American Artists from 1792 to the Present*, Pantheon Books, 1993, pp. 73–4, 77

[. . .]

Back in Rome [1876], Lewis found that all the American artists were preparing for the Centennial Exposition.

Congress was sending a ship to carry their work to Philadelphia. William Story was sending his *Cleopatra* and his *Libyan Sybil*, which had been highly praised at the 1862 London exhibition. Anne Whitney had already left with her *Roma*, a forlorn beggar woman, symbolic of what Rome had become in her eyes.

Lewis decided immediately to send copies of *Asleep*, *The Old Indian Arrowmaker and His Daughter*, and terra-cotta portraits of John Brown, Charles Sumner, and Longfellow.[1] She also wanted to challenge Story, the preeminently popular sculptor of that day, who had sneered at women sculptors. She had mentally prepared for this for years, selecting as her subject Cleopatra in the throes of death, not contemplating death as Story had done. She made clay studies several years before the Centennial. In the final sculpture she abandoned Neoclassical concepts to create a strikingly original work.

Of the 673 sculptures exhibited at the Centennial, 162 were by Americans. No sculpture prizes were awarded. Of 43 'certificates of excellence,' only five went to Americans, but neither Story nor Lewis received one. Nevertheless, Lewis's *Death of Cleopatra* [plate xxv] became one of the Centennial's most talked about statues. In his *Centennial Exposition*, J. S. Ingram wrote:

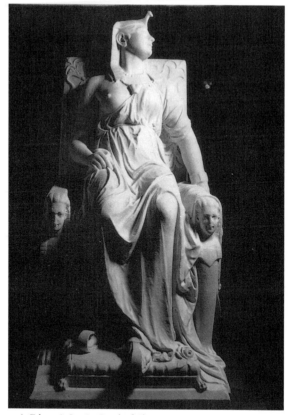

xxv) Edmonia Lewis, *Death of Cleopatra*, 1876, National Museum of
American Art, Smithsonian Institution, Washington, DC / Art
Resource, NY.

The most remarkable piece of sculpture in the American section was perhaps
that in marble of *The Death of Cleopatra* by Edmonia Lewis, the sculptress and
protégé of Charlotte Cushman. The great queen was seated in a chair, her head
drooping over her left shoulder. The face of the figure was really fine in its nat-
uralness and the gracefulness of the lines.

The face was full of pain, for some reason – perhaps to intensify the expres-
sion – the classic [i.e., neoclassic] standard had been departed from, and the
features were not even Egyptian in their outline, but of a decidedly Jewish cast.
The human heads which ornamented the arms of the chair were obtrusive, and
detracted from the dignity which the artist succeeded in gaining in the figure.
A canopy of Oriental brightness in color had been placed over the statue.[2]

Lewis had actually modeled the face from depictions of Cleopatra on ancient
Roman coins. Story, on the other hand, had used contemporary Egyptian faces as
his models.

Anything realistic in art, especially the death throes of a great queen in the days
of Queen Victoria, was very disturbing to those who doted on the idealization of

'noble suffering.' What was expected was a presentation like Story's sculpture of Cleopatra, showing her sitting in regal repose, calmly contemplating the asp without apparent suffering. The distaste for realism was so strong that Centennial officials refused to show Thomas Eakins's realistic depiction of surgery, *The Gross Clinic*, as art, relegating it to a section on medicine. Art was supposed to be noble, not bloody.

Despite this attitude, Ingram and some other critics considered Lewis's statue outstanding. So did thousands of visitors. Lewis was particularly pleased when one of Oberlin's best-known citizens, A. A. Wright, the father of a former class-mate, who knew what she had been through at Oberlin, pushed through the crowd to shake her hand and congratulate her.[3] The *Oberlin Review*, identifying her as 'the renowned sculptor,' boasted: 'Miss Lewis took her first lessons in art in Oberlin about 16 years ago.'[4] These Oberlin reactions were a bittersweet triumph for Edmonia Lewis, a vindication she had sought ever since her humiliating expe-riences there. It satisfied her Chippewa desire for revenge.

An artist himself, Walter J. Clark wrote of *The Death of Cleopatra*: 'This is not a beautiful work, but it is a very original and striking one, and it deserve[s] par-ticular comment, as its ideals [are] so radically different from those adopted by Story . . . The effects of death are represented with such skill as to be absolutely repellent. Apart from all questions of taste, however, the striking qualities of the work are undeniable, and it could only have been produced by a sculptor of gen-uine endowments.'[5] Reflecting the bias that confronted Lewis throughout her career, the only words in Clark's comment to be widely quoted were 'absolutely repellent.' His praise continues to be ignored even today.

[. . .] That Edmonia Lewis was 'a sculptor of very genuine endowments,' to repeat Clark's assessment, appears accurate and perceptive. Her struggles and achievements have a legendary, inspirational quality that makes them unique in American art. Yet until the late 1960s, she remained unknown.

Although Hosmer, Whitney, Lewis, and other American sculptors working in Rome in the 1860s and 1870s were serious artists, none produced a larger vision of life or one uniquely expressive of America. Instead, they turned for the most part to the outworn myths of ancient times with a literary and sentimental approach that was devoid of the severity required by the classical idiom. As a consequence, their art has a frozen, cosmetically 'ideal' quality without passion or transcendence.

Every artist is part of his or her time. It is tragic that Edmonia Lewis had to work against herself. In her effort to gain acceptance as an artist, she adopted the same bland style as her colleagues – a rigid, mannered style in which no artist could develop a distinctive, recognizable voice. Sculpture had to await the appear-ance of Rodin in France and Augustus Saint-Gaudens in the United States to gain a new vitality.

What must be remembered is that a major portion of Edmonia Lewis's energies were devoted simply to being accepted on the same aesthetic level as her fellow artists at the time. Within that framework, she struggled to honor in her work those whom she felt represented the best in American life – Colonel Shaw, John Brown, Lincoln, Sumner, Longfellow, and Harriot Hunt. She also honored her

own dual heritage in such works as *The Old Indian Arrowmaker and His Daughter*, the *Hiawatha* series, and *Forever Free*. In *Cleopatra* she dared to break away from sterile conventionality. Hers was a daring life.

Edmonia Lewis rose above the meanness and violence she experienced in her homeland. In courageous men and women who fought against slavery, in women like Hagar and Harriot Hunt who struggled against the oppression and suffering of women, in the spirituality of Native Americans, and ultimately in her religious faith, Lewis found her great themes. In her work she attained a dignity that, in her own life, she was often denied. Years of silence have deprived most Americans of knowledge of her historic achievements.

She is a heroic and legendary figure in American art.

[. . .]

NOTES

1 The 'Official Catalogue' (Philadelphia: U.S. Centennial Commission, International Exhibition. Art
 Department, 1876) lists on p. 52 'Edmonia Lewis. No. 1231: Death of Cleopatra' and on p. 59 'No. 1409,
 Asleep (group in marble); Hiawatha's Marriage: Old Arrow-Maker and His Daughter (groups in mar-
 ble); terra-cotta busts: Henry W. Longfellow, Charles Sumner, John Brown.'
2 J. S. Ingram, *The Centennial Exposition* (Philadelphia: Hubbard Bros., 1876), p. 372.
3 A. A. Wright, Oberlin archives, box 1.
4 *Oberlin Review*, Nov. 1876, p. 201.
5 Clark, *Great American Sculptures*, p. 141.

vi) Edward W. Said, from *Culture and Imperialism* (1993)

Edward Said (b. 1935) is University Professor of English and Comparative
Literature at Columbia University, New York. Said was born into a Christian
Palestinian family and has occupied a prominent role in Palestinian politics.
Through his many books he has been at the forefront of drawing attention to the
way in which imperial and post-imperial interests created a view of the world
that was structured by the distinction between 'Western' and 'Eastern' or 'Orien-
tal' societies. In his influential book *Orientalism: Western Concepts of the Orient*
(1978) Said argues that this distinction is based on a Western fantasy that reduces
dynamic and diverse non-Western societies to a static and monolithic imaginary
'Orient'. In *Culture and Imperialism* (1993) he examined in a more general per-
spective the way that the colonisers' economic and political interests were well
served by their cultural representations. In this book, in addition to criticising the
culture produced from a colonial point of view he also surveyed the cultural
manifestations of those struggling for independence from colonial domination.
At the same time he warned against the polarisation into 'our' and 'their' men-
talities and stressed the value of forms of cultural synthesis which resulted from
imperial journeys. As a specialist in comparative literature, Said bases his discus-
sion of the relations between culture and power in the colonial and post-colonial
era on literary texts. However, many students considering other types of cultural
representation (as here in the field of artistic and architectural representation)
have found his lines of enquiry enormously suggestive.[CK/SE]

Source: Edward W. Said, from *Culture and Imperialism*, Vintage, 1993, pp. xi–xv; 406–8

About five years after *Orientalism* was published in 1978, I began to gather together some ideas about the general relationship between culture and empire that had become clear to me while writing that book. The first result was a series of lectures that I gave at universities in the United States, Canada, and England in 1985 and 1986. These lectures form the core argument of the present work, which has occupied me steadily since that time. A substantial amount of scholarship in anthropology, history, and area studies has developed arguments I put forward in *Orientalism*, which was limited to the Middle East. So I, too, have tried here to expand the arguments of the earlier book to describe a more general pattern of relationships between the modern metropolitan West and its overseas territories.

What are some of the non-Middle Eastern materials drawn on here? European writing on Africa, India, parts of the Far East, Australia, and the Caribbean; these Africanist and Indianist discourses, as some of them have been called, I see as part of the general European effort to rule distant lands and peoples and, therefore, as related to Orientalist descriptions of the Islamic world, as well as to Europe's special ways of representing the Caribbean islands, Ireland, and the Far East. What are striking in these discourses are the rhetorical figures one keeps encountering in their descriptions of 'the mysterious East', as well as the stereotypes about 'the African [or Indian or Irish or Jamaican or Chinese] mind', the notions about bringing civilization to primitive or barbaric peoples, the disturbingly familiar ideas about flogging or death or extended punishment being required when 'they' misbehaved or became rebellious, because 'they' mainly understood force or violence best; 'they' were not like 'us', and for that reason deserved to be ruled.

Yet it was the case nearly everywhere in the non-European world that the coming of the white man brought forth some sort of resistance. What I left out of *Orientalism* was that response to Western dominance which culminated in the great movement of decolonization all across the Third World. Along with armed resistance in places as diverse as nineteenth-century Algeria, Ireland, and Indonesia, there also went considerable efforts in cultural resistance almost everywhere, the assertions of nationalist identities, and, in the political realm, the creation of associations and parties whose common goal was self-determination and national independence. Never was it the case that the imperial encounter pitted an active Western intruder against a supine or inert non-Western native; there was *always* some form of active resistance and, in the overwhelming majority of cases, the resistance finally won out.

These two factors – a general worldwide pattern of imperial culture, and a historical experience of resistance against empire – inform this book in ways that make it not just a sequel of *Orientalism* but an attempt to do something else. In both books I have emphasized what in a rather general way I have called 'culture'. As I use the word, 'culture' means two things in particular. First of all it means all those practices, like the arts of description, communication, and representation,

that have relative autonomy from the economic, social, and political realms and that often exist in aesthetic forms, one of whose principal aims is pleasure. Included, of course, are both the popular stock of lore about distant parts of the world and specialized knowledge available in such learned disciplines as ethnography, historiography, philology, sociology, and literary history. Since my exclusive focus here is on the modern Western empires of the nineteenth and twentieth centuries, I have looked especially at cultural forms as the novel, which I believe were immensely important in the formation of imperial attitudes, references, and experiences. I do not mean that only the novel was important, but that I consider it *the* aesthetic object whose connection to the expanding societies of Britain and France is particularly interesting to study. The prototypical modern realistic novel is *Robinson Crusoe*, and certainly not accidentally it is about a European who creates a fiefdom for himself on a distant, non-European island.

A great deal of recent criticism has concentrated on narrative fiction, yet very little attention has been paid to its position in the history and world of empire. Readers of this book will quickly discover that narrative is crucial to my argument here, my basic point being that stories are at the heart of what explorers and novelists say about strange regions of the world; they also become the method colonized people use to assert their own identity and the existence of their own history. The main battle in imperialism is over land, of course; but when it came to who owned the land, who had the right to settle and work on it, who kept it going, who won it back, and who now plans its future – these issues were reflected, contested, and even for a time decided in narrative. As one critic has suggested, nations themselves *are* narrations. The power to narrate, or to block other narratives from forming and emerging, is very important to culture and imperialism, and constitutes one of the main connections between them. Most important, the grand narratives of emancipation and enlightenment mobilized people in the colonial world to rise up and throw off imperial subjection; in the process, many Europeans and Americans were also stirred by these stories and their protagonists, and they too fought for new narratives of equality and human community.

Second, and almost imperceptibly, culture is a concept that includes a refining and elevating element, each society's reservoir of the best that has been known and thought, as Matthew Arnold put it in the 1860s. Arnold believed that culture palliates, if it does not altogether neutralize, the ravages of a modern, aggressive, mercantile, and brutalizing urban existence. You read Dante or Shakespeare in order to keep up with the best that was thought and known, and also to see yourself, your people, society, and tradition in their best lights. In time, culture comes to be associated, often aggressively, with the nation or the state; this differentiates 'us' from 'them', almost always with some degree of xenophobia. Culture in this sense is a source of identity, and a rather combative one at that, as we see in recent 'returns' to culture and tradition. These 'returns' accompany rigorous codes of intellectual and moral behaviour that are opposed to the permissiveness associated with such relatively liberal philosophies as multiculturalism and hybridity. In the formerly colonized world, these 'returns' have produced varieties of religious and nationalist fundamentalism.

In this second sense culture is a sort of theatre where various political and ideological causes engage one another. Far from being a placid realm of Apollonian gentility, culture can even be a battleground on which causes expose themselves to the light of day and contend with one another, making it apparent that, for instance, American, French, or Indian students who are taught to read *their* national classics before they read others are expected to appreciate and belong loyally, often uncritically, to their nations and traditions while denigrating or fighting against others.

Now the trouble with this idea of culture is that it entails not only venerating one's own culture but also thinking of it as somehow divorced from, because transcending, the everyday world. Most professional humanists as a result are unable to make the connection between the prolonged and sordid cruelty of such practices as slavery, colonialist and racial oppression, and imperial subjection on the one hand, and the poetry, fiction, and philosophy of the society that engages in these practices on the other. One of the difficult truths I discovered in working on this book is how very few of the British or French artists whom I admire took issue with the notion of 'subject' or 'inferior' races so prevalent among officials who practised those ideas as a matter of course in ruling India or Algeria. They were widely accepted notions, and they helped fuel the imperial acquisition of territories in Africa throughout the nineteenth century. In thinking of Carlyle or Ruskin, or even of Dickens and Thackeray, critics have often, I believe, relegated these writers' ideas about colonial expansion, inferior races, or 'niggers' to a very different department from that of culture, culture being the elevated area of activity in which they 'truly' belong and in which they did their 'really' important work.

Culture conceived in this way can become a protective enclosure: check your politics at the door before you enter it. As someone who has spent his entire professional life teaching literature, yet who also grew up in the pre-World War Two colonial world, I have found it a challenge *not* to see culture in this way – that is, antiseptically quarantined from its worldly affiliations – but as an extraordinarily varied field of endeavour. The novels and other books I consider here I analyse because first of all I find them estimable and admirable works of art and learning, in which I and many other readers take pleasure and from which we derive profit. Second, the challenge is to connect them not only with that pleasure and profit but also with the imperial process of which they were manifestly and unconcealedly a part; rather than condemning or ignoring their participation in what was an unquestioned reality in their societies, I suggest that what we learn about this hitherto ignored aspect actually and truly *enhances* our reading and understanding of them.

[. . .]

I find myself returning again and again to a hauntingly beautiful passage by Hugo of St Victor, a twelfth-century monk from Saxony:

> It is therefore, a source of great virtue for the practised mind to learn, bit by bit, first to change about in visible and transitory things, so that afterwards it may be able to leave them behind altogether. The person who finds his

homeland sweet is still a tender beginner; he to whom every soil is as his native one is already strong; but he is perfect to whom the entire world is as a foreign place. The tender soul has fixed his love on one spot in the world; the strong person has extended his love to all places; the perfect man has extinguished his.[1]

Erich Auerbach, the great German scholar who spent the years of World War Two as an exile in Turkey, cites this passage as a model for anyone – man *and* woman – wishing to transcend the restraints of imperial or national or provincial limits. Only through this attitude can a historian, for example, begin to grasp human experience and its written records in all their diversity and particularity; otherwise one would remain committed more to the exclusions and reactions of prejudice than to the negative freedom of real knowledge. But note that Hugo twice makes it clear that the 'strong' or 'perfect' person achieves independence and detachment by *working through* attachments, not by rejecting them. Exile is predicated on the existence of, love for, and a real bond with one's native place; the universal truth of exile is not that one has lost that love or home, but that inherent in each is an unexpected, unwelcome loss. Regard experiences then *as if* they were about to disappear: what is it about them that anchors or roots them in reality? What would you save of them, what would you give up, what would you recover? To answer such questions you must have the independence and detachment of someone whose homeland is 'sweet', but whose actual condition makes it impossible to recapture that sweetness, and even less possible to derive satisfaction from substitutes furnished by illusion or dogma, whether deriving from pride in one's heritage or from certainty about who 'we' are.

No one today is purely *one* thing. Labels like Indian, or woman, or Muslim, or American are no more than starting-points, which if followed into actual experience for only a moment are quickly left behind. Imperialism consolidated the mixture of cultures and identities on a global scale. But its worst and most paradoxical gift was to allow people to believe that they were only, mainly, exclusively, white, or black, or Western, or Oriental. Yet just as human beings make their own history, they also make their cultures and ethnic identities. No one can deny the persisting continuities of long traditions, sustained habitations, national languages, and cultural geographies, but there seems no reason except fear and prejudice to keep insisting on their separation and distinctiveness, as if that was all human life was about. Survival in fact is about the connections between things in Eliot's phrase, reality cannot be deprived of the 'other echoes [that] inhabit the garden'[2]. It is more rewarding – and more difficult – to think concretely and sympathetically, contrapuntally, about others than only about 'us'. But this also means not trying to rule others, not trying to classify them or put them in hierarchies, above all, not constantly reiterating how 'our' culture or country is number one (or *not* number one, for that matter). For the intellectual there is quite enough of value to do without *that*.

NOTE

1 Hugo of St Victor, *Didascalicon*, trans. Jerome Taylor (New York: Columbia University Press, 1961), p. 101.
2 T.S. Eliot, 'Burnt Norton', *Four Quartets*, 1935, Faber and Faber. [CK].

vii) David Dabydeen, from *Hogarth's Blacks in Eighteenth-Century British Art* (1987)

David Dabydeen is a poet and Professor in Caribbean Studies at the University of Warwick. In this book, he illustrates one of Said's cardinal assertions that 'imperial concerns' are 'constitutively significant to the culture of the modern West' (Said, 1993, p. 78). In *Culture and Imperialism* Said noted that colonisers and their heirs thought that Western art could be studied as if its productions had nothing whatever to do with Western imperialist activities. By contrast Western viewers considered that the history of colonial subjects and their descendants was to be told in relation to that of their 'masters' who were often seen as giving them history. Dabydeen's study exemplifies research that insists on noticing the centrality of assumptions about power over colonised subjects for the production of meanings in metropolitan canonical art. Dabydeen takes as his topic of investigation the paintings of Hogarth, that are seen to be quintessentially 'English' and shows how this English identity depends on images of those designated to be different. In the extract published here he demonstrates how stereotypical images of Africans as savages associated with primitivism and coarse sexuality played an important role in Hogarth's *Marriage à la Mode* (1745) and were central to its contemporary interpretations. [CK]

Source: David Dabydeen, from *Hogarth's Blacks in Eighteenth-Century British Art*, Manchester University Press, 1987, pp. 74–9

[. . .]

The following scene [plate xxvi] continues the exploration of the idea of the savage and the civilized, using the black positively, as the norm against which the inadequacies of his masters are measured. The setting is the Countess's boudoir. She is having her hair styled whilst conversing with her lover. There is musical entertainment, the singer being an Opera star of the time, a castrated Italian named Senesino, who sang mezzo-soprano and whose London performances drew crowds of aristocrats. Hogarth hated Italian Opera – he felt that it was pretentious and that the money lavished on Italian singers by the English aristocracy could have been better spent supporting home-grown art such as his own: he also prided himself as a virile, beef-eating male and scorned the effeminacy of castrated warblers like Senesino. The black man serving chocolate contrasts with the whiteness of the woman's dress and person, but he is more a satirical than an aesthetic device, throwing light on the nature of the white society he serves, for it is from the perspective of the black man, and in his laughter on looking at the neutered Senesino, that Hogarth's attitude to Italian singers is revealed. The black man, representative of primitivism, and the Opera Singer, representative of High Culture, are paired off with satirical intent, recalling the way Hogarth had juxtaposed the 'savage' black and the 'civilized' white beau in *Noon*.

The black man is a symbol of the type of hottentot fertility that is lacking in the white Opera singer. His coarse, natural, paw-like fingers are deliberately depicted in contrast to the bejewelled, effeminate fingers of Senesino. His type of sexuality plays an intricate part in the network of sexual innuendoes in the picture. The

foppish youth sitting beside Senesino with curlers in his hair is related to Senesino in terms of their shared effeminacy. In the eighteenth century the homosexuality of castrated singers was a byword and a point of mockery; in Hogarth's picture a homosexual relationship between the obese Senesino, the passive partner, and the slender fop, the active partner, is hinted at by the painting on the wall behind them, of the *Rape of Ganymede*. The lady listening to Senesino swoons in ecstasy, the spread of her arms echoed in the parting of the curtain of the bed behind her, an obvious vaginal symbol, echoed too in the parting of her gown in the direction of her waist, in the parting of Senesino's coat above his crotch and in the tightly crossed legs of the effeminate fop: in other words the three figures are linked in terms of shared sexual excitement. What is abnormal about the lady's sexual rapture is that it is inspired by a castrated man and is therefore as infertile and 'unnatural' as the homosexual relationship. The effect of these comic sexual innuendoes is to strip away from Italian Opera all the values ascribed to it by the aristocracy. Italian Opera was held to be a high point of human *creativity*, hence the aristocracy patronized it as a public declaration of their own civilized and developed tastes. Hogarth shows them all to be sexually deviant and uses the black man, who was widely held as the embodiment of sexual and cultural savagery, to laugh at them, thereby reversing conventional roles and perceptions.

As to the couple on the other side of the picture, Hogarth employs another black to comment on their morality. The lover points to a screen showing a masquerade, inviting the Countess to accompany him – masquerades being notorious places for illicit sexual encounters in the eighteenth century. The black boy grins, pointing to Actaeon's horns to indicate that the wife will cuckold the young Earl who is absent from the scene. Hogarth employs a third black to laugh at the whites: a black boy, a detail painted on the masquerade screen, grins as he looks down on the Countess and her lover. The whites are therefore being laughed at from all levels – from on high, from the horizontal, and from below.

The pictures on the wall, of Jupiter embracing Io and of a drunken Lot being seduced by his daughters, reinforce the mood of sexual obscenity as does the erotic novel, entitled *Sopha*, lying appropriately on the sofa ('sofa' was spelt 'sopha' in the eighteenth century). The novel, by Crébillon, is peppered with references to ladies who are 'liberal of their Favours to their *Negroes*'. In the novel one young lady betrays her master by sleeping with Massoud, 'a frightful, mishapen Negro' who was capable of 'giving a Loose to all the Fury of vigorous Desire'. Another 'lay'd with all the Negroes of the Palace', and a third genteel lady with a reputation for purity has in private a strong sexual inclination towards her black slaves, for those 'who, in spite of the Baseness of their Employment, are yet capable of the most hidden Mysteries of Love'. The same lady abandons her body to her young slave, her satisfaction being in the freedom from civilized restraints and civilized codes of behaviour. In Hogarth's picture reference to Crébillon's novel serves, among other things, to indicate one of the roles of the black man in the household of the English aristocracy. He does more than serve chocolate – the aristocratic ladies call upon their male black slave to relieve them of the burdens of civilization, in the moments when they felt the urge to be purely and passionately savage. [. . .]

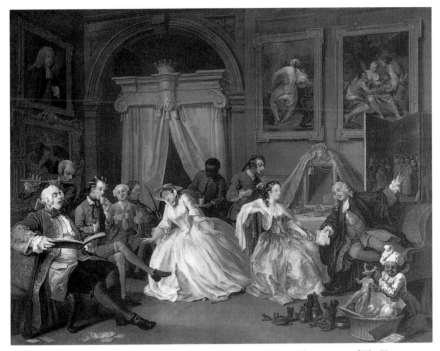

xxvi) William Hogarth, *The Countess's Morning Levée*, 1743. Reproduced by courtesy of The Trustees, The National Gallery, London.

viii) Partha Mitter, from *Much Maligned Monsters: A History of European Reactions to Indian Art* (1977)

In *Much Maligned Monsters: A History of European Reactions to Indian Art* (1977) Partha Mitter, Reader in Art History at the University of Sussex, surveys the texts produced by Europeans on Indian art. In this study Mitter took the kind of sweeping world-view normally associated with 'Western' observers. Coomaraswamy had rebutted European evaluations by comparing Indian art to European medieval styles, and offered new interpretations and information on Sri Lankan and Indian art. Mitter, however, writing after the end of direct colonial rule, did not produce different accounts of Indian art: instead he discovers for European culture the history of *their* ideas (and fantasies) of Indian art, in a neat riposte to the way generations of Europeans saw themselves as giving the history of Indian art to Indians. Reproduced here are Mitter's summary from his preface and his analysis of a rare Indian intervention in European historiography: Rám Ráz's publication in 1834 of the Indian treatises on art – the *Śilpa Śāstras*. In the context in which European historians have, by-and-large, seen the art of Greece, Rome and Europe after the Renaissance as exclusively qualifying to be called 'art' – because these periods were supposedly alone in producing histories and theories – the contribution of Ráz was a salient one. (Notes re-ordered.) [CK]

Source: Partha Mitter, *Much Maligned Monsters: A History of European Reactions to Indian Art*, Oxford University Press, 1977, pp. vii–viii, 180–86

The reception of Indian art in Europe presents a curious paradox. On the one hand, it still remains a misunderstood tradition in the modern West, whose aesthetic qualities are yet to be properly appreciated. On the other hand, possibly no other non-European artistic tradition has been responsible for so much discussion among intellectuals from the very end of the Middle Ages. It therefore offers a striking case study of the cultural reactions of a particular society to an alien one. And nowhere can this clash of the two essentially different, even antithetical, cultural and aesthetic values be better studied than in European interpretations of Hindu sculpture, painting, and architecture. Indo-Islamic architecture or Mogul painting did not present any serious problems of assimilation for the European, as they reflected a taste that could be understood in the West. Accordingly, collections of Mogul paintings began at an early period. On the other hand, there is very little in literature to indicate whether they had much effect on prevailing tastes and interests, apart from being objects of curiosity. The great Rembrandt was exceptional in his appreciation of their aesthetic qualities. In contrast to Indo-Islamic art, although very little Hindu art was collected before the nineteenth century, travellers, ethnographers, philosphers, and the literati in general showed an almost obsessive interest in it. In short, the problem of accommodating multiple-limbed Indian gods in the European aesthetic tradition became the leading intellectual preoccupation as early as the sixteenth century.

India had meant a great deal to Europeans since the time of Alexander, but the actual knowledge about it had become confused in the final days of the Roman empire and had given rise to certain myths. These myths about India could not but influence the way Indian art was seen in the West. Arguably, Indian art presented a test case for the Western understanding of India, because its aesthetic standards differed so much from those of the classical West. In the early period of European explorations of Asia, travellers saw Hindu sacred images as infernal creatures and diabolic multiple-limbed monsters. This early attitude may not be entirely unexpected; what is remarkable is that the attitude persisted even into the modern period, though different critics sought to evaluate these alleged monstrosities in different ways. A further aspect of Indian art which presented problems of assimilation, the eroticism connected with certain cults and images, was responsible for numerous speculations in the eighteenth century. The end of the century was marked by the discovery of the wealth of Sanskrit literature and Indian philosophy which went hand in hand with increasing archaeological explorations of the subcontinent. However, even in the nineteenth century, the new accession of information was generally fitted into an earlier framework. Thus, Hegel saw in the supposedly formless images of Indian art an expression of Indian mentality which was identified by him as dreaming consciousness. A new aspect of Indian art came into focus with the growing Victorian concern with the industrial arts and decorative ornament. Ruskin approved of the sense of colour and form of the native Indian craftsmen but abhorred Indian sculpture, painting, and

architecture as representing unchristian ethos. It was only with the general revolt against the classical tradition that the search for alternative values led from the appreciation of medieval European art to the praise of the Indian tradition which was exalted for its spirituality. The examination of these attitudes strongly suggests that the Western world still has to find a way to appreciate the values of Indian art in its own context and in its own right.

[. . .]

Until 1834 the principles of Indian architecture known in Europe were almost exclusively based on observations of existing buildings made by European travellers and archaeologists. Those who sought to make formal studies of these monuments drew their conclusions from an application of European methods of studying works of architecture. But they had no way of knowing whether the same principles had any application at all in the case of Indian architects and their particular methods of building. Very little was known about the aesthetic manuals, the *Śilpa Śāstras*, although William Jones with his usual perspicacity had stressed the importance of these texts. To a young south Indian, Rám Ráz, fell the task of communicating to learned Europeans the substance of Indian aesthetics, the architectural problems faced by Hindu craftsmen, and the solutions they came up with. Descended from an impoverished noble family, Rám Ráz began his career as a petty clerk, subsequently becoming the headmaster of an English-language school and ultimately rising to the position of a local judge. Richard Clarke, an English resident in India, recognized his linguistic abilities and encouraged him to translate into English Sanskrit texts on architecture. Rám Ráz at once set about this task with great enthusiasm. Although he enlisted the help of learned Brahmans, he realized at the same time that the technical terms used in the texts collected by him would be very difficult to interpret. On realizing further that most of these words had gone out of use he decided to seek the assistance of a certain sculptor from the Cammata tribe who was well acquainted with the applied side of Indian architecture. Although Rám Ráz was able to complete the work he did not live to see its publication. Thus in 1834 Europeans had their first glimpse of original Indian texts elucidating the principles of Indian architecture and the aims and achievements of Indian artists and architects.[1]

The importance of *The Essay on the Architecture of the Hindus* was fully recognized by Richard Clarke who stated in the introduction: 'If it shall appear that he has established the claim of his countrymen to the possession, in an eminent degree, of a knowledge in the art, and this at a period when its principles were but little understood among Europeans, he will have accomplished a task which he fondly looked forward to with every confidence of success . . .'[2] But recognition was slow to come. William Daniell and the Sanskritist Wilkins received the *Essay* with enthusiasm.[3] It was used by the German art historian Franz Kugler in 1842[4] and by the designer Owen Jones in 1856. An admirer of Indian design, Jones had quoted the following lines from Rám Ráz in support of his view that ancient Indians had a higher form of architecture than was generally supposed: 'Woe to them who dwell in a house not built according to the proportions of symmetry. In building an edifice, therefore, let all its parts, from the basement to the roof, be duly considered.'[5]

In his general discussion of Indian architecture Rám Ráz took note of the anti-quarian debate on the antiquity of Indian civilization:

> A correct account . . . of the art of building practised by the *Hindus*, must throw considerable light on the early progress of architecture in general. Some of the Western authors have traced a certain resemblance in the leading features of the buildings in Egypt and India, and have thence concluded that there has very early been a communication of architectural knowledge between the two countries.[6]

He was at the same time able to see that this superficial resemblance between Indian and Egyptian architecture could have been accidental. He also sensibly refused to speculate on the respective indebtedness of the two countries until he had more supporting evidence.[7]

Proceeding to deal with actual Sanskrit texts he, first of all, corrected William Jones's error that the traditional sixty-four treatises of the *Śilpa Śāstra* did not deal with sixty-four different arts and crafts but with either architecture or sculpture. The greater part of the *Essay* was based on the aesthetic manual called *Mānāsara*. This text, which had preserved detailed instructions regarding the building of sacred edifices, was consulted by practising architects down to Rám Ráz's day. *Mānāsara*, available for the first time in English translation, gave exact measurements of the different proportions used in different styles of architecture. It was indispensable for the construction of both sacred and secular buildings for it had something to say about each of the craftsmen involved in their construction, namely, the architect, the measurer, the joiner, and the carpenter. The various qualifications of an architect mentioned in *Mānāsara* – that he had to know different sciences, arithmetic, geometry, drawing, sculpture, mythology, and astrology – reminded the Indian scholar at once of Vitruvius.[8]

Other texts used by Rám Ráz were *Māyāmata*, *Kāśyapa*, *Vaikhānasa*, and *Āgastya* which were mainly concerned with sculpture. Different classes of temples (*vimāna*) and *gopuras*[9] were studied as well as different orders of columns. Various sections of the column, namely, the pedestal, the base, the pillar, and the entablature, were given consideration.[10] The 'orders' of Indian architecture were compared with ancient Egyptian, Greek, and Roman examples: 'The difference in the Indian orders consists chiefly in the proportion between the thickness and height of pillars; while that of the Grecian and Roman orders depends, not only on the dimensions of columns, but also on the form of the other parts belonging to them.'[11] Rám Ráz mentioned the important principle in traditional architecture that the benevolent forms of divine images should look towards the village while terrifying forms looked away from it. The *Essay* which contained forty-six carefully drawn plates also discussed the types of building material used by Indian architects, such as stone, stone-brick, timber, and a combination of brick, stone, and metal.[12]
[. . .]

NOTES

1 Rám Ráz, *Essay on the Architecture of the Hindus*, London, 1834, pp. iii–xi.
2 Ibid., p. v.
3 Ibid., p. v., note.

4 Franz Kugler, *Handbuch der Kunstgeschichte*, Stuttgart, 1892, p. 114
5 Rám Ráz, op. cit., p. 15, quoted by Jones, O., *The Grammar of Ornament*, London, 1856, ch. XIII,
 p. 2.
6 Rám Ráz, op. cit., p. xiii.
7 Ibid.
8 Ibid., pp. 1–14.
9 Gatehouses [CK]
10 Ibid., pp. 25 ff. (pedestals), p. 28 (bases), pp. 28 ff. (columns), pp. 48 ff. (*vimānas*), pp. 60 ff. (*gopuras*).
11 Ibid., pp. 37 ff.
12 Ibid., pp. 45–9.

ix) Jo-Anne Birnie Danzker, 'Am I Authentic?' from *Dreamings. Tjukurrpa: Aboriginal Art of the Western Desert* (1994)

Danzker is the director of the Museum Villa Stuck, Munich. In post-colonial debates surrounding the making of modern art, groups who have not achieved independence from colonial rule, such as the First Australians, occupy a distinctive place. This is primarily because the culture of these groups is produced within an alien, dominant culture. Relations between the culture of First Australians and this dominant culture involve a complex range of interchanges. As well as making art works for themselves, communities and individuals dispersed into cities have also been developing designs for sale. For the former, both government and non-government organisations have provided elements of instruction, outlets and materials. Tom Byra Mixie Mosby points to the power of instructors and to cases where artists have had their work appropriated – as in the use by the Australian Reserve Bank of a bark painting by David Malangi for a bank note design – but stresses the important position occupied by contemporary art in maintaining and reasserting First Australian cultural integrity. In contrast to either the Zaria artists of the nationalist generation, or the subsequent internationalist grouping, these communities and their dispersed members evolve a shared language of art – an art of belonging together in however diverse ways. This art aims to represent First Australians politically and culturally, benefit them economically, and requires an 'external' audience. (Notes re-ordered.) [CK]

Source: Jo-Anne Birnie Danzker, from *Dreamings. Tjukurrpa: Aboriginal Art of the Western Desert*, Prestel, 1994, pp. 61–2

A customer in the South Australian Museum shop asked if their carved boomerangs were 'authentic'. The artist, Bluey Roberts, who happened to be in the shop, overheard the conversation and replied, 'Well, am I authentic?'[1] This anecdote, recalled by Peter Sutton, is at the centre of the so-called authenticity debate. What is authentic Aboriginal art? Is it a pre-contact object found during a dig; one gathered by anthropologists from First Australians still living a 'traditional' life; or an object made by an Aboriginal person? Is contemporary painting of the Western Desert authentic?

Reception of Aboriginal art by Europeans, and its classification into authentic, contemporary, art and craft is an extension of colonialist nineteenth-century debates as to whether First Australians are people. It is based on a form of cultural

apartheid whose justifications have become so entrenched in our vocabulary and institutions that they have almost become invisible. The terminology of control is authentic, native, ethnic, and quality. Aboriginal artists produce ethnographic artefacts, white artists make art,[2] Picasso, for example, is not considered 'inauthentic' because he adopted techniques and forms from non-European cultures. Nor is a time limit set on the legitimacy of his work, suggesting, for example, that only those works produced before he viewed African art are genuine. Gauguin, who worked in cultural exile, is not considered alienated from his artistic heritage. When European artists adopt and adapt non-western art to revitalize their own traditions, they are regarded as innovative. Borrowing of 'white means' by Aboriginal artists, on the other hand, is often considered highly questionable.

The attractiveness of Desert painting to collectors and institutions often depends on the lifestyle of its author rather than the quality of the work. Should the artist be engaged in 'traditional' life on an outstation in the desert, the work's supposed authenticity increases. Should the artist be living in a town or large urban centre, his or her work may no longer be considered genuine or true. Djon Mundine, an internationally renowned Aboriginal curator, comments:

> The problem of contemporary innovations versus classical Aboriginal art has vexed art historians since at least the turn of the century. This has happened in two ways: the refusal to see classical Aboriginal art (bark paintings and sculpture, and 'dot' paintings) in a contemporary sense, and the refusal until the last ten years to see non-classical, so-called 'urban' Aboriginal art as true Aboriginal work.[3]

The debate is not only rampant in European art circles, it is also to be found within the Aboriginal community. The globalizing terms Aborigine and Aboriginal, both colonial imports, never take into account the extreme diversity of peoples among First Australians. It also obscures the enormous differences between urban and rural First Australians, separated by language, experience, and political power. Abe Jangala from Lajamanu explains:

> We are Warlpiri Aborigines, *Kardiyakurlangu* or white man's law alone is no good to use and you can see that when you look at those Aborigines who live in towns like Darwin, Alice Springs or Katherine. They cannot live properly like Aborigines, they are away from their Dreaming sites and cannot go to their rituals.[4] There are Aborigines and part-Aborigines who live in cities and want to speak for us, on our behalf. We don't want to have anything to do with them. We are Warlpiri and we can speak for ourselves. We have our own ways, our own traditions and our own law, and with it we want to decide our own future.[5]

Aboriginal artists living in large urban centres, who may never have seen or known their traditional Country, often occupy a no-man's land. Having suffered most from the effects of colonization, they find themselves straddled between two worlds, unaccepted in either. Urban artist Gordon Bennett:

> I didn't even know about my Aboriginality until I was about eleven. I learnt about Aborigines at school through social studies just like any other child . . .

xxvii) Gordon Bennett, *The Nine Ricochets* (*Fall Down Black Fella, Jump Up White Fella*), 1990.

I grew up to be ashamed of my Aboriginality . . . I remember my work (I left school at 15) sitting around at smoko and listening to 'boong' jokes – there was no way I could identify myself to be the butt of those jokes . . . You must understand my position of having no designs or images or stories on which to assert my Aboriginality. In just three generations that heritage has been lost to me. Dots are my bridge to my Aboriginality. They connect to their obvious relationship to Western Desert paintings. I am constantly searching for ways to connect, to express my Aboriginality and dots obsess me now.[6]

In attempting to assert his cultural identity as an Aborigine. Bennett first used an image of a Mimi spirit figure – and offended Mimi spirit dancers. Having vowed not to appropriate aboriginal images again. Bennett now sees his work as a kind of history painting which attempts to deconstruct the Eurocentric view of Aboriginal people.[7] Subsequently recognized as one of Australia's leading contemporary artists, Bennett sees himself as working within Western aesthetic and iconographical traditions. His artistic strategies are quotation and appropriation

in a kind of ethnographic investigation of a Euro-Australian system of representa-
tion in general . . . focused on the representation of Aboriginal people in particu-
lar'.[8] 'The images I select exist between the pages of art books and history books.
Their unifying factor is the dot screen of their photomechanical reproduction
. . .'[9] Bennett's use of dots recalls not only the process of reproduction: 'It is Abo-
riginal-referential in the dot's relationship to the unifying space between cultural
sites of identification in a landscape that is not experienced as separate from the
individual, but as an artefact of intellect.'[10] [. . .]

NOTES

1 Peter Sutton, ed., *Dreamings: The Art of Aboriginal Australia* (New York, 1988), p. 205.
2 See Jo-Anne Birnie Danzker, 'Organizational Apartheid.' *Third Text*, No. 13, Winter 1990/91, pp.
 85–95.
3 Djon Mundine, 'Spot the Primitive', *Aboriginal Art in the Public Eye*, an *Art Monthly Australia* sup-
 plement, 1992–93, p. 5.
4 Michael Nelson Tjakamarra from Papunya concurs: 'We hadn't lost all of that; not like those people
 living here in Sydney. They've lost all their culture, they just follow the European way. But we still
 hold fast to our culture. North of us, south of us, west of us, our language and culture is still intact,
 right there in the middle of the desert, among the spinifex and sand dunes:' Sandy Nairne. *State of
 the Art: Ideas and Images in the 1980s* (London, 1987), p. 217.
5 Cited in Judith Ryan, ed., *Paint up Big: Warlpiri Women's Art of Lajamann*, National Gallery of Vic-
 toria, Melbourne, 1990, p. 12
6 From an interview in *Tension Magazine*, quoted by Celestine Doyle, Queensland Art Gallery in an
 unpublished letter to Hendrik Gout, dated February 9, 1990.
7 Ibid.
8 Gordon Bennett, 'Aesthetics and Iconography: An Artist's Approach', in Bernhard Lüthi, *Aratjara:
 Art of the first Australians*, Hayward Gallery, 1993, p. 89.
9 Ibid., p. 89.
10 Ibid., p. 90.

x) Ikem Stanley Okoye, from 'Tribe and Art History' (1996)

The notion that modern art could have been created outside the home territories
of the colonising cultures is one that, Ikem Stanley Okoye suggests, even at
the end of the twentieth century, is not likely to be taken seriously by Western
'academe'. Okoye argues that art historians in the USA and Europe have begun
to study the arts of cultures outside European traditions, but still group this work
together regardless of when or where it was made. It would, he argues, be
preferable to group specialists of twelfth-century African and European art
together, as well as to analyse each tradition chronologically without prioritising
one component as the mainstream. Okoye argues that a new art history would
recognise the possibility that modern sculpture was being invented in West Africa
(*c.* 1890–*c.* 1910). Ikem Stanley Okoye is Assistant Professor in the Department of
Art History at Northwestern University, Chicago. (Notes re-ordered.) [CK]

Source: Ikem Stanley Okoye, 'Tribe and Art History', *Art Bulletin*, LXXVII, no. 4,
December, 1996, pp. 614–15

[. . .] The idea of modern sculpture *as such* was as likely invented in Africa (south-

xxviii) Northcote Thomas, *Image of Anyanwu, c.* 1910.

eastern Nigeria) as in Western Europe (France). [. . .] I know of no exhibition of African art of the early twentieth century (for Africa, a moment whose objects are thought to realize a pre-'modern,' traditional world) that includes the reconstructed installation of an object such as the one discussed below. This object, and others like it produced in or before 1912, predates the many traditional woodsculpted figures that populate the African sections of art museums and galleries in the United States and the European Community. A characterization of the object as Igbo (that is, as representative of the art of Igbo peoples of southeastern Nigeria among whom it was found soon after the turn of the century) might be contested in terms of its authenticity by a viewer inclined to assume that particular stylistic qualities, indicative of a wider aesthetic code, define ethnicity in 'tribal society.' For such a viewer, the traditionality which might be assumed to have been true for Igbo society at the turn of the century would preclude the possibility that an object whose significance is, as the reader will see shortly, so central to the religious life of the location could be produced, let alone accepted, in this context. This is because it is typically assumed that in such contexts the very definition and self-recognition of individual and communal ethnicity is constituted by aesthetics (and not simply reflected or representative of aesthetics). Onto such places, if not in Western poststructuralist (and postcolonial) contemporary societies, we tend to project ethnicity, in this instance belonging to a 'tribe' such as 'the Igbo.' Always implied in such projections are claims for stability and essence, as evidence for

which we point to the recognizability of the aesthetics of objects,[1] quite unlike how we claim to experience Western culture. It is thus easy to imagine why potentially disruptive objects like the one illustrated remain conspicuously absent from exhibition-located representations of 'African' art. The role that the construction 'Africa' plays in Western monetary valuation of African art objects is one barely acknowledged reason for this absence. Another one, less bearable for its direct relation to art-historical writing, is the resilience revealed by such exclusions.

The object in question [plate xxviii] is a representation of Anyanwu,[2] a deity considered supreme in Oka and its vicinity,[3] and who is manifested in (sun)light.[4] We might therefore expect this to be a charged site for the representation of tradition.[5] Instead, this Anyanwu consists of a large number of bottles of Schnapps,[6] stacked in narrowing circles that take on a conical form. The bottles are stacked at a slight upward angle, so that the mouth of each bottle 'addresses' the viewer in a way that it would not were the rows arranged on a completely horizontal plane. With the bottle necks creating the conical form's external surface, we can imagine the brilliance of the effect produced in the tropical intensities of light and shadow. We cannot seriously question the intentional sculpturalism of the object, or the intensity of its originality against the more usual wood-carved and/or vegetal assemblages which previously represented the site of communion with this deity.

This installation, apparently located close to the entrance courtyard of a house, was photographed in 1912, but we have no reason to assume that such a date marks anything more than a limit. The object may, for example, easily date to 1890 or 1905. The point is that it predates, or at least coincides with, the invention of artistic practices that we now characterize as modern and/or postmodern in the locales of Western Europe, the Soviet Union, and New York. It certainly predates Warhol (*Brillo Boxes*, 1964, and *Green Coca Cola Bottles*, 1962) by perhaps a good half century,[7] and may have even been produced twenty years before Duchamp's found-object pieces. Moreover, the Oka object's complexity is indicated by the possibility that it was read locally as a metonymic commentary on the power of industrial production (read as ethnically English) to standardize and replicate taste.[8] It was also a comment on the power behind the seemingly arbitrary force of the colonial interloper, a power whose agency was believed nevertheless to inhere in the dispersed reproduced objects themselves. Thus, at this moment, its English usurpers were not any more crucial to this power's multiplication than were its local (Igbo) consumers. The object is therefore a radical transformation of earlier representational practices.

Of course, in order to indicate more persuasively how the genealogy of this image of Anyanwu might in addition constitute a discourse from which a history of *Western* modernism was written in southern Nigeria (and from which a specifically art-historical writing might be attempted), much more evidence than I present in this brief essay would have to be offered. I have, at this point, to insist on the basis of my own research that such evidence does exist and that the non-Western did in its own modernity construct narratives (histories) of modernity. I might add here that such histories do not, as might easily be assumed, give over

the invention of modernity to Europe and the United States.
[. . .]

NOTES

1 Sidney Kasfir had, however, already indicated the permeability of 'tribal' boundaries to stylistic trans-
 mission in questioning the then largely held view that particular styles (say, a particular mask type and
 its aesthetics) belonged to (and self-reflexively identified) particular 'tribes.' See Sidney Littlefield Kas-
 fir, 'One Tribe, One Style? Paradigms in the Historiography of African Art,' in *History in Africa*. II,
 1984, 163–93.
2 Igbo people, like most African peoples, do not attempt to represent deities as such; the sculpture is
 therefore not an attempt to produce a likeness this god. It would be more accurate to think of it as an
 attempt to represent the god's qualities or persona.
3 Oka, a northern Igbo town, is most generally rendered Awka in English-language texts.
4 It is nevertheless interesting that many major works on Igbo culture, including G. T. Basden, *The
 Niger Ibos*, London, 1938, and Azuka Dike, *The Resilience of Igbo Culture: A Case Study of Awka Town*,
 Enugu, 1985, remain strangely silent on the subject of Anyanwu (a notable exception is Francis Arinze,
 Sacrifice in Igbo Belgium, Ibadan, 1970, 55–7), even while they address cosmological futures the likes
 of Chukwa, the latter being the more widely recognized Igbo supreme God. This indicates some of
 the problems associated, as I have indicated earlier, with text-based scholarship in this context. What
 is in print on African cultures, therefore, is not necessarily an accurate reflection of local knowledge
 and its 'scholarship.'
5 The site is also the place through which mediation and communication with its force is expected (it
 is, in other words, both an altar and a shrine).
6 Schnapps, an imported Dutch gin, was a highly prized commodity in this location. It functioned in
 certain contexts of exchange, including, for example, marriages and funerals, where it acquired a cer-
 tain cachet by the turn of the century. Ultimately, Schnapps was introduced into religious practice as
 a medium of libation to the earth goddess Anti (Ala) and to the ancestral realm.
7 I might add here that, regardless of the particular brand involved, each of the Oka sculptor's green
 bottles would have had a quite legible embossed brand name running vertically down its two sides.
8 Local palm wines and spirits have distinctive tastes, nearly as regionally specific and variable as those
 of French wines.

xi) The Other Story (1989–90), An Exhibition Curated by Rasheed Araeen and its Critical Reception

In 1989, after numerous previous attempts to stage this project, the artist Rasheed
Araeen curated a large exhibition of the work of artists from African or Asian back-
grounds who had worked in post-war Britain. This exhibition, held at the
Hayward Gallery, London, became an important focus for debates on the ques-
tion of how artists practising in the Western metropolis who were colonial
subjects, or the descendants of them, were regarded. While the exhibition was
criticised in the 'quality' press for sacrificing the values of Western art in the
interest of gathering together the works of African and Asian artists, it was also
berated by critics writing for publications representing the political Left and fem-
inist interests for having given insufficient showing to the works of African and
Asian women as well as neglecting the so-called minor arts. Collected here are
Araeen's statement of his intentions from his postscript to the exhibition cata-
logue, and reviews and comments representing a range of views expressed.
Araeen (1935–) has played a key role as artist, curator, and founding editor of the
journal *Third Text* in questioning modern art where it appears eurocentric. [CK]

Sources: a) Rasheed Araeen, 'Postscript', *The Other Story. Afro-Asian artists in post-war Britain*, Hayward Gallery, London, 1989, pp. 105–6. b) Brian Sewell, 'Pride or Prejudice', *Sunday Times*, 26 November, 1989, p. 8. c) Peter Fuller, 'Black Artists: Don't forget Europe', *Sunday Telegraph*, 10 December, 1989, p. 10. d) Homi Bhabha and Sutapa Biswas, 'The Wrong Story', *New Statesman*, 15 December, 1989, pp.40–42. e) Rita Keegan, 'The Story so far', *Spare Rib*, February 1990, pp. 36

a) Rasheed Araeen, 'Postscript'

It may seem strange that I should end the Story on the ironic note of Sonia Boyce's success. But is it not through irony that we recognize the complexity of things? Who would have thought that this exhibition would take place in a major institution during Mrs. Thatcher's government?

It was a difficult project, however; it has taken eleven years to realize. When I first went in 1978 to the Arts Council, I was given the cold shoulder. I went again in 1983, but received the same response.[1] I then spent two years marching up and down the corridors of the socialist GLC, but without result.[2] In fact my dealing with the GLC was one of the most humiliating experiences of my life.

Early in 1986, demoralized by the GLC experience, I casually approached the Arts Council once again. To my surprise, I was asked to come and discuss the matter, and after one year of committee meetings my proposal was accepted.

My selection of the artists was based on multiple factors: historical, ideological, aesthetic, as well as personal. My main consideration was that the work must engage with the idea of modernity (or postmodernity), with its historical formations as well as its socio-cultural constraints and contradictions. It must be regretted that there will inevitably be artists who did not come to my attention or whose work I did not understand, and who have thus been excluded; it was necessary to make a tight selection, given the limited resources and the specific objective of the project; it was never meant to represent *every* Afro-Asian artist irrespective of the quality or historical importance of their work.

It may be argued by some that I have fallen into the trap of 'white' culture or that I am an elitist when I talk about 'quality'. But is it not facile to assume that artistic quality is the prerogative of white culture? It is not a question of accepting or rejecting the white culture's notion of quality in favour of some mythical black aesthetic, but of engaging and questioning the dominant artistic practice. In other words, if prevailing artistic criteria are based on the sensibilities of a white society – which is no longer exclusively white but multiracial – then these criteria must be challenged and changed. Of course, for this community rhetoric is not enough; what we need is intellectual rigour of artistic practice.

In fact there is no single monolithic standard of quality within the dominant discourse. Changes are taking place all the time. There are cracks and crevices in its white pyramid by which one can explore and penetrate its inner space. The Other Story is a story of this exploration.

The different sections of the Story do not represent exclusive categories. Some

artists have simultaneously been involved in more than one grouping, while the work of others has changed considerably since their early output; but putting the artists in different sections has helped me to concentrate on the central aspects of their work. Moreover, various sections represent the fact that what is under consideration here is not a 'fixed' cultural practice but a part of the socio-historical changes that have taken place in the last 50 years or so.

The uniqueness of Afro-Asian achievement is that it does not represent separate categories of 'ethnic arts' or 'black art' but is firmly located within or in relation to the mainstream; it reflects the complex articulation of modern developments in art that have taken place in post-war Britain.

We must in fact oppose separate categories, whether they are racial, ethnic or cultural. If this Story is a contradiction, it has been imposed upon us by this society. Some people are going to accuse me of separatism, but are not these the very same people who believe in the status quo? Who believe in and have willy-nilly perpetuated the supremacy of the Western/white male artist in the paradigm of modernism?

Why is there no open or public debate about the absence of non-European artists from the history of modern art? If it is not due to racism, how, then, do we explain the prevailing complacency? The argument that *all* artists face difficulties regarding recognition, irrespective of race or colour, is facile and masks the ideological structure of this society. Of course, it will be argued that the recent success of Anish Kapoor, Shirazeh Houshiary and Dhruva Mistry invalidates my position. But were not Souza and Chandra, among others, successful in the early 60s? What happened to them, after their brief success? Was not their attraction due to them being seen as 'different' or 'exotic'? Has the present situation really changed regarding the position of non-European artists within Modernism? If a shift has taken place, where is the proof? Where is the debate? Will Postmodernism's cultural eclecticism (re-)inscribe the 'other' as a historical subject?

Kapoor, Houshiary and Mistry, as well as Kim Lim and Veronica Ryan, were in fact invited to participate but they declined. I understand their fears, and I sympathize with their positions. But the success of these artists does not vindicate the establishment or invalidate my argument. Can we separate the success of some of the above artists from the anti-racist struggle waged particularly against the art establishment in the 70s? Instead of a serious debate within the dominant discourse, we now have new categories – 'black art', 'ethnic arts', and phoney pluralism to confuse the issue.

I must express my particular sadness at not having Kim Lim in the show. Her absence has left a big gap in the Story, because she was both an important modern sculptor in the 60s and after, and a *woman* artist who has not received due recognition.

The issue of equal gender representation remains unresolved here. We have included only four women artists, which is regrettable. But this must be understood in terms of socio-historical factors, rather than through a continually repeated rhetoric of mythical 'blackwomen artists' who have been ignored. It seems that in the 50s and 60s 'black' women artists who had come here from

Africa, Asia or the Caribbean, returned home when they had completed their education, unlike male artists who stayed on. On the other hand, black women artists who have recently emerged were either born or brought up in Britain, and they have no choice but to assert their presence here. They are an important part of our Story.

This Story is only a part of the whole, and I hope it will not be necessary to tell it again *separately* or removed from mainstream history. My effort is only an initiative; it is now up to society as a whole to take this initiative seriously and to try to see its significance as part of its advancement towards a truly multiracial and multi-cultural culture.

[. . .]

NOTES

1 Correspondence about this has been published in my book *Making Myself Visible*, Kala Press, London, 1984.
2 I did receive some money from GLAA and the GLC in 1983 for preliminary research work.

b) Brian Sewell, 'Pride or Prejudice'

Western art, while having its own well-documented tradition, has not been unreceptive to the influences of other cultures. If the resemblance of French Romanesque cathedrals to the great churches of Armenia can be dismissed by some as chance likeness, Picasso's dependence on African fetish sculpture cannot, for all the vital evolutionary works of Cubism demonstrably stem from it.

Those who argue now, in Britain, that art should embrace the influences of its ethnic minorities, and that we should acknowledge the mastery of those who practise it, present us with a dilemma, for their work is too new, too immature, too hybrid to exert any influence on the western stream from which, in essence, it derives.

[. . .] Rasheed Araeen, who has devised this winter's Afro-Asian exhibition at the Hayward Gallery, asks why such artists have failed to become part of the history of art; perhaps he should have asked, 'Why have Afro-Asian artists failed to achieve critical notice and establish a London market for their work?' To that the answer is short – they are not good enough. They borrow all and contribute nothing.

Consider the work of Francis Souza, the grand old man of this exhibition, who came to London from Bombay in 1948. The residual Indian characteristics in his pictures were immediately swamped by western mannerisms and he imitated every style and subject from the pin-up and the grotesque late Cubism of Picasso to the jagged repetitive drawing of Bernard Buffet, with Massimo Campigli his most fruitful source of ideas and images. Araeen blames the London art world for Souza's failure to turn a brief flurry of interest into a long-term market for his work, but when a disappointed Souza moved to the indulgent atmosphere of New York he did no better, and for exactly the same reason – his work was simply not good enough to attract and hold serious critical acclaim.

If the history of contemporary Indian art dates back a mere half century, the history of African and Caribbean art in a western mode is even shorter and even more derivative. Araeen blames the British Empire, the cultural imperialism of America, the promotion of Greek art by Hegel and the damning of the primitive by John Ruskin for what he sees as white English contempt for Afro-Asian art. It is a pity that he did not read the essays and lectures of Roger Fry (far and away the most influential of English critics in this century), for in these, devoted to the art of Bushmen, Incas, Aztecs, African sculptors, Chinese and Indian painters, he would have found a broad mind and an enthusiastic voice wholly contrary to Ruskin's view. Unlike Araeen, however, Fry could see no virtue in multicultural confusion; for him each strand of cultural history stood in its own right.

The colour of a painter's skin is of no relevance when judging pictures – it is only the qualities of the imagination and the work that matter, the imagery, drawing, colour and the handling of paint. To some extent Afro-Asian artists acknowledge this, and yet when they are not successful they fall back on the old and easy excuse that their failure is due to conscious and deliberate exclusion, to a prejudice against their race or colour that puts them beyond the margin or into the ghetto.

Last year, to a proposal that the Commonwealth Institute should house an exhibition of contemporary art from South Africa, the Institute's response was that it could be only of work by black artists, not white. Contacts in the ANC who had given the proposal their necessary blessing, refused to accept this apartheid in their favour, wishing blacks and whites to be exhibited only on equal terms. The project died, a victim of inverse illiberalism in this country.

It is a combination of that brand of discrimination and an illogical, half abjured demand for patronising patronage, that lies behind Rasheed Araeen's exclusive exhibition. If he really wishes his chosen group of Afro-Asian artists, born or choosing to work here, to be seen as a match for the English whites whom he derides as privileged, then he should relish the competition and comparison inevitable in a mixed exhibition.

The dilemma for the Afro-Asian artist is whether to cling to a native tradition that is either imaginary, long moribund, or from which he is parted by generations and geography, or to throw in his lot with an ancient tradition of white western art, from which he borrows, but with which he has scant intellectual or emotional sympathy. Whichever he chooses, he must not require praise, nor demand a prime place in the history of art, simply because he is not white. For the moment, the work of Afro-Asian artists in the west is no more than a curiosity, not yet worth even a footnote in any history of 20th-century western art.

c) Peter Fuller, 'Black Artists: Don't Forget Europe'

A few weeks ago, the national newspaper editors got together and agreed a code of practice in which they undertook never to mention an individual's colour, except where this was deemed to be relevant. Those of a progressive disposition thought this to be 'a good thing'.

But only last week considerable publicity was given to an exhibition, called The Other Story: Afro-Asian Artists in Post-War Britain (at the Hayward Gallery until February 4) and selected by Rasheed Araeen, in which only the work of non-whites was considered.

Thus *The Other Story* is the first exhibition of contemporary British art held in a major public institution of which the criteria for inclusion are explicitly and exclusively racial. How can this be a good thing?

Commenting last Sunday on the newspaper editors' decision, Peregrine Worsthorne remarked that, in his view, a person's colour was almost always relevant; but I imagine he would agree that one occasion on which race had no relevance was when evaluating the quality of an artist's work. (This is why several of the most prominent black artists who are successful, or talented, or both, have declined to take part in the show; for example Anish Kapoor, the fashionable choice to represent Britain at next year's Venice Biennale.)

Araeen justifies his approach on the grounds that black artists must fight what amounts to an 'imperialist' or 'neo-colonialist' (he loves such words) conspiracy on the part of the historians of modern art to exclude what he calls *The Other*, or worse still, to confine black artists to the ghettos of 'ethnic' art. But much of the work Araeen has reinstated is quite simply of little, if any, aesthetic or artistic value.

Almost all the exceptions occur in the early part of the exhibition which focuses on the work of a number of talented, if second-rank, artists who came to Britain in the late 1940s and 1950s, for the most part from Commonwealth countries. In his rambling and confused catalogue introduction, Araeen makes it clear he has reservations about this older generation, none of whom can readily be accommodated within his thesis.

Take the case of Souza. His erotic and expressionist images got him into trouble with the authorities in India. He came to England in 1949, where, after a few obligatory years of Bohemian poverty, he became a spectacular success. He was showered with awards, prizes and one-man shows. He was soon boasting that he earned more from his painting than the Prime Minister earned from politics.

How good an artist was he? Beside, say, Auerbach or Kossoff, he is minor. But the painting, *Black Nude* (1961), from the V & A, certainly has a brash and arresting vigour. It looks a lot fresher than much other Fifties expressionism does today. Souza brought a dash of something exotic and different – and this no doubt helps to explain his runaway success.

Araeen makes much of the fact that Souza's reputation faded in the 1960s; predictably, he relates this to the rise of Powellism, and what he regards as growing racism in Britain. But what happened to Souza at this time happened to a good many white figurative expressionists of his generation – John Bratby, for example – as well.

In fact, with success, the fire went out of Souza's belly; his painting became vapid. And it did so just at the time when new fashions – abstract expressionism and Pop Art – were sweeping the London art world.

But it is not difficult to see why Araeen prefers racial explanations. He trained as an engineer, came to England from Pakistan in 1965, and decided to become an

avant-garde sculptor. He began by imitating Anthony Caro's work in industrial steel I-beams; but, unlike Caro, he had no sculptural imagination, and chose simply to pile up his prefabricated elements in regular stacks.

In the late 1960s the fashion changed to events, performance art, and so forth – so did Araeen. In the 1970s, the avant-garde art world went stridently political – so did Araeen. After a visit to Pakistan, he announced that he had joined the Black Panthers; and thenceforth devoted much of his time to hysterical polemics.

When the Arts Council turned down his proposal for an exhibition similar to that now at the Hayward, he wrote to Andrew Dempsey, who then ran the gallery for the Council: 'How extraordinary that the views of Enoch Powell should also echo in the committee rooms of such a liberal and an enlightened institution!'

So why did the Arts Council and the Hayward Gallery change their minds, and invite Araeen to put on this show after all? Encouraged by the GLC-funded 1986 report *Art on the South Bank*, which argued the case for a muddled multiculturalism. Araeen seems simply to have bullied and cajoled them into it. As Peter Dormer wrote in *Modern Painters* last year. 'People, especially arts administrators, are afraid of what [Araeen] represents – and what he represents is "white guilt"; they dare not turn him down because in rejecting him they are rejecting blacks. Quality of art is not the issue, it is race.'

Certainly, the younger artists in this show are not interested in aesthetics or beauty. They offer a drab parade of posters, installations and video displays, spiced with tired slogans: Eddie Chambers's *How Much Longer You Bastards*, for example – an uninspired attack on Barclays Bank for their South African involvements.

Franz Fanon is much quoted at the Hayward: but black artists in today's Britain are hardly among the wretched of the earth.

The truth is that everything Araeen does is showered with public subsidies. An exhibition he organised under the auspices of the Chisenhale Gallery. *The Essential Black Art*, which toured Britain last year, received funds directly and indirectly from, among other organisations, Greater London Arts, the Henry Moore Foundation, Art Place Trust, and the Arts Council – a remarkable achievement.

Araeen's thesis needs to be stood on its head. The real question, surely, is why, given all these opportunities, is the recent art in *The Other Story* so mediocre? The answer is no doubt complicated. But in part it is because Araeen and his colleagues are obsessed with attacking what they call Eurocentrism.

They have thus blinded themselves to the fact that there was anything special about European civilisation, in general, or European painting, in particular. Sadly, today's 'internationalist' and 'multicultural' arts policies do everything to endorse this blindness.

d) Homi Bhabha and Sutapa Biswas, 'The Wrong Story'

HOMI BHABHA

'The Other Story' contends that the British art establishment has consistently

failed to recognise the particular 'modernism' of the postwar postcolonial artist. Critics who celebrate the 'international' styles of modernist and postmodernist art, and revere the artist as jet-set *flaneur* (the Italian artist Clemente who moves from Madras to Milan to New York), seem to deny the potential for innovation of those who emerge out of the post colonial cultural migration to the west.

Critics claim that the postcolonial artist is forever the *atelier ingenue* – belated, derivative, second-hand. Unable to handle the mastery of conceptual or abstract forms, the identity of the postcolonial artist must be sought in attenuated 'oriental' imagery, an exotic colour tone, a reposeful spiritual calm, an archaic detail.

Now this is not just another theory – it is the story of the reception of this exhibition. Most reviewers have fanned the polemic and the controversy, arguing that the best postcolonial British artists – always the same two solitary figures, Anish Kapoor and Dhruva Mistry – have kept out of the 'ghetto' show. None has attempted to ask whether the self-image of metropolitan (post)modernism has to be rethought in relation to this particular, postcolonial hybridity, its cultural migration and its translation of artistic traditions.

Where major questions have to be asked of the show, the critics have failed to do so. For instance, there is an unacknowledged problem running through the exhibition in its conflation of modernism and masculinism. The inadequate representation of women artists is dealt with by Sutapa Biswas below.

There remains a serious, unasked question, particularly relevant to one of the most celebrated paintings 'in the citadel of modernism' section – Francis Souza's *Black Nude*. Without questioning the expressionist energy of Souza's amazon, there is something unexplored in the use of the woman's body as the erotic object that enables a postcolonial 'Indian' iconography to emerge in its modernist form. Despite the obvious reference to the goddess Kali, there is an association of the primitive, the raw and the exotic with women's sexuality, which provides an easy naturalistic reference for his work, making it both accessible and acceptable.

The general complacency among the critics comes from a value given to the immediate visibility of the image which gives art a spurious autonomy. 'What, after all, can the work of artists from such a differing range of backgrounds – Guyana, Pakistan, Sri Lanka, China, India – have in common?' asks Andrew Graham-Dixon (*Independent*, 5 December 1989).

Only the fact, of course, that British imperialism touched them all, imposed a conformity of administrative, educational and cultural practices on the most diverse regions. Only the obvious historical fact that the experience of migration and the formation of minority identities in postwar Britain have been a response to discriminatory strategies of marginality and stereotype that treat you almost equally whether you are Guyanese, Sri Lankan or Indian.

As the essays in the exhibition catalogue testify, these are the other stories – personal, historical, aesthetic – that the artists have attempted to inscribe in their work. But treated as events external to the art-work can only lead Graham-Dixon to give them a more common identity: '*The Other Story* . . . raises important issues, but is not a particularly convincing exhibition, partly for the simple reason that much of the art displayed is *not very good*.'

xxix) Gavin Jantjes, *Untitled*, 1989, Edward Totah Gallery, London.

Why should I believe him? Because he tells me that Avinash Chandra's squiggled biomorphs are 'uninspired responses' to Klee and Ernst; or that Balraj Khanna's embarrassing figure paintings are on Athena art lines. If a whole *genre* or tradition of artists, who share a postcolonial history, are 'tame and derivative', then I want to know more about the power of the precursors, the anxiety of influence, the aesthetic conditions of a 'strong' reinterpretation or a creative misreading.

It is, for instance, predictable to suggest that Gavin Jantjes juxtaposes a figure from *Demoiselles d'Avignon* with an African mask: 'The point being that Picasso has received too much credit for innovations made considerably earlier by an unknown artist from the Congo.' That is *not* to read the balance and disposition of the images.

The line-drawing of the translucent *demoiselle* gazes wide-eyed at the viewer in a familiar figurative pose; the mask, at the other end of the canvas, turns away from the priority of the figurative and the visual to suggest other senses of identity. The two images are linked through umbilical cords that suggest not an unmasking of the Picasso figure, but a challenging tension across the terrain of cultural difference between the visual locus of the aesthetic, and the *sensoria* of other cultural systems. In one sense the two figures are incommensurable; in another, it is this difference that makes possible the negotiation of cultures on equal terms.

The other criteria present themselves in a careful relocation and deconstruction

of the values of the 'eye'. Sonia Boyce's *Big Woman's Talk* provides a feast of sensuous colour and exotic forms that cover the woman's body. But the viewer's eye is elided by the canvas that cuts the woman's head half-way. As you reconstruct her face – outside the frame – her open mouth becomes the displaced eye – a speaking eye through which you hear an 'other' story; a story of those whose political and social visibility is often denied, whose testimony is resoundingly silent . . . as in a painting.

No, Mr Graham-Dixon, despite the levels and luminosity of paint, the thickness of description, Frank Bowling's *Great Thames II* shines with a quite different light from Auerbach's *Primrose Hill.* The importance of this exhibition lies in our being able to acknowledge the presence of both artists in a city, and a country, whose vision of itself must change with the emergent, hybrid cultures of its people.

SUTAPA BISWAS

'The Other Story' is the first time a major exhibition of Afro-Asian artists' work has been shown at the Hayward. So far, so good. But in common with many 'overview' exhibitions it has many problems. *The Other Story* misleadingly implies a collective authority of narrative. It might have been better titled 'Rasheed Araeen's Other Story'.

A major exhibition, involving contemporary and older generation Afro-Asian artists' work, is long overdue. Given that the bulk of the most exciting work produced in Britain in the past ten years has been the work of younger generation Afro-Asian artists, Araeen jeopardises this by his 'hang-ups' about modernism, neglecting what would have been the show's major strengths, particularly the contribution of black women.

In fact, Araeen seems to be misrepresenting the implications of this, by cleverly separating the works of artists Mona Hatoum and Lubaina Himid from the work of Sonia Boyce by the use of isolated categories. Also, he has deliberately missed out the work of artists like Houria Niati, Marlene Smith, Claudette Johnson, Sokari Douglas Camp, Nina Edge, Bhajan Hanjan, Shanti Thomas, Ingrid Pollard, Zarina Bhimji, Amanda Holiday, and so on, whose work would knock the spots off several of the less well chosen pieces in the show.

It is difficult to follow Araeen's hypothesis. But his argument is with modernism. He is saying that modernism was not exclusive to the west since capitalist development was also taking place in non-western cultures. He asks why it was that, when Afro-Asian artists were involved in modernist debates, they were first framed as 'other' in relation to the dominant culture, and second, erased from mainstream history. Araeen rightly places the racist nature of British society as the cause.

However, Araeen's flying the flag for modernism, is a shaky premise for this show. Over the past two decades, there has been strong argument against, for example, the sexist nature of modernism. Ivan Peries's work *The Arrival,* for instance, evokes some of the limitations of modernism. In discussing this work,

Araeen reveals his complicity with modernism. 'The sensuousness of its main sub-jects,' he writes, 'three nymphs [I think here Araeen means three women] in a lotus pond,' is an expression of 'repressed desires'. This does not adequately decode the power of the image.

In the painting, the juxtaposition of three naked black women and phallocen-tric symbols does not question, but reinforces the power relationship between the male as active creator of the work, and the female as its passive, created subject. The artist places the figure of the women, not only as passive and non-participating, but also as object of the artist's work and spectacle.

That Araeen's selection predominantly comprises painting and sculpture gives rise to other problems. The show omits film, photographic and mixed-media work, which are also common formats in contemporary art practice. The films *Handsworth Song*, by Black Audio Film Collective, *Territories*, by Sankova, and Isaac Julien's brilliant *Looking For Langston* are excluded.

Noticeably absent, too, are the works of Donald Rodney and Sunil Gupta, whose powerful images explore the body politic: issues that will undoubtedly be central in the 1990s. On the issue of patronage, the most recent work of Helen Chadwick, for example, is fairly well known. Also dealing with the body politic, Chadwick's work has been written about a great deal, but is not as powerful or deeply felt as Rodney's work. Rodney's work is equally worthy of exposure, as is the work of many of the younger generation of Afro-Asian artists.

In the event of Araeen bringing to the public's attention the work of older gen-eration Afro-Asian artists, artists who have been 'erased' from history, it is ironic that Araeen himself erases from history the contribution of younger Afro-Asian artists of today.

e) Rita Keegan, 'The Story So Far'

As women, we all have experiences of the fact that there is another side to most stories. We also understand the need for it to be told, and that no one is going to tell it for us, so we have to write it, act it, sing it and paint it for ourselves. With this in mind, we can approach the exhibition appropriately titled *The Other Story: Afro-Asian artists in post-war Britain*. The main aims of the exhibition is to show the 'other side' of art in Britain, and how Black artists have been at work here for almost five decades. Rasheed Araeen the curator, responsible for the choice of work and the criteria for inclusion says, 'This is a unique story. It is a story that has never been told. Not because there was nobody to tell the story, but because it only existed in fragments . . .'

The reviews in the mainstream press have been very negative, and predictable. Much of the criticism that was levied at the show were almost identical to the kind that one gets at exhibitions by women artists. This is not to say the show does not deserve serious constructive criticism. But most of the critics revealed more about themselves with their poison pens and barbed comments, than about the show, its makeup and its contents.

The problem arises when the art work of one culture is only seen as art with a

xxx) Sonia Boyce, *Big Woman's Talk*, 1984, private collection. Photograph courtesy of the African and
 Asian Visual Artists Archive.

capital A, when it is reinterpreted through, and for the eyes of the dominant cul-
ture, namely European. That is to say that African imagery only becomes art when
utilized by Picasso. The practice of appropriating another culture's art tradition,
has lead to the silencing of the said culture/country, and has assured its loss of
place and status in the art world, thus leading to a tight cordon around the narra-
tive and perspective of what can be considered 'art'.

 I was raised and received my art education in the States where there is a more
liberal meaning to questions like 'What is Art?' The answer you get to this ques-
tion is, 'If you can hang it on the wall or put it on a plinth it's art!' There is also
less of a differentiation between the arts and crafts.

 Noticeably there are no craft based works, ceramics or fibre art in this exhibi-
tion, maybe it was the fear of association with 'native' craft that rendered this. Art
based photography has also, for the most part, been sadly over looked. The photo-
graphy in this show is mostly of a documentary nature. With the exception of
Mona Hatoum's videos and Keith Piper's installation tape slide, *Adventures Close*

to Home, (documenting the shooting of Cherry Groce), the photo essay, *Go West* and Rasheed Araeen's piece, *Green Painting*, which would not have the same meaning without the five photos.

Which brings me to my biggest problem with this exhibition: out of 24 exhibitors there are only 4 women. All the artists should be seen, and not at the expense of each other, but to have so few women must be addressed. When you look at the last 10 years, some of the strongest, most relevant and diverse work has been done by black women artists. No Asian women were included, and I could make a list of women that are obvious by their absence.

Nevertheless, the four women that are shown are strong, and totally confident with their chosen media.

Mona Hatoum who is Palestinian, was born in Beirut and has lived here since 1975. Her work draws directly on her experience of people in exile. She deals with the issues of freedom on both a personal and political level, by using her body as her media for expression, she creates performances that are movingly beautiful, and painfully shocking. Included in the exhibition are documentations of live performance, video works and a poist [*sic*] piece, *Over My Dead Body* in which the imagery is as direct as its meaning.

In sharp contrast to the black and white of Mona Hatoum, is the work of Japanese artist Kumiko Shimizu, who works with found objects which she then paints vivid colours. She says about her approach, 'Gradually I realized that everything could be art, that I didn't need a studio, but could work with environments. I decided I would work only to support myself enough to live. Even if I became a tramp, I would do art'. And with this in mind, her work must be seen. To me, this is a very strong statement about her need, and desire to create and translate everyday objects into art. In her work, there are underlining issues of ecology and a comment on the disposable society that the West perpetuates. She transforms the ordinary into the extraordinary.

In this exhibition, there is a chance to see a bit of history (or do I mean herstory) with Lubaina Himid's recreation of a piece she did for the I.C.A. exhibition *The Thin Black Line*. Born in Tanzania, but brought to England within a year of her birth, her work is a direct experience of growing up as a black woman in Britain. Issues of sexual politics, culture and imperialism are examined. She is not afraid to mix media, and her work literally runs off the canvas, as collage and painting twin with alarming effects. Her work is both powerful and poetic.

Sonia Boyce, the youngest exhibitor, has all the strength and vision of any of the older artists. Born in London, her work is essentially personal using images of the family and self portraiture. The size, power and sensitivity in the piece *Big Woman's Talk* strikes a common c[h]ord in all who see it. She deals with British imperialism in *Lay back, keep quiet and think of what made Britain so great*, by making the links; the rose, the missionary cross, and some of the countries that they colonised. With the use of collage and drawing, she has developed her own stunningly visual language.

Rasheed Araeen, the curator, is to be applauded for the years of struggle, and all the hard work that it took to curate a show of this size, not to mention the

changes in funding, and the fact that this show is in such a major venue. But it must be stated that this is one man's choice, and it should not be seen as the quintessential show of work by people of colour working in Britain. I sincerely hope that when major galleries are approached in the future about black exhibitions, they do not say, 'Oh we did that back in 1989/90 and we don't need to do it again.' This must not be the 'The Only Story'.

Section Six
Contemporary Cultures of Display

As was pointed out in the introduction to this book, the division of the texts included in this section into 'source texts' and 'critical approaches' is rendered problematic by the recent origin which they all share. However, there are certain distinguishing features between them. The first set of texts contains statements by individuals actively involved in the display of art, as museum directors and curators, as well as critical reflections on specific museums and contemporary exhibitions. Thus, for example, David Batchelor's discussion of a key issue relating to the display of contemporary art takes an annual exhibition-cum-media event, the Turner Prize, as its starting point. By contrast, several of the texts in the second part of this section are not directly concerned with the display of art but offer theoretical perspectives that can be applied to museums and exhibitions. These authors come from academic disciplines other than art history, such as sociology and geography. They all present some form of cultural critique, with the exception of André Malraux whose text is also the earliest of all those in either the source texts or the critical approaches. This second set of texts provides a historical framework for some of the assumptions revealed in the source texts, which predominantly date from the 1990s.

The source texts include statements by the current directors of two major London art institutions that can usefully be compared with each other. Whereas Nicholas Serota discusses various modern art museums as models of display, Neil MacGregor is primarily concerned with the policies adopted and problems faced by his own institution. The extracts relating to the Musée d'Orsay in Paris raise a rather different set of concerns. Michel Laclotte and Françoise Cachin not only seek to explain and defend its conception and installation but also explicitly defend their approach to display from that adopted elsewhere, especially in the United States. Their contributions also highlight the question of the canon, revealing the difficulty of reconciling recent trends in art history with the prevailing conception of the art museum as a space dedicated to aesthetic contemplation. The belief that the art museum exists first and foremost to encourage visitors to commune with great, beautiful or otherwise significant works of art is shared by all the curators and directors represented here. By contrast, Madeleine Rebérioux (a historian rather than a curator) condemns the aesthetic mode of display adopted at Orsay on the grounds that it is élitist.

Certain differences on the issue of access can also be discerned among the art

world professionals represented in this section. Whereas Serota seems to assume an initiated spectator whose careful scrutiny of works of art takes account of the most minute aspects of the display, MacGregor insists that no knowledge is needed to understand and appreciate old master paintings. While the latter combines a belief in the primacy of aesthetic experience with a concern to expand access, Rebérioux argues for a more historical mode of display at Orsay as a necessary precondition for broadening its public. The conventional idea that art must be made accessible is challenged by Batchelor whose contention that 'the public' exists as a convenient fiction for officialdom can be compared to the analysis of Thomas Crow (Section One, text xiii), above. The problematics of display and access emerge especially clearly in respect of exhibitions that are also discussed by MacGregor. The source texts conclude with two reviews of the 'Africa' exhibition held at the Royal Academy in London in 1995. On the one hand, this exhibition is praised for encouraging public appreciation of non-canonical art and, on the other, deplored for imposing a modern Western notion of art on objects that were not originally meant for aesthetic contemplation but had culturally specific meanings and functions.

This kind of appropriation is exemplified by the extract from Malraux's *Museum without Walls*, which effectively replaces the traditional Western canon with an expanded definition of art. Malraux's text has been included on the grounds that its central concept offers a helpful model for understanding contemporary spectatorship of art. At the same time, he represents the concern with cultural democratisation that emerged in the immediate post-Second World War era. This project of diffusing high culture to a mass public has been called into question by Pierre Bourdieu who, in *The Love of Art*, argues that working-class people are excluded from appreciation of art by their lack of familiarity with the requisite aesthetic codes. For Bourdieu, both the category 'art' and the art museum are fundamentally ideological institutions, operating to consecrate existing cultural and social distinctions. Although this position retains much (if not all) of its force today, it can also be located within the context of the political and cultural radicalism of the later 1960s. The same historical moment is also represented here by an extract from Guy Debord's *Society of the Spectacle*. For Debord, in modern capitalist society peoples' lives are mediated by images. Debord's book was written as a contribution to a political practice that would bring 'spectacular society' to an end. The term 'spectacle' has since gained wide currency as a key concept for cultural critique and, more particularly, for defining the nature of a 'postmodern' condition.

The work of both Bourdieu and Debord informs David Harvey's analysis of the impact of global capitalism on modern cities which the author subsequently developed into a broad-ranging examination of postmodernism. The main object of Harvey's critique is the contemporary politics of urban regeneration which, he argues, benefits the affluent sections of society at the expense of the poorest. This text can be placed in the political and economic context of the mid and later 1980s, the era of the right-wing governments of Thatcher and Reagan, but also raises issues that are of continuing and even growing relevance today.

Robert Hewison's *The Heritage Industry* addresses the pervasive nostalgia and cultural nationalism that, in his view, characterised Britain during this period. More broadly, the heritage phenomenon can be seen as (among other things) a reaction to the homogenising effects of globalisation discussed by Harvey. For Hewison, 'heritage' shares in the superficiality and escapism of postmodernism, its concentration on glossy surface appearances at the expense of the fundamental problems of lived experience. In other words, it can be seen as part of the contemporary culture of spectacle. This kind of critique is problematic to the extent that it tends to suggest an indictment of visuality as such. Nevertheless, these writings can help to define the conditions of spectatorship in the contemporary Western world. [EB]

i) From Nicholas Serota, *Experience or Interpretation: The Dilemma of Museums of Modern Art* (1996)

After directing the Museum of Modern Art, Oxford and the Whitechapel Art Gallery, Nicholas Serota became Director of the Tate Gallery, London in 1988. The text printed here is the final section of a lecture he delivered at the National Gallery, London in 1996. The lecture is largely concerned with a new form of display that has emerged in modern art museums since the 1980s: the practice of devoting an entire space to the work of a single, usually living artist. As Serota argues, this form of display involves a shift away from the analytical, comparative approach encouraged by the traditional museum convention of arranging the works of art by school or movement (interpretation) towards a much more intense, primarily visual experience that approximates to worship (experience). Serota seeks to explain this development by reference to a growing concern on the part of artists with space in general and the museum in particular not simply as a setting for their work but as an integral part of it. While generally favourable to the single artist mode of display, Serota also expresses some reservations. In the section reproduced here, he goes on to discuss some alternative ways of exhibiting art that he especially admires. Serota's notes have been omitted and no attempt has been made to give details on the artists he mentions. [EB]

Source: Nicholas Serota, *Experience or Interpretation: The Dilemma of Museums of Modern Art*, Thames and Hudson, 1996, pp. 42–55

[. . .] What do we expect from museums of modern art at the end of the twentieth century?

We may agree that the encyclopaedic and dictionary functions of the museum are neither achievable nor desirable. But there is less general agreement on how to balance the interests of the artist, the curator and the visitor. Some of the larger institutions have begun to explore new approaches.[. . .] However, the most stimulating developments have occurred in smaller museums, where the sense of institutional responsibility towards conventional expectations is less pressing.

One influential model is the Hallen für Neue Kunst in Schaffhausen, Switzer-land. The institution occupies three floors of a former textile factory which is lit by windows on both sides. The open floors are divided into a sequence of spaces rather than chambers, as in the permanent installation by Beuys of *Das Kapital*.[1] Artists are generally represented by several works presented as clusters, which has the effect of creating overlapping and merging zones of influence. As a result unexpected readings and comparisons occur. In Robert Ryman's paintings the spectator's pleasure at reading modifications of surface, from warm to cool or from refined to expressive, is heightened by the close juxtaposition of his work with Carl Andre's sculpture *Thirty-Seven Pieces of Work*, in which light is absorbed or reflected across the surface of six different metals. Such subtleties should be one ambition of the museum of modern art.

Schaffhausen draws together artists of approximately the same generation and of related sensibilities. Greater daring is present at the Insel Hombroich, an iso-lated private museum established by Karl Heinz Müller on a wasteland at Neuss outside Düsseldorf. Müller houses his collection in a series of pavilions constructed according to the designs of the sculptor Erwin Heerich. These are strikingly simple but offer considerable variety, with rectangular and square rooms, and even some asymmetrical, of different heights and proportions arranged in contrasting plans. Each has its singular quality of light and volume. Müller adds to this complexity by showing work from earlier cultures alongside contemporary art, as in the installation of Khmer sculptures and abstract paintings by Gotthard Graubner, and by making surprising comparisons, as in the display devoted to Fautrier and Corinth, both represented by exemplary groups of works.

Such juxtapositions are perhaps a more natural strategy for the private collector, or for the exhibition maker, than for the museum curator. In recent years exhibi-tions and displays have been presented according to this dialectical principle with increasing frequency. The main room in the exhibition *A New Spirit in Painting* at the Royal Academy in 1981 brought together three artists of two generations, Balthus, de Kooning and Baselitz, in an assembly which disclosed unexpected par-allels and contrasts between three contemporary approaches to the figure.

A comparable strategy, devised by Rudi Fuchs for *documenta 7* in Kassel in 1982, was subsequently introduced to the museum at Castello di Rivoli outside Turin in 1984, and more recently in a series of so-called 'Couplet' exhibitions at the Stedelijk Museum in Amsterdam. According to the Fuchs principle, works by a single artist are dispersed to different parts of the exhibition or museum. Works by Baselitz, for instance, might be seen initially alongside Beuys, then alongside Chamberlain. On each encounter another aspect of the work is emphasized. At best this broadens and complicates the spectator's understanding of the work, though for some viewers these juxtapositions can sometimes appear perverse or obscure.

I have been suggesting that a willingness to engage in personal interpretation, to risk offence by unexpected confrontation, can yield rewards. Nowhere is this curatorial courage more evident than at the new Museum für Moderne Kunst in Frankfurt. From unpromising beginnings, Jean-Christophe Ammann has created

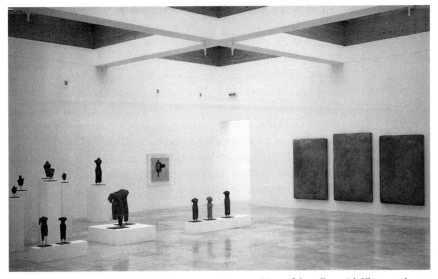

xxxi) View of the Insel Hombroich Gallery, Neuss, Germany. View of the gallery with Khmer sculptures
and paintings by Gotthard Graubner.

a dynamic and often challenging view of the art of the 1960s and 1990s. The build-
ing by Hans Hollein occupies a wedge-shaped plot and was completed in 1991.
Hollein resolved some of the awkward geometries of the site by grouping his
galleries on three floors around the high central room. This gives a point of
orientation and allows the architect to play with staircases and levels. But it
remains a difficult building in which to install art. Ammann has responded with
wit, inviting artists to occupy spaces designated as service spaces. Fischli and
Weiss, for instance, have installed a work under the stairs, and a work by Boltan-
ski is shown in what was to have been a store cupboard. Ammann works, as he
says, 'from the perspective of my mind's eye' and has sought to bring appropriate
works into rooms with a particular character, as in a triangular room containing a
sculpture by Katharina Fritsch. But he has not shied away from interpretation,
grouping works and artists which seem to connect with one another in what he
terms 'climatic zones', a process comparable with the zones of influence which I
have identified at Schaffhausen. In contrast to most other museum curators
Ammann does not arrange temporary loan exhibitions. Certain installations and
rooms in the museum are permanent. Others change on a periodic basis as works
are added to the collection, creating new confrontations and echoes.

One final example may serve as a cautionary reminder that stasis also remains
a valuable component of the museum. Permanent installation offers an encounter
with a particular work of art within a given space where change is brought about
not by new juxtapositions but by the changing natural light at different times of
the day and by the changing perspective of the viewer. This was the ideal that
drove Donald Judd to create a new form of museum at Marfa, Texas in the late

1970s. Judd was critical of the way in which museums display contemporary art in anthologies of short duration. At Marfa he took a range of disused military buildings and with removals of sparing economy and finely judged additions designed by himself, he created space in which to show his own work extensively and the work of others in selected installations. As installations they are exemplary; as an experience of the work they afford a deep and measured view. And from this example lessons have been learned with regard for the need in museums for places of prolonged concentration and contemplation.

However, we have seen how 'experience' can become a formula. The best museums of the future will, like Schaffhausen, Insel Hombroich and Frankfurt, seek to promote different modes and levels of 'interpretation' by subtle juxtapositions of 'experience'. Some rooms and works will be fixed, the pole star around which others will turn. In this way we can expect to create a matrix of changing relationships to be explored by visitors according to their particular interests and sensibilities. In the new museum, each of us, curators and visitors alike, will have to become more willing to chart our own path, redrawing the map of modern art, rather than following a single path laid down by a curator. We have come a long way from Eastlake's chronological hang by school,[2] but the educational and aesthetic purpose is no less significant. One-artist displays have a part to play, especially in presenting site-specific work and in facilitating concentration, but in my view we still need a curator to stimulate readings of the collection and to establish those 'climatic zones' which can enrich our appreciation and understanding of the art of this century. Our aim must be to generate a condition in which visitors can experience a sense of discovery in looking at particular paintings, sculptures or installations in a particular room at a particular moment, rather than find themselves standing on the conveyor belt of history.

NOTES

1 Joseph Beuys (1921–86) was a German artist who became prominent for his symbolic events and objects that were often made with felt, fat, and other unconventional materials. Earlier in the lecture, Serota singles out the Beuys Block, seven rooms installed by Beuys himself, in the Hessiches Landesmuseum in Darmstadt as exemplary of the single-artist space. [EB]
2 Sir Charles Eastlake (1795–1865), was appointed first director of the National Gallery in 1855. Eastlake made important innovations in the display of museum collections, adopting a policy of chronological hanging by school. [EB]

ii) Three Extracts on The Musée d'Orsay from *Le Débat* (1987)

The Musée d'Orsay in Paris, which houses Impressionist and other nineteenth-century works of art in a converted railway station from the period, excited immense controversy when it opened in December 1986. In this light of this, the French journal *Le Débat* invited several of the principal figures involved in the institution's creation, as well as various other art historians and writers, to present their views of the museum. The extracts published here are taken from interviews

with Michel Laclotte, the leader of the curatorial team who went on to become the director of the Louvre (extract a), and Françoise Cachin, another curator involved who went on to become the first director of Orsay (extract c). Also published here is an extract from an article by Madeleine Rebérioux, a social historian who was appointed vice-president of the official body in charge of the Orsay project in 1981 (extract b). Whereas the two curators are primarily concerned to reject the accusation that the museum is not sufficiently concerned with aesthetic quality, Rebérioux deplores the failure to adopt a systematically historical approach that, she argues, is necessary to make the museum accessible to a working-class audience. The extracts were translated for this volume by Emma Barker. [EB]

Source: *Le Débat*, no. 44, March-May 1987: a) 'The Orsay Project': Interview with Michel Laclotte, pp. 4–19. b) Madeleine Rebérioux: 'History in the Museum', pp. 48–54. c) 'Orsay as we see it': Françoise Cachin interviewed by Krysztof Pomian, pp. 55–74

a) 'The Orsay Project': interview with Michel Laclotte

[. . .]

Interviewer: This brings us precisely to the point that has aroused the most lively reactions, that is, the disinterrment of another style of painting besides the great works of the Impressionists to which we are accustomed.

ML: I must admit that I was a little surprised by the violence of the reactions that were expressed. It seems to me that those who reacted in this way were affected by a kind of blindness. Had they really looked at the paintings that they lumped together disdainfully as 'Pompiers'?[1] There are in fact relatively few pictures that answer to this appellation. What we have tried to do is to distinguish different tendencies within the mass of so-called Pompier paintings. Fifteen years ago, for example, Puvis de Chavannes and Gustave Moreau were placed among the Pompiers, whereas it is clear that both artists are independents, and have nothing to do with academic art. The association was absurd.

[. . .] and finally there are the allegorical, mythological or simply erotic scenes with naked women. Here, we reach Pompier painting properly speaking, of which we show very few examples. The only obvious ones are the *Birth of Venus* by Cabanel and the one by Bouguereau and *Truth* by Jules Lefebvre. It is here we can talk of Pompierism and of reactionary academicism. The other ['official'] paintings at least have the historical merit of presenting forceful images. It is an obvious function of painting and it is one of the answers that I would make to our detractors: this painting imposes forceful images which remain in the memory.

Interviewer: So you systematically excluded the real Pompiers?

ML: Yes, and also out of concern for quality: no little pastrycooks or highly-finished harems! To take one example, we had a picture by Rochegrosse, a very competent painting from the end of the century, representing Parsifal – the knight amidst the flower girls. There was however a moment when it was hung on

the walls and I personally thought that it should be left there but it provoked such an outburst of giggles that it went back to the storerooms. I tell you this to show that we were determined to avoid all pictorial vulgarity.

Interviewer: So you would reject the accusation made by some people to the effect that you have confused matters by creating a museum of great paintings that is also a historical museum?

ML: [. . .] But I do hope that the hang makes our critical perspective apparent. The fact of having placed Cézanne, Gauguin or Monet in a good light and with much more space clearly indicates our hierarchy. The question faced us because certain museums, such as the Metropolitan Museum in New York, are willing to display the different artistic currents, the Impressionists and the others, in the same rooms or in rooms very close together. At least that was what the Metropolitan did three or four years ago [actually in 1981] when the so-called André Mayer galleries were opened. They subsequently made modifications, showing that they were aware of the problems. We were determined to avoid such confusion. Let us take an obvious example. In one of the six non-Impressionist rooms, we have hung a Puvis de Chavannes, a Redon, a Burne-Jones, a Gustave Moreau and a Böcklin; it is otherwise empty, whereas the others are very crowded. Those artists who are in some sense the followers of these great masters are shown together in the next room in a much denser hang. The aesthetic hierarchy is thus not denied but inscribed in the space of the museum.

Interviewer: The striking characteristics of the Musée d'Orsay also of course include the architecture of Gae Aulenti about which a great deal has been written. Perhaps we could start by clarifying things: in what circumstances did you have recourse to her?

ML: [. . .] We could see from the competition that her ideas exactly corresponded with ours, especially as regards the architectural distinction that needed to be made between the original architecture of Laloux and the new structures. We have always thought that such a huge building needed a substantial architecture, not one as delicate as a spider's web or as clinical as Bauhaus architecture. Besides there has been a general evolution of museum architecture in this direction. We have all had pretty much enough of those vast open spaces with partitions installed in them. The idea of having new restrictions with fixed rooms, doorways and passages instead of infinitely flexible spaces corresponded to what we wanted.

The architecture of ACT and Gae Aulenti is in effect an architecture that makes itself seen. This new architecture also involves, indirectly, a certain return to the nineteenth century. In the nineteenth century, museum architecture played a very important role. The staircase at the Kunshistorisches Museum at Vienna, for example, is grand architecture. So is the staircase with the Winged Victory of Samothrace at the Louvre. It seems to me that there is a return to this kind of architecture [. . .]. It is true that it sometimes takes a somewhat postmodern form, with all that means in terms of artifice and pastiche, but this is not at all the case with Gae Aulenti's architecture. I totally reject the accusation that it evokes ancient Egypt. [. . .]

b) Madeleine Rebérioux: 'History in the Museum'

[. . .] For the most part, however, [history] remains outside its museology. For some, this is an irritation; for others, a relief. I admit that I am annoyed by the containment of history on the margins of the museum – in the reception area or the 'passage of dates' and the view of history that this seems to imply. [. . .] Won't this history on the sidelines tend to be viewed as a convenient way of outlining a context without any real purchase on the works of art, with no serious relationship with them? Distanced from the pictures, photographs and objects, the information presented here loses whatever power it has to strike the visitor. It is by no means certain that this benefits the works of art. [. . .]

The museum aims first and foremost to offer aesthetic pleasure to its visitors. Its objective is simply to delight them, to provide a few moments of contemplation and happiness, as a respite from their busy lives. Great works of art are made to sing in a purified space; those that are defined as art by 'nature' – painting, for example – and on account of their market value are given a central place in the museum display; space is also allocated to those – such as furniture and architectural drawings – that are not usually placed in this category, whilst maintaining a strict separation of the different art forms; in all of this, the curator is true to his principal mission: he is Merlin the enchanter. Underlying this strategy is the conviction that masterpieces speak for themselves, that any accompanying discourse would simply weaken their voice. [. . .]

To begin with, is it really the case that works of art all sing the same song and that it is sufficient to display them for everyone to feel pure pleasure? The patterns of museum attendance indicate that this is not so. The amazing increase in the number of visits has not significantly modified the social and cultural recruitment of visitors; recent studies [. . .] have confirmed the conclusions of Pierre Bourdieu: the love of art is unlikely to be felt by those who have not already experienced it. Undoubtedly, the way that the works are displayed, their silent sacralisation, is not the only reason for the social and cultural segregation that characterizes most museums. Winning over new audiences involves systematic contacts: it requires [. . .] links with community organizations, worker's committees. It is less difficult when a museum evokes, through all the forms of aesthetic expression, the sounds and passions of a fabulous epoch [the nineteenth century], one sufficiently close to us for us to feel our links with it, sufficiently removed for us to feel that we are discovering it. In this respect, there is some hope for Orsay, even if the industrial aesthetic is only evoked through the medium of the station. Isn't there some means not only of avoiding misinterpretation but also of providing a foundation for looking, helping all those who might stand in need of it, facilitating questioning and comprehension? In any case, this would surely not only benefit those who, given the absence of a museology that courts history (if not actually wedded to it), tend not to go to museums. How could historical curiosity, the pleasure of understanding, undermine visual pleasure, even for those who already experience it? [. . .]

c) 'Orsay as we see it': Françoise Cachin interviewed by Krzysztof Pomian

[. . .]

KP: Doesn't it seem to you that at a certain moment, around the mid-1970s, a shift of attitude towards the art of the nineteenth century took place in museo-logical circles and also in the circles that decide cultural policy? Wasn't it this evolution of sensibilities that gave rise to the Musée d'Orsay? [. . .]

FC: You know, it wasn't a new theoretical vision of the nineteenth century that engendered the museum but, once again, a fortunate chance which permitted us to display in one space works that were scattered in different places, and to show them in chronological order in a wider context. [. . .] We wanted to create a serene museum, one that did not take sides but stood for quality and invention in art, in strong images as well as new forms. So we attempted in all honesty to look afresh at the collections of the old Luxembourg museum.[2] There were debates between us as to what we should or should not take out of the storerooms but none about essentials since, we mustn't deceive ourselves, the best works in the museum are evidently still the contents of the old Jeu de Paume museum and the Louvre. Although we hoped that the storerooms would yield up discoveries, they mostly confirmed us in the view that they contained bad painting. That – the real 'Pom-pier' painting – stayed in the storerooms. [. . .]

KP: One of the innovations of the Orsay project has been to try to place the museum in history and art in its context. This has provoked both surprise and per-plexity. In practice, how far do you think you can go in this direction?

FC: You know, people have said a great many things that have little to do with the reality of our project. In practice, we wanted a museum with an interdiscipli-nary, 'open' character. But firstly it had to be a museum in the traditional sense, one that displays works of art, with the possibility of opening onto the cultural dimension as an extra element. The solution that we finally adopted was estab-lished by 1979: free entry dossier-exhibitions in the main body of the museum, which would be thematic but rooted in the artistic content of the museum. If we want to deal with literature, for example, we will deal with Zola, but as an art critic; the Goncourts, but in their role as collectors. The visual must always take precedence over the document or the usually dreary didactic panel. [. . .] Orsay does not claim to be either the reconstruction of a period or a didactic museum. For example, we display furniture less for what it teaches of the nineteenth-century way of life than for the aesthetic genius that it expresses.

KP: You benefited for a time from the assistance of a historian, Madeleine Rebérioux, whose intervention seemed to symbolize this aim of giving a greater role to context. What were the results of this relatively unusual collaboration?

FC: In effect, Madeleine Rebérioux [. . .] tried – without success – to modify our programme. She wanted us to show the sociological context of each work of art, and to make space for popular art alongside 'bourgeois' art, etc. In the end, the result of her involvement was positive but limited to the display cases on the history of France on the lower level, to the 'passage of dates' where information about the history of the nineteenth century is delivered by various audio-visual

methods, and to the section on the press. Let us say that this constitutes a useful supplement of information about the period with which were are dealing but that nothing more could be done. It just isn't possible to reconstruct an entire period. For the same reason, we have excluded from our displays those evocations of the past that Anglo-Saxons call *period rooms*. The power of the works speaks for itself and history, in an art museum, is art history.

KP: So we arrive quite naturally at the decisions that underlay the display of the works. What, in retrospect, seem to you to have been the crucial decisions in this area?

FC: [. . .] For the general display, we were guided by two main principles. Firstly, we wanted to keep it chronological, presenting the works in sequence. [. . .] Our second principle was to refuse any mixing, whether of different techniques – painting, sculpture, decorative arts – or of styles and genres. If there are to be confrontations, they must be made in the mind of the visitor, after the event, on reflexion. Take *The Romans of the Decadence* by Thomas Couture, which has a very prominent place, at the transept crossing, but in the central 'street', creating a decorative effect along with Gae Aulenti's architectural setting and the sculptures that people the 'street'. However, it doesn't have a room to itself as Courbet's work does. We did not intend to juxtapose or even to oppose Courbet and Couture. For us, there is an immense difference between them and we did not wish to accord equal treatment to the masterpieces of Courbet and the theatrical and superficial work of Manet's teacher. In short, for us, there can be no comparison between Cézanne and Bouguereau, and there was no question of introducing any equivocation in this hierarchy of values. . . .

KP: So you haven't created a radically revisionist museum. . . .

FC: If the public derived the impression that they were in the presence of a revisionist museum, we would feel we had failed [. . .]

NOTES

1 'Pompier' is a traditional term of disdain for nineteenth-century French academic painting. It supposedly derives from the helmets in classical subject paintings, which are said to resemble those of firemen ('Pompiers'). [EB]

2 In the nineteenth century, the Luxembourg Museum in Paris housed works by living artists. It was eventually closed in 1937 once most of the paintings in the collection had fallen from critical favour. It was effectively replaced by the Jeu de Paume museum, opened 1947, which housed canonical work of the period (i.e. Impressionism). [EB]

iii) From 'Personality of the Year: Neil MacGregor, Director, the National Gallery' (1996)

Neil MacGregor was appointed director of the National Gallery, London in 1986; previous to this he was the editor of the *Burlington Magazine*. In 1996, as recognition of his achievements at the National Gallery, the arts magazine *Apollo* designated MacGregor as its 'Personality of the Year'. Since his appointment the National Gallery has undergone many changes, with the opening of the

Sainsbury wing in 1991, the redecoration of the main building, the acquisition of important paintings and the expansion of access. MacGregor has also become one of the strongest advocates for maintaining the historic British principle of free access to museums. In the interview with Paul Josefowitz printed here, he discusses the gallery's aims and activities and considers some of the broader changes affecting art museums in the late twentieth century. (Notes omitted.) [EB]

Source: 'Personality of the Year: Neil MacGregor, Director, the National Gallery' (an interview between Neil MacGregor and Paul Josefowitz), *Apollo*, December, 1996, pp. 23–32

PJ You have been Director of the National Gallery now for almost ten years. What do you think are your two greatest achievements since coming here?

NM One of the two greatest things to have happened – I would rather distinguish what has happened in the Gallery from my achievements – has been the opening of the Sainsbury Wing. It really would be ridiculous to think of it as my achievement, but it's clearly one of the great things that have happened in the last ten years. The second thing has been, I think, the expansion of the access to the collection through education, through touring pictures, through television, through the micro-gallery, whatever. I think it's now much easier for people to enjoy the collection, find out about the collection. These seem to me to be the two most important things.

PJ If you take the next five years, is there a single major objective that you would like to accomplish?

NM The big hope for the next five years is to extend the meaning of access to the collection. That means, first of all, I hope we are able to preserve free admission for the next five years, which is absolutely essential to the relationship between the public and the pictures in the National Gallery. And, secondly, to extend to a quite new level the idea of electronic access to the collection. We are working on the scheme of putting a whole visit to the gallery onto the Internet. I think that's the logical extension of the position of free admission and I think one of the really exciting prospects of the next five years is what electronic media allow us to do in developing what is essentially an eighteenth-century ideal, that everybody should be able to enjoy these great things.

PJ How do you think that will affect attendance?

NM I think it will increase it. All the evidence suggests that, when you publish, more people come. But they'll come with more discernment, they'll come with a clearer idea of what they want to look at. So I think we'll have a larger number of better informed, more focused, visitors.

[. . .]

PJ Is there a particular acquisition that you are most proud of, either because of what it is or how difficult it was to acquire, or because during your youth you were particularly intrigued by it, or whatever?

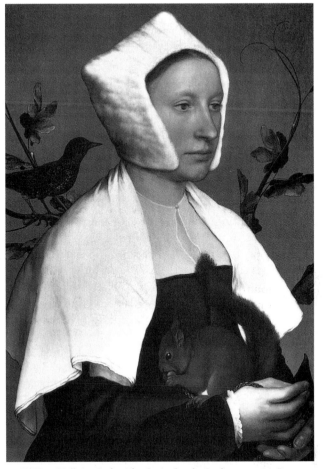

xxxii) Hans Holbein, *Lady with a Squirrel and a Starling, c.* 1526-8. Repro-
duced by courtesy of The Trustees, The National Gallery, London.

NM I think, if it were a single acquisition, it would have to be the Cranach
double portraits. You can never really have a policy on acquisitions, you've got to
respond to what's available and I felt very strongly that the German School in the
National Gallery was under represented – it was hard really to get an impression
of the level of quality of German renaissance painting. Normally that part of the
collection could have been strengthened only by pictures coming out of collec-
tions in this country, like the Holbein *Lady with a Squirrel and a Starling* [plate
xxxii] a great picture but, in a sense, it was already here and it was a picture we
were always likely to be able to have a go at. The Cranach double portraits came,
of course, from a Swiss collection. They are portraits of the highest level and I
think it was a marvellous thing to be able to buy abroad.

[. . .] because there is always a danger that the National Gallery will be seen as having its first obligation to defend, to keep pictures in this country rather than to build the best possible collection where people can see the finest works of art. [. . .]

PJ Do you think it's easier to get funding for something which has a resonance in terms of national heritage?

NM Of course. It's clearly much much easier for the Heritage Lottery Fund or the National Heritage Memorial Fund to support works of art that really have a connection with the country, something like the Holbein *Lady with a squirrel and a starling*.
[. . .]

PJ Do you get offered stacks of paintings every week?

NM We get lots of paintings offered. We do, of course, buy masterpieces as the predominant obligation, but in the greater debate, the other picture I think I was most pleased about acquiring [. . .] is the little Thomas Jones *Wall in Naples*, which of course is right at the other end of the scale in terms of expense, and a very small picture, but absolutely supreme of its kind, I think that sort of buying for the National Gallery is very difficult because, in a collection where the overall standard is uniquely high, to add works by lesser artists that can stand that competition is challenging and interesting. The Jones I think does that triumphantly. I also feel the same about the little Gaertner *The Friedrichsgracht, Berlin*. Those are the most difficult kind of pictures to buy in a strange way. There's no dispute about *The Lady with a Squirrel and a Starling* – everybody can see that's a great picture and that that's the one to go for. It's much harder with pictures like the Gaertner or the Jones.
[. . .]

PJ On another note, there have been a lot of directorships opening, in the United States in particular, and a lot of people who would normally have wanted these jobs no longer want them. There seem to be too many problems with trustees, too much fund-raising involved. What do you think is going to happen to the 'métier' of museum director in that art people generally are not attracted to a lot of these tasks?

NM I think first of all there's a big difference between Europe and America, and the key difference is that all great European collections still have at the centre a predominance of public funding. That funding seems to be essential: these collections can only properly be run if it is acknowledged it is something that the country is going to do as a political decision. That makes running a European museum a much more interesting enterprise, because what you're raising the funds for is in a sense the extra things: it's making the building better, the extra acquisitions, the new projects. Very few European museum directors have to raise money for running costs, which is the most exhausting thing. [. . .]

PJ Many people have found it's getting harder and harder to get sponsorship for

travelling exhibitions or temporary exhibitions. If that is the case, what is going to happen to this gigantic exhibition industry with more and more museums wanting to do exhibitions, including yourselves. What happens when it dries up?

NM I'm not sure it will. We have certainly not found this to date. We still find it is possible to find sponsorship, even with quite difficult exhibitions and I really would question the premise that you based that on. With an exhibition like 'Spanish Still Life' which was academically fairly pioneering – certainly in terms of public taste it was new, and in every way a risky exhibition – we found the sponsors, Glaxo, were very willing to sponsor it and to sponsor it fully, and we have found this consistently, that the sponsors are willing to go on doing it if they think they're interesting projects.

PJ But do you generally lose money on a temporary exhibition?

NM Sometimes we don't charge admission fees at all. Esso, for example, which sponsors our *Making and Meaning* exhibitions, don't charge and the sponsors cover the costs. So it's not really an economic venture at all, and we were perhaps fortunate in being able to keep our exhibition programme tied very closely into our education programme.

PJ For instance, does 'Degas: Beyond Impressionism' make money or lose money?

NM Oh yes, it makes money. I think the danger is that there is a kind of exhibition which will earn a lot of money not just in terms of the ticket receipts but of course from the extra sales in the shops and restaurants. It's clear that you can, particularly on the product end, make a lot of money on certain kinds of exhibitions and therefore if you have to raise your running costs, the pressure to produce that kind of exhibition grows. The real worry about exhibitions is not whether the sponsor will go on supporting a blockbuster. It's really whether the economic pressures on museums will be so great that they will only be able to consider putting on exhibitions which will generate a great deal of peripheral profit, and that would be very sad indeed. We were lucky, because we are government funded for our running costs, that we could take the risk of 'Spanish Still Life' but the worry is that, if museums are not in a position to take that risk, they really have to take decisions on exhibitions that are commercial rather than academic.

PJ Do you think the public will ever tire of Impressionism? I mean, in 100 years do you think Impressionism, which seems now with Picasso (and maybe Matisse) to rule the roost, can you conceive that taste would shift, popular taste that is?

NM It is certainly conceivable. The analogy would be with the complete collapse of popular and informed enjoyment of Bolognese painting in the middle of the last century after Ruskin's attack, and it clearly is possible through a certain kind of critical campaign rather like that mounted against Victorian narrative painting later on. Enormously popular kinds of art do suddenly lose their appeal and it would be surprising if one kind of painting went on holding the supreme position for ever. [. . .] While Impressionism may remain very popular, I think public demand is actually very elastic. One is by no means tied to a particular kind of exhibition –

'Spanish Still Life' made that very clear. There is a very large appetite for new things, if the right new things are presented.

[. . .]

PJ What are the other points that you think made London a uniquely favourable environment for art?

NM The devolved autonomy of the trustee museums. The trustee tradition, which is a long-standing one, has meant that the individual museums are free really to pursue the policies that best suit their collections and their publics. That was put together with the control of the buildings, which came to the trustees in the late 1980s, together with the change in government-funding arrangements: previously we used to be funded directly by Parliamentary vote; we are now grant aided. That's a technical thing but it matters because, until it was changed in the late 1980s, any money that museums earned they had to hand back to the Treasury, so it was hardly surprising museums were not entrepreneurial. Once that was changed so that museums could actually organize their own affairs and benefit from organizing them well, it meant that all the great collections in London were free to pursue their own policies, to renew their buildings, to increase their income, to extend their collections and to build their educational activities with no central control and with a diversity that is noticeably absent in any other European country. I think that's why the level of public engagement in museums in Britain, in permanent collections above all, has gone on growing whereas in most other countries the engagement with the permanent collections has receded and the exhibition has taken over.

[. . .]

PJ How many loan requests do you get a year, would you say?

NM It's difficult to quantify. I suppose we get somewhere around 100–150 loan requests a year. We approach them rather differently, depending whether they're from the United Kingdom or from abroad. Clearly the first thing is, is the picture fit to travel? And, if it can't travel, that's the end of it. But the trustees have always taken the view that pictures should really be subjected to the risk of travel abroad only if there is going to be some kind of gain in knowledge so, when we consider exhibitions abroad, it's the academic scope of the exhibition, how far the picture will be viewed differently as a result of the exhibition, which is the key issue.

[. . .]

PJ Do you think today pictures can compete with great movies in exploring those [human] issues?

NM Yes, I do, without any question. I think the more easily because they are still images and still images are now very rare. We have all become so used to scanning images that move that the idea of engaging for ten or fifteen minutes with a single image has, I think, recovered a specialness that gives it new power. This is why it is important that all our education activities, our lecturing activities, are really about giving people the confidence to stop in front of one picture for long

enough for the picture to speak. And it seems to me that, if you take a great picture like the Titian *Bacchus and Ariadne* [plate xxxiii] as an investigation of human love, disappointment, hope, frivolity, seriousness, that can compete with any of the great movies.[. . .]

PJ But don't you think you need more knowledge about the picture to appreciate it, whereas with a movie it's an immediate easy access?

NM I don't think you need more knowledge. What I think you need is time to let the picture give its own account. It is very interesting if you watch our schools programmes here that, if you ask children to look at a picture and tell you what is going on, they might not know the specific story but it is almost always possible for them to work out what is going on in the picture. It doesn't matter if you know the names of the people, what is happening is effectively clear on being investigated, and that is why they're so powerful. I don't think it is knowledge that is required, it is two quite different things: firstly time; and secondly the willingness to bring to the picture your own experience.

PJ Many people in the press and privately have expressed their concern that the National Lottery Fund should be applied towards sporting facilities in less privileged areas, creating educational or vocational opportunities for disadvantaged people in Britain or even doing medical research. I thought you might want to take this opportunity to express why you think a portion of Lottery funds should go towards the arts and why they are of national importance to this country.

NM The whole history of the National Gallery is that it was set up because it was believed that people need aesthetic refreshment, that the contact with really great works of art gives a kind of pleasure that changes people's lives. That's why it was set up, that's why it was set up free, and particularly why it was set up in the middle of London so that the poor could get to it. I think that's absolutely true today as it was in 1824. If you look at the number of people who come to look at, let's say, the Impressionist pictures in the National Gallery, and the sort of pleasure they give to millions of people, I think it is perfectly proper that Lottery money should be spent. What is unique, I think, about the money spent on buying pictures is that the pleasure it provides goes on year after year after year. [. . .] I can see no other form of public expenditure that actually has such a long life of public benefit.

PJ Are there any studies as to the social demographic aspects of attendance here?

NM Not very many. We are just beginning to do it, but it's quite a complicated thing. What we do know about the National Gallery, which is unique among European collections, is that most of our visitors are actually British nationals and we have a very high proportion of people who visit about once a month. What is very pleasing, and entirely a result of free admission, is that a lot of people use the gallery for ten minutes or quarter of an hour on their way to the station, on the way home, at lunch time. They use great pictures as part of everyday life. That seems to me now more important than ever. [. . .]

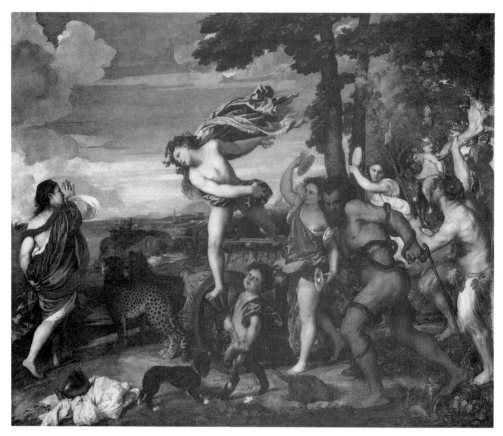

xxxiii) Titian, *Bacchus and Ariadne*, 1522-3. Reproduced by courtesy of The Trustees, The National Gallery, London.

PJ With the elections coming up I thought it would be interesting to know, if you were Prime Minister and wanted to ensure for the country the proper legislation regarding the arts, besides throwing money at the various museums, is there a particular policy or attitude that you would take?

NM I would want to make it quite clear that these public collections are the property of the entire nation and that they are the most extraordinary inheritance. If national heritage means anything it is the inheritance of these collections that we own, which are the finest collections in the world, and to make that public ownership a real thing seems to me to involve a number of policies. Firstly, it needs free admission. People must be able to use these collections as though they were their own, as they *are* their own, just as they use public libraries. It also means making it as easy as possible for the national collections to lend their works outside London. We for instance, have a programme of lending masterpieces around the country, and that's a programme that we have to find the funding for. Most

galleries outside London can't afford the costs of borrowing and displaying great works of art and that seems to me to be something that the government ought to think about helping and encouraging. And, again, the new technology can allow public ownership to become something quite different. We discovered through our compact disc of the Micro Gallery that, if people can plan a visit before they come, explore the collection before they arrive, they can use the visit in a quite different way. When we talk about access to the arts, what that means above all is free unimpeded enjoyment of, and familiarity with, the collections we have inherited. Old Master paintings are now the most valuable moveable objects which our society recognizes, and there is something of enormous symbolic importance in those being available on equal terms, free, to every member of society. That seems to me to be very important. And it was, of course, the intent and the aim articulated when the National Gallery was set up that, as well as allowing people access to great pictures, Prime Minister Robert Peel said that the purpose of the Gallery was to cement the bonds of union between the richer and poorer orders of the state. I think the power of museums and other collections to promote social cohesion is as great as it ever was. It is something that ought to be identified by politicians and something they should encourage. I'll get off my soapbox now!

iv) David Batchelor, 'Unpopular Culture' (1995)

David Batchelor is an artist and critic who has published widely on aspects of modern and contemporary art. His recent work includes an exhibition of sculpture at the Henry Moore Institute, Leeds (1997) and a book entitled *Minimalism*, published by the Tate Gallery, London in 1997. Batchelor is a Senior Tutor in Critical Studies at the Royal College of Art. In this essay, published in the contemporary art magazine *Frieze*, he questions the assumptions that underpin the Tate Gallery's annual Turner Prize. The Turner Prize, like its literary equivalent the Booker Prize, is a showpiece event that, through its structures of shortlist, jury, and substantial monetary award, is designed to be media friendly. By focusing the media spotlight on the work of a number of artists, the Turner Prize aims to popularise recent art. In its own terms this event is spectacularly successful, with attendance at the Tate Gallery soaring during the short period each year when the nominees' works are on display. Batchelor questions who really benefits from this media jamboree and rejects the idea that contemporary art should necessarily appeal to a wide and popular audience. He argues, in opposition to this populist agenda, that modern art is a specialist practice, and that like mathematics or mechanics it cannot be understood without a sustained effort of study and critical attention. [SE]

Source: David Batchelor, 'Unpopular Culture'. *Frieze*, January–February, 1995, p. 5

The Turner Prize signals that point in the year when the general public is reminded of the existence of contemporary art. Initiated by the Tate Gallery,

brokered by Channel Four Television and monitored by the national press, it works as a kind of blind date between recent art and a wider audience, producing the usual array of mismatches, gaffes, bad jokes and awkward silences typical of such encounters. But however embarassing it may turn out to be in practice, the principal is generally held to be a good thing. While the particular structure, timing, organisation, and coverage of the prize is constantly criticised, revised, re-examined, re-interpreted and re-presented, the founding idea – that it is virtuous to bring current art to the attention of more people – is rarely questioned.

But what exactly is the value of popularising or trying to popularise – contemporary art? What, or rather who, benefits from this ritual? The artists? The public (whoever they are)? The Tate? The press? Obviously the last two stand to gain something in terms of visitors or readers and one artist gets a decent cheque out of it, but that really isn't the point. Such quantifying exercises may mean something to administrators but they say nothing at all about art and people's relationship with it. Why is the prospect of more people going to art galleries assumed to be, in itself, a positive development? Why and how is it better for art to be, or to be seen to be, popular?

Modern art of the last 150 or so years generally has not generally been very popular; moreover, it is a commonplace that modern art has in part defined itself in opposition to conventional taste. Certainly artists have exploited popular sources in a number of ways – from Courbet and Seurat to Warhol and Koons – but this has had little to do with courting popularity. It isn't necessarily that artists have consciously set out to defy 'the public' so much that this largely imaginary body has been irrelevent to the development of art. The point is that art has been subject to exactly the same forces that affect every other meaningful activity in modern culture: the forces of specialisation. It always strikes me as an odd complaint that modern art is difficult to understand. Why should anyone expect it to be anything else? I have never heard the same charge levelled against science, mathematics, mechanics or dentistry. It is accepted (if not welcomed) that these subjects are 'difficult'; that in order to understand them it is necessary to read some books, go to some lectures, learn the language, and so on. When art is 'difficult', abstract, not-immediately-accessible, it is labelled 'elitist'.

It is probably a condition of saying or making anything significant in our culture that it will be said to or made for relatively few people. General truths are for the most part empty words. Leger wrote in 1913: 'Each art is isolating itself and limiting itself to its own field. Specialisation is a characteristic of modern life, and pictorial art, like all other manifestations of the human mind, must submit to it.' Pure modernism. But the point for Leger was that this condition 'results in a gain in *realism* in visual art'. That is, for Leger, modernism *was* the realism of the 20th century, not its imaginary other. 80 years after Leger's observation, there hasn't been a noticeable easing off in the process of specialistion. Yet still there's a deep resistance to art's inevitable position in the modern world.

Not only the art becomes an increasingly specialised activity, it has also subdivided into a series of sub-specialisms. Art criticism, at least in the 'specialist' journals, has become increasingly bound up with its own methods and means and

increasingly autonomous from art. The same is true of art history which in some instances seems to have abolished the connection with art altogether. It is telling and ironic that at least as many – and probably most – complaints about the 'elitism' of modernism come from these sub-specialist areas as from outside art. It is not the first time art has become a scapegoat for other's professional, social or political insufficiencies.

The psychological condition which tends to accompany specialisation is paranoia. As we become more and more dependent on 'experts' to mediate between the specialist and the non-specialist, we have to take a lot on trust, and trust involves the possibility of being taken for a ride. Art, it seems, has become a focus for the paranoid anxiety which is inherent in our relationship with modernity in general. This being the case, any self-appointed mediator between art and the public – the Tate Gallery or Channel Four for example – has their work cut out. The danger of doing exactly the opposite of what was intended, of intensifying rather than dissolving public doubt and cynicism, will always be present. Add to this the recognition both that a significant amount of art and art-talk really is pretentious and self-satisfied, and that a rather more significant proportion of the media act wholly in bad faith – and then ask whether it's worth the trouble. Certainly if the trouble amounts to a small annual four-person exhibition and a couple of short TV features, then no one should be surprised when absolutely nothing noticeable changes.

The point is not that 'the public' doesn't matter, but that it doesn't exist. Like the-silent-majority, people-in-general, and the-man-in-the-street, it is a self-justifying fantasy of politicians, civil servants, administrators and journalists. It is a mythical creature with invisible interests on whose behalf people claim to speak, so as to disguise the self-interest of their own actions. It's one of the great self-deceptions of our age. Artists have a responsibility to art, not to anything or anyone else. So much for bringing contemporary art closer to 'the public'. It's a blind date with a ghost.

v) Two Responses to the Royal Academy's 'Africa' Exhibition (1995)

The exhibition 'Africa: The Art of a Continent' was staged at the Royal Academy in London from October 1995 to January 1996. It was selected by Tom Phillips, one of the artist members of the Academy, and included an immense range of objects, varying in date from prehistoric times to the recent past, but excluded contemporary African artists. At the same time, however, 'Seven Stories: about Modern Art in Africa' (Whitechapel Art Gallery) and several other exhibitions were also staged in London as part of the 'africa95' season, which was conceived as a direct riposte to the Royal Academy show. Both of the authors of the texts included hare are academics of African origin. The first of the two articles extracted here is by Kobena Mercer, an independent cultural critic; it has been selected to represent the concerns expressed about the Royal Academy exhibition by many commentators at the time. By contrast, the second extract is taken

from a reworking of an article originally written for the catalogue that accompanied the Royal Academy show by Kwame Anthony Appiah, Professor of African-American Studies at Harvard University; Appiah also refers to a version of the exhibition that was shown at the Guggenheim Museum in New York in 1996. The quotation from Appiah used by Mercer is from an earlier section of the article, not included in this extract. (Notes to Kwame Anthony Appiah omitted.) [EB]

Source: a) Kobena Mercer, 'Art of Africa', *Artists Newsletter*, December, 1995, pp. 28–30. b) Kwame Anthony Appiah, 'The Arts of Africa', *New York Review of Books*, 24 April, 1997, pp. 46–51.

a) Kobena Mercer, 'Art of Africa' (1995)

Anchored around the Royal Academy's blockbuster show, 'Africa – The Art of a Continent', the exhibitions hosted by numerous galleries and museums, from 'Big City' at the Serpentine, London, to 'Seven Stories about Modern Art in Africa', at the Whitechapel, London, have provided British audiences with a rare and valuable opportunity to engage with contemporary African art; but what kinds of questions have been brought out for debate? The sheer range of styles and idiom highlight Africa's internal cultural diversity, which is often minimised or homogenised by Western preconceptions of what Africa is supposed to be. But in the dichotomy between contemporary work, and the mythical timelessness evoked by the Royal Academy's ethnographic display, there are inevitably political as well as aesthetic questions raised. africa95's far-reaching potential as an artist-led initiative seems uncomfortably overshadowed by the lingering colonial paradigm informing the prestige bestowed on its artistic centrepiece, the Royal Academy show.

I came away from 'Africa – The Art of a Continent' feeling disappointed. Not on account of the 700 items on display, which are each quite overwhelming, but on account of the cautious, timid and ultimately conservative curatorial framework. With the aim of encouraging the appreciation and enjoyment of African art, curator Tom Phillips has undoubtedly been successful. Even though images of African art objects are already familiar, by having an opportunity to engage with artefacts in the flesh, one is brought into the realm of their aura, which elicits aesthetic pleasures that photographs cannot emulate.

The glorious Ife zinc-brass heads, or the delicate Nefertiti torso swathed in sculpted pleats, for example, are much smaller than photographs suggest. The hand-held scale of a miniature Nubian statuette from Eighteenth Dynasty Egypt calls for a tactile response. At the other end of the scale, two towering Kaguru poles from Tanzania, or the awe-inspiring Senufo headdress, edge you into a liminal space between humans and gods by way of their majestic height.

There is also the sensual pleasure of the materials in play – woods, metals, textiles – which speak of art's ability to survive time. The Namibian narrative rock painting dated to 25,000 BC: the Giryama funerary posts encrusted with red earth; the termite eaten Urhobo mother and child; the weathered grain of the Nbembe figures – all of these works inspire a sense of the African sublime, something formed by individual consciousness but going far beyond it. The only appropriate

response is humility. Yet in the midst of their powerful aura, one comes across the arrogance of the decision to display a five-seated Ngome royal stool not horizontally but vertically, such that it is made to resemble Brancusi's *Endless Column*. In my view this gesture encapsulates the core question the show fails to address: that by de-contextualising utilitarian artefacts, detaching them from their original intentions then repositioning them in a museum environment where they [are] appropriated for their aesthetic qualities alone, the complex historical relationship that brought these beautiful African objects into various Western collections is erased, and cancelled out of the conversation.

As Kwame Anthony Appiah remarks: 'we might as well face up to the obvious problem: neither *Africa* not *art* – the two animating principles of this exhibition – played a role as ideas in the creation of the objects in this spectacular show'. Indeed, alongside objects intended for ritual usage – masks and fetishes – or exceptional occasions – the Nyamwesi high-backed chief's stool – it is the integration of an aesthetic dimension into artefacts used in everyday life that makes them all the more remarkable – such as the Dinka headrests or the Igbo and Dogon carved doors. However, although many of the works acknowledge the cultural traffic that results, for instance, in Asante kente cloth woven from silk remnants left by Europeans, the Royal Academy's curatorial premise downplays the dynamic criss-crossing of cultural elements and thus encourages the view of Africa as a static place outside modern history.

When the exhibition brochure suggests that 'the sensory presence of a work of art can transcend historical context and move the viewer, even if it is not fully understood', my own responses force me to agree, even though what disturbs me is the exhibition's refusal to take responsibility for perpetuating a de-historicised view of African aesthetics. Similarly, by framing the multiplicity of objects on display with the notion of an all-embracing African identity, the exhibition effaces the historical character of the idea of 'Africa' itself. This idea originating in the European ideology of 'race' – seeing Africa as the domain of the Negro – which was turned around when people used racial discourse to create a new Pan-African identity.

With the volume of insights generated by contemporary scholars who have unearthed the volatile interconnections between colonialism and modernism, it strikes me that the Royal Academy has lost an opportunity to tell the story of how Europe and Africa are deeply implicated in each other's cultural history. Rather, falling back on the Self/Other polarities of traditional ethnography, the audience is ensconced within an outmoded fantasy of otherness which in no way prepares you for the vibrant hybridity of contemporary African art.
[. . .]

b) Kwame Anthony Appiah, 'The Arts of Africa' (1997)

[. . .] If African art was not made by people who thought of themselves as Africans; if it was not made *as* art; if it reflects, collectively, no unitary African aesthetic vision; can we not still profit from the assemblage of remarkable objects we find in Western collections of African art?

What, after all, does it matter that this pair of concepts – *Africa, art* – was not used by those who made these objects? They are still African: they are still works of art. Maybe what unites them as African is our decision to see them together, as the products of a single continent; maybe it is we, and not their makers, who have chosen to treat these diverse objects as art. But the Guggenheim exhibition was also *our* show – it was constructed for us now in Europe and America. It might be anything from mildly amusing to rigorously instructive to speculate what the creators of the objects celebrated in London and New York would make of our assemblage. (Consider: some of these works had religious meanings for their makers, were conceived of as bearers of invisible powers; some, on the other hand, were in use in everyday life.) But *our* first task, as responsible exhibition-goers, was to decide what *we* would do with these things, how *we* were to think of them.

In presenting these objects as art objects, the curators of the exhibition invited us to look at them in a certain way, to evaluate them in the manner we call 'aesthetic.' This means that we were invited to look at their form, their craftsmanship, the ideas they evoke, to attend to them in the way we have learned to attend in art museums. (It is hard to say more exactly what is involved here – at least in a brief compass – but most adults who go regularly to exhibitions of painting and sculpture will have practiced a certain kind of attention and found it worthwhile; and if they haven't, it is hard to see why they should keep going.) So what's important isn't whether or not they are art or were art for their makers: what matters is that we are invited to treat them as art, and that the curators assure us that engaging our aesthetic attention will be rewarding. (That these assurances were warranted could be seen on the faces of the crowds in London and New York.)

We can also accept that, because the objects were selected as coming from an entire continent, there is no guarantee of what they will share, no certainty about how these objects will respond to each other. Provided you did not expect to discover in these creations a reflection of an underlying African artistic unity, an engagement with the whole exhibition could be more than the sum of the unrelated experiences of each separate object, or each separate group of objects from a common culture. How these individual experiences added up depended of course, as much as anything else, on the viewer, which is as it should be. But there are questions that might have guided a reading of this show and, in closing, I would like to suggest a few of mine.

First, the exhibition decisively established that anyone with half an eye can honor the artistry of Africa, a continent whose creativity has been denigrated by some and sentimentalized by others, but rarely taken seriously. I have been arguing that to take these African artworks seriously does not require us to take them as their makers took them. (If that were so, we should, no doubt, be limited to religious evaluations of Western European art of the High Middle Ages.) And one other way to take them seriously would be to reflect through them on how the enormous temporal and spatial range of human creativity exemplified in the exhibition has been adapted in our culture over the last few centuries to an interpretation of Africa as the home of people incapable of civilization.

What does it teach us about the past of Western culture that it has had such

great difficulty learning to respect many of the artworks in the Guggenheim show because they were African? Many of these objects come from European collections, and were assembled as curiosities or as puzzles or as scientific data: they were undoubtedly appreciated – loved even – by many of the persons who gathered them. But they have rarely lived at the heart of our aesthetic consciousness; and when they have, it has often been with astonishing condescension. Ladislas Szesci told readers of Nancy Cunard's *Negro* (a work published in 1934 in celebration of black creativity):

> The Negroes have been able to create works of art because of their innate purity and primitiveness. They can be as a prism without any intentional preoccupation, and succeed in rendering their vision with certitude and without any imposition of exterior motive.[1]

It is part of the history of *our* culture – something that bears reflection as we travel among these African artifacts – that half a century ago, this was an obvious way of speaking up for African art.

What (more hopefully, perhaps) does it tell us about our cultural present that the shows at the Royal Academy and the Guggenheim brought together, for the first time, so many, so marvelous African artifacts not as ethnographic data, not as mere curiosities, but for the particular form of respectful attention we accord to art? How, in fact, may we interpret the exhibition itself as part of the history of our Western culture: a moment in the complex encounter of Europe and her descendant cultures with Africa and hers? This is a question that everyone who visited this exhibition was equipped to reflect on: all of us can dredge up a common sense that we have picked up about Africa, and we can test that common sense against these uncommon objects.

I saw *Africa: The Art of a Continent* for the first time at the Royal Academy. I flew to London for the weekend and spent a day among the treasures. By a mixture of luck and planning I was able to meet up with an assortment of my kin; and so I began in the morning, going around with my sister (who lives with her Norwegian husband in Namibia), her eldest son, my eldest Nigerian nephew, and an English aunt and cousin. My sister and I have grown up with goldweights[2]: my Nigerian nephew has seen the treasures of Benin often in the national museum in Lagos: my Norwegian-Namibian nephew knows well the artifacts of Southern Africa, including the cave drawings and the ivory *omakipa* from Namibia: but for my English aunt much of the show was entirely unfamiliar [. . .] It is a measure of the show's power that all of us in this disparate group of people, drawn together by my family's all-too-apparent xenophilia, found the exhibition both exhilarating and exasperating.

My sister (with her sense of what was lost to the gallery visitors who did not know, as she did, the place of goldweights and of *omakipa* in the lives of those who made them) felt the labels were too perfunctory. (What is one to do with '*Nkisi nkondo*, Kongo, Zaire, before 1878, wood, cord, iron, cloth'?) My aunt, on the other hand, was entranced by the look of so many unfamiliar things: they engaged her senses, they surprised her . . . and there were too many of them.

I agreed with them both. There *was* too much to see; the labels *were* too cryptic; some of them, I fear, *were*, as we happened to know, plain wrong. But the consensus over lunch was that the show was wonderful; and what made it wonderful was that the eye could linger with pleasure on the forms, the shapes, and the surfaces, the patination and the pigment, and engage each object with whatever we happened to know of its materials, its history, its origin. In short, we found ourselves responding naturally to these African artifacts *as* art; which, when all is said and done, was all that Tom Phillips, the curator, and the Academy had invited us to do.

NOTES

1 Nancy Cunard, editor, *Negro*, abridged with an introduction by Hugh Ford (Frederick Ungar, 1970), p. 431
2 Earlier in the article Appiah discusses the Asante (West African) goldweights, depicting figures, animals, tools, etc., that his mother collected. [EB]

vi) André Malraux, from *Museum without Walls* (1947)

The concept of the 'museum without walls' created by photographic reproduction has gained wide currency since the French novelist André Malraux published *Le Musée Imaginaire* (literal translation: The Imaginary Museum) in 1947. With its mass of illustrations, the book forms part of the phenomenon that it describes, though, for today's reader, the predominant absence of colour serves as a reminder of how far the technology has been improved since the mid-twentieth century. Malraux's central argument is that photography extends the decontextualizing effect of the museum, which allows an object to be appreciated for its formal qualities alone without regard for whatever setting or function that it may once have had. Reproduction further deprives objects of their material qualities, such as texture and scale, and, in so doing, fosters an analytical and comparative approach to every kind of art that undermines traditional hierarchies of aesthetic value. It also involves, as Malraux acknowledges without apology, imposing a distinctively modern Western notion of art on artefacts from many different cultures and periods. One of the principle sources for *Museum without Walls* is Walter Benjamin's influential essay 'The Work of Art in the Age of Mechanical Reproduction' (1936) but, whereas Benjamin predicted that photography would undermine the 'aura' of the unique work of art, Malraux suggests that it will simply have the welcome effect of making that aura, the quasi-magical power of art, more widely accessible than ever before. In this respect, *Museum without Walls* anticipates the policy of democratization pursued by Malraux as France's Minister for Cultural Affairs between 1959 and 1967. Since the later 1960s, however, Malraux's conception of art as the collective inheritance of humanity has been seen as inherently élitist in its failure to register the class-specific nature of its appeal; this critique is exemplified by the work of Pierre Bourdieu (see text vii of this section). In this text Malraux makes reference to many of the most acclaimed works of European and world art. [EB]

Source: André Malraux, *Museum without Walls*, part. 1 of *The Voices of Silence*, trans. Gilbert Stuart, Doubleday and Company, 1953, pp. 16–17, 21–7, 37, 44–6

[. . .]

Nowadays an art student can examine color reproductions of most of the world's great paintings, can make acquaintance with a host of second-rank pictures, archaic arts, Indian, Chinese and Pre-Columbian sculpture of the best periods, Romanesque frescoes, Negro and 'folk' art, a fair quantity of Byzantine art. How many statues could be seen in reproduction in 1850? Whereas the modern art-book has been pre-eminently successful with sculpture (which lends itself better than pictures to reproduction in black-and-white). Hitherto the connoisseur duly visited the Louvre and some subsidiary galleries, and memorized what he saw, as best he could. We, however, have far more great works available to refresh our memories than those which even the greatest of museums could bring together. For a 'Museum without Walls' is coming into being, and (now that the plastic arts have invented their own printing-press) it will carry infinitely farther that revelation of the world of art, limited perforce, which the 'real' museums offer us within their walls. [. . .]

Photography, which started in a humble way as a means of making known acknowledged masterpieces to those who could not buy engravings, seemed destined merely to perpetuate established values. But actually an ever greater range of works is being reproduced, in ever greater numbers, while the technical conditions of reproduction are influencing the choice of the works selected. Also, their diffusion is furthered by an ever subtler and more comprehensive outlook, whose effect is often to substitute for the obvious masterpiece the significant work, and for the mere pleasure of the eye the surer one of knowledge. An earlier generation thrived on Michelangelo; now we are given photographs of lesser masters, likewise of folk paintings and arts hitherto ignored: in fact everything that comes into line with what we call a style is now being photographed.

For while photography is bringing a profusion of masterpieces to the artists, these latter have been revising their notion of what it is that makes the masterpiece.

From the sixteenth to the nineteenth century the masterpiece was a work that existed 'in itself', an absolute. There was an accepted canon preconizing a mythical yet fairly well-defined beauty, based on what was thought to be the legacy of Greece. The work of art constantly aspired towards an ideal portrayal; thus, for Raphael, a masterpiece was a work on which the imagination could not possibly improve. There was little question of comparing such a work with others by the same artist. Nor was it given a place in Time; its place was determined by its success in approximating to the ideal work it adumbrated.

[. . .] the Museum without Walls, thanks to the mass of works its sets before us, frees us from the necessity of [a] tentative approach to the past; by revealing a style in its entirety – just as it displays an artist's work in its entirety – it forces both to become *positive*, actively significant. To the question 'What is a masterpiece?' neither museums nor reproductions give any definitive answer, but they raise the question clearly; and, provisionally, they define the masterpiece not so much by

comparison with its rivals as with reference to the 'family' to which it belongs. Also, since reproduction, though not the cause of our intellectualization of art, is its chief instrument, the devices of modern photography (and some chance factors) tend to press this intellectualization still farther.

Thus the angle from which a work of sculpture is photographed, the focussing and, above all, skilfully adjusted lighting may strongly accentuate something the sculptor merely hinted at. Then, again, photography imparts a family likeness to objects that have actually but slight affinity. With the result that such different objects as a miniature, a piece of tapestry, a statue and a medieval stained-glass window, when reproduced on the same page, may seem members of the same family. They have lost their colors, texture and relative dimensions (the statue has also lost something of its volume); each, in short, has practically lost what was specific to it – but their common style is by so much the gainer.

There is another, more insidious, effect of reproduction. In an album or art book the illustrations tend to be of much the same size. Thus works of art lose their relative proportions; a miniature bulks as large as a full-size picture, a tapestry or a stained-glass window. The art of the Steppes was a highly specialized art; yet, if a bronze or gold plaque from the Steppes be shown above a Romanesque bas-relief, in the same format, it becomes a bas-relief. In this way reproduction frees a style from the limitations which made it appear to be a minor art.

Indeed reproduction (like the art of fiction, which subdues reality to the imagination) has created what might be called 'fictitious' arts, by systematically falsifying the scale of objects; by presenting oriental seals the same size as the decorative reliefs on pillars, and amulets like statues. As a result, the imperfect finish of the smaller work, due to its limited dimensions, produces in enlargement the effect of a bold style in the modern idiom. [. . .]

In the realm of what I have called fictitious arts, the fragment is king. Does not the *Niké of Samothrace* suggest a Greek style divergent from the true Greek style? In Khmer statuary there were many admirable heads on conventional bodies; those heads, removed from the bodies, are now the pride of the Guimet Museum. Similarly the body of the *St. John the Baptist* in the Rheims porch is far from bearing out the genius we find in the head, when isolated. Thus by the angle at which it is displayed, and with appropriate lighting, a fragment or detail can tell out significantly, and become, in reproduction, a not unworthy denizen of our Museum without Walls. To this fact we owe some excellent art-albums of primitive landscapes culled from miniatures and pictures; Greek vase paintings displayed like frescoes; and the lavish use in modern monographs of the expressive detail. Thus, too, we now can see Gothic figures in isolation from the teeming profusion of the cathedrals, and Indian art released from the luxuriance of its temples and frescoes; for the Elephanta caves, as a whole, are very different from their Mahesamurti, and those of Ajanta from the 'Fair Bodhisattva.' In isolating the fragment the art book sometimes brings about a metamorphosis (by enlargement); sometimes it reveals new beauties (as when the landscape in a Limbourg miniature is isolated, so as to be compared with others or to present it as a new, independent work of art); or, again, it may throw light on some moot point. Thus, by means of the

xxxiv) "Sumerian art (early third millennium BC): 'Demon' [Musée du Louvre, Paris]", photograph and original caption from André Malraux, *The Voices of Silence*, 1953, p. 27.

xxxv) Detail of plate xxxiv, photograph from André Malraux, *The Voices of Silence*, 1953, p. 29.

fragment, the photographer instinctively restores to certain works their due place in the company of the Elect – much as in the past certain pictures won theirs, thanks to their 'Italianism.'

Then, again, certain coins, certain objects, even certain recognized works of art have undergone a curious change and become subjects for admirable pho-tographs. In much the same way as many ancient works owe the strong effect they make on us to an element of mutilation in what was patently intended to be a per-fect whole, so, when photographed with a special lighting, lay-out and stress on certain details, ancient works of sculpture often acquire a quite startling, if spuri-ous, modernism.

Classical aesthetic proceeded from the part to the whole; ours, often pro-ceeding from the whole to the fragment, finds a precious ally in photographic reproduction.

[. . .]

Tapestry which, owing to its decorative functions, was so long excluded from objective contemplation and whose color shared with stained glass the right of diverging from the natural colors of its subjects, is becoming, now that reproduc-tion obliterates its texture, a sort of modern art. Thus we respond to its 'script' (more obvious than that of pictures), to the scrollwork of the Angers *Apocalypse*, to the quasi-xylographic flutings of fifteenth-century figures, to the *Lady with the Unicorn* and its faint damascenings. For any refusal to indulge in illusionist realism appeals to the modern eye. The oldest tapestries, with their contrasts of night-blues and dull reds, with their irrational yet convincing colors, link up with the great Gothic plain-song. Minor art though it be, tapestry can claim a place in our Museum without Walls, where the Angers *Apocalypse* figures between Irish illumination and the Saint-Savin frescoes.

But the stained-glass window is to play a far more important part in our resus-citations.

[. . .]

Reproduction has disclosed the whole world's sculpture. It has multiplied accepted masterpieces, promoted other works to their due rank and launched some minor styles – in some cases, one might say, invented them. It is introduc-ing the language of color into art history; in our Museum without Walls picture, fresco, miniature and stained-glass window seem of one and the same family. For all alike – miniatures, frescoes, stained glass, tapestries, Scythian plaques, pictures, Greek vase paintings, 'details' and even statuary – have become 'colorplates.' In the process they have lost their properties as *objects*; but, by the same token, they have gained something: the utmost significance as to *style* that they can possibly acquire. It is hard for us clearly to realize the gulf between the performance of an Aeschylean tragedy, with the instant Persian threat and Salamis looming across the Bay, and the effect we get from reading it; yet, dimly albeit, we feel the difference. All that remains of Aeschylus is his genius. It is the same with figures that in reproduction lose both their original significance as objects and their function (religious or other); we see them only as works of art and they bring home to us only their makers' talent. We might almost call them not 'works' but 'moments'

of art. Yet diverse as they are, all these objects [. . .] speak for the same endeavor; it is as though an unseen presence, the spirit of art, were urging all on the same quest, from miniature to picture, from fresco to stained-glass window, and then, at certain moments, it abruptly indicated a new line of advance, parallel or abruptly divergent. Thus it is that, thanks to the rather specious unity imposed by photographic reproduction on a multiplicity of objects, ranging from the statue to the bas-relief, from bas-reliefs to seal-impressions, and from these to the plaques of the nomads, a 'Babylonian style' seems to emerge as a real entity, not a mere classification – as something resembling, rather, the life-story of a great creator. Nothing conveys more vividly and compellingly the notion of a destiny shaping human ends than do the great styles, whose evolutions and transformations seem like long scars that Fate has left, in passing, on the face of the earth.

[. . .] Thus it is that these imaginary super-artists we call styles, each of which has an obscure birth, an adventurous life, including both triumphs and surrenders to the lure of the gaudy or the meretricious, a death-agony and a resurrection, come into being. Alongside the museum a new field of art experience, vaster than any so far known (and standing in the same relation to the art museum as does the reading of a play to its performance, or hearing a phonograph record to a concert audition), is now, thanks to reproduction, being opened up. And this new domain – which is growing more and more intellectualized as our stock-taking and its diffusion proceeds and methods of reproduction come nearer to fidelity – is for the first time the common heritage of all mankind.

vii) Pierre Bourdieu and Alain Darbel with Dominique Schnapper, from *The Love of Art: European Art Museums and their Public* (1969)

Pierrie Bourdieu, Professor of Sociology at the Collège de France, Paris, and his collaborator, Alain Darbel, present here a sociological analysis of museum-visiting based on research conducted in the mid-1960s (the book was first published in French in 1969). Their work, therefore, largely predates the improvement of educational services and other facilities for museum visitors during the late twentieth century. While their analysis needs to be modified in the light of these developments, it is not simply invalidated by them. Bourdieu and Darbel start by demonstrating that attendance at art museums is dominated by well-educated members of the most privileged sections of society. Their central argument is that aesthetic pleasure is not a spontaneous experience, requiring only an innate capacity for visual perception, as it is conventionally supposed to be, but, on the contrary, contingent on the individual's prior knowledge of the relevant artistic codes. Visitors with a high degree of 'artistic competence' are able to adopt an appropriately aesthetic mode of looking, perceiving works of art in terms of their stylistic features, whereas uninitiated visitors are only able to refer what they see to their experience of everyday life. Although museum-visiting is shown to be

closely associated with academic qualifications, it does not follow that what Bourdieu terms 'cultural capital' (a form of social prestige based on a knowledge of high culture) is transmitted only or even primarily through formal education; children who are taken by their affluent, art-loving parents to visit museums and exhibitions acquire the same tastes and habits. On the basis of these findings, Bourdieu and Darbel develop a critique of the very notion of art as a transcendent quality, existing over and above society. According to them, both 'art' and the museums devoted to it are fundamentally ideological institutions, operating to consecrate existing cultural and social distinctions: 'in the tiniest details of their morphology and their organization, museums betray their true function, which is to reinforce for some the feeling of belonging and for others the feeling of exclusion' (*The Love of Art*, p. 112). (All footnotes have been omitted.) [EB]

Source: Pierre Bourdieu and Alain Darbel with Dominique Schnapper, *The Love of Art: European Art Museums and their Public*, trans. Caroline Beattie and Nick Merriman, Polity Press, 1991, pp. 37–9, 47–9, 53–5, 69–70

Statistics show that access to cultural works is the privilege of the cultivated class; however, this privilege has all the outward appearances of legitimacy. In fact, only those who exclude themselves are ever excluded. Given that there is nothing more accessible than museums and the economic obstacles that can be seen at work in other spheres count for little here, it seems quite justified to invoke the natural inequality of 'cultural needs'. However, the self-destructive nature of this ideology is obvious. If it is indisputable that our society offers to all the *pure possibility* of taking advantage of the works on display in museums, it remains the case that only some have the *real possibility* of doing so. Aspiration to cultural practice varies in the same way that cultural practice does and 'cultural need' increases the more it is satisfied, the absence of practice being accompanied by an absence of awareness of this absence. The wish to take advantage of museums can be fulfilled as soon as it exists, so it must be concluded that such a wish only exists if it is being fulfilled. Objects are not rare, but the propensity to consume them is, that 'cultural need' which, in contrast to 'primary needs', is the result of education. It follows that inequalities with regard to cultural works are only one aspect of inequalities in school, which creates the 'cultural need' at the same time as it provides the means of satisfying it.

 In addition to visiting and its patterns, all visitors' behaviour, and all their attitudes to works on display, are directly and almost exclusively related to education, whether measured by qualifications obtained or by length of schooling. Thus the average time actually spent on a visit, which can be taken as a good index of the objective value given to the works on display, whatever the corresponding subjective experience might be (aesthetic pleasure, cultural goodwill, sense of duty or a mixture of all of these) increases in proportion to the amount of education received, from 22 minutes for working-class visitors, to 35 minutes for middle-class visitors and 47 minutes for upper-class visitors. [. . .]

 The time a visitor devotes to contemplating the works on display, in other words the time needed for him or her to 'exhaust' the meanings proposed to him

or her, is without doubt a useful indication of his or her ability to decipher and appreciate these meanings, the inexhaustibility of the 'message' means that the richness of 'reception' (measured, roughly, by its length) depends primarily on the competence of the 'receiver', in other words on the degree to which he or she can master the code of the 'message'. Each individual possesses a defined and limited capacity for apprehending the 'information' proposed by the work, this capacity being a function of his or her overall knowledge (itself a function of education and background) of the generic code of the type of message under consideration, be it painting as a whole, or the paintings of a certain period, school or painter. When the message exceeds the limits of the observer's apprehension, he or she does not grasp the 'intention' and loses interest in what he or she sees as a riot of colours without rhyme or reason, a play of useless patches of colour. In other words, faced with a message which is too rich, or as information theory says, 'overwhelming', the visitor feels 'drowned' and does not linger.

[. . .]

Those to whom the works of high culture speak a foreign language are condemned to bring to their perception and appreciation of works of art extrinsic categories and values, those which organize their everyday perception and guide their practical judgements. As they cannot apprehend the representation in a truly aesthetic manner they do not see the colour of a face as one element in a system of relationships between the colours (those of the jacket, the hat, or the wall in the background), but, 'placing themselves immediately in its meaning' (to evoke Husserl), they directly read into it a psychological or physiological meaning, as they do in everyday experience. Conception of the picture as a system of opposing and complementary relationships between the colours presupposes not only a break with the primary perception which is the condition and constitution of the work of art as work of art – that is to say, of the conception of this work according to an intention consonant with its objective intention (irreducible to the intention of the artist) – but also presupposes possession of the analytical framework essential for understanding the subtle differences which separate, for example, a range of colours organized according to the rules of a sophisticated modulation in a painting by Turner or Bonnard.

This is why, therefore, aesthetics can only be, except in certain cases, a dimension of the ethics (or, better, the ethos) of class. In order to 'taste', that is 'to differentiate and appreciate' the works on display and in order to understand them and give them value, the uncultivated visitor can only invoke the quality and quantity of the work put into them, with moral respect taking the place of aesthetic admiration:

> It's important to show the value of everything here, because it's the work of centuries . . . If they've preserved all this, it's to show the work done over hundreds of years, and that everything you do isn't a waste of time.
> I really appreciate the skill of the work.
> To appreciate a painting, I always read everything on the label, such as the date, and I'm amazed when it was a long time ago and they did such good work then.

One of the surest and most infallible reasons given for bestowing positive admiration on a painting is without doubt its age:

> It's very good . . . it's really old. Maybe there should be museums with modern stuff in them, but it wouldn't be a proper museum. Here, there's really old things, isn't there?

After all, is not the value of old things demonstrated by the sole fact that they have been preserved, and is not the antiquity of the things preserved sufficient to justify their preservation? Here the comment serves no other function than to provide the individual who makes it with the reasons for an unconditional support for a work whose meaning escapes him or her. Is it not significant that, when the least cultivated visitors are invited to offer their opinion on the works and their presentation, they give them their total and wholehearted approval, which is only another way of expressing a confusion commensurate with their reverence.

> It's very good. You couldn't present them any better than they are now.
> I thought everything was very nice.

In the same way, the less cultivated the visitors, the more likely they are to feel the entrance fee is good value, as if by doing this they wanted to show that they know how to appreciate what the museum offers them at its true worth.

How can a perception so lacking in organizing principles apprehend the organized meanings comprising a body of cumulative knowledge?

> Trying to remember is something else. I didn't understand Picasso; I can never remember names. (shopkeeper, Lens)
> I like all pictures with Christ in them. (industrial manual worker, Lille)

Two-thirds of the working-class visitors cannot cite, at the end of their visit, the name of one work or one artist which they liked, any more than they retain from a previous visit knowledge which could help them in their present visit. It is also clear that a visit, often made by chance, is not enough to induce or prepare them to undertake another visit. Totally reliant on the museum and the aids it provides, they are particularly out of their depth in museums which deliberately address themselves to the cultivated public. 77 per cent of them would like the help of a guide or a friend, 67 per cent would like the visit to be signposted with arrows, and 89 per cent would like the works to be supplemented by explanatory panels More than half of the opinions they expressed voiced this wish:

> It's hard for someone who wants to take an interest. You only see paintings and dates. To be able to see the differences between things, you need a guidebook. Otherwise, everything looks the same. (manual worker, Lille)
> I prefer to visit the museum with a guide who explains and helps ordinary mortals understand the obscure points. (office worker, Pau)

Working-class visitors occasionally see, in the absence of any information which might make their visit easier, evidence of a desire to exclude through esotericism, or if not, as the more cultivated visitors are more willing to suggest, a commercial intent (in other words to promote the sale of catalogues). In fact,

arrows, notices, guidebooks, guides or receptionists would not really make up for a lack of education, but they would proclaim, simply by existing, the right to be uninformed, the right to be there and uninformed, and the right of uniformed people to be there: they would help to minimize the apparent inaccessibility of the works and of the visitors' feeling of unworthiness which is well expressed by this comment heard at the château of Versailles: 'This château wasn't built for ordinary people, and nothing has changed.'

[. . .]

It is probably not excessive to suggest that the profound feeling of unworthiness (and of incompetence) which haunts the least cultivated visitors as if they were overcome with respect when confronted with the sacred universe of legitimate culture, contributes in no small way towards keeping them away from museums. Is it not significant that the proportion of visitors who exhibit the most reverential attitude to museums decreases very sharply with higher social position (79 per cent of members of the working classes associate the museum with a church compared with 49 per cent of the middle classes and 35 per cent of the upper classes), while the proportion of individuals wishing that there were fewer visitors increases (39 per cent of the working classes, 67 per cent of the middle classes, and 70 per cent of the upper classes), preferring the intimacy of the chapel to the bustle of the church?

Is it not also significant that hostility towards efforts to make works of art more accessible is mostly encountered amongst members of the cultivated class? Paradoxically, it is the classes most equipped with personal aids to visiting such as guidebooks and catalogues (because knowledge of these instruments and of the art of using them is a matter of culture) who most often reject the institutional and collective aids:

[. . .]

> I remember with nostalgia the old Salon Carré in the Louvre, where there were so many things to discover. Now, they deprive us of the intense pleasure of discovery and compartmentalize all the paintings. We're forced to look at just one thing. Visiting is no longer a celebration but like going to primary school. With this pedantic trinity, see all, understand all, know all, all enjoyment disappears. (teacher, Lille)

[. . .]

Is it surprising that the ideology of the natural gift and of the fresh eye should be equally widespread amongst the most cultivated visitors and most curators, or that experts in the academic analysis of art are so often reluctant to provide for the non-initiated the equivalent of, or a substitute for, the programme of informed perception which they carry with them and which constitutes their culture? If the charismatic ideology, which makes an encounter with a work of art the occasion of a descent of grace (*charisma*), provides the privileged with the most 'indisputable' justification for their cultural privilege, while making them forget that the perception of the work of art is necessarily informed and therefore learnt, working-class visitors are well placed to appreciate that the love of art is not love at first sight but is born of long familiarity:

Yes, love at first sight does exist, but for that you've got to have read stuff before, especially for modern painting. (industrial manual worker, Lille)

[. . .]

The charismatic ideology opposes the authentic experience of the work of art as 'affection' of the heart or immediate intuitive experience, with the painstaking steps of logical understanding and its cold commentaries, while ignoring the social and cultural conditions which make such an experience possible, and while at the same time treating the virtuosity acquired through a long process of familarization, or through the disciplines of a methodical apprenticeship, as a natural gift. In contrast to this, sociology establishes, both logically and experimentally, that an adequate understanding of a work of culture, and especially of high culture, presupposes, by virtue of an act of decipherment, possession of the cipher in which the work is encoded. Culture, in the objective sense of cipher (or code), is a precondition for the intelligibility of the concrete meaning systems it organizes while remaining irreducible to them, as language is to speech, while culture, in the sense of competence, is nothing other than culture (in the objective sense) internalized and transformed into a permanent and generalized disposition to decipher cultural objects and behaviour using the cipher in which they are encoded. In the particular case of works of high culture, complete mastery of the code cannot be acquired by the simple and diffuse training of everyday experience, but presupposes methodical coaching, organized by an institution specifically designed for this purpose. It follows that understanding a work of art depends, in its intensity, modality, and even its existence, on the viewer's mastery of the generic and specific code of the work (in other words, on his or her artistic competence), and that it derives partly from learning at school. The value, intensity and modality of pedagogic communication, which is, among other things, responsible for transmitting the code of works of high culture (at the same time as passing on the code in which this communication is made), are themselves functions of the culture (as a system of schemes of perception, appreciation, thought and action, historically constituted and socially conditioned) that the receiver owes to his or her family background, and this varies in its congruence, both in its content and in its attitude to works of high culture or to the cultural training implied by it, with the high culture transmitted by schooling and with the linguistic and cultural models by which schooling effects this transmission. Given that direct experience of works of high culture, and the institutionally organized acquisition of the culture necessary for the appropriate experience of these works, are subject to the same rules, the difficulty of breaking the circle which ensures that cultural capital reproduces cultural capital becomes clear: the school only has to let the objective mechanisms of cultural diffusion run their course and refrain from working systematically to provide everyone, in and through the educational message itself, with the instruments necessary for an adequate reception of the academic message, for initial inequalities to be intensified and for the transmission of cultural capital to be legitimated by its sanction.

viii) Guy Debord, from *The Society of the Spectacle* (1967)

Guy Debord (1931–94) was a central figure in the Situationist International, a group of artists and political activists operating in Paris, and elsewhere, from 1957 until 1972 when it was disbanded. *The Society of the Spectacle* was the main theoretical statement of the Situationists. In this book Debord draws upon the work of Karl Marx and subsequent Marxist thinkers to argue that the production and consumption of commodities have developed, in modern capitalist society, to such an extent that life is lived in, and through, a series of images. Debord describes the social relationships between people established by these images as 'the spectacle'. Unlike many subsequent thinkers, Debord believed that the spectacle was rooted in the economic inequalities of society. This book, in which Debord undertook a sustained examination of the way in which this mystificatory condition was produced and sustained, is best understood as part of a project to find an appropriate revolutionary strategy with which to challenge capitalism at this stage of its development. Situationist ideas had a substantial impact on the radical student movement of the 1960s with slogans such as: 'Live Your Dreams', 'Let us be realistic and demand the impossible', 'Beneath the cobble stones, the beach'. More recently Debord's book, and the more general ideas of the Situationists, have had a major influence on the analysis of contemporary culture. For those who are unfamiliar with Marxist philosophy, this is a difficult text that is composed of a series of dialectical meditations. [SE]

Source: Guy Debord, from *The Society of the Spectacle* (1967), trans. Donald Nicholson-Smith, Zone Books, 1994, pp. 12–13, 16, 23–4, 29–30

1 THE WHOLE LIFE of those societies in which modern conditions of production prevail presents itself as an immense accumulation of *spectacles*. All that once was directly lived has become mere representation.

2 IMAGES DETACHED FROM every aspect of life merge into a common stream, and the former unity of life is lost forever. Apprehended in a *partial* way, reality unfolds in a new generality as a pseudo-world apart, solely as an object of contemplation. The tendency toward the specialization of images-of-the-world finds its highest expression in the world of the autonomous image, where deceit deceives itself. The spectacle in its generality is a concrete inversion of life, and, as such, the autonomous movement of non-life.

3 THE SPECTACLE APPEARS at once as society itself, as a part of society and as a means of unification. As a part of society, it is that sector where all attention, all consciousness, converges. Being isolated – and precisely for that reason – this sector is the locus of illusion and false consciousness; the unity it imposes is merely the official language of generalized separation.

4 THE SPECTACLE IS NOT a collection of images; rather, it is a social relationship between people that is mediated by images.

5 THE SPECTACLE CANNOT be understood either as a deliberate distortion of the visual world or as a product of the technology of the mass dissemination of

images. It is far better viewed as a weltanschauung[1].that has been actualized, translated into the material realm – a world view transformed into an objective force.

6 UNDERSTOOD IN ITS TOTALITY, the spectacle is both the outcome and the goal of the dominant mode of production. It is not something *added* to the real world – not a decorative element, so to speak. On the contrary, it is the very heart of society's real unreality. In all its specific manifestations – news or propaganda, advertising or the actual consumption of entertainment – the spectacle epitomizes the prevailing model of social life. It is the omnipresent celebration of a choice *already made* in the sphere of production, and the consummate result of that choice. In form as in content the spectacle serves as total justification for the conditions and aims of the existing system. It further ensures the *permanent presence* of that justification, for it governs almost all time spent outside the production process itself.

7 THE PHENOMENON OF SEPARATION is part and parcel of the unity of the world, of a global social praxis that has split up into reality on the one hand and image on the other. Social practice, which the spectacle's autonomy challenges, is also the real totality to which the spectacle is subordinate. So deep is the rift in this totality, however, that the spectacle is able to emerge as its apparent goal. The language of the spectacle is composed of *signs* of the dominant organization of production – signs which are at the same time the ultimate end-products of that organization.

[. . .]

15 AS THE INDISPENSABLE PACKAGING for things produced as they are now produced, as a general gloss on the rationality of the system, and as the advanced economic sector directly responsible for the manufacture of an ever-growing mass of image-objects, the spectacle is the *chief product* of present-day society.

16 THE SPECTACLE SUBJECTS living human beings to its will to the extent that the economy has brought them under its sway. For the spectacle is simply the economic realm developing *for itself* – at once a faithful mirror held up to the production of things and a distorting objectification of the producers.

17 AN EARLIER STAGE in the economy's domination of social life entailed an obvious downgrading of *being* into *having* that left its stamp on all human endeavor. The present stage, in which social life is completely taken over by the accumulated products of the economy, entails a generalized shift from *having* to appearing: all effective 'having' must now derive both its immediate prestige and its ultimate raison d'être from appearances. At the same time all individual reality, being directly dependent on social power and completely shaped by that power, has assumed a social character. Indeed, it is only inasmuch as individual reality *is not* that it is allowed to *appear*.

[. . .]

30 THE SPECTATOR'S ALIENATION from and submission to the contemplated object (which is the outcome of his unthinking activity) works like this: the more he contemplates, the less he lives; the more readily he recognizes his own needs in the images of need proposed by the dominant system, the less

he understands his own existence and his own desires. The spectacle's exter-
nality with respect to the acting subject is demonstrated by the fact that the
individual's own gestures are no longer his own, but rather those of someone
else who represents them to him. The spectator feels at home nowhere, for
the spectacle is everywhere.

31 WORKERS DO NOT produce themselves: they produce a force independent of
themselves. The *success* of this production, that is, the abundance it generates,
is experienced by its producers only as an *abundance of dispossession.* All time,
all space, becomes *foreign* to them as their own alienated products accumu-
late. The spectacle is a map of this new world – a map drawn to the scale of
the territory itself. In this way the very powers that have been snatched from
us reveal themselves to us in their full force.

32 THE SPECTACLE'S FUNCTION in society is the concrete manufacture of alien-
ation. Economic growth corresponds almost entirely to the growth of this
particular sector of industrial production. If something *grows* along with the
self-movement of the economy, it can only be the alienation that has inhab-
ited the core of the economic sphere from its inception.

33 THOUGH SEPARATED FROM his product, man is more and more, and ever more
powerfully, the producer of every detail of his world. The closer his life comes
to being his own creation, the more drastically is he cut off from that life.

34 THE SPECTACLE IS *capital* accumulated to the point where it becomes image.
[. . .]

42 THE SPECTACLE CORRESPONDS to the historical moment at which the
commodity completes its colonization of social life. It is not just that the
relationship to commodities is now plain to see – commodities are now all
that there is to see; the world we see is the world of the commodity. The
growth of the dictatorship of modern economic production is both exten-
sive and intensive in character. In the least industrialized regions its presence
is already felt in the form of imperialist domination by those areas that lead
the world in productivity. In these advanced sectors themselves, social space
is continually being blanketed by stratum after stratum of commodities.
With the advent of the so-called second industrial revolution, alienated con-
sumption is added to alienated production as an inescapable duty of the
masses. The *entirety of labor sold* is transformed overall into the *total com-
modity.* A cycle is thus set in train that must be maintained at all costs: the
total commodity must be returned in fragmentary form to a fragmentary
individual completely cut off from the concerted action of the forces of pro-
duction. To this end the already specialized science of domination is further
broken down into specialties such as sociology, applied psychology, cyber-
netics, semiology and so on, which oversee the self-regulation of every phase
of the process.

[. . .]

NOTE

1 A world view or overarching ideology. [SE]

ix) David Harvey, from *The Urban Experience* (1989)

David Harvey is Professor of Geography at Johns Hopkins University, Baltimore, a
labour organizer and Marxist theorist. He is best known for his book *The Condition of
Postmodernity* (1989), which seeks to explain recent cultural shifts in terms of political
and economic developments, which are summarized as 'the emergence of more flex-
ible modes of capitalist accumulation'. This analysis develops out of, and draws on,
his earlier work on cities and capitalism, which was published as *The Urban Experience*
in 1989. Harvey discerns a fundamental connection between the emergence of a
postmodern approach to urban design, exemplified by the proliferation of big,
glossy shopping malls, and increasing competition between cities since the early
1970s in order to secure investment from international capitalism and the 'consump-
tion dollars' of the rich. To this end cities invest in tourist attractions and other facil-
ities that could enhance their 'quality of life'. Drawing on Bourdieu's concept of
'symbolic (or 'cultural') capital', Harvey argues that these trends have had the effect
of making taste and lifestyle even more important indicators of social status than ever
before. His main concern, however, as we can see from the extract included here, is
to develop a critique of postmodern urban culture on the grounds that it reinforces
social inequalities, leaving many people worse off than before. In so doing, he makes
reference to the ancient Roman policy usually referred to as 'bread and circuses',
which he reinterprets through the concept of spectacle formulated by Debord.
Although Harvey is writing here specifically about cities in the United States and is
primarily concerned with overtly commercial developments, his arguments are per-
tinent to the growing reliance on art museums, galleries, etc., as a means of urban
regeneration in many different countries. (References have been omitted.) [EB]

Source: David Harvey, *The Urban Experience*, Blackwell, 1989, pp. 260–1, 270–3

[. . .]
First, inter-urban competition has opened spaces within which the new and more
flexible labor processes could be more easily implanted and opened the way to much
more flexible currents of geographical mobility than was the case before 1973.
Concern for a favorable 'business climate', for example, has pushed urban govern-
ments to all kinds of measures (from wage-disciplining to public investments) in
order to attract economic development, but in the process has lessened the cost of
change of location to the enterprise. Much of the vaunted 'public-private partner-
ship' of today amounts to a subsidy for affluent consumers, corporations, and
powerful command functions to stay in town at the expense of local collective con-
sumption for the working class and the impoverished. Secondly, urban governments
have been forced into innovation and investment to make their cities more
attractive as consumer and cultural centers. Such innovations and investments (con-
vention centers, sports stadia, disney-worlds, down-town consumer paradises, etc.)
have quickly been imitated elsewhere. Inter-urban competition has thus generated
leap-frogging urban innovations in life-style, cultural forms, products, and even
political, and consumer based innovation, all of which has actively promoted the

transition to flexible accumulation. And herein, I shall argue, lies part of the secret of the passage to post-modernity in urban culture.

This connection can be seen in the radical reorganization of the interior spaces of the contemporary US city under the impulsions of inter-urban competition. [. . .]

THE MOBILIZATION OF THE SPECTACLE

'Bread and Festivals' was the ancient Roman formula for social pacification of the restless plebs. The formula has been passed on into capitalist culture through, for example, Second Empire Paris, where festival and the urban spectacle became instruments of social control in a society riven by class conflict.

Since 1972, the urban spectacle has been transformed from counter-cultural events, anti-war demonstrations, street riots and the inner-city revolutions of the 1960s. It has been captured as both a symbol and instrument of community unification under bourgeois control in conditions where unemployment and impoverishment have been on the rise and objective conditions of class polarization have been increasing. As part of this process, the modernist penchant for monumentality – the communication of the permanence, authority, and power of the established capitalist order – has been challenged by an 'official' post-modernist style that explores the architecture of festival and spectacle, with its sense of the ephemeral, of display, and of transitory but participatory pleasure. The display of the commodity became a central part of the spectacle, as crowds flock to gaze at them and at each other in intimate and secure spaces like Baltimore's Harbor Place, Boston's Faneuil Hall, and a host of enclosed shopping malls that sprung up all over America. Even whole built environments became centerpieces of urban spectacle and display.

The phenomenon deserves more detailed scrutiny than I here can give. It fits, of course, with urban strategies to capture consumer dollars to compensate for de-industrialization. Its undoubted commercial success rests in part on the way in which the act of buying connects to the pleasure of the spectacle in secured spaces, safe from violence or political agitation. Baltimore's Harbor Place combines all of the bourgeois virtues that [Walter] Benjamin attributed to the [shopping] arcades of nineteenth century Paris with the sense of the festival that attached to world expositions, 'places of pilgrimage to the fetish Commodity.' Debord would take it further: 'the spectacle is the developed modern complement of money where the totality of the commodity world appears as a whole, as a general equivalence for what the entire society can be and can do.' To the degree that the spectacle becomes 'the common ground of deceived gaze and of false consciousness,' so it can also present itself as 'an instrument of unification'. Mayor Schaefer and the urban class alliance ranged behind him in Baltimore, have consciously used the spectacle of Harbor Place precisely in that way, as a symbol of the supposed unity of a class-divided and racially segregated city. Professional sports activities and events like the Los Angeles Olympic Games perform a similar function in an otherwise fragmented urban society.

Urban life, under a regime of flexible accumulation, has thus increasingly come to present itself an 'immense accumulation of spectacles.' American downtowns no longer communicate exclusively a monumental sense of power, authority, and corporate domination. They instead express the idea of spectacle and play. It is on this terrain of the spectacle that the break into the post-modern urban culture that has accompanied flexible accumulation has partially been fashioned, and it is in the context of such mediating images that the opposition of class consciousness and class practices have to unfold. But, as Debord observes, the spectacle 'is never an image mounted securely and finally in place; it is always an account of the world competing with others, and meeting the resistance of different, sometimes tenacious forms of social practice'.

URBAN STRESS UNDER FLEXIBLE ACCUMULATION

Flexible accumulation has had a serious impact upon all urban economies. The increasing entrepreneurialism of many urban governments (particularly those that emphasized 'public-private partnership') tended to reinforce it and the neocon-servativism and post-modernist cultural trends that went with it. The use of increasingly scarce resources to capture development meant that the social con-sumption of the poor was neglected in order to provide benefits to keep the rich and powerful in town. This was the switch in direction that President Nixon sig-nalled when he declared the urban crisis over in 1973. What that meant, of course, was the transmutation of urban stresses into new forms.

[. . .] A tension arose between increasing unemployment of workers in traditional occupations and the employment growth triggered by downtown revivals based on financial services and the organization of spectacle. A new and relatively affluent generation of professional and managerial workers, raised on the cultural discontents with modernism in the 1960s, came to dominate whole zones of inner city urban space seeking product differentiation in built environments, quality of life, and command of symbolic capital. The recuperation of 'history' and 'community' became essential selling gimmicks to the producers of built environ-ments. Thus was the turn to post-modernist styles institutionalized.

There are serious social and spatial stresses inherent in such a situation. To begin with, increasing class polarization (symbolized by the incredible surge in urban poverty surrounding islands of startling and conspicuous wealth) is inher-ently dangerous, and given the processes of community construction available to the poor, it also sets the stage for increasing racial, ethnic, religious, or simply 'turf' tensions. Fundamentally different class mechanisms for defining the spa-tiality of community come into conflict, thus sparking running guerilla warfare over who appropriates and controls various spaces of the city. The threat of urban violence, though not of the massive sort experienced in the 1960s, looms large. The breakdown of the processes that allow the poor to construct any sort of com-munity of mutual aid is equally dangerous since it entails an increase in individual anomie, alienation, and all of the antagonisms that derive thereform. The few who 'make it' through informal sector activity cannot compensate for the multitude

who won't. At the other end of the social scale, the search for symbolic capital introduces a cultural dimension to political economic tensions. The latter feed inter-class hostilities and prompt state interventions that further alienate low income populations (I am thinking, for example, of the way street corner youths get harassed in gentrifying neighborhoods). The mobilization of the spectacle has its unifying effects, but it is a fragile and uncertain tool for unification, and to the degree that it forces the consumer to become 'a consumer of illusions' contains its own specific alienations. Controlled spectacles and festivals are one thing but riots and revolutions can also become 'festivals of the people.'

But there is a further contradiction. Heightened inter-urban competition produces socially wasteful investments that contribute to rather than ameliorate the over-accumulation problem that lay behind the transition to flexible accumulation in the first place. Put simply, how many successful convention centers, sports stadia, disney-worlds, and harbor places can there be? Success is often short-lived or rendered moot by competing or alternative innovations arising elsewhere. Overinvestment in everything from shopping malls to cultural facilities makes the values embedded in urban space highly vulnerable to devaluation. Downtown revivals built upon burgeoning employment in financial and real estate services where people daily process loans and real estate deals for other people employed in financial services and real estate, depends upon a huge expansion of personal, corporate, and governmental debt. If that turns sour, the effects will be far more devastating than the dynamiting of Pruitt-Igoe[1] ever could symbolize [. . .]

Flexible accumulation, in short, is associated with a highly fragile patterning of urban investment as well as increasing social and spatial polarization of urban class antagonisms.

NOTE

1 The architectural theorist Charles Jencks designated the demolition, in 1972, of the Pruitt-Igoe housing development in St Louis [Missouri, USA] as the symbolic ending of modernist architecture and the shift towards postmodern practices. [EB]

x) Robert Hewison, from *The Heritage Industry: Britain in a Climate of Decline* (1987)

Robert Hewison is Professor of Literary and Cultural Studies at the University of Lancaster, and author of a series of books dealing with the arts in Britain and British cultural policy since the beginning of the Second World War. Although many of its concerns had previously been raised in Patrick Wright's *On Living in an Old Country* (1985), *The Heritage Industry* has played an important role in stimulating discussion in the contemporary debate on fascination with the past. Its central thesis has been challenged on the grounds that, far from testifying to a peculiarly British malaise, heritage is an international phenomenon which cannot

simply be explained in terms of national decline. As the term 'heritage industry' suggests, Hewison is also concerned with the commercialisation of the past and, in particular, with the way that 'real' manufacturing is being replaced by 'heritage centres' and museums commemorating the industrial past. In rejecting the idea that the provision of leisure facilities can offer a solution to fundamental economic problems, he adopts a position similar to Harvey (see text ix in this section). As the following extracts reveal, the heritage industry also accords a key role to the British (or rather English) 'country house', especially as it has been preserved and opened to the public by the National Trust. According to Hewison, 'the cult of the country house' typifies a pervasive nostalgia for a fantasy past that functions as a refuge from the grim present and also reveals the fundamentally ideological, anti-democratic character of heritage. Hewison's critics contend that his account of heritage overemphasises its manipulative aspects and fails to do justice to its genuine popular appeal. (Footnotes renumbered.) [EB]

Source: Robert Hewison, *The Heritage Industry: Britain in a Climate of Decline*, Methuen, 1987, pp. 9–10, 47, 53

[. . .]

The story of this book is of the growth of a new cultural force [. . .] I call it the 'heritage industry' not only because it absorbs considerable public and private resources, but also because it is expected more and more to replace the real industry upon which this country's economy depends. Instead of manufacturing goods, we are manufacturing *heritage*, a commodity which nobody seems able to define, but which everybody is eager to sell, in particular those cultural institutions that can no longer rely on government funds as they did in the past. Which means every single one, from the universities to the Arts Council.

The reason for the growth of this new force is suggested by my subtitle: whatever the true figures for production and employment, this country is gripped by the perception that it is in decline. The heritage industry is an attempt to dispel this climate of decline by exploiting the economic potential of our culture, and it finds a ready market because the perception of decline includes all sorts of insecurities and doubts (which are more than simply economic) that makes its products especially attractive and reassuring. Looking at a Laura Ashley catalogue, it is possible that we imagine ourselves living in a museum already.

At best, the heritage industry only draws a screen between ourselves and our true past. I criticise the heritage industry not simply because so many of its products are fantasies of a world that never was; not simply because at a deeper level it involves the preservation, indeed reassertion, of social values that the democratic progress of the twentieth century seemed to be doing away with, but because, far from ameliorating the climate of decline, it is actually worsening it. If the only new thing we have to offer is an improved version of the past, then today can only be inferior to yesterday. Hypnotised by images of the past, we risk losing all capacity for creative change.
[. . .]

Nostalgic memory should not be confused with true recall. For the individual, nostalgia filters out unpleasant aspects of the past, and of our former selves, creat-

ing a self-esteem that helps us to rise above the anxieties of the present. Collec-
tively, nostalgia supplies the deep links that identify a particular generation;
nationally it is the source of binding social myths. It secures, and it compensates,
serving, according to Davis, 'as a kind of safety valve for disappointment and frus-
tration suffered over the loss of prized values'.[1]

As the very act of publishing a sociology of nostalgia in 1979 implies, the nos-
talgic impulse has become significantly stronger in recent years. For Davis, 'the
nostalgia wave of the Seventies is intimately related – indeed, the other side of the
psychological coin, so to speak – to the massive identity dislocations of the Six-
ties.'[2] Writing in 1974 Michael Wood noted that 'the disease, if it is a disease, has
suddenly become universal.' He stressed the contemporary longing for the past.
'What nostalgia mainly suggests about the present is not that it is catastrophic or
frightening, but that it is undistinguished, unexciting, blank. There is no life in it,
no hope, no future (the important thing about the present is what sort of a future
it has). It is a time going nowhere, a time that leaves nothing for our imaginations
to do except plunge into the past.'[3] Nostalgia can be a denial of the future.

Yet it is also a means of coping with change, with loss, with *anomie*, and with
perceived social threat. It is around these unpleasant aspects of the present that our
ideas of the past begin to coalesce. In 1978 Sir Roy Strong wrote:

> It is in times of danger, either from without or from within, that we become
> deeply conscious of our heritage . . . within this word there mingle varied and
> passionate streams of ancient pride and patriotism, of a heroism in times past,
> of a nostalgia too for what we think of as a happier world which we have lost.
> In the 1940s we felt all this deeply because of the danger from without. In the
> 1970s we sense it because of the dangers from within. We are all aware of prob-
> lems and troubles, of changes within the structure of society, of the dissolution
> of old values and standards. For the lucky few this may be exhilarating, even
> exciting, but for the majority it is confusing, threatening and dispiriting. The
> heritage represents some form of security, a point of reference, a refuge perhaps,
> something visible and tangible which, within a topsy and turvy world, seems
> stable and unchanged. Our environmental heritage . . . is therefore a deeply
> stabilising and unifying element within our society.[4]

As this passage unconsciously reveals, nostalgia is profoundly conservative.
[. . .]

The impulse to preserve the past is part of the impulse to preserve the self. With-
out knowing where we have been, it is difficult to know where we are going. The past
is the foundation of individual and collective identify, objects from the past are the
source of significance as cultural symbols. Continuity between past and present cre-
ates a sense of sequence out of aleatory chaos and, since change is inevitable, a stable
system of ordered meanings enables us to cope with both innovation and decay. The
nostalgic impulse is an important agency in adjustment to crisis, it is a social emol-
lient and reinforces national identity when confidence is weakened or threatened.

The paradox, however, is that one of our defences against change is change
itself: through the filter of nostalgia we change the past, and through the

conservative impulse we seek to change the present. The question then is not whether or not we should preserve the past, but what kind of past we have chosen to preserve, and what that has done to our present.

[. . .] the peculiarly strong hold that such places [country houses] have on the British – though for once it seems more appropriate to say English – imagination. Because there has been no foreign invasion, civil war or revolution since the seventeenth century these houses both great and small represent a physical continuity which embodies the same adaptability to change within a respect for precedent and tradition that has shaped the common law. With a garden, a park and a greater or lesser estate, they enshrine the rural values that persist in a population that has been predominantly urban for more than a century. Some are works of art in themselves, but continuity, accumulation, even occasional periods of neglect, have meant that the furnishings and pictures of even minor houses have considerable historic and market value. [. . .]

The country house is the most familiar symbol of our national heritage, a symbol which, for the most part has remained in private hands. That it has done so is a remarkable achievement in the face of the egalitarian twentieth century. It may well be that the century is less egalitarian than it might have been, not because the buildings and their contents have survived, but because of the values they enshrine. They are not museums – that is the whole basis on which they are promoted – but living organisms. As such they do not merely preserve certain values of the past: hierarchy, a sturdy individualism on the part of their owners, privilege tempered by social duty, a deference and respect for social order on the part of those who service and support them. They reinforce these values in the present. It is true that in some of the grander buildings adjustments to the twentieth century have had to be made, but the middle-scale houses continue much as before. *The National Trust Book of the English House* stresses: 'Unlike the great houses they still serve the needs of modern life as well as they served the needs of their builders. Their appeal is that they can be lived in; they remain essentially private even when they are open to visitors.'[5]

Sir Roy Strong has captured the sense of privacy of these national institutions exactly:

> We glimpse the park gates as we hurtle down a road, or we sense, behind some grey, mouldering stone wall, the magic of a landscape planting. Majestic trees pierce the skyline and a profusion of shrubs leads the eye through the artificial landscape in successive tantalising vistas. Alerted, we strain our eyes for a brief, fleeting glimpse of some noble pile floating in the distance, either embraced within some hollow or standing proud on a prominence.

Yet in spite of this charged description of the scenic voyeur, Strong continues: 'The ravished eyes stir the heart to emotion, for in a sense the historic houses of this country belong to everybody, or at least everybody who cares about this country and its traditions.'[6]

Such is the power of the cult of the country house. A building that can only be glimpsed becomes the erotic object of desire of a lover locked out. Yet he seems

unaware of his exclusion. By a mystical process of identification the country house becomes the nation, and love of one's country makes obligatory a love of the country house. We have been re-admitted to paradise lost.

[. . .]

In the 1980s country houses have become more than ever symbols of continuity and security, as *The National Trust Book of the English House* (1985) reminds us: 'They look back to periods of apparent stability and order that, to some people, seem preferable to the chaos of the present.'[7] The National Trust's role as the guardian of this order has been acknowledged by its present director-general, Angus Stirling, who wrote in his 1985 report 'The concept of benefit deriving from the Trust's care of much of the country's finest landscape and buildings has special significance at this time, when the nation is so troubled by the effect of unemployment, the deprivation of inner cities and the rapidity of change in society.'[8]

Although the Country Landowners' Association and the Historic Houses Association now also exist as lobbies for the protection of private ownership, the Trust still sees its function as protecting owners as well as houses, as Stirling's report makes clear: 'The Trust prefers to see historic houses remain in the ownership of the families who cared for them in the past, and therefore continues actively to support legislation designed to make that possible. The fiscal climate for the private owner is at present somewhat better than it was ten years ago and it is reasonable to hope that the number of houses being offered to the Trust may reduce.'[9]

Throughout the post-war period the country house has retained a central position as one of the definitive emblems of the British cultural tradition – principally through appeals to its 'national' significance in the face of economic threat. The National Trust's commitment to the continued occupation of houses for whom it accepts responsibility by the families that formerly owned them has preserved a set of social values as well as dining chairs and family portraits. Some sixty National Trust properties retain accommodation of some kind for the family of their original donors. That these houses are therefore not perceived as museums is presented as a great virtue. The Trust's policy is to show objects 'in their natural setting and in the ambience of the past.'[10] But the 'ambience of the past' raises questions of definition and interpretation: a museum has as its objective not just the preservation of evidences of the past but the interpretation of that evidence to the present, yet this is precisely what the National Trust approach refuses to do.

Even when the facts of history mean that a house cannot be lived in because the line has died out, it is still presented, in the view of the Trust's chief expert on interior decoration in the Fifties and Sixties, so that it 'should look like one where the family had just gone out for the afternoon.'[11] This suggests that history is treated, not as a process of development and change, but something achieved on arrival at the present day. However scholarly the presentation of each item, there is an implicit decision to present the house and its history in the best possible light.[. . .]

Part of the magic of the country house is that the privilege of private ownership has become a question of national prestige. Those who have held on to their houses, and the majority of all country houses remain in private hands, have had to concede a greater degree of public access in exchange for tax exemptions and

repair grants, others have turned their historic houses into commercial enterprises, but the hierarchy of cultural values that created the country houses remains the same. Private ownership has been elided into a vague conception of public trusteeship. The Earl of March [. . .] has said of his successful enterprise at Goodwood House in Sussex: 'I never feel that I am the owner – only a steward for my lifetime, and not principally for the benefit of the family but for the whole community.'[12]

[. . .]

Imperceptibly, history is absorbed into heritage. But a heritage without a clear definition, floating on the larger frame of the present. The first annual report of the National Heritage Memorial Fund, for 1980–81 confronted the absence of any definition in the Act of Parliament that had set it up, and concluded that the question of definition was unanswerable:

> We could no more define the national heritage than we could define, say, beauty or art. Clearly, certain works of art, created by people born in this country were part of the national heritage – paintings by Turner and Constable, for instance, or sculptures by Henry Moore or Barbara Hepworth – as were buildings such as Chatsworth or Edinburgh Castle. But, beyond that, there was less assurance. So we decided to let the national heritage define itself. We awaited requests for assistance from those who believed they had a part of the national heritage worth saving . . .
>
> The national heritage of this country is remarkably broad and rich. It is simultaneously a representation of the development of aesthetic expression and a testimony to the role played by the nation in world history. The national heritage also includes the natural riches of Britain – the great scenic areas, the fauna and flora – which could so easily be lost by thoughtless development. Its potential for enjoyment must be maintained, its educational value for succeeding generations must be enriched and its economic value in attracting tourists to this country must be appreciated and developed. But this national heritage is constantly under threat.[13]

The thought process is revealing: a refusal to define the heritage is followed by a definition that embraces art, buildings and landscape, and then justifies its existence as an economic resource. But the key to the passage is that the heritage is something that is *under threat*. The threat is multiple: there is decay, the great fear of a nation that feels itself in decline; there is development, the great fear of a nation that cannot cope with change; there is foreign depredation, the great fear of a nation that is losing works of art it acquired from other nations in the past to economically more powerful nations like the United States and Japan.

And so we polish up a history that has been reselected and rewritten. The past is made more vivid than the present. It never rains in a heritage magazine. By the use of microchip technology the past is made more engrossing with slide presentations, taped sounds, film and ghost rides to the tenth century. The past becomes more homogeneous than the present, it becomes simply 'yesteryear'; if there is development it is 'progress' where continuity is discovered in the place of chance,

and where rooms and houses are restored to a uniform conception of a period, and objects are standardised by their display [. . .]

[. . .]

Had we more faith in ourselves, and were more sure of our values, we would have less need to rely on the images and monuments of the past. We would also find that, far from being useless except as a diversion from the present, the past is indeed a cultural resource, that the ideas and values of the past – as in the Renaissance – can be the inspiration for fresh creation. But because we have abandoned our critical faculty for understanding the past, and have turned history into heritage, we no longer know what to do with it, except obsessively preserve it. The more dead the past becomes, the more we wish to enshrine its relics.

Disconnected, it seems, from the living line of history by world war, and the successive strokes of modernisation and economic recession, we have begun to construct a past that, far from being a defence against the future, is a set of imprisoning walls upon which we project a superficial image of a false past, simultaneously turning our backs on the reality of history, and incapable of moving forward because of the absorbing fantasy before us.

[. . .]

NOTES

1 Fred Davis, *Yearning for Yesterday: A Sociology of Nostalgia*, Macmillan, 1979, p. 105.

2 Ibid., p. 105.

3 Michael Wood, 'Nostalgia of Never: You Can't Go Home Again', *New Society*, 7 November, 1974.

4 Roy Strong, introduction to Patrick Cormack, *Heritage in Danger* (second edition), Quartet, 1978, p. 10.

5 Clive Aslet and Alan Powers, *The National Trust Book of the English House*, Viking/National Trust, 1985, p. 8.

6 Roy Strong, *The Destruction of the Country House 1875–1975*, Thames & Hudson, 1974, p. 7.

7 Arthur Jones, *Britain's Heritage: The Creation of the National Heritage Memorial Fund*, Weidenfeld, 1985, p. 120.

8 National Trust, *Annual Report*, 1985, p. 4.

9 ibid., p. 6.

10 Robin Fedden, *The Continuing Purpose. A History of the National Trust, its Aims and Work*, Longman, 1968, p. 12.

11 John Cornforth 'John Fowler', *National Trust Studies 1979*, ed. G. Jackson-Stops, Sotheby Parke Bernet, 1978, p.40.

12 Quoted in *Heritage in Danger*, op.cit., p. 3.

13 Quoted in Arthur Jones, *Britain's Heritage*, op.cit., pp. 206–7.

Index

Due to the different conventions of the languages represented in this anthology, users are advised that if they cannot find an artist's or author's name under their second name, they should also look under their first name.